Creativity Class

Creativity Class

Art School and Culture Work in Postsocialist China

Lily Chumley

PRINCETON UNIVERSITY PRESS
Princeton and Oxford

Copyright © 2016 by Princeton University Press

Published by Princeton University Press,
41 William Street, Princeton, New Jersey 08540
In the United Kingdom: Princeton University Press,
6 Oxford Street, Woodstock, Oxfordshire OX20 1TR

press.princeton.edu

Jacket image, courtesy of the author

ISBN 978-0-691-16497-7

Library of Congress Control Number: 2016935712

British Library Cataloging-in-Publication Data is available

This book has been composed in Sabon Next LT Pro

Printed on acid-free paper ∞

Printed in the United States of America

1 3 5 7 9 10 8 6 4 2

CONTENTS

ILLUSTRATIONS

PREFACE

When I told my first roommate in Beijing that I was doing research on art students, she replied that they were not a good subject population for social science: not at all representative of "normal" Chinese people. I heard this often during my years of research. People in China, as elsewhere, often regard those who "do art" (*gao yishu*) as radically different from those who do not. Artists, designers, art teachers, and art students consider themselves—and are considered by others—to be unusual, bohemian, unconventional. But despite these claims of difference, the ordinary conditions of mainstream urban life form the parameters of art and design practice. And though relatively few people call themselves artists, many of those who do, occupy social positions that can hardly be called marginal, with influence on the circulation of culture and capital far beyond their numbers.

Most of the places you go and people you meet during years of fieldwork never come to serve as objects of analysis in ethnography. But for a project that sketches complex social formations in a very large country, an accounting of the sites that inform this text is necessary. The book is based on fieldwork in China from 2006 to 2008, mainly in Beijing and Jinan, as well as short visits to Qingdao, Zibo, Xi'an, Daqing, Wuhan, and Luohe. Field sites ranged from the institutional to the inchoate, the venerable to the fleeting, the public to the private (whether in terms of access or funding): galleries, museums, small private art test prep schools, art school entrance test grounds, art supply stores, art bookstores, art institutes, coffee shops, design firm offices, and living rooms. Some have since disappeared. Only a few of them—the academies, museums, established galleries, and large firms—had histories, in the sense of self-conscious narratives of becoming.

The same is true of my interlocutors. Some of the strongest voices in this book come from the established artists, successful designers, teachers, and school administrators with whom I conducted interviews, studio visits, and class observations—those with the most fully articulated biographical

narratives who appear under their real names. However, the culture workers I met were diverse in social role, status, income, lifestyle, ethics, and aesthetics. I spent most of my time with art students and recent art school graduates just beginning or still trying to develop narratives about their own creative personality in order to make a living, who appear with pseudonyms. Much of the analysis and commentary in this book is drawn from lunches at restaurants, dinners at home, chats in the studio; only some of these moments were caught on tape, and most appear in the book as I recorded them in my notebooks, during our conversations or immediately after.

In my years of fieldwork a great many people treated me very generously, guiding me around cities and through institutions and graciously helping to manage my gaps in comprehension. Artists, designers, and art professors offered not only extensive interviews, but also instruction and assistance. Students shared their stories with me. There were and are a lot of Americans and Europeans in the art and design scenes in Beijing, and many of the artists and designers I talked to recognized me as one of the foreigners who came to make money in China. When I protested that I was not, they told me I should become one. After all, wasn't it hard to find work in America?

I was fortunate to have affiliations with a series of prominent institutions, which in addition to offering invaluable resources and opportunities for research, gave credence to my story about being a researcher and a student. I was also fortunate to have friends who helped me find a series of residences that showed me various worlds beyond the institutions. In Beijing I spent the academic year 2006–7 as a language student at Tsinghua University's Inter-University Program for Chinese studies—with a grant from IUP—while working as a translator in a small art book publishing office, going to galleries and art exhibitions and independent music events, visiting art institutes and art test prep schools. I shared an apartment in the Zhongguancun technology area with a recent college graduate turned "little white collar" in a biotech firm. In 2007–8, I was a visiting scholar at the Central Academy of Fine Arts, and spent most of my time observing classes, participating in activities, and interviewing students and faculty. I also frequently visited other cities, especially Jinan, talking to artists, designers, students, visiting art institutes and art test prep schools. During this year and a half I lived in a narrow lane behind the Houhai tourist area, in a one-story (*ping fang*) cinderblock house, sharing an outdoor cooking and washing space with three migrant families from Heilongjiang province. I spent many evenings with a group of bohemian culture workers at a coffee shop in what was just becoming the trendy shopping street of Nanluoguxiang.

In the summer of 2008 I moved to the Huoying neighborhood, recently a rural suburb at the northernmost edge of the city, where the elderly neighbors planted corn and subdivided their houses to rent rooms to migrant laborers, their middle-aged children often driving taxis in the city, while old neighborhoods were torn down all around to accommodate new housing developments for the little white collars and *beipiao* (people who had come from elsewhere for work) who were being pushed out from the city center. Huoying had a large community of underemployed hipsters, artists, and musicians.

In the fall of 2008 I was a visiting scholar and lecturer at the Shandong Academy of Art and Design in Jinan, teaching and visiting classes and critiques, interviewing students and faculty, visiting studios, living in the foreign faculty dorms (which were chained shut at ten o'clock each evening, even before the student dorms were locked), and taking the faculty bus from the campus in the city to the suburban campus where the students lived and took their classes. In 2009, 2010, and 2011, my family moved back and forth between Chicago and Beijing. I wrote up most of my research in a typical upscale housing development close to the Olympic stadium, where many apartments were occupied by unmarked offices. Wealthy middle-aged professionals, their children, and their elderly parents lived in the apartments above ground, while domestic workers and security guards lived down below, in the underground spaces between the parking lots full of Audis and Mercedes. I learned much from talking with these neighbors on the playground; this "mainstream" community gave me a different perspective on the artistic subcultures that I was writing about, and a more intimate sense of the bourgeois life that the young artists and designers I knew were aspiring toward or, in some cases, seeking to escape.

I composed this book as a junior faculty member at NYU in the second term of the Obama administration. Living in New York City, watching from afar the Xi Jinping administration crackdown on intellectuals and artists, Occupy Hong Kong, and the attacks on dissent and Western thinking in 2015, inevitably colored my descriptions of events from the preceding decade. Many passages originally written in the Hu Jintao/Wen Jiabao era no longer made sense in the present tense. Ethnography is always already becoming history. Ethnography has also often been described as a translation project, prone to imperfections and distortions that come through the gaps between languages, particularly when the ethnographer is still struggling to achieve fluency among heterogeneous registers and dialects. I have represented this multiplicity of voices and perspectives as much as possible, and hope that I have not misrepresented them too badly.

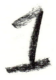

CREATIVE HUMAN CAPITAL

Will Marxism not destroy a creative impulse? It will; it will certainly destroy the creative impulse that is feudal, bourgeois, petty bourgeois, liberal, individualistic, nihilistic, art-for-art's-sake, aristocratic, decadent, or pessimistic, and any creative impulse that is not of the people and of the proletariat.

—MAO ZEDONG, TALKS AT THE YAN'AN FORUM
ON ART AND CULTURE

This book considers the return of the creative impulses (and practices) that Maoists once sought to destroy. It describes how ideologies of creativity and practices of self-styling contributed to the formation of a variety of bourgeois, liberal, individualistic, decadent, and pessimistic subjectivities. Creative practice changed as teachers who began their professional lives in state-assigned work units prepared their students to enter "free" labor markets. Recent generations of Chinese art students have had to learn to perform creative personality and sell style, as they progress from art school entrance test preparation to art school and to work in the culture industries. Their efforts to fit creative individuality into markets in aesthetic commodities have been framed by the opposing forces of global commodity culture and nationalist state ideology, with by the dream-worlds of developmentalist utopias, and by postsocialist disenchantment.[1]

Chinese "reform and opening up" (*gaigekaifang*) was defined by new industries rather than new political organizations: economic transformation without structural political change. As many scholars have argued, the culture industries played a central role in the development of Chinese

market socialism or "capitalism with Chinese characteristics" by shaping commodities and stimulating consumer desire.[2] From 1978 to 2008, culture industries proliferated. Print and television advertising interpellated new consumers; film and television programming publicized new imaginaries.[3] Artists and designers working in fashion and packaging, graphics, film and television, animation and gaming, architecture, interior, landscape and urban design transformed material culture and the physical environment.[4] Contemporary art spread from tiny clusters of apartment-galleries to huge gallery districts in Beijing and Shanghai, now recognized as major centers in the international art world.[5] Traditional-style Chinese ink paintings (*guohua*) command an enormous prestige market within China, and highly trained Chinese realist painters provide the labor force for the global market in reproductions and made-to-order portraits.[6] Culture industries reflexively communicate their importance to Chinese publics through every medium: advertising, television, film, fashion, product design, and art.

Many observers regarded the growth of these industries as a spontaneous "market" process: an explosion resulting from the relaxation of state controls on culture. However, in a number of respects the formation of the cultural industries was facilitated by state interventions, including investments in export-oriented film production and urban art districts.[7] This book argues that state-run (though not always completely state-controlled) art and design schools formed the foundation of China's cultural industries, reproducing creative "human capital" (*rencai*) and "incubating" aesthetic communities and networks of culture workers.[8] The Chinese education system has often been described as an obstacle to creativity. This book shows how Chinese art students and teachers have practiced creativity—and other types of socially privileged agency—within this system.

Beginning in 1997, the Chinese government embarked on a dramatic expansion of higher education, with the goal of moving beyond manufacturing to develop a "knowledge economy" or "creative economy" in which value is produced through innovation, both techno-scientific and aesthetic.[9] In the late 1990s and early 2000s the "creative economy" discourse became popular with urban and national governments throughout Asia, many seeking to develop export-oriented economies based on intellectual property.[10] In the words of Li Wuwei, former chairman of the People's Consultative Conference, "Develop the creative industries (*chuangyi chanye*) to promote economic transformation. Only by truly respecting and encouraging the creative industries to become a core industry, can China's creative industries establish an international presence, and like the Korean wave that happened a few years ago,[11] let a Chinese wind blow around the world."[12] In the

PRC, this policy discourse followed closely after the aesthetic reformation of the 1980s, the shift from state-socialist material culture to commodity capitalism. "Creation" (*chuangyi, chuangxin, chuangzao*) and "creativity" (*chuangzaoli, chuangzaoxing, chuangzao jingshen*) became key terms for state economic and education policy discourse just as the market economy made individual style into mass culture.[13]

By 2009, of the nearly nineteen million students in Chinese universities, over one million studied art and design, outnumbering students in the fields of science, math, education, economics, law, and agriculture.[14] In the decade from 1998 to 2008, universities around the country established hundreds of new art and design programs; central and provincial art institutes established new departments such as video game design, urban design, multimedia, and experimental art; the "eight big art schools" increased to nine, when the former Industrial Art Academy became the Tsinghua Academy of Art and Design, housed at the nation's most prestigious scientific and technical university; and all the major art schools, as well as many minor ones, built new massive, state-of-the art campuses (many with flagship buildings designed by famous architects) to house their expanding student bodies. By the late 1990s, most Chinese art students were no longer assigned state jobs, instead graduating into labor markets as entrepreneurs, freelancers, and wage workers. They took up careers across the spectrum of China's contemporary social order, with different relations to the concept of creativity and the commodity mode of production.

Students preparing for entry into art academies have long come from a surprisingly wide range of class and regional backgrounds, from rural families that sell grain for tuition to wealthy elites seeking safe harbor for their less academically motivated children. In between these extremes lie families who claim long lineages of artists and art teachers. Their investments in art education—from the years of expensive training in test prep schools, to tuition, to support in their years after graduation—are enormous. Schools are sites in which multiple generations interact and frequently conflict: where teachers who grew up in a monologic state culture and were assigned to their jobs upon graduation prepare students born into a world of global commodity circulations for "free" markets in aesthetic labor. Nearly everyone involved in every field of visual culture, from high art to fashion to architecture, has studied in an institute of art or design (and trained in realist drawing and painting to gain admittance to those schools). Because Chinese universities generally pay teachers a spartan wage, art and design professors are almost always practicing professionals, relying on work in the market for much of their income. Consequently, art schools constitute a world of

intersecting communities far beyond the narrow fields of fine arts or design, and offer a viewpoint on the much larger field of culture work.

Artists (*yishujia*) and designers (*shejishi*) occupy newly prominent positions in the nation, as model producers, consumers, and citizens/subjects. As paragons of what Richard Florida called the "creative class," artists and designers often figure as models for aspirational fantasies in television series and movies aimed at young audiences.[15] Chinese publics are now more often invoked and addressed as consumers (*xiaofeizhe*) or citizens (*guomin*, *shimin*) rather than workers or producers. But members of the "creativity industries" (*chuangyi chanye*) are represented as elite producers of value in bureaucratic discourses and policies that extol the importance of cultural industries.[16]

Culture workers are alternately framed as vital for and antithetical to market socialism: on the one hand, they are the consummate stylish subjects, producing the endless streams of aesthetic forms that mobilize conspicuous consumption and planned obsolescence, and through which others practice self-styling. On the other hand, in a variety of contexts, artists, designers, filmmakers, and other culture workers represent themselves as pursuing an aesthetic value that transcends markets. Many of them express resistance to commodification and to the restrictions of the state, disaffection for the present and nostalgia for the socialist past. Art school graduates produce mainstream commercial and official cultural products, from advertising to propaganda, but also (albeit more rarely and on a smaller scale) forms of counterculture, dissent, and critique. Because of these dual roles, art and design schools offer a unique site in which to examine the contradictions of what Kellee Tsai called "capitalism without democracy."[17]

While focusing ethnographically on small and relatively marginal communities of designers, artists, drawing teachers, and art students, this book traces the broad contours of the ideas of selfhood (*ziji, zishen*), personality (*gexing, xingge*), and individuality (*gerenzhuyi*), and their many imagined relationships to a marketized economic system in contemporary China. In the following sections, I outline the four major themes of the book—creative practice, self-styling, aesthetic community, and postsocialism—then summarize the chapters and their specific contributions to these arguments.

PRACTICING CREATIVITY

In the late nineteenth and early twentieth centuries, Chinese progressive reformers contrasted Chinese traditionalism with Western modernity, defined by aesthetic and technological innovation.[18] Maoism extended and

reframed this binary, celebrating an anti-capitalist version of technological modernity while emphasizing anti-imperialist self-reliance and national pride. The advent of creative human capital discourse in the late twentieth century coincided with a post-Tiananmen discourse of remembering imperialist national humiliation. At the beginning of the twenty-first century, policy officials and publics in China echoed their foreign critics in framing creativity as a particular weakness for China, a problem extending far beyond the professional fields of art or design. The following anonymous questions, addressed to an anonymous public through the ask function on Baidu, China's (once) primary search engine (an early form of internet discourse), illustrate the stigma that surrounds the topic of creative lack:

> *"Why is it that Chinese people are always producing* (chuangzao) *but never innovate* (chuangxin)? *No creativity* (chuangzaoli). *Why are we always taking tests and examinations,*[19] *and in the end copying technology and ideas* (chuangyi) *from developed countries. I just don't believe Chinese people can't think of new ideas . . . I am in the third year of college. Everyone around me is testing for grad school, and I feel sorry for them. They are just testing for a job, but I want to pursue beauty. I want to pursue knowledge."*

Best Answer: "Only with educational reform can the country develop." (Baidu web forum, December 1, 2010)

> *"Is it true that Chinese people lack creativity? Is there a way to fix it? How can creativity be cultivated?"*

Best Answer: "From the Nobel prizes, you can see that it is true. The problem is Chinese people are too conservative; there's no reason for this, no way to cultivate it. If you want to fix it, go tell the Party Chairman to switch to an American-style lifestyle, or else you can try yourself to invent something."

Other Answers: "It has a lot of truth. The problem is the educational system. If you want to fix it you have to start from infants, to improve their independent thinking and creative thought."

"It's not that Chinese people don't have imagination. Imagination is something every person is born with, and afterwards the way that education releases (*fahui*) imagination is very important. Chinese education pays too much attention to foundations (*jichu*), reading

writing and arithmetic, but doesn't give students space to freely imagine. The onerous pressure makes children lose their childish heart (*tongxin*) and at the same time lose their imagination (*xiangxiangli*)." (Baidu web forum, February 10, 2011)

In these conversations, echoing many that I heard in my fieldwork, the "problem" of Chinese creativity is drawn broadly. These commentators bemoan China's lack of creativity in culture, technology, science, and so on compared to developed countries. They explain this lack in the following terms: stunting or loss of early childhood imagination and freedom leads to utilitarianism (e.g., testing to get a job as opposed to pursuing beauty and knowledge), which leads to theft or copying of intellectual property, and ultimately to deficiency in key international competitions such as the Nobel Prize. According to this discourse, creativity is a mental faculty developed in early childhood. But the examples of fully developed creativity adduced here are all professional: Nobel Prizes, key industries, technology, science, popular culture, media, design, and arts. In these quotes, deficits in such international competitions are ultimately blamed on China's test-oriented education system (see figure 1.1).[20] These self-criticisms echo the racist rhetoric of Western politicians and pseudoexperts: "I've been doing business in China for decades, and sure, the Chinese can take a test; but what they can't do, is innovate."[21] "East and West work differently in relation to design and innovation because of differences in cultures."[22] "[In China] creativity and innovation tend to occur only in increments rather than in large, dramatic changes as in the West."[23]

Both anonymous Chinese netizens and prominent American critics reference China's international reputation as a country of copies and fakes, a country of violators of intellectual property law. Of course, many other countries produce counterfeits, but no country is as widely and invidiously associated with the practice as China. Not all copies violate intellectual property law, but accusations of copying blend in transnational imaginations with ethnic stereotypes and corporate legal battles that followed China's entry into the WTO. As Laikwan Pang and Constantine Nakassis (among others) have argued, all cultural production cites, repeats, or responds to prior cultural forms, and copying is often creative.[24] Nevertheless, copying continues to be represented both within and outside of China as a cultural and institutional tendency antithetical to creativity, while creativity is regarded as a national resource crucial to global geopolitical and market competition.

FIGURE 1.1 "Education must face modernity, face the world, face the future": Teacher parking lot of Zibo Technical Arts High School.

Creative practice in China is framed by three transnational discourses on the economic and political powers of creative individuals. There is, first, an ethno-national discourse of economic and cultural competition between Asia and the West (or China and the United States), according to which major powers need creative subjects to compete in "innovation" and intellectual property. Second, there is the liberal discourse of economic development, which in China takes on a pseudo-Marxist aspect of historical stages, or what Liu Xin calls "a great chain of modern becoming, a hierarchy of a developmental order of being."[25] The production of creative individuals is central to the Party-state's effort to transform China from an industrial producer to a creative designer, in order to reach the next stage of economic development.[26] And third, there is a political discourse that describes creative individuals as having a liberatory potential in a repressive environment—the capacity to live differently, if not always to effect political change.[27] Through these discourses, the Chinese government is called upon to produce creative subjects, while Chinese creative subjects are tasked with producing forms of value that are simultaneously economic, political, and ethical.[28]

The protean character of creativity is central to its ideological signifi-cance in "new economies," where according to theorists and policy makers everything is always changing, workers must be "flexible," going from ca-reer to career, "learning to learn" throughout their lives.[29] Insofar as cre-ativity is conceived as a fundamentally undisciplined mode of response (the creative worker, faced with a problem, thinks of a new, innovative solu-tion), it fits into the transition from the model of "discipline" to the model of "performance."[30] Like a skill, creativity is regarded as a psychological fac-ulty embedded in an individual human mind-body. However, creativity is imagined not as a routinized form of knowledge, but as a quality of mind: an essentially unconscious, unlimited power. Unlike most other skills or forms of knowledge, creativity is thought (following Piaget) to develop best in very early childhood. As a result, cultivating creativity has become the paramount goal of elite preschools around the world, while secondary and tertiary institutions seek to unleash creative powers formerly repressed.

Laikwan Pang has argued that in China, as elsewhere, creativity is a trin-ity: a fundamental problem of modernity, a form of labor (the "authorial" work of producing ideas), and a legal regime of authorial property rights, a way of retaining claim on the value of intellectual property.[31] Many of the chapters of this book are primarily concerned with creativity in its second aspect: as a constellation of practices, learned through practice. The most ambitious art students seek to use creative labor to generate authorial value: to be recognized as "creators," or as people who "do art" (*gao yishu*). Like cul-ture workers everywhere, they often have to choose between work that earns money and work that generates authorial value. However, when there are regimes to protect the authorial value they produce, these are more of-ten social than legal (and often fail).

Insofar as the practice of creativity is the pursuit of a self, it is—as Pang argues—a way of becoming "modern," in a world where "global modernity is characterized by the hegemony of a particular Western thinking."[32] In discourses of creativity, the creative subject, partaking of all the values of modernity—freedom, individuality, knowledge—stands at the nexus of cul-tural and economic development. On both sides of the Pacific, politicians, education officials, and pundits describe creativity as one last mode of pro-duction eluding China, for now retained by the United States.[33] In both countries, creativity is regarded as an extremely valuable form of human capi-tal, defined by an aesthetic subjectivity as much as if not more than a techni-cal skill: the "creative class" is valued as much for its consumption behaviors as its productive capacities.[34] This belief in the economic value of creativity is

combined with the implicit assumptions that creativity can be taught, or at least encouraged, on a mass scale (unlike, for example, genius), and that it is the responsibility of national education systems to inculcate it (as opposed to identifying a small number of people who are inherently creative). The Chinese education system has been widely blamed for its supposed failure in this responsibility, while in the United States critics of high-stakes testing have suggested that education reforms oriented to competition with Asia threaten American creativity.

In this context, how do Chinese art schools teach creativity to students who are regarded by their teachers, not to mention by education theorists and policy makers around the world, as singularly uncreative? How do teachers who grew up in what is now regarded as a singularly uncreative cultural system predicated on state control go about fashioning themselves as creative pedagogues?[35] How do adolescents who view themselves as having been warped by the very training that got them into those schools learn to practice creativity? How are Chinese art students—members of an increasingly large mass—asked to "find themselves" in order to produce value for others (an audience, society, the nation, etc.) (see figure 1.2)?

This book answers these questions using the methods of semiotic anthropology, rather than developmental psychology. I treat creativity as a social role and mode of being that art students learn to perform in what Erving Goffman called "interaction rituals" and Hanks called "discourse genres."[36] Much as MBAs learn to be managerial or RNs learn to be caring, BFAs and MFAs learn to perform creativity in the classroom, in meetings and presentations, exhibitions and lectures, interviews and personal statements.[37] Just as some MBAs are more managerial than others (and some nurses more caring), some art students are recognized as particularly creative, by both teachers and classmates. These students perform creativity by generating a recognizable self in and through a *style*: a multimodal complex that links modes of speech and behavior, texts and verbal narrative to plastic and graphic form.

As Judith Irvine has argued, style—both linguistic and not—"crucially concerns distinctiveness; though it may characterize an individual, it does so only within a social framework (of witnesses who pay attention); it thus depends upon social evaluation . . . and interacts with ideologized representations."[38] Other skills and forms of knowledge learned in art school—such as painting, carving, or printmaking—index belonging in a tradition and community, but creativity sets a person apart. In order for art students to be regarded as creative by others, they must represent themselves as unique individuals with a "unique" but recognizable style. Like a brand, this usually

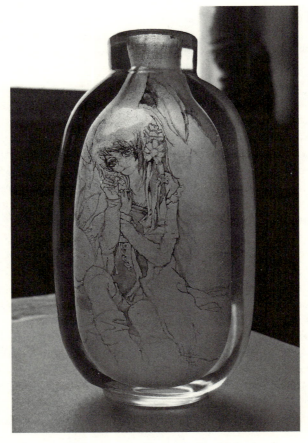

FIGURE 1.2 *Neihua* anime self-portrait, by a high school student at Zibo Technical Arts High School.

involves attaching a recognizable and repeatable graphic element—such as Pollock's drips or Picasso's figures—to a proper name and a persona or character.[39] This character can be "animated" in ways that allow it to circulate independently of the artist or designer through exhibitions, art objects, images, and commodities.[40] However, unlike a corporate brand, style in contemporary art and design is supposed to index an individual personality composed of "unique" experiences and sensibilities, as well as broader social conditions that can be framed as sources of transcendent meaning.

SELF-STYLING

Creativity is the anchoring center of the broader culture of self-making through style: its ideological basis and authorizing force. It is the form in which the "regime of self" becomes a means (and mode) of production.[41] Self-styling was crucial to *gaigekaifang*; aesthetic self-consciousness was one of the constitutive elements of postsocialism. With the rise of a market economy, clothes, hairstyles, watches, food, cigarettes, liquor, entertainments, cars, and apartments were aestheticized and subjectified, made to serve as extensions, reflections, and icons of a consuming individuality.[42]

Over the past four decades the culture industries have continuously transformed the qualia (or perceived qualities) of everyday life: colors, textures, shapes, tastes, and sounds. Art school graduates are now involved in every aspect of material life; not just film, television, art, advertising, and clothes, but also the packaging that surrounds food and household goods, the signs attached to all the buildings. There is no clear line between style and substance, between the visual culture industries and industries as such; the cosmetics industry relies on graphic designers and videographers as much (if not more) than chemists. The aestheticization of the world required and engendered a new kind of aesthetic subjectivity: an interest in style, a susceptibility to the attractions of commodities, a desire for contemporaneity and anxiety about lacking it, a habit of looking at and making small talk about commodities and their appearances. Shopping has become a pastime, whether on the street, in a magazine, or online.

Culture workers generate value in part by cultivating an aesthetic subjectivity and identifying an "individual" self. Personality is projected into style through dialogues, performances, and narratives, in face-to-face interactions and texts (such as brochures, critical essays, websites).[43] In this way, projects of aesthetic self-styling are crucial to creative practice. Culture workers may not keep the "selves" they construct in art school—they often remake their styles, or as Liu Xin puts it, "become other."[44] But these successive remakings depend on a proficiency in self-styling.

The links between aesthetic form and social persona that artists and designers construct can persist as a style is reproduced and marketed, coming to serve as models for the "self-styling" efforts of others (colleagues, consumers, admirers, etc.). This is not to say that only credentialed artists and designers innovate aesthetically; visual culture workers often pick up on associations between style and social persona made by nonprofessionals, as Vivienne Westwood took up the clothing and hairstyles that first appeared

"on the street" in the early punk scene.[45] But as professionals involved in the industries of promotion and reproduction, their self-styling practices are systematically reproduced—or conventionalized—even without name recognition.[46] For example, Westwood's version of punk style, as worn by the Sex Pistols, became the model for generations of teenage rebels (including one in Beijing now), many of whom were not aware of the role that she played in creating the genre of their own self-styling.

It goes without saying that such selves and styles are inevitably framed by socioeconomic distinctions. As Bourdieu has shown, the elite university reproduces class by certifying authorial privilege.[47] In the contemporary Chinese context, as in late twentieth-century France, creativity is a discourse that often reinscribes and conceals what Bourdieu regarded as "objective" class categories, such as the distinction of urban and rural deployed in the nationwide education movements and policy initiatives aimed at "improving the quality" of the Chinese people (tigao suzhi).[48] Many conflicting evaluative frameworks and hierarchies are invoked through aesthetic distinctions: not only suzhi or "quality," and not only class or "social level" (jieceng), but also gender, regional background, generation, ethnicity, discipline, and aesthetic community.

Self-styling is ideologically overdetermined, enacting both creativity and individuality—key forms of subjectivity in capitalism. However, commodity culture is by no means produced only (or even primarily) through processes directed toward the self. In professional life, art and design work is often directed toward others, addressing an imagined audience or clientele. Some areas of culture work (such as fine art) systematically conceal their attention to market demands, while others (such as domestic architecture) foreground it.

One night in 2008, I was on the new Number Five subway line headed home to a village-turned-suburb outside the northern Fifth Ring Road. It was after ten o'clock, but the train was full of young people in their twenties and thirties, professionals in stylish clothes, many of whom had just gotten off work.[49] Just outside the Third Ring Road, I sat next to a man in his thirties, wearing a tasteful gray coat, black slacks, and stylish shoes. He pulled out a large fashion catalogue from an Italian brand. It was full of pictures of skinny blond models on the beach wearing loud, trendy, loose-fitting clothing. He looked at the pictures again and again, drawing increasing attention from myself and the woman seated on his left. Then he sighed and asked us, "What do you think of these clothes? Do you like them?" We both pointed out a few pieces that looked nice. He asked hopefully, "But how much do you think that skirt would cost?" The woman guessed four

hundred yuan. He said, "No, it's a thousand yuan." We looked nonplussed, and he flipped through the catalogue again. "Would anybody buy this for a thousand?" We looked doubtful, and he sighed again. "Looks like there's no way to sell these things here," he lamented. "Too expensive." The woman said, "But these things aren't really right for China anyway. Look how loose they are—foreign women are bigger." She smiled apologetically at me. The train called out the man's stop, and he put his catalogue away and said good-bye. This young man was engaging in idle market research on his way home (just as I was engaging in idle ethnographic research). In this conversation, the two of us willingly participated in his attempts to imagine a market in terms of a *type* or sociological category defined by the style of clothes and their cost. This reckoning was the inverse of the process through which designers design clothes to fit a type (e.g., a certain aesthetic, a certain income, a certain body shape). Such attempts at understanding others, from consultations with clients to large-scale statistical market research, form an essential part of the work of culture industries and of capitalism more broadly. These forms of imagination of markets and consumers—the parts of creative practice that are concerned with the styling of others—are beyond the scope of this book. Nevertheless the certification to conduct these forms of labor depends on mastery of the intertextual and performative work of self-styling.[50] This book shows how self-styling is learned and authorized in art school, in classes that model the relationships between self and other, individual and society, and object and subject that students will have to negotiate in culture work, even as they insulate students from "market forces."[51]

AESTHETIC COMMUNITY

Creativity is performed as a social persona. How you speak, how you dress, and how you interact with others may be as significant as the art (or design, etc.) you make. To be recognized as creative, all these aspects of self-presentation, as well as the aesthetic work itself, must be recognizable, and in that sense conventional.[52] In art, design, film, advertising, and related fields of visual culture, developing a personal style is a process of socialization to *aesthetic communities*.

Like language communities, aesthetic communities share an orientation to a set of conventions: a "language" or code of colors, forms, materials, and genres. "Aesthetic community" bridges the gap between what Bourdieu called the professional "field" and what Hebdige called the "subculture."[53] Aesthetic communities include constellations of artists and designers, teachers

and students, collectors, consumers, and admirers: all the people who are oriented toward a style, an aesthetic, a set of forms. Aesthetic communities cut across fields and professions; they include producers, consumers, and a host of intermediaries. But unlike what Becker called "art worlds," an aesthetic community does not include all the people whose support is necessary to make any particular work of art. I use "aesthetic community" not to disrespect the work of janitors, landlords, babysitters, chemists, and computer programmers, but to exempt those who might not be aware of or care for the indirect products of their labor.

In linguistic anthropology, the "language community," which is organized around a shared code or sign system, contrasts with the "speech community," which is a community of people who actually interact with one another and share norms of interaction.[54] Likewise, aesthetic communities can include several "practice communities," consisting of those who actually interact with one another in a professional field. There are often several overlapping practice communities within an aesthetic community. Some practice communities are organized around institutions such as schools, others through markets, and still others through kinship and social networks (or all of the above). There are, conversely, often overlapping aesthetic communities within a single practice community: for example, the contemporary art scene includes those who decorate their homes in gray and wear only black, and those whose art, clothing, and domesticity are eclectic and polychrome.

Because the ideology of creativity emphasizes individualism, in some aesthetic communities participants may be reluctant to identify with a label or to engage in explicit boundary work.[55] This is especially true of those who are involved in establishing the forms and standards to which such communities orient (prominent artists, critics, collectors, etc.). The conventionality of creativity is systematically erased by the performance of unique individuality.[56] Nevertheless, even in unnamed aesthetic communities there is a pragmatic recognition of belonging and a more subtle form of boundary marking characterized by a tendency to engage personally and professionally only with others in the same community while ignoring or mocking others. Like the shibboleths of voice (or "accent"), subtle aesthetic differences that provoke admiration or scorn map social terrains defined by the same axes of distinction that divide communities of practice: high and low, male and female, north and south, old and young, wealthy and poor, state and private.[57] In this way the semiotics of aesthetic community reflect and refract the underlying structures of contemporary Chinese society.

POSTSOCIALISM

Chinese creative workers played a central role in the formation of market socialism: in the formation of the visual culture industries and in self-styling. They were able to play such a central role because in the absence of substantive political reform, especially after the retrenchments that followed student movements in 1979 and 1989, aesthetic transformations were both pragmatically and ideologically central to China's transition from Maoism, or socialism, or a planned economy, to a market society.[58]

Of course, it was precisely because Mao and other communist thinkers (like their contemporaries, the Frankfurt school theorists of capitalist aesthetics) recognized the role of "creative impulses" in producing bourgeois and individualistic subjectivities—and the role played by aesthetic styles in reifying economic inequalities—that so many socialist states sought to "destroy" these impulses. Early twentieth-century Chinese socialists regarded the practices of self-styling conducted in "decadent" urban centers as manifestations of capitalist individualism (*genrenzhuyi*). From 1949 to 1978, Chinese communism sought to eliminate the elaborately personalized, stratified, gendered, and sexualized styles that characterized elite life under prerevolutionary feudalism, colonialism, and imperialism. Just as Chinese socialist subjects were called on to resist desire for other bodies, they were also called on to resist desires for things.[59] Under socialism, the aesthetics of self was repressed through a series of rituals of sacrifice ranging from the traumatic to the banal, sublimating the individual in the collective. Even for those who did not experience famine, socialism enjoined ascetic self-denial: eschewing certain treats, foregoing certain pleasures cutting off long hair, destroying heirlooms and treasures.[60] Maoist campaigns frequently encouraged people to destroy all those seductive and elegant things that are now being lovingly re-created, not least in period movies and television shows about 1930s Shanghai.

The growth of the culture industries in China over the past thirty years has coincided with the growth of many other industries of desire. There is a general recognition that fashion and style are fundamental structures of capitalism. Despite worries about the moral effects of consumerism and commodification, for many people—especially those born after 1980—the space that aesthetics opens for self-styling is understood as a substantive freedom (*ziyou*) linked to the relaxation of sexual mores over the same period.[61] It is part of a broader expansion of the field of private, sensual experience that Farquhar calls "the indulgence of appetites": food, wine, vacations, pedicures, sex.

Twentieth-century communist critiques of self-styling are now echoed by, among others, the anthropologist Yan Yunxiang, who accuses postreform Chinese society (and especially the postsocialist generations born after 1980) of a consuming self-interest.[62] Likewise, critics of neoliberalism describe the choosing, selecting, self-serving individual as the fundamental structural unit (and ideological foundation) of neoliberalism.[63] In the 1990s and early 2000s, many scholars argued that Chinese postsocialism was really neoliberalism, echoing similar arguments about the Soviet Union.[64] However, the enduring power of the Communist Party, and of the state institutions that continue to organize many aspects of social and political life in China—not to mention state hold over key industries from banking to energy to media—have lately given credence to the Chinese government's claim that the current system is "market socialism." Contrary to the aspirations of Chinese liberals, the Chinese state shows no signs of releasing its control of media, culture, or education, and continues to invoke the ethics of socialism, leading scholars to search for alternatives to the phrase "postsocialism," such as "late socialist neoliberalism."[65]

In the period from the mid-1990s up to 2008, contemporary art was allowed ever greater freedom of expression so long as it avoided pointed reference to politically sensitive questions.[66] Many exhibitions and performances that made critical reference to social problems—including some that are described in the next chapter—went on without incident. After 2008, a new phase began in the long-term, ongoing cycle of opening and repression that characterized both the Maoist era and the thirty years of reform. Censorship intensified and became more obvious, as "secret" bans on news topics issued to media became frequent topics of discussion; sensitive terms disappeared from the Internet overnight; and online forums were overrun by the so-called fifty-cent party of state shills posting progovernment talking points. Events such as concerts and film screenings and gallery exhibitions were canceled more frequently. Small events were canceled with threatening visits from *chengguan* and Public Security Bureau officers unknown to anyone but their organizers, while large events were shut down in ways that demonstrated the new limits to a general public.[67] Xi Jinping's media-savvy party leadership promoted a heavily branded "Chinese Dream" while simultaneously relying on more traditional methods of cultural control such as arrests and disappearances.

Although Western observers initially took the Chinese culture industries as harbingers of revolution, it is now clear that those industries have not threatened the party's power. Nor have the culture industries eliminated

official culture, from propaganda to state news to academic art. Many culture industries are tightly linked to the state, and most culture workers are employed by hybrid entities: as graphic designers who print banners for both local city governments and corporate events, architects who work on projects organized by state-owned but nominally private real estate firms, or artists who hold teaching jobs at state institutions.

The state wields considerable powers (ideological, technological, carceral), but these powers are not absolute. Chinese cultural politics is a dialogic cacophony, full of side talk and back talk, across media platforms and physical spaces.[68] The admittedly permeable firewall that prevents access to Facebook and Twitter, and the more impenetrable wall of language, sets bounds to this dialogue. As chapter 4 of this book demonstrates, Maoist genres and styles are still part of Chinese public culture, albeit in more or less modified forms. On the other hand, wealthy and/or educated Chinese increasingly participate in transnational circuits of commodities, texts, and persons: from fast fashion, luxury, and technology (made in China, but "designed in California") and milk products imported from pastoral paradises such as New Zealand, to rapid translations of news items and viral videos, to increasingly easy-to-obtain travel visas to the United States and Europe, which in the past ten years have given an expanding class of Chinese urbanites personal access to New York, London, and Paris. These forms of commerce map networks of aesthetic communities and practice communities that cross boundaries of language and nation.

If the Maoist aesthetic—tin cups, sturdy cotton clothes, simple bob haircuts, cloth shoes—was suffused with transparent political meaning, the political implications of contemporary rituals of self-styling are less clear. This is particularly true of the nostalgia for socialist aesthetics, which figures in everything from official propaganda to contemporary art exhibitions to indie rocker fashion to television soap operas. These overlaps produce ambiguities: is this the voice of the state, of commerce, of the avant-garde? In liberal-democratic societies, some aesthetic communities are aligned with political ones; you might be able to tell how others vote by the way they style themselves. But in mainland China, politics (usually translated as *zhengzhi*, a word that might be better translated into English as governmentality, since the Chinese state itself has a Foucauldian view of the diverse strategies of governance) is not clearly articulated as an identity category that typifies individuals or social roles. Opinions on questions of policy cannot be readily used to assign individuals to political camps or categories aligned with other sociological distinctions (the way that green and blue are aligned with heritage

in Taiwan, or red and blue with urban and rural in the United States). Instead of being attributed to politics, differences in ethical sensibilities or attitudes toward the state are often described in terms of differences between the generations (-*dai*, measured by the decade of birth) that are used to figure historical change, or between social categories such as urban and rural. Consequently, to examine the politics of self-styling we must pay attention to *stances*: ways of indexing alignments with, against or outside of the ideological and aesthetic fields of governmentality.[69]

To the extent that the practices of self-expression and self-actualization made possible by *gaigekaifang* have contributed to the development of avant-garde art scenes that have, at various moments in the past thirty years, been involved in political dissent, aesthetic freedom seems to offer possibilities of resistance. On the other hand, in many contexts anti-mainstream (*feizhuliu*) fashion is devoid of any specific political meaning. To describe the politics of self-styling in China, I offer a series of analyses of the many ways that Chinese artists and designers position their creative practices: as a field for publicly asserting antiauthoritarian and liberal forms of sovereignty; as a contribution to the ethno-nation and its status and influence; and as field for private, apolitical, individualist self-satisfaction.

CHAPTERS

This book offers a critique of creativity through a series of ethnographies of creative practice in China: the test-focused art education that is said to suppress creativity, the state institutions and pedagogical forms through which creative individuals are produced, and the aesthetic communities constructed out of and through self-styling. These ethnographies alternate with a series of chapters using interpretations of artwork and media texts—from installation art to propaganda videos—to illustrate the contradictions of creative practice.

Chapter 2, "Thirty Years of Reform," begins with an oral history of the Central Academy of Fine Arts, describing how the school changed over the course of *gaigekaifang*. This institutional history is given a broader social context through interpretations of three art exhibitions commemorating the thirtieth anniversary of reform and opening up in 2008. These exhibitions offer perspectives on the legacies of socialism and the novelties of reform that are variously aligned with or critical of official state narratives, showing how contemporary Chinese dreamworlds contest with one another.

Chapter 3, "Art Test Fever," examines the art test prep classes that are widely blamed for overproducing the wrong kinds of subjects, with neither

creativity nor style, making students who are "blind" and "aimless" (*mangmu, mangran*). This chapter describes the expansion and standardization of the art test system over the thirty years of reform as a result of tensions between families, profit-motivated test prep industries, and public institutions, showing the limits of education policies and ideologies of creativity in the complex social world of postsocialist China.

Chapter 4, "New Socialist Realisms," considers the legacies of socialism in realist genres and political visions. This chapter explores the relationships between official and unofficial visual cultures by tracing the links between three contemporary genres of realism—art test prep realism, avant-garde realism, and official/academic realism. Following on the work of scholars who have argued for the persistence of socialist ethics in postreform China,[70] this chapter shows how all three genres represent icons of the working classes and express a postsocialist form of class recognition and an ethics of inequality.

Chapter 5, "Self-Styling," examines the pedagogical forms through which students who matriculate to art academies after years of highly technical test prep are taught to practice creativity and "find themselves." This chapter offers an ethnography of the discussion-based, "critique"-style "creativity classes" (*chuangzaoke*) that are a central part of university-level art and design curriculum. Building on the linguistic anthropology of pedagogy, this chapter describes how art students are taught to "entextualize" a style by narrating a self,[71] performatively anchoring an aesthetic that is always drawn from the work of others in a unique and highly personal subjectivity. The chapter reflects on the political implications of this subjectivity and its forms of practice.

Chapter 6, "Aesthetic Community," looks at how such distinctions and the communities indexed by them continue to shape the work of creativity beyond the school, examining the ways that categories of aesthetics, practice, and socioeconomics are contrasted and laminated in interactions between visual culture workers in studios, coffee shops, restaurants, and karaoke bars. This chapter shows how creative work is alternately aligned with and positioned against "the market" and the specter of commodification.

Finally, the conclusion returns to Gorky's 1932 question: "On which side are you, 'Masters of Culture'?" Examining the role of creative human capital in an urban service economy by analyzing a 2008 propaganda video titled "Reunion," this chapter shows how the "creative class" is positioned intermediate to the socialist class categories of capital and labor. The culture workers who are supposed to transform the nation, the culture, and the economy with their innovative potential appear as labor to capital (in

the person of the client or collector) and capital to labor (in the person of working-class service providers). Their professional activities can be framed as either authorial power or subaltern service, depending on context. This ambivalence demonstrates the antinomies of class in China's already post-socialist, but increasingly postindustrial, political economy.

THIRTY YEARS OF REFORM

> What has happened is that aesthetic production today has become integrated into commodity production generally: the frantic economic urgency of producing fresh waves of ever more novel seeming goods . . . now assigns an increasingly essential structural function and position to aesthetic innovation and experimentation.
>
> —FREDRIC JAMESON (1991: 4)

Over the course of the eighties and nineties, the fields of work that produce aesthetic form (graphic design, packaging, product design, fashion, architecture and interior design, film and television, visual art) followed a familiar trajectory: decentralizing, privatizing, fragmenting, expanding, commodifying, marketizing, and speeding up. As they grew they produced a gradually and then rapidly shifting array of new images and styles. These forms and their contrast with the past became emblems of the change from socialism to what came after—still officially called socialism, because state rhetoric contradictorily emphasizes both change and continuity.

The culture industries offer more than a case study in the transition to a market economy. Rather, as a fundamental mechanism of capitalism all over the world, they played an essential role in establishing the new economy in China. Just as one of the basic tactics of Maoist socialism was the control of aesthetic form, the proliferation of images and styles was endemic to reform and opening up. First, establishing a market economy meant making commodities, which required styling, packaging, and advertising. In that respect artists, designers, photographers, stylists, and others gradually became involved in every industry, from pharmaceuticals to household appliances.

Second, the culture industries played a central role in facilitating the new forms of subjectivity necessary for a market economy. Comrades (*tongzhi*) were converted into consumers (*xiaofeizhe*) in part through their experiences being addressed by advertisements, looking at arrays of packages on a shelf, and "self-styling" by choosing between different materials, shapes, and colors.[1]

Third, and most important for this chapter, marketized culture industries offered a new way of experiencing the passage of time: through the periodicity of planned obsolescence. The temporality of the fad, the chronotope of the fashionable—utterly opposed to communism's teleological model of history—makes aesthetics both the measure and the substance of historical change. To describe the past thirty years, Chinese movies and TV shows use montages of changing clothes, commodities, and interiors. Histories of the first thirty years of socialism do not operate this way, because the socialist state intentionally eliminated the oscillations of fashion. Instead of marking changes in clothes or furniture, histories of Maoism use political campaigns or movement (*yundong*) slogans. Style is one way to know you are in capitalism.[2]

This chapter does not attempt the impossible task of telling a detailed history for each of the culture industries; such histories have been written in a variety of disciplines, in both Chinese and English.[3] Instead, the chapter explores the role of the art schools in *gaigekaifang* (reform and opening up) through histories told by culture workers. I begin with a brief oral history of the Central Academy of Fine Arts (CAFA), as both an exemplary case and central site of *gaigekaifang* as political, cultural, and economic change. This history shows how state institutions were transformed by and participated in reform and opening up, anchoring new aesthetic communities, new fields of production and new subjectivities. I then translate and comment on three art exhibitions from 2007 and 2008, each of which tells a story about the transition to a commodity economy, its particular subjectivities, and its ways of marking time.

Gaigekaifang is often referred to in English as "reform" (*gaige*), putting the stress on the structural adjustments that fomented change. But *kaifang* (opening up) much more accurately captures the complexity of the process. With many of the same valences of the English word "open," it means, first, to bloom or flower; second, to lift a ban or restriction; third, to be opened to the public (as in an exhibition); fourth, to start up or turn on; fifth, to be privatized (as in a government monopoly). To say that a man is *kaifang* generally means that he is open-minded and progressive, while to say that a woman

is *kaifang* implies that she is sexually promiscuous. The first part of this chapter, the institutional history, is primarily concerned with *gaige*; the second part—the analysis of the retrospective exhibits—is primarily concerned with *kaifang*.

CAFA

The development of commodity aesthetics and the visual culture industries in postsocialist China is sometimes narrated as a kind of "rebirth" in the wake of the gradually receding state-planned economy. But *gaigekaifang* was planned by the state: rather than submitting to a foreign-orchestrated shock doctrine, Jiang Zemin and Deng Xiaoping oversaw a market transition with socialist state-management techniques.[4] Although many state factories closed or converted to a profit model, most state institutions did not wither or recede. Rather, these institutions shifted roles in order to facilitate economic liberalization and in so doing grew in power and influence. As Zhang Xudong argues, "the surviving Chinese state infrastructure (was) a conditioning factor in the making of a 'socialist market economy.'"[5] This was equally true of the educational institutions that produced the *rencai* (human capital) for the culture industries: the schools that fostered the development of many of the new professional fields and aesthetic communities that gave shape to *gaigekaifang*.

The institution of the art school was central to the development of Chinese art and design industries, as well as to state aesthetics, not only as a reproductive apparatus and a source of stable employment, but also as an anchoring site for aesthetic communities and a place for experimentation in new styles. The Central Academy of Fine Arts in Beijing, the most prestigious of the eight (later nine) big art schools (*badameiyuan*), run directly by the central Ministry of Education, served as a leader in the massive projects of institutional expansion and subdivision through which Chinese art schools channeled, encouraged and controlled the growth and diversification of culture. The stories below trace this expansion and show how it resulted in two parallel and correlative inversions of status in the 1990s and 2000s. As employment in the school (and by extension in the state) lost its value relative to success in the market, the fine arts, which had formerly held a privileged position relative to industrial arts—at CAFA, in the education system, and in society more broadly—lost that status to the new fields of design. At the same time, higher education was transformed, from small, centrally located, intimate academies, built on networks of "strong ties" between

mentors and students, to large, suburban, or peripheral institutions, relatively anonymous, which foster large networks of "weak ties" oriented to market practice.[6]

In 1978 CAFA admitted its first new class of students after the traumatic upheavals of the Cultural Revolution, including occupation by Red Guards and political struggle sessions within the school.[7] They began rebuilding and restoring its pedagogical apparatus, following the mandate of Deng Xiaoping's Four Modernizations policy. The students who tested into college in that first cohort and in most of the later cohorts of the 1980s (born in the mid-1950s to the end of the 1960s) had mostly learned drawing first from state media such as *lianhuahua* (graphic novels) and taken their first drawing lessons at the local *wenhuabu* (cultural affairs office). Many of them were children of artists and teachers. Test registration cost five yuan (not an insignificant sum at the time),[8] and the tests were held only once, on campus; all test drawings were reviewed by every single teacher in the department.[9]

CAFA was then located in a small building south of the National Art Museum, just east of Wangfujing (now a major shopping center), the campus it had occupied since 1950. The school was divided into small departments, including oil painting, Chinese ink painting (*guohua*), and printmaking. In the 1980s CAFA added only two departments, one in Mural Painting (to meet the demand for big art installations in public buildings) and the other Folk Art (devoted to preserving local culture). The first few cohorts (*ban*) counted fewer than a dozen students. The students were all undergraduates, but many were in their early twenties, having tested repeatedly before finally matriculating. There was one dormitory for both teachers and students, who frequently ate and drank together in their small rooms. One current CAFA professor who graduated from CAFA in 1987 remembers that "if there was a lecture, we would all walk there together. . . . We could walk to the museum, didn't even have to take a bus; a sweater only cost five yuan . . . almost nobody worked, unless they were from very poor families, then they might paint little drawings for magazines or things like that." For those who did side work, there was a wide market for handmade images, from advertisements to technical drawings.

People who studied at CAFA (and many other art schools) in the 1980s remember that teachers were extremely strict; they would tell students to throw bad paintings away and would not allow music in class. Similar restrictions applied to teachers: the artist Xiao Yu, who taught at the Applied Fine Arts Academy of the Industrial Arts Institute from 1990 to 1998, remembers in an interview with Ai Weiwei that when he "performed an experiment" by playing a symphony in class and asking the students about

their experiences drawing while listening to music, the director of the department wanted to kick him out and the head of the school told him he wasn't allowed to perform experiments and disrupt order (*pohuai zhixu*).[10]

Schools were then devoted to producing highly trained art teachers. In the mid-1980s, according to one faculty member who stayed at the school to teach, "only the worst students went to work in publishing or design. The best all went to teach art at colleges, and the very best stayed at CAFA to teach" (*liuxiao*, to stay in the school, is still a standard practice at Chinese universities and art schools). Most of the artists and designers I met who graduated before 1995 were assigned teaching jobs of some kind after graduation. As a result, until the 1990s most of the faculty members in industrial art schools (*gongyi xueyuan*) had never practiced the kind of design that they were teaching.

Over the course of the 1980s and 1990s, the gap between pedagogy in state institutions and "practice" in the market expanded. The "New Wave" art scenes that developed in the early 1980s and coalesced with the world-renowned "Stars" exhibition in 1985, included many aesthetically and politically disaffected members of the first generation of CAFA students, at that point just beginning their careers as art instructors; many of these artists were involved in the protests in 1989 and went abroad shortly after, while the underground art scenes in Beijing developed into the bohemian community living around the old Summer Palace (*Yuanmingyuan*). As film, fashion, advertising, and architecture developed in new directions—first in the special economic zones and then in other big cities—successive generations of new graduates and older faculty members decided to *xiahai*, jump into the sea, leaving their state-assigned work units for freelancing, private firms, and entrepreneurship. They went off to "play" (*wan*) or "float" (*piao*). Often they explained this decision in terms of a sudden whim, or an irrational feeling: "When I quit my job, it was just—I was sitting in my office, and the longer I sat I got uncomfortable. I had been a teacher for eight years, even half an hour before I wasn't uncomfortable, but suddenly in the blink of an eye (*shunjian*) I was uncomfortable, and I didn't want to stay another second. . . . I went straight to the leader (*lingdao*) and told him I wouldn't be coming back the next day."[11] As artists and designers who jumped into the sea told me, in this period only the *least* capable stayed behind to teach in the school or accepted their assigned jobs. The (self-annointed) best and brightest all left the institutions to work in design firms, freelance, sell paintings to galleries, or open their own businesses.

However, throughout the 1980s and early 1990s, even as the gap between institutional pedagogy and independent aesthetic communities grew, art

schools continued to play a central role in the new deinstitutionalized aesthetic communities, in part by providing new cohorts of students and young professors with the advantages of urban residence permits, but more importantly by providing central sites for network building in nascent visual culture industries, including graphic design, fashion, and architecture. Involvement in these professional and social networks, which also became new aesthetic communities, oriented to new styles, was crucial for later success in those industries. Several Chinese designers who went to school in this period remember that they learned little about their trades in their actual classes; nevertheless, their first exposure to design work was through the networks provided by the school, for example working for teachers who were doing commercial projects on the side. The former art students and teachers who left CAFA in this period all continued to circulate and work in CAFA-based aesthetic communities.

In the mid-1990s, the art schools themselves began to change, shifting in orientation and internally dividing to accommodate the new visual culture industries. According to an administrator at the Design Division at CAFA, faculty at CAFA began debating the question of adding a design department in 1993. Many faculty members initially resisted the change, arguing that design belonged in the Industrial Art Academy, but in 1996 they finally added a Department of Design and Architecture. The Industrial Art Academy merged with Tsinghua University and became the very prestigious Tsinghua Academy of Art; rather than "Industrial Art" (*gongyi*), the new academy taught "Design" (*sheji*). Following these changes, art schools and academic universities all over China opened design departments. Although these structural changes followed long internal controversies, they were and still are regarded as elements of a national effort at modernization: "Since the beginning of *gaigekaifang*, the Central Academy of Fine Arts has energetically carried out educational reform, academic construction and reform of the educational management system, building on the basis of its original superiority and adding new disciplines that meet the nation's modernizing development needs, vigorously launching international cooperation and foreign exchange activities, while establishing a structure of multiple disciplines advancing together."[12]

In 1997, two new education policies radically restructured CAFA and other art schools: the drastic expansion of higher education, and the relocation of colleges from city centers to new, larger campuses outside the city, in most cases remote "college towns" (*daxue cheng*): huge new college campuses surrounded by large walls. In 2001, CAFA left its little Wangfujing building for a massive complex in what was then the suburb Wangjing, beyond the Fourth Ring Road (by 2008, Wangjing, which is also home to nearly

all the major arts districts and studio complexes in Beijing, was considered part of Beijing proper, and the "suburbs" had moved beyond the Sixth Ring Road). In this new complex there were four major academic buildings: one for the Fine Arts Division (*Zaoxing Xueyuan*), one for administration and exhibitions, and one for the new, considerably expanded Design Division (*Sheji Xueyuan*), with offices for multimedia, architecture, and design (there is also a separate building at the back of the campus for the Art History Division). Although the traditional Fine Arts majors are still listed first in the school's literature, and the whole complex was designed by a single architectural firm and built at the same time, the Design Division's facilities are vastly superior. The Fine Arts buildings have bare-walled studios, cramped offices, and institutional furniture; the Design Building has high-tech facilities and interior design, appointed with black marble, smoked glass, and brushed steel.

Like most other schools, CAFA was required to finance its own state-mandated expansion, and as a result found itself in serious debt. In 1996, annual tuition went from four thousand to fifteen thousand renminbi. The 1997 policy expanding secondary education also included a mandate for schools to expand "revenue collection" and public/private collaborations. At CAFA, the most prominent example of this kind of institutional cooperation was the elaborately designed art museum on the Wangjing campus; it was partly privately funded and its very first exhibition upon opening in 2007 was a car show.

The new focus on moneymaking extended beyond the institution to include faculty and students. CAFA teachers circulate in a particularly fashionable scene and desire a higher standard of living than teachers in some provincial schools. Because of its real estate debt, the school has been unable to raise faculty salaries (which in 2008 started around four thousand renminbi), so teachers are always working on contracts or selling paintings, leaving less time for teaching. The same is true of students, as both teachers and students told me: "Now, all the students work, except for one or two who come from very wealthy families—but lots of the students are from poor backgrounds, they have to earn their tuition. The city kids don't have to work so much, but they still have to earn their living money, by teaching test prep classes, or working for designers or magazines." Even in the fine arts, the focus on selling art increased during this period: "The prices have gone up so quickly, gallery owners who used to buy a lot of my [oil] paintings can't afford anything but the watercolors; people who used to trade in well-known artists' work can't afford anything but stuff from students who've just graduated. I've even heard of people buying student homework

for several thousand renminbi!" Many informants suggested that the pursuit of money is destabilizing the pedagogical function of higher education in China, distracting students and teachers, leaving classrooms empty. Undergraduates are now faced with the problem of anonymity: with so many students in each class, most teachers don't know their students' names until at least the third year; only a few undergraduates in every class manage to develop "thick" (*miqie*) relationships with their teachers. However, both faculty and students have much more extensive experience in private industry than they had twenty years ago and much wider networks, which are as important as ever.

During the mid-2000s, when the market in contemporary Chinese art was at its peak, many artists considered the regular salary and benefits of a teaching job unnecessary. Nevertheless, the status of a position in a major art school retained some of its allure: one female teacher went back to work at CAFA's new Design Division in 2005, after years of "floating outside" (*piao zai waimian*) because as a woman, she felt she needed the prestige even more than the economic security, and because the "requirements weren't too high" (meaning the workload was very light).

Teaching positions became more desirable after the art market collapse in 2008, when many formerly successful artists found themselves in serious financial difficulty. However, they also became more difficult to procure. Teaching positions at CAFA are no longer simply distributed to recent graduates. CAFA's Design Division now requires all faculty members to have been educated overseas (one administrator told me he and his friends see CAFA as their children's first stop before going abroad: "After CAFA, they can go to England for two years and America for two years, then come home to work"). By contrast, CAFA's Fine Arts Division now requires faculty members to have doctorates in studio art—degrees that are available only in the PRC—in effect requiring faculty members to pass the difficult master's and doctoral examinations in government thought, and thus counteracting the tendency to cosmopolitanism.[13]

These contrasting tendencies illustrate an ongoing tension in *gaigekaifang* China. On the one hand, political, cultural, linguistic, and economic forces pull cultural workers inward to local Chinese networks and markets, toward state institutions and party membership. On the other hand, economic, cultural, and state forces push culture workers outward, toward transnational markets and professional networks. Over the past thirty years, many Chinese people, including visual culture workers, have experienced the push and pull of these centripetal and centrifugal forces and come to regard themselves as subjects of dialectical history, caught between the territorial

logic of state institutions (*gaige*) and the "opening up" of a "private" or "natural" and cosmopolitan social life grounded in consumer culture, media, and global markets (*kaifang*). In the remainder of this chapter I examine three commemorative art exhibits that describe this history, to show how the artists position themselves, their generations, and their practice communities in relation to *gaige* and *kaifang*. Each of these art exhibits tells a different story about reform and opening up.

ART HISTORIES

The year 2008 marked the thirtieth anniversary of Deng Xiaoping's rise to power following Mao's death. State media celebrated this anniversary with CCTV documentaries and biopics, video montages and propaganda billboards, as well as enormous public ventures including the Olympics and the first Chinese space walk. There were retrospective art exhibitions in every major museum and art school, for which thousands of academic artists and art students produced works on specially selected historical themes (*ticai*). The anniversary year was mediated by a constant stream of patriotic *xuanchuan* that presented all aspects of contemporary Chinese material life (food, apartment buildings, trains, cars, hair, clothes) as evidence of development.[14]

This stream of *xuanchuan* was all the more constant because in 2008 China was beset by an unrelenting series of national tragedies: a cataclysmic snowstorm during the Lunar New Year's travel season that left thousands stranded for days on trains; a major train wreck in Shandong in April; an earthquake in Sichuan that killed at least seventy thousand people in May; a separatist bus bombing in Kunming in July; and a crisis over melamine-contaminated milk and infant formula that erupted after the Olympic closing ceremonies, having been suppressed by censors all summer long. The censorship itself became a scandal after the Olympics when journalists publicly reported on government efforts to prevent them from reporting the contamination.

Each of these events had the potential to threaten the Communist Party's legitimacy or at least cast a pall over the commemoration. Indeed, the Sichuan earthquake became a turning point in the relationship between the government and the art impresario Ai Weiwei, who participated in the design of the Olympic stadium in 2006 and 2007, but by January 2008 was denouncing the Olympics as a "propaganda show." In December 2008 Ai used his blog to publicize corruption, and set up an online memorial to the thousands of Sichuanese children killed by collapsing schools.[15] The corruption scandals of 2008 gave new vigor to nascent political resistance. In

December of 2008, hundreds of Chinese dissidents signed and published a prodemocracy petition called Charter 08; among them was Liu Xiaobo, who was arrested in 2009 and awarded the Nobel Peace Prize in 2010.

However, these Internet-based antigovernment discourses were more widely publicized abroad than in China. Within the stream of authoritative discourse projected on the radio, on television, in newspapers, and by ordinary citizens, the tragedies of 2008 gave the anniversary a heightened emotional tenor: a thirty-year narrative of struggle, triumph, and unity was dramatically, metonymically retraced in a single year, as People's Liberation Army troops rescued those trapped on trains and stuck under buildings and government-service doctors provided free treatment to infants who had drunk the tainted milk. Many Beijing residents were enthusiastically engaged in this narrative: there were public displays of patriotic identification, from the earthquake donation drives organized by schools, neighborhood committees, and movie stars to the crowds of student volunteers who put on Olympic T-shirts to conduct crowd control and provide information services at Olympic venues and subway stations, to the senior citizens in every neighborhood of Beijing, who spent the summer wearing Public Security T-shirts (*zhianfu*) and managing security from their customary stoops and street corners (see figure 2.1).

The commemoration of *gaigekaifang* extended far beyond the propaganda bureau. Independent cultural organizations also produced commemorations, which used material culture as history in ways very similar to the CCTV montages, and focused on the same historical themes. Here I examine the histories of *gaigekaifang* explicit and implicit in three unofficial exhibitions: a 2008 series of memory paintings by the artist Chen Xi, displayed at the New Art gallery in Beijing; a late 2007 installation with performance at the Arario Gallery in Beijing by the artist Xiao Yu called "Material Reality Play: The World, Chilling and Warming"; and a 2008 group show called "Homesickness: Memory and Virtual Reality" at T-Space in Beijing.

These exhibitions combined national retrospection with private introspection. For Chinese visual culture workers at the end of the long twentieth century, lived experience is national history. The generation born in the 1960s— which includes many of the artists whose work is described in this chapter, as well as the three astronauts who participated in the spacewalk mission— witnessed the establishment of the markets and institutions they now lead. There were no major design firms or contemporary art galleries in China when they went to college. Their nostalgia is informed by a reflexive recognition of the historical significance of their own memories.[16] These exhibitions reflect

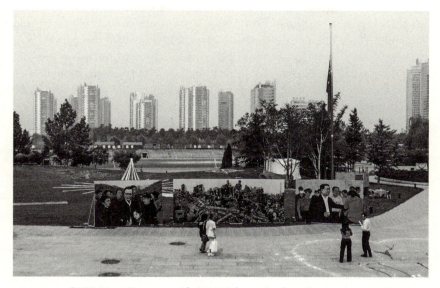

FIGURE 2.1 CAFA New Campus, with 2008 Sichuan Earthquake commemorative art.

the institutionalization of nostalgia, showing how such memories are articulated in relation to more official or more institutionalized genres of history.

In the tradition of Lu Xun's "Ah Q" and Zhang Yimou's *Raise the Red Lantern*—narratives in which subaltern individuals appear as allegories of the nation—life stories are always potentially inflected with national narratives. Many of the artworks described in this chapter make this inflection explicit by positing personal memories as national history. In this respect, these artists engaged in a representation of national subjectivity that has often been controversial in the Chinese art world. International collectors have preferred Chinese artists' work to be about China, and Chinese artists often resent this requirement.[17] Many artists protest that they are not trying to depict China, its history or its current situation. But whether in a Chinese political context or in Western markets for Chinese art, every subject stands potentially for the nation.

Like all unofficial histories, these exhibitions could not help but be in dialogue with official history.[18] As Prasenjit Duara argues, the nation-state frames historical consciousness, and historical consciousness has been one of the most important tools of nation building in China. And yet "the state is never able to eliminate alternative constructions of the nation."[19] There

are the alternative nationalisms of separatist groups in Taiwan, Tibet, and Xinjiang, which Duara calls "self-conscious Others within the nation." But there are also alternative versions of history in China from within the "us" of mainstream Han Chinese identification. Some of the contemporary artists I discuss in this chapter draw on traditions of irony and parody to critique official versions of history, while others uncritically echo official histories. I begin with an example of the latter: Chen Xi's "China Memories" series. Chen Xi takes up the trope of the individual as metonym of the nation and lays out its mechanics by focusing on the television: as a piece of material culture, an instrument of memory production, and a technology of interpellation.

Chen Xi: "China Memories"

In 2008, Chen Xi (b. 1968), a professor at CAFA since 2005, presented a new series of works on history: highly realistic oil still lifes of old televisions, ranging from the late 1970s to the late 1980s, on desks or tables. On the screens of some of these televisions are officially designated important moments in history, on others pictures of young families standing in front of Tiananmen Square.[20] The televisions as objects and the fragments of rooms visible around them suggest a relationship between mass media and material culture: each image constructs a time-space or chronotope. Rendered in oil, the images on the screen seem as ageless, as permanent, as the television machine (*dianshiji*) itself. These images suggest the nation and its shifting self-projections, while the televisions and furniture record a growing material culture and material wealth. The television has been, since the 1980s, itself a fashionable commodity, as well as an instrument in promoting the desire for newer, prettier, and better things. By fixing the television in a freeze-frame, the paintings draw attention to the contrast between scales of time, from the events on the screen to the eras of the furniture (see figure 2.2).

In these paintings and in her artist's statement about them, Chen Xi articulates the role of visual culture, especially television and film but also visual art, in constructing both personal memories and the nation as a public. In her artist's statement, "Through the Door of Memory,"[21] Chen Xi articulates retrospection through the metaphor of film:

Before I was thirty, I was completely unaware of the change that I was experiencing as this country went from suffering to reform, and soon after got on the high-speed train of change, finally arriving at this flourishing and prospering time. Now that I am forty, it's as if I can finally see clearly how fortunate I was. In the span of history, forty

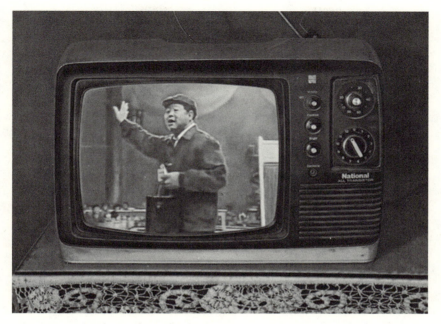

FIGURE 2.2 Artist photo. Chen Xi, "China Memories": Spring Festival Gala series. Courtesy of the artist.

years is just the blink of an eye (*shunjian*), but it's as if I was watching a perfect movie: with my own eyes I saw this country in the blink of an eye (*shunjian*) exploding forth with too much brilliance.

The chronotope of "in the blink of an eye" (*shunjian*), which Chen Xi repeats twice in one sentence, was frequently used to describe *gaigekaifang* in many 2008 commemorations. The experience of *kaifang* is described as being inherently televisual; it is "as if I was watching a perfect movie," a complete narrative that can be appreciated only as a viewer, retrospectively. In watching this perfect movie, Chen Xi discovers the political aspect of the personal: "I always believed I was a person with no interest in government or history, until this year, when I made a new series of nostalgic and retrospective works, which surprised and even scared me a little. When I thought about the reason, I realized that some things are like genes buried deep inside the body." Chen Xi describes herself as a spectator of her own paintings, which serve as a mirror, reflecting back the "government and history" buried in her apolitical body, in the most private memories. From this point on, her essay figures history in terms of the rhythm of mediated events that

constitute national histories in the modern era, events made public by the televisions that also bring them into private spaces all over the nation, far away from where they occurred. It traces a series of events almost identical to the historical *ticai* (topics) of the official painting exhibitions organized to commemorate thirty years of reform, to the contours and trajectories of the official historical narrative, even while positing itself as an individual memory.

Official culture plays a role in her earliest memory, as in the following story from her childhood (her mother was in a group of revolutionary opera performers): "When I was three or four years old I liked best to get grownups to dress me up in the red costumes of Tiemei from the revolutionary opera *The Red Lantern*, to tie on red dancing shoes, and perform in a circle of adults." Another kind of official culture figures in her primary memory of the Cultural Revolution, of a young cousin with a strange habit: "Every day she did just one thing, she stood ramrod-straight in front of the radio, with her head down low, softly chanting. After a while we pretended she wasn't there. . . . At night when my mother came home, the cousin would interrogate her, asking: what, are you back from your reactionary Dengist meeting again?" The cousin's total involvement in the radio (and, by implication, the stream of political discourse) marks her as unusual and possibly dysfunctional; Chen Xi asks her mother if the cousin is crazy and is told that she is just pitiful. Soon after this the cousin leaves. From then on memory is organized according to events of news, information passed from person to person directly: grown-ups talk about the earthquake in Tianjin, and then Chairman Mao's death in 1976 (when Chen Xi was eight years old): "We were on the street and there was a burst of panic, the grown-ups were quietly passing some news and I was scared because their faces were all stricken with pain and some of them started to cry. . . . For a while after that I didn't dare talk or laugh on the street or play at school." The period of mourning following Mao's death soon lifts, however, with another, even more dramatic event, the arrival of a new communication device:

One summer, I found out that a friend's house had a strange new thing, a thing that could play movies! My friend's dad told me this was called a television. At the time I was completely fascinated by it. Whenever I had a chance I would go to her house, and if they hadn't turned on the television, I would be very sad. Actually most of the time what we saw when we watched was static; when finally a person would appear, I would get terribly excited. A few years later, my house also got its first, tiny television set. After work, the neighbors who

didn't have televisions would all gather in our house, or the house of another neighbor who had one, watching and talking until very late. I knew the grown-ups were all enchanted by the television. From the time it appeared, it seemed that the world got smaller. Through a tiny little screen, people could watch all the human drama (*xinuaile*) of every corner of the earth. In those years, and even until today, so many people's spirit and visual field were locked into this tiny heart (*fangcun*). It has certainly had a profound influence on modern people, including myself. It is now coming clearly into view (*lilizaimu*).

The arrival of the television is the clearest of all the "memories" described in Chen Xi's narrative. The television appears not as a medium of political messages, but rather as a forum for voyeuristic linkage with the "human drama" beyond the nation. It is a technology of interpellation that brings neighbors physically together into the same room to watch and also converts them into members of a smaller "world," by "locking" (*suoding*) them into itself. In Chen Xi's narrative the television, which arrives at the end of the 1970s, is both the emblem and the implement of *gaigekaifang*. It transforms China by bringing new forms of subjectivity and new aesthetic experiences (or qualia):[22] "Once the 1980s began, it was as if this country's people had suddenly woken up: even though the city was still just as old and shabby, the crowd of people popped out with more and more bright and shining colors (*xianliang secai*); people's expressions weren't dull anymore. A new wave (*fengchao*) had begun, and all the young people were transformed." Chen Xi posits the television as the fundamental technology of *kaifang*, producing a totalizing commensuration (joining the community of the world), an emotional engagement and release (sharing human drama, newly expressive faces), and an aesthetic transformation (new colors, new wave).

In the remainder of the essay, Chen Xi's personal memories are interspersed with televisual memories. The women's volleyball team wins the world championship and Chen Xi adopts their lead player's signature hairstyle. She goes to high school and fellow Sichuan native Deng Xiaoping stands atop Tiananmen reviewing the troops: "The grown-ups said, Old Deng went up, our days are about to get better. Life really did get better, everybody's mood was improving; at the end of the year the feeling of celebration was at its peak, and the [annual CCTV] Spring Festival Extravaganza was the main dish for New Year's Eve dinner. I remember the last years of the eighties and the first years of the nineties were the golden age of the CCTV spectacular, all the biggest stars of the time wanted to appear on that stage" (see figure 2.2). Despite having been at CAFA in 1989, during the student

protests and the crackdown that followed, that is all she has to say about the end of the 1980s. Her own critic, Wang Jing, describes Chen Xi's time at CAFA as the period "when Cui Jian's rock'n'roll poured from the roof of CAFA, when intense longing and the image of freedom permeated the air . . . political and social transformation made social values uncertain." But Chen Xi passes over the turmoil of the late eighties in silence, focusing instead on the rise of the CCTV spectacular as a consummate performance of national unity: "All the stars of the time wanted to be on that stage."

Chen Xi then relates how she graduated from CAFA in the early 1990s, got married, and "became an artist" (*cheng yishujia*) in Beijing. When friends began leaving for Shenzhen to *chuangye* ("pioneer," meaning start a career or a business), she and her husband followed them to "go play" (spending the year 1994–95 there in Shenzhen). Informal or independent work can be called "play" in contrast to working for a state-assigned work unit, which is never referred to as such. Chen Xi emphasizes the phantasmagoric effect of new capitalism: "I painted a year's worth of paintings there, because that place gave me a really special feeling: there were building sites everywhere, everyone was going in for big construction (*daxingtumu*), the women dressed in gorgeous clothes (*chuande huazhizhaozhan*);[23] at night the streets were extremely lively, full of stalls and stands, there was a restless spirit in the air, everyone was looking to wash out his first bucket of gold." Rapid construction, fashionable women, lively nightlife, restless spirit, money: these are the emblems of Shenzhen's protocapitalism, which by the late 1990s had begun to spread out from the "special economic zone" (just as classic socialist propaganda had asserted that capitalism would) and gradually transformed all of mainland China.

Chen Xi's description of the late 1990s is less synesthetic: "Everybody started to get rich." The stock market starts up and her mother (the former revolutionary opera performer) starts playing her luck. Soon Chen Xi is watching the evacuation of the Three Gorges area in preparation for the building of the dam: "Often, in front of the television, watching the crowds of emigrants from Three Gorges quietly and peacefully leaving their homes, my heart was full of an inexplicable feeling. That was a construction project that seemed to take forever." Chen Xi assimilates the Three Gorges Project to the "construction projects" that overtook Shenzhen in the early 1990s. There is no attribution of agency in her history of this period: everything happens as if capitalism and its "construction projects" were a natural force. Over and over Chen Xi uses metaphors of uncontrolled momentum to describe *gaigekaifang*: a speeding train, a car going down a hill, and a wildfire spreading across a prairie.

At the start of the new century, everything began moving faster like a car speeding down a hill, and then there appeared in China's televisions a "choosing-girl-singers" program: Supergirl. This program had an astonishing influence, it roused the whole nation of young men and women and fired their dreams of stardom. I remember that night we were all gathered around the television, we all wanted Shang Wenjie to win, because she had moved us with her song. And our wishes were fulfilled (*ruyuanyichang*). . . . Soon all kinds of viewer-choice programs took over all the channels like a wildfire, the girls and boys were all on the streets fanatically debating their heroes, it seems that Chinese people had never before expressed themselves (*ziwo*) so recklessly and crazily (*siyi fakuang*).

Chen Xi describes both the Three Gorges Dam relocations *and* the Supergirl show as television events, involving herself (and, by extension, the whole Chinese nation) in a kind of emotional communion: first, the "inexplicable feeling" provoked by nameless villagers leaving their homes in an orderly fashion, performing a national sacrifice; second, the thrill of "dreams fulfilled" and the "reckless self-expression" provoked by the competition between "heroic" singers.

Chen Xi finishes her narrative as so many official histories did in that period: with the serial spectacles of the Olympics and the spacewalk. In the summer of 2008 her parents come to visit her in Beijing, partly because of the earthquake in Sichuan, but mainly to see China grandly (*honghonglielie*) host "its first Olympics." Her parents go to watch a practice performance and spend all evening in the stadium doing the wave, and take pictures standing in front of the Olympic architecture: the Bird's Nest stadium and the Water Cube swimming pool. They describe these monuments as having a lot of *qishi*, momentum (also energy or force), picking up on the metaphors of momentum used to describe *gaigekaifang*.

Chen Xi and her parents echo the tropes of the 2008 commemorative *xuanchuan* images of these stadiums, regarding them not as temporary icons of the Olympics, but rather as permanent emblems of the apotheosis of "China's rise," of a development (*fazhan*) that culminates in 2008, without ever ending. Indeed, these buildings have joined (if not begun to replace) Tiananmen in both nationalist *xuanchuan* and the kinds of pilgrimage photographs that figure in Chen Xi's paintings and Liu Yuanwei's photobiography. Years later, the area around these two stadiums is always filled with Chinese tourists—many of them aging farmers and their migrant-laborer children—posing for photographs, with other migrant workers selling

instant-print photographs. This permanent monumentality raises the problem of life after thirty years of reform (or post-postsocialism): did the 2008 anniversary mark the end of *gaigekaifang* as a historical period?

Chen Xi's essay addresses this question by continuing past the last staged, celebratory, national event of 2008: the spacewalk. The spacewalk would have been a proper ending for the year's dramas and for her narrative; but unfortunately it was almost immediately eclipsed (in the screen of the television) by a less manageable event:

> We were again in front of the television, watching the astronauts slowly crawl out of the shuttle, waving a little Chinese flag in the middle of the cosmos. It seemed that China stood on the towering peak of the world. But then the fall came, Wall Street met misfortune, the financial crisis touched the every corner of the world and everyone felt winter's cold; but life continues. Too many things happened in 2008, happy things, terrible things, tragic things, unknown things. It was certainly hair-raising, but next year in March the forsythia (*yingchunhua*, spring-welcoming flower) will open again. All we can do is bear everything that life gives us.

When the tiny flag in the giant cosmos appears in the television, "China stands on the towering peak of the world"; but then comes the fall. Suddenly a teleological narrative of momentum and progress, of gravity and trajectory—a narrative that coincides at every moment with official narratives of history, and works continuously to ground the narrative in its own most powerful means of reproduction, the television—is replaced by a cyclical chronotope of seasonal fluctuation. The forsythia is a device that allows the periodized narrative of commemoration to give way to the ongoing flow of time (as well as the ongoing flow of television broadcasts): it is a way of referencing the future without making any predictions. At the end of this memoir, in a few short sentences, Chen Xi goes from the anticlimax of the narrative to the cyclicality of seasons to the linear chronotope of the biography, which is also the chronotope of the cohort: "Now I use paintings to preserve memories that belong to most Chinese people. When this generation gets really old, we will turn around and see our lifetime of memories, of major national events and of little personal things; having such an abundant life, shouldn't we be satisfied?" Chen Xi's televisual history of *gaigekaifang* ends with the deictic center of the cohort born in the late 1960s. This cohort defines itself as one that experienced all of reform; as in Chen Xi's

narrative, for them 2008 marked not just a national anniversary but also a coming of age, as they transition from the work of *chuangye* and prepare to step into major leadership roles in central Chinese institutions, including CAFA. Chen Xi makes no explicit reference to these future possibilities; she refers only to the "abundant life" that her cohort will in the future have to remember.

That Chen Xi's systematic silences and near-relentless optimism dovetailed so neatly with the sanitized versions of history presented by the central government's propaganda apparatus is not surprising. As a professor at CAFA, she could have many reasons to find the "genes" of government and history "buried deep inside the body."[24] In the spring of 2008, I watched a conservative professor at CAFA tell his graduate students, who were working on a group series of paintings for historical exhibitions, to meet "the nation's requirements" (*guojia yaoqiu*; also *biaozhun, shuizhun*). He told them that if they could do so, they would "become artists, the nation will collect your work." When one student (who wore a camouflage baseball cap in the pseudo-military style worn by many avant-garde artists in those years) suggested working on a piece about the burning of the Summer Palace by the eight Western powers in 1860, a common subject of nationalist histories, Professor Zhang—who always wore a black zip-up bomber suit and looked as if he'd just come from a Politburo meeting—told him "your attitude (*zhuangtai*) is very dangerous, your thought (*silu*) is dangerous"; compared him to a certain female painter who liked to read, but "read too much"; and told him to avoid "sensitive questions." Political control filters unevenly through pedagogy, creating absurd dangers. In the next section, I examine an installation that critically examines these absurdities.

Xiao Yu, "Material Reality Play: The World, Chilling and Warming"

Xiao Yu, the artist cited in the first section of this chapter as having experimented with music in the classroom, who left his teaching position in "the blink of an eye" when he could no longer stand the institution, was not subject to such pressures, nor was he required to make art on historical *ticai*. Nevertheless in September 2007 he presented a historical installation exhibit at the Arario Gallery in Beijing. This installation comprised a series of rooms organized like a museum of Chinese national history. "Material Reality Play" traced the long twentieth century (1890–2008) from the "last emperor's casket" to the Bird's Nest Olympic stadium, self-consciously referring to the roles that visual culture industries, from film to advertising

to interior design to contemporary art, play in producing historical narratives. Where Chen Xi's painting series aligned with official commemorations to celebrate economic development in the era of reform and opening up, Xiao Yu's installation rejected those commemorative frames for an acerbic critique of the whole century. Xiao Yu's installation was distinctive for its clever use of text, inverting the traditional relationship between text and object. The objects in the rooms, some very simple and others gorgeous, massive installations, all served to give context to the tiny label texts (in English and Chinese) posted next to them: little phrases that kept pointing to the instability of historical discourse, and which were available for viewers in printed form on the way out.

The viewer began the installation in the lobby of the gallery, where a small television screen showed a video of a middle-aged man in contemporary clothing sitting at a white table in a white room, reading from a large document, the pages stacked on the table before him. The text was Chinese, and his speech sounded like Mandarin but made no sense; it took me a while to realize that he was reading the most famous passages of Marx's *Capital* in English, transliterated into Chinese characters. On the wall next to the television was a small slip of paper with the phrase: "There are some things you must read, you must read them aloud, and it is important to read them carefully." Thus Xiao Yu began the exhibition by alerting the viewer to the importance of recitation, rather than reference, in a political culture built partly on translated socialist texts; to the relevance of Marx's analysis of the commodity form in "market socialism"; and to the importance of reading the wall texts in the exhibit.

From this well-lit lobby the viewer passed through a narrow door covered by a black curtain into a dark room, where a cheap Qing dynasty imperial costume of the sort offered by photo-vendors at tourist sites lay in a coffin, a miniature tree growing where the head of the corpse would be. Around the room a few objects hung on the wall, marked by labels (translated here in plain text; my descriptions of the objects are in parentheses and italics).

1. The First Scene: The Emperor Committed Suicide

The strong countries' leaders together presented a stainless-steel coffin we made ourselves to bury him in.

A. The emperor cut down the doorsills, because they got in the way.
 (*A traditional raised wooden doorsill, used to protect the house against ghosts and to mark wealth and rank*)

B. The telephone the emperor used to communicate with the intellectuals. (*An antique telephone*)

C. The emperor's favorite painting. (*A cheap reproduction of a landscape painting*)

In this room Xiao Yu began with the beginning of so many official, academic, and popular histories of modern China: the decline of the Qing dynasty and the "semi-colonization" of China by the "strong countries" (the European powers, the United States, Russia, and Japan) in the late nineteenth and early twentieth centuries. Xiao Yu points to the traditional themes of most Chinese histories of this period: first, Manchu weakness (the emperor has removed the doorsills that should have kept the "ghosts," or foreigners, out of the palace); and second, Chinese complicity with colonization (the emperor's coffin was made by "us").

Xiao Yu presents this emperor as a sympathetic figure, who appreciated art, talked privately to intellectuals, and welcomed change, if only to bring on his own misfortune. This is not Puyi, the so-called "Last Emperor" famous in the West and puppet monarch of Japanese Manchuria, but rather his uncle Guangxu (r. 1874–1908), who with the intellectual Kang Youwei attempted to introduce major modernization reforms in 1898, only to be put under house arrest for ten years and finally poisoned to death by General Yuan Shikai and Empress Dowager Cixi. The little bonsai tree growing in place of the emperor's head suggested the possibility of rebirth, the continuous revival of reform movements in twentieth-century China. On the other hand, the little tree also brought to mind the big tree in Jingshan Park where the last Ming emperor hung himself in 1644, suggesting continuous cycles of dynastic collapse.

Xiao Yu's use of museum conventions such as dark rooms with spot lighting and serious wall labels suggests an aura of authenticity. But the combination of cheap reproductions, genuine antiques, and a modern coffin references both historical tourism and period TV shows. The telephone evidently came from one of the prop houses that rents old things for use in period movies. The "doorsill" looked as if it belonged to one of the brand-new traditional courtyard houses, including shiny new *menkan*, which were in 2007 and 2008 appearing all around the back alleys of the central *Xicheng* area in Beijing, replacing aging, crowded socialist-era *ping fang* (one-story brick houses).[25] Even as it represented a starting point in the historical narrative, this room pointed out the contemporary popularity of the imperial aesthetic.

From this dark room the viewer walked through a door onto a lighter winding path, with a bumpy foam floor resembling rocks, divided by a

series of walls of stage scrim. Passing back and forth as if from backstage to front stage, the viewer emerged into a large room, where a tree (with shackles hanging from its trunk and branches) stood by a wall of rocks. Looking back at the path from which she had come, the viewer saw a stage set depicting a sunset over a mountain road. On the wall at the side hung a few objects.

2. The Second Scene: The Hero Left

Walking on the path the hero walked, we blithely, merrily stroll along.

A. The hero's favorite grass sleeping mat. (*A straw mat*)
B. The grass shoes the hero used to wear. (*Straw shoes*)
C. Fish bones left from the hero's meal. (*Fish bones glued to a plastic plate*)

Coming after the death of the emperor, the rocky road through the mountains, the tree with its shackles, and the paltry remnants of the hero's life suggested early Communist Party revolutionaries. The winding path along a bumpy road evoked their Long March through the mountains during the war with the Nationalists. At the same time, the red sunset and lone tree and the straw shoes and mat called to mind an itinerant kung fu hero of the kind frequently depicted in Hong Kong martial arts films such as *Tai-Chi Master* and *New Dragon Gate Inn*. In those films the itinerant heroes are almost always drawn directly from history, usually remnant loyalists to a defeated dynasty. This sequence managed to articulate multiple dimensions of the trope of the defeated hero wandering in the mountains.

The text positioned viewers as the followers "blithely" walking along the hero's path, calling attention to the (uncertain) temporal distance between the present and the past. Like the earlier scene of the dead emperor, this passage described not only the loss of an idealized hero but also a general contemporary sense of loss, a vague nostalgia for something unknown and possibly unreal: the early years of socialism, or perhaps the bare-bones simplicity of premodern, preindustrial life. The arrangement of the hero's possessions evoked archaeological fetishism. But the use of the stage set materials (foam and scrim) emphasized the theatricality of the exhibit, as did the fish bones, absurdly glued to a plastic plate.

At the other end of this room, far away from the straw mat, a giant wall of rusted steel stood at an angle, more than ten feet high and almost two

feet thick. In the wall were embedded gigantic bullet casings, as if caught in the moment of piercing through. On the other side of the wall, visible only when the viewer reached the far end of the room, the shells "emerging" from it blossomed into giant golden flowers.

3. The Third Scene: Each Time the Great Guns Sound, Ten Thousand Gold Ducats

Fireworks spend money, bullets earn money.[26]

A. A coatrack made of bullets. (*A coatrack made out of large artillery shells*)
B. Fireworks waste money, bombs earn money. (*The rusted steel wall*)
C. Handmade guns. (*Model guns made of bent wire and rubber bands*)

This part of the room called to mind, first, the frequently cited contrast between Chinese and Western uses of gunpowder as fireworks and artillery, respectively. It also suggested the grand military projects and massive industrialization of the fifties and sixties, especially the Great Leap Forward, when pots, pans, and tools were collected from households to be melted down for steel to be used in military and industrial constructions (the coatrack made of bullets inverts that process). The oversized flowers bursting from the wall seemed to connote the grandeur of Maoist spectacle: the parades, the brightly colored posters, the giant paper flowers, the weapons. On the other hand, the little handmade guns, in their resemblance to children's toys, suggested the nostalgic stories of scrappy, handmade childhood games that I have often heard from middle-aged Chinese artists and designers, stories about the ingenuity of deprivation that characterized their childhoods in a world without commodities (in contrast to their own children's passive reliance on the market to provide objects of entertainment).

In the first three rooms of the installation, Xiao Yu managed to describe the first half of the twentieth century, by displaying the detritus of grand imperial visual culture; an archaic or revolutionary, heroic simplicity; and Maoist industrialism, a world of parades and poverty. From this point on the installation shifted in emphasis, as the viewer went through a small door into a small dark room, painted black. In the center of the room was a large sculpture made of a solid piece of red glass; it looked like a giant bowl full of liquid, with a bottle appearing to float or sink among concentric waves. It was lit in such a way that it seemed to glow.

4. The Fourth Scene: Thought Problems

Our brains aren't always producing thoughts; once thoughts are produced, they are certain to be misinterpreted.

A. A note that may have recorded thoughts, but was put through the wash in a pants pocket. (*Scraps of paper with traces of ink, in a frame*)
B. Under this lantern, thoughts might have been produced. (*An old glass lantern*)
C. "Those who believe have; those who don't, lack"—Ancient bone inscription, unintelligible. (*Leg bone of a cow or horse, covered in scratches or tooth marks*)

The objects in this dark room were all concerned with uncertainty and inscrutability (see figure 2.3). The floating/sinking bottle might contain a message, but it is unreachable; the ink on the note might at one time have had meaning; the lantern might have shed light on something. Only the bone inscription suggests a more menacing cause for uncertainty. Here what looks like nothing more than a chewed-up bone is labeled as a *jiaguwen*, the ancient oracle bone inscriptions that are the earliest examples of Chinese writing. From one interpretation, the label "*xinze you, bu xinze wu*" taunts the viewer, suggesting that in order to "have" a person must learn to believe that tooth marks are an ancient, mystic script. From another angle, this bone suggests the redemptive potential of a scrap of faith in something chewed over and left behind.

The title of the scene, "Thought Problems" (*sixiang wenti*), is a phrase that has been used by the Communist Party in political criticism throughout its tenure, including during the repressions of the Cultural Revolution. The scene's place in the historical sequence of the installation, coming after the Great Leap Forward, would indeed suggest that it was about that period, from the mid-sixties to the end of the seventies. However, aside from the phrase "Thought Problems" there was nothing in the room to suggest the 1970s: no Red Guards, no green uniforms, no crowds or kneeling people, no dunce caps, no Mao buttons, no big character posters. In the field of Chinese contemporary art, where nothing has been more commonly repeated than the images of Red Guards, and in the context of contemporary Chinese historical discourse, where the Cultural Revolution is relatively open to public criticism, Xiao Yu's treatment of this topic was beyond subtle.

FIGURE 2.3 Artist photo. Xiao Yu, *The Fourth Scene: Thought Problems*. "Material Reality Play," 2007. Courtesy Arario Gallery Beijing.

However, this room made reference to communication in paranoid, hyper-political environments, precisely by deploying the kind of ambiguity that often characterizes such communications (such as the CAFA professor who told the student his "thought path" was dangerous). There is a sly under-statement about this part of the installation that was a distinctive feature of Chinese intellectual discourse in the seventies and eighties. For instance, the subtitle suggests that "thought problems" take two forms: not thinking enough and getting misinterpreted when you do think. This part of the exhibition put the Cultural Revolution in the broader context of political repression.[27] The glass bottle and the scraps of paper point to the difficulty of holding on to something meaningful, without suggesting the reason for the difficulty. Only the label accompanying the chewed bone hints at the

presence of obstacles to believing the evidence of one's own eyes, or thinking for oneself.

Similarly subtle was a side room at the back, divided off by a black wall. It was also dark. In the center sat another large monument, a giant cube of polished black granite, inscribed with the subtitle of the scene in Chinese, English, French, German, Dutch, Japanese, and Korean:

5. The Fifth Scene: Dog Memorial

Loyal, grateful, fearless, fervent—we deeply cherish you, and memorialize all dogs that have died since they were domesticated by people.

A. The bird the dog would most like to kill. (*A taxidermied eagle attached high on the wall, its beak open as if shrieking*)
B. The dog's favorite chew toy. (*A pair of slippers*)
C. The dog's most hated tool. (*A stick*)

This scene might be construed as a monument to the socialist ideal person: "loyal, grateful, fearless, fervent," once-ideal personal qualities that have now changed their meanings, lost their virtue. At another level it refers to China's relations to other countries, to the situation of postcolonialism and subjugation. The memorial to all dogs is inscribed in the languages of the colonial aggressors (English, French, German, Dutch, Japanese) and contemporary competitors (Korean). The eagle "the dog would most like to kill" is a reference to the United States. This room, positioned as a sidetrack to the main path of the exhibition, suggests a kind of subaltern subconscious, which like the "Thought Problems" scene overflows its temporal position in the installation.

Given their position in the sequence of the exhibit, these rooms also make veiled reference to the end of the 1980s, to things that happened in the vicinity of certain monuments, to certain uses of force and ideas left behind. Xiao Yu, who graduated from CAFA's attached high school in 1985 and from CAFA in 1989, and must have been there in Wangfujing just a few blocks northeast of Tiananmen in June when the student demonstrators (including many from CAFA) occupied the square, collapses a sequence of unmentionable history into two small rooms: "Thought Problems" and "Memorial to All Dogs."

From this room the viewer could only circle back into "Thought Problems," and from there to a small door, which led onto a brightly lit narrow white hallway lined with white painted bricks and white pebbles. In the

wall were a series of round Plexiglas windows like those on ships, lit from behind. At each window was a small label:

Intermission: History has laid many roads before us,
but we are always coming along just one

A. Life-smarts—Don't get lost.
B. Life-smarts—Combine work and play.
C. Life-smarts—Caution.[28]
D. Life-smarts—Walk toward the future.

This path brought the viewer into a new era. Like the hard-minded, upbeat aphorisms on the labels, the white walls, bricks, pebbles, and round windows all evoked trendy, modernist interior design. These materials and colors marked this intermission as a description of the 1990s, when this kind of global modern interior design first appeared in a few urban centers, in shopping malls and nightclubs. The instruction to "combine work and play" echoes Chen Xi's reference to entrepreneurship (*chuangye*) as a form of "play."

This passageway resembled the mountain path that led the viewer to "The Hero Left." But where that path was built out of the materials of theater, this walkway was built of the materials of architecture: it was real, hard, and not at all fanciful or nostalgic. There was an irony in the reminders "don't get lost" and "walk toward the future"; there was only one path, a very narrow one, so despite the "many roads" history lays before us, there wasn't any choice of which way to go.[29]

From this point on, the exhibit took on a terse humor that requires little explication. The white brick road opened onto a small, brightly lit room painted sky blue, occupied by an Astroturf stage, on which sat a model of a spaceship the height of a man, robotically opening and closing its launching gear like a pair of wings.

6. The Sixth Scene: The Plan to Get to the Moon

It was a tool for communicating with heaven anyhow, might as well use it to go to heaven.

A. A moon-vehicle prepared long ago. (*The space rocket opening and closing its launching gear*)
B. When Chang E went to the moon, she took these pills. Every country's astronauts should take them, they really work. (*Large*

balls of Chinese medicine in a box labeled "bull's gallstone," niuhuang shangqingwan)

 C. The animal best suited to live on the moon. (*A taxidermied rabbit with white wings attached high on the wall*)

This room made light of the astronautical goals of the Chinese government,[30] putting futuristic national ambitions in context of ancient Chinese mythology and childhood fantasy.[31] In the context of the exhibition, coming after the white path with its hard-minded aphorisms, the whole stage setup suggested the feeling of explosive, unreal transformation of the late 1990s and early 2000s, as incomes, prices, and apartment buildings all shot upward and the Communist Party developed ambitious plans for domestic infrastructure and global military power. The brightly lit stage with its Astroturf and the winged rabbit gave tribute to the phantasmagoria of economic growth and political power at the height of *gaigekaifang*.

The final room in Xiao Yu's exhibit contained three scenes depicting the present-just-then-coming-into-being through very recognizable governmental and nongovernmental spectacles, and in particular the Bird's Nest (*niaochao*) Olympic Stadium designed by Ai Weiwei and the architectural firm Herzog and de Meuron.

7. The Seventh Scene: Futuristic Fashion

Rich people should do rich people stuff.

 A. Grandeur and style are very important. (*A military hat in the shape of the Bird's Nest*)
 B. You can't be without beautiful women. (*A model, who puts the crown on her head*)
 C. You gotta have baubles, the bigger the better. (*A scale model of the Bird's Nest about the size of a car*)

During the exhibit opening, these scenes became set pieces for a performance: a beautiful model wearing a pant suit and very high heels put on the Bird's Nest hat which resembled both a military cap and a crown, and then stood ramrod straight, not looking at the viewers, even when they drew close to read the label (B) pinned to her breast. The next sequence extended this satire of pecuniary expenditure by mocking the Chinese contemporary art world, which was at that point still breaking price records at auction (see figure 2.4).[32]

FIGURE 2.4 Artist photo. Xiao Yu, *The Seventh Scene: Futuristic Fashion*. "Material Reality Play," 2007. Courtesy Arario Gallery Beijing.

8. The Eighth Scene: Big Business

If you're gonna do business do it big; first sell the few big things nearest to us.

A. Sell the moon. (*A map of the moon, printed on canvas*)
B. Sell Mars. (*A map of Mars, printed on canvas*)
C. Sell the sun. (*A map of the sun, printed on canvas*)

During the opening Xiao Yu, an auctioneer, his assistant, and a group of "collectors" held a mock auction. As each piece was "sold" the assistant cut a large section of the canvas from its frame, leaving a gaping hole. In this sequence Xiao Yu indicted the state's reliance on real estate development, and the art world for selling things that shouldn't or couldn't be sold.

The final scene, at the far end of the room, consisted of a stage with a podium and microphone, from which the auction was conducted. At the back of the stage was a red curtain; bent over between the curtains was a mannequin in the distinctive Chinese long green army surplus coat worn by migrant laborers, digging in a pile of red flowers spilling out from under the curtain, as if still preparing for the event. One label was affixed to the wall next to the stage, a set of instructions for a ceremony:

9. The Ninth Scene: The Award Ceremony

A. Athletes' processional.
B. Only pull out the microphone when the ceremony starts.
C. Give red flowers to the heroes.

In the fall of 2007, when the Olympic stadium was still surrounded by steel construction gates, this room elicited nothing more than familiar chuckles.

This short history of the long twentieth century in a series of bullet points demonstrates Asif Agha's insight that irony can be an effect of "metricalized text structure." The installation combines nostalgia and cynicism, while focusing attention on the role of the culture industries in producing that nostalgia, by indexing the industries that manufacture memory: film, television, museums, archaeology. If Chen Xi echoed official history in narrating development as progress, and Xiao Yu repudiated it as phantasmagoric decadence, the last exhibit discussed here, a group show, took a well-trodden middle path: ambivalent nostalgia. This show addressed the rise of the design industries by lovingly memorializing the lost material culture of the socialist "past."

Fu Xiaodong: "Homesickness: Memory and Virtual Reality"

Those cruel things from the past, when we look at them today all seem sweet.

—NEON SIGN, PART OF AN INSTALLATION ARTWORK BY
ZHUANG HUI IN THE EXHIBITION "HOMESICKNESS"

In summer 2008, the gallery T-Space in the 798 arts district of Beijing presented a group show curated by Fu Xiaodong (b. 1977). The exhibit included artists from all over China, ranging in age from their twenties to their fifties. Their works were diverse in media and style, with no linear chronological or narrative arrangement. Yet the exhibit shared with Xiao Yu's "Material Reality Play" a basic interest in the nostalgias precipitated by the transformation of visual and material culture in China over the past few decades. In Fu Xiaodong's curatorial essay and in the art pieces she selected, "home" was figured not as a place left behind but rather as a time past:

With the arrival of the new century, time has turned us into exiles in multiculture. We seem more melancholy and lost due to "homesickness" (*xiangchou*). . . . China has been involved in the process of great transition from a productive society into a consumer one and therefore the structure of all social strata has undergone a deep-going transformation. Precisely speaking, the inner disintegration has taken place among the original (classes of) workers, peasants and intellectuals; more and more independent intellectuals have composed a new large social class. In the process of development, we are experiencing the dislocation of values and the changes of lifestyle, and face an entirely capricious personalized choice. Shall we contribute to the international collective loss of memory or directly confront Chinese reality?[33]

Many of the artworks in this exhibition used everyday objects—from pieces of furniture to gas tanks to old photographs—to describe "intimate experiences" of the transformation to a consumer society and the "dislocation of values."

Liu Zhuoquan's *Jiuwu*, which was translated in the catalogue as "Used Goods," could be better translated as "Old Things." In this piece, Liu (b. 1964) hired craftsmen of the traditional glass bottle "interior painting" (*neihua*) technique to paint haunting images of old things inside of old glass bottles. The bottles, which he had found in garbage heaps, were only twenty or thirty years old, but to American eyes many of them looked as if they might have been made in the early twentieth century. They were relics of a time before plastic, when all containers were made of tin and glass. The objects inside them looked like the daily stuff of life under socialism, the simple material culture that persisted well into the eighties in most parts of China: a wooden stool, a tin cup, a pedal-powered sewing machine, a woven grocery basket, a lock that Liu described as being "from the Cultural Revolution" (see figure 2.5).[34]

In a similar vein, the artist Qiu Xiaofei (b. 1977) presented a seemingly real (but actually fiberglass) representation of a wooden desk from the late seventies or early eighties, with an old-style clock, lamp, small white television, and photographs stuck under the glass surface. Called "7:00," the piece used objects that were rendered historical by their recognizable *oldness* (as much or more than by their fabrication) to depict a moment in the past. In the context of the exhibition, there was a connotation of childhood memory, a suggestion that these might be things that used to be "at home."

FIGURE 2.5 Liu Zhouquan, *Old Things*. "Homesickness: Memory and Virtual Reality." Source: T-Space Beijing (2008: 14).

"Old Things" and "7:00" get their meaning from the implication of a historical disjuncture. These pieces present objects that index not merely a different stage in the stylistic cycles of capitalism but a time "before" such cycles. These things are not merely dated or out of style. All these objects have a poignant aura of lost permanence to them, because they were not born into a world of planned obsolescence. They were built to last, and now they have been thrown away.

However, the chronotope of the "past" associated with these objects is subject to a disjuncture that can be understood only in terms of the reorganization of class and its distinctions in postsocialist China, which Fu Xiaodong pointed to in the exhibition essay. This disjuncture is most evident in another of Qiu Xiaofei's pieces in this exhibition. These pieces consisted of dozens of (acrylic representations of seemingly genuine) cooking gas tanks: the type used in Chinese households of lower income, not poor enough

FIGURE 2.6 Qiu Xiaofei, *Cakravarta Mountain*. "Homesick-ness: Memory and Virtual Reality." Source: T-Space Beijing (2008).

to cook with coal or cornstalks, but not wealthy enough to live in Western-style apartment buildings where gas is delivered through pipes. For upper-middle-class urbane visitors to this Beijing gallery, these gas tanks could pro-voke "memories" of past lives, the sorts of apartments they used to live in before they had made their money, or maybe their natal homes. And yet these endlessly recycled gas tanks, which are picked up, refilled, and redelivered by truck or bicycle cart, are by no means obsolete.[35] For many working people and migrant laborers in China in 2008, these gas tanks were a central part of daily domestic life, not emblems of distant memories. And in the exhibition, the tanks—painted in various shades of gray, standing clumped haphazardly, a few lying on their sides—indeed looked like a crowd of ordinary people (see figure 2.6).

These few examples show how this exhibit used the temporal signposts of material culture to call up a national narrative of transformation. In his

essay accompanying the exhibit, Qiu suggested that the piece "7:00" represents a collective memory, literally the "big family's same memory" (dajia xiangtong de jiyi). As seven o'clock is the hour when the news begins and people eat dinner, in front of "the same TV, the same furniture," Qiu described this piece as "a reflection of the group controlling the individual."[36] The antique television here looks very much like the televisions in Chen Xi's paintings. But where Chen Xi described the television as a wellspring of transformational aesthetic spectacle, Qiu Xiaofei (who is almost the same age as Chen Xi) described the television in "7:00" as an instrument of social control and regulation.

On the other hand, these objects also articulate the unequal access to commodities that opened a historical gap between classes in the years after reform. The years to which viewers would date that kind of desk, that kind of clock, that kind of TV might depend on their socioeconomic position. Gaigekaifang led to dramatic class mobility. Many spectacularly wealthy people in their forties and fifties grew up in poverty, while many of those who grew up in families that were relatively comfortable prior to the reforms have fallen into a fixed-income subsistence, never managing to integrate themselves into the consumer economy. In this period of class "disintegration," the "independent intellectuals" and culture workers such as artists and designers, who have not fared as well as businesspeople, frequently accuse shangren of what Fu Xiaodong calls "the refusal of refined culture, the negation of elegance," trying to leverage culture as an alternative to wealth.[37] On the other hand, class distinction undercuts the commensurating narratives about the unity of national experience promoted by xuanchuan.

Several pieces in the exhibit collapsed temporal narratives and spatial constructions of the distance between poverty and wealth. Xu Shun presented a series of soft-focus, faintly colored paintings of a simple room, possibly a farmer or worker's home, based on a photograph found on the Internet. Xu wrote that these places "are dark, shabby and far away from consumer culture's psychological standards, also lack any kind of stylish decoration."[38] As an artist, he claimed, "using cheap and ordinary materials allows me to tell stories of other places. When a momentary image becomes a painting, it becomes a point in relation to time and history." He explicitly positioned himself as conducting history by depicting "other places," places untouched by "stylish decoration" or "consumer culture."

Similarly, the quote about how "cruel (canren) things from the past . . . now look sweet" with which this section began, an installation piece by the artist Zhuang Hui (b. 1968), was written in pink neon, in an installation replicating a dirty lean-to against a brick wall, titled "Bamboo Structure." It is

an environment of uncertain date. What marks this building as the "past" is what Xu Shun identified in his pictures of spartan rooms as a distance from the "psychological standards of consumer culture": a lack of style, a bare functionality. In the interview printed in the exhibit catalogue, Zhuang Hui says, "We think what happened during the Cultural Revolution was very cruel. Think about it, in a few years how will we regard what is happening today in this so-called era of reform and opening up?" The interviewer (Liu Zhuoquan, the artist who made the painted bottle series) replies, "Our behavior today is really a continuation of the Cultural Revolution." Zhuang responds, "Exactly. Really, it's our inheritance from thousands of years of authoritarianism in China. Common people have never had the respect they deserve. It reminds me of the time from 1979 when I entered the factory to 1996 when I left, the 'worker's class' which had been the 'master class' suddenly became 'the laid-off workers.' A human being in this society is like a beast of burden." Zhuang Hui equates workers' decline in status after the end of the Cultural Revolution, and his own experience entering the industrial workforce in the period of this decline, with the political repressions of the Cultural Revolution: all "cruelties."

All of the pieces discussed above—Liu Zhuoquan's paintings of old things in bottles, Qiu Xiaofei's fiberglass models of an old desk and a pile of gas tanks, Xu Shun's paintings of sparse rooms, and Zhuang Hui's installation depictions of decrepit environments—seek to build on the aura of things that lie outside the aesthetic world of Chinese contemporaneity. These artists employed an archaeology of reform to create a postsocialist pastoral, memorializing and romanticizing a lost world of workers and peasants. By moving unstyled objects into this highly stylized exhibition space—a sleek gallery with white walls, exposed pipes, and buffed concrete floors—these artists sought to recapture a kind of authenticity belonging to things whose aesthetic qualities are not reflections of their performances as commodities in markets.

The idea that such unaesthetic things belong to the past is implicit in all these works, and in the exhibition themes of "homesickness" and transformation. In the catalogue, Zhuang Hui talks about buying a digital video camera in order to "record the places where I lived during my childhood" to "preserve some memories for my late years. You know this society is changing too fast, and nothing can last very long." He talks about watching the horizon as a child, and Liu Zhuoquan agrees that "this can only be a memory; in our present life, to see a horizon is nothing but a dream" (because of the sprawl of high-rise construction).

The aura of the undesigned became most evident by its contrast with the pieces in the exhibition that dealt with contemporary material culture. Liu

Chuang (b. 1978) presented one piece from a series called "Buying Everything on You," displaying the entire personal effects of an ordinary woman: a ruffled summer dress, a pair of high-heeled shoes, bra and underwear, purse and wallet and all their contents, including money, identity cards, photographs, and makeup, arranged in neat rows on a flat white platform. This piece, far from attempting to give any aura to contemporary material life, made it seem pathetic, meaningless, and far too alienable. Likewise, He An's text piece, a sentence that began "Brother do you think you can you help her . . ." spelled out in bits of discarded neon signs, played on the alienating effect of the overwhelming addressivity of consumer culture. He An (b. 1971) took fragments of the giant red, yellow, and blue neon characters that are attached to every building in the city—always calling for attention, addressing people as consumers—and stitched these fragments together into an ambiguous plea, a fragment of a communication overheard or intercepted, which seem nonetheless to directly address the viewer.

From Liu Chuang and He An's dark cynicism to Liu Zhuoquan and Qiu Xiaofei's postsocialist pastoral, each of these artists illustrated Fu Xiaodong's theme of homesickness and dislocation. From relatively elite visual artists enjoying the fruits of marketization, nostalgia for a pre-reform material culture might seem disingenuous.[39]

There was only one piece in the exhibition that pushed back against this assessment of *gaigekaifang*: a photo-biography by Liang Yuanwei, one of the younger artists in the exhibition (b. 1977) and the only woman other than the curator (also b. 1977). Liang Yuanwei presented a series of photographs of herself from early childhood to the present, a banal response to the "retrospection" projects of 2008, taking the problem of history literally in terms of biography.

Liang Yuanwei's family album consisted of a few dozen photographs. The series traced the history of the development of photography over the course of reform. The earliest photographs were black-and-white and printed by hand, later ones in color on stiff paper with white edges; they formed a long sequence of ordinary family photographs of a sullen, plain, ordinary girl, laid out on a shelf. But at the end of a shelf sat a ThinkPad laptop, playing a seemingly endless slideshow of party pictures: Liang Yuanwei and friends, wearing stylish clothes and unusual haircuts, posing, smoking, perhaps drunk, definitely happy (see figures 2.7, 2.8).

In her interview in the catalogue, Liang described this piece as a narrative of self-realization, a story of escape from the pressures and expectations of family and fulfillment through individualization. In this piece, *gaigekaifang* and what Fu Xiaodong called its "changes of lifestyle . . . capricious personalized choice" took on a straightforwardly positive valiance. There was

FIGURE 2.7 Liang Yuanwei, *1978–2008*. "Homesickness: Memory and Virtual Reality." Source: T-Space Beijing (2008: 87).

FIGURE 2.8 Liang Yuanwei, *1978–2008*. "Homesickness: Memory and Virtual Reality." Source: T-Space Beijing (2008: 91).

no interest in the material culture of the past, no disaffection for the materialism of the present. Liang Yuanwei here inverted the image of the dissolute party girl that, in the years running up the commemoration, had so often been used by male painters as a shorthand for the disorder of *kaifang*. The annual Art Beijing exhibition was always full of paintings of leering *meinu* ("pretty girls") with cigarettes, liquor bottles, and exposed flesh. Instead, Liang showed self-possessed women playing with their own cameras, seemingly uninterested in the male gaze. The photographic eye informing her party pictures was much more interested in clothes, hats, haircuts, and sunglasses than in bodies, cigarettes, or liquor. It was a celebration of self-styling.

Like Chen Xi's paintings and Xiao Yu's installation, Liang Yuanwei's biopic describes the role of technologies of visual representation and visual culture industries in the production of memory. Instead of memorializing material culture, Liang Yuanwei showed how the visual is implicated in commodity culture as a *medium*: a mode of enregistering style by picturing it. The slow progression of a handful of precious family photos giving way to the rapid, dramatic shifts of style of her party pictures demonstrated the relationship between the chronotope of the fashionable and technologies of visual reproduction. New photographic technology increases the pace of self-representation and demands an increasing variety of self-presentation. Much as Xiao Yu's treatment of history kept pointing to the role of the visual culture industries in producing memory, this piece pointed to the crucial role of photography in the practice of style, and thus to the fundamental reflexivity of self-styling.

CONCLUSION

Each of these retrospective exhibits used national narratives as frameworks for individual experience, and individual lives as allegories of national history. In these narratives the state appears only in its "biggest" forms: references to the "movement" (*yundong*) politics of the Cultural Revolution, to political repression ("thought problems"), and to spectacular projects such as the CCTV New Year's broadcast and the space program.

In many Chinese accounts of *gaigekaifang*, as in many of the artworks discussed in this chapter, the proliferation of visual culture industries in the 1990s is depicted as a natural efflorescence. Chen Xi naturalized consumer capitalism and its "reckless self-expression" by likening it to physical forces and climatological phenomena: momentum, gravity, wildfire, a wave, a wind. Other, more critical artists framed *kaifang* in terms of unbound greed

and desire: as Xiao Yu says, "you gotta have baubles, the bigger the better." But as Zhang Xudong has pointed out, the explanation of capitalism by self-interest has problems as a mode of critique: "Whereas critical humanist intellectuals view the advertising and television industry as creating a culture of consumer hedonism and materialist corruption, thus representing the evil of the market, the political dissent communities inside and outside China see a sinister maneuver by the political state to cling to power and detract challenge to its legitimacy." By contrast, Ai Weiwei—who in 2008 began to criticize the Olympics as propaganda and was targeted by security forces for his efforts to record the names of Sichuan earthquake victims—engaged in straightforward dissent.[40] Xiao Yu's 2007 "Material Reality Play" offered a particularly nuanced version of the "critical humanist intellectual" position. Like the authoritative discourse of momentum (wave, wind, wildfire), the critical discourse of hedonism (greed, yearning, lust) downplays the role that state institutions play in cultural industries, the manifold interconnections of state and nonstate. It also naturalizes the desiring consumer self. The next chapter, which examines the art test prep system in which the post-1980 generation of art students was formed, describes the obstacles those students face as they seek to become self-styling individuals like Liang Yuanwei, the bored child turned wild party girl.

ART TEST FEVER

Nobody studies art because they like it. Basically everyone
is here because their grades are bad.

—EIGHTEEN-YEAR-OLD ART TEST TAKER

From the late 1990s to 2008, the numbers of students taking art school en-
trance tests in mainland China increased rapidly, to a 2007 high of approxi-
mately half a million—170,000 in Shandong province alone.[1] According to
the students, teachers, and parents involved, "art test fever" (*meishu gaokao
re*) had little to do with passion for art or design, much less with affection
for the Soviet-style genres of socialist realist drawing and painting that form
the basis of the tests. Rather, it was a speculative bubble incentivized by
the intricate pressures of the academic college entrance examination (*ga-
okao*) system: families put their children through grueling, expensive years
of preparation for the art school entrance test because the *gaokao* scores re-
quired for art school are lower than those for academic schools. Art test fever
was a strategic rush on a loophole, a rational response to the complex reg-
ulations of the *gaokao*; it came to seem increasingly irrational as more and
more people passed through it, and the costs of participation increased. As
the number of test takers grew with the mass expansion of higher education
that began in 1997, the tests centralized and standardized, and the education
bureaus finally intervened with the implementation of province-wide uni-
fied tests (*tongkao*) in 2008, which by 2009 had drastically reduced the num-
ber of students preparing for art school (see figure 3.1).[2]

This expansion, centralization, and standardization of Soviet-style realist
painting was not driven by an explicit state policy, as language standardiza-
tion projects are in many countries including China, nor was it motivated

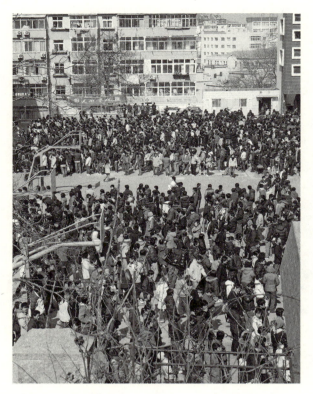

FIGURE 3.1 Crowds at art test registration fair, Jinan, Shandong, 2007.

by an "aesthetic ideology" analogous to the "language ideologies" that often motivate language standardization projects.[3] Rather, in this case standardization emerged from the relationship between the state institutions that administered the tests (art institutes, universities, and education bureaus) and the private art test prep industries that proliferated during art test fever: the test prep studios called *huaban* (also called *huashi, kaoqianban, peixunban*); for-profit art test information websites; test prep copybook (*mofangshu*) publishers; bookshops; art supply manufacturers (especially the largest brand, "Maries"); and art supply stores.[4] As a result of the development of these profit-seeking industries, the manual techniques and regimented pedagogy of Soviet socialist realism, though increasingly disconnected from the new aesthetics and new technologies of the visual culture industries in China, survived and were refined and formalized into a total system of drawing supplies, plaster models, instruction books, and training procedures, surpassing

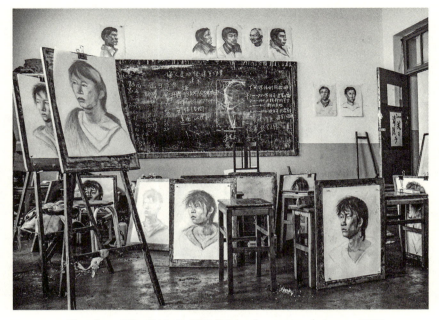

FIGURE 3.2 Shandong, Zibo Technical High School, test prep classroom, 2007.

in both complexity and scale anything available in the heyday of state visual culture. New genres of realist imagery—the most prominent among them highly detailed pencil portraits of work-worn, expressionless faces—emerged from older forms of socialist realism (see figure 3.2).

Thus, over the past thirty years, the *huaban* has reproduced and remade Soviet-style realism. What it has not done, however, is to reproduce the slogans, titles, descriptions, interpretations, analyses, and arguments that used to go along with these pictures.[5] There are no more standardized political interpretations for these images; there are no interpretations at all. There are no exegeses of ideological history or aesthetic significance in the copybooks that students buy, which are composed entirely of successful exam images and drawing decompositions.[6] No interpretations are recited in the *huaban*, and none are required by the art school entrance tests. The discourses surrounding art training focus on drawing as a form of manual-technical skill oriented exclusively toward the entrance examination. As a result, the political and historical meanings of these realist genres have been erased.[7]

The development of the art test system was an example of the "hybridization" characteristic of Chinese movements toward "academic capitalism,"

parallel to those in the United States.[8] By the end of the 1990s, private test prep businesses and state-run art education institutions had become functionally interdependent, as entry into formal art institutes became impossible without years of training in a *huaban*, using copybooks and plaster busts. Realist drawing training moved from state-run art institutes into private *huaban*, while the art institutes' curriculum diversified along with the culture industries.

Like the broader privatization of Chinese state industries over the course of the nineties, the development of the test prep industry and its adoption of the function of realist drawing training would seem to exemplify the influence of global "neoliberal" paradigms on the Chinese state-run education system, at least in the sense described by Ong and Collier: "a political rationality that seeks to operate not through command and control operations but through calculative choice of formally free actors."[9] However, as Kipnis argues in his analysis of Chinese audit cultures, apparently neoliberal procedures can emerge in a wide variety of illiberal ideological contexts and have illiberal effects.[10] In fact, a very similar mode of "hybridization" appeared in the Chinese imperial examination system, as over time private test prep tutors and schools became the dominant form of basic literacy and Confucian education; the state organized only the tests, leaving preparation to the people and the market.[11] Art test fever repeated the history of the Ming and Qing dynasty imperial examination system, in which the expansion of test preparation and its reflexivity (i.e., the use of successful test essays as test preparation materials) led test graders to rely on minor technical details to eliminate candidates. By the mid-Qing dynasty, disputations on Confucian classics and governance, which had in the Song dynasty been conspicuously ideological and political, came to be regarded as empty, formulaic "eight-legged essays." Despite repeated attempts to restore a sense of content and meaning, preparation for the test ceased to be a practice of reading, and became a practice of memorization.[12] Likewise, in art test fever, realist drawing ceased to be artistic practice.

All this occurred against the expressed will of "the state," or at least the education bureau officials involved in regulating the test. Education officials trying to reform test-focused education (*yingshi jiaoyu*) in favor of "quality education" (*suzhi jiaoyu*) described art test fever as irrational and counterproductive, producing the wrong kind of talent and skills, and accused the art test prep industries of reducing students' creativity and individualism.[13] From their perspective, art test fever was a product of the market, an effect of "calculative choice of formally free actors." But unlike school reform movements such as charter schools in the United States, public "experimental"

and private "international" schools in China, or "creativity" education—all of which can properly be described as neoliberal insofar as they have the explicit purpose of decentralizing education and producing liberal subjects—art test prep privatization was not mobilized by a political rationality, let alone by the state education bureaucracy, and it did not lead to the fragmentation of the state art education system, much less to curriculum diversity. Rather, just as fragmented and profit-motivated media markets can produce a unified discursive landscape, in this case privatization and deinstitutionalization functioned "centripetally," as Bakhtin put it, leading to increasing centralization and standardization, and to the large-scale reproduction of realist painting genres rooted in socialist history.[14]

Art test fever and the informal institution of the *huaban* were produced by the tension between the state-run test system and the intimate obligations of population control has imposed on nuclear families. This dialogic relationship is described in the expression *shangyouzhengci, xiayouduici*: "policy above and strategy below," which is used to suggest that an organization "above" (usually the state) and the mass of people "below" are locked in a conflict that neither can win.[15] Every new policy brings new strategy, and vice versa. In contrast to the various twentieth-century Chinese aesthetic movements described in other chapters of this book, all of which were "ideological" in a number of senses, art test fever was not the outcome of an ideology about aesthetics, or even about proper forms of training relevant to personal development.[16] Instead, the fever and the new genres were regarded as products of the increasingly technical training demanded by the logic of the test itself, a logic moving in the opposite direction from contemporary visual culture and education reform.

For parents, teachers, and children in China, the exacting requirements of the test appeared not as a function of state power, but rather as an effect of the competition generated by overpopulation: as so many interviewees told me over and over "mei banfa, ren tai duo" (nothing can be done, because there are too many people).[17] Because participants in the *meishu gaokao* viewed the increasingly detailed and demanding requirements of the test as effects of population rather than realizations of state policy, the new realist genres were not regarded as ideological messages from the state. Rather than viewing years spent drawing in the *huaban* in terms of reanimating authorial texts, most participants regarded it as a process of developing largely obsolete hand-eye skills. The aesthetic features of these increasingly specific genres went unrecognized or were explained as mere by-products of the technical demands or material conditions of standardized art testing. This is ironic, of course, because while the *huaban* was not a product of state

FIGURE 3.3 Security guard at test registration looks on as
father and daughter discuss choices, Jinan, Shandong, 2007.

policy, it came to be responsible for what is in some contexts understood as
a traditional project of the Chinese Communist Party-state: the production
of realist images.[18] The history of state culture in China imbues certain real-
ist genres with an air of governmentality (*zhengzhi*), an authorial vision, and
newer realist genres form the basis of the official paintings still routinely
displayed in state exhibitions celebrating national events.[19] Given this con-
text, it is doubly surprising that the participants in art test fever—students,
teachers, and education officials—came to regard the realist images that the
fever reproduced as merely technical forms, standards of skill to be tested
(see figure 3.3).[20]

Participants on all sides of the *gaokao* examination, including parents,
students, teachers, and test administrators, express dissatisfaction with the
system and desire for reform, but change is difficult to effect given the cen-
trality of the system to Chinese society and the scale of time and resources
families have invested in preparation at any one moment (not to mention
the profit margins of the associated industries and hybridized institutions).
All sides are aware of the tragic fates of "lost generations" created by the dis-
solutions of the imperial examination system in 1911, and of the entire edu-
cation system during the Cultural Revolution.[21]

The governmental power deployed in the *huaban* is grounded not in
ideological unity between state and family (as Althusser argues) but rather
in an ideological opposition between them.[22] This chapter describes the
fundamental tension between the values reproduced in the examination
system—skills of memorization and reproduction, habitus of diligence and

obedience—and the values of the family and its exchange networks, which emphasize personal ties and social graces. One is an ideology of party-led mass rule, in which the education system is supposed to identify future leaders on merit; the other is an ideology of relationality according to which the education system is a site through which an actor (individual, family, corporation) can effect conversions of economic, social, and political capital.[23] The family/network is now and has repeatedly been framed as the source of the "corruptions" that threaten bureaucratic structure, although it is possible to read both the network and the corruption scandals as being interdependent with the political system.[24]

STRATEGY BELOW AND POLICY ABOVE

Study hard and get into a good college.

—MOTHER COOING TO HER ONE-YEAR-OLD

Contemporary Chinese families of all social classes approach college preparations with intense anxiety, and a complex series of calculations that begin years in advance.[25] College entrance in China does not require narratives of self and calling: no "personal statements," resumes, letters of recommendation, professional histories, narratives of past (formative experiences and influences) and future (what you "want to be"). Throughout East Asia, college entrance is negotiated through a discourse of often explicitly mathematical probabilities, rather than through a discourse of personal choice. In China, as in many other East Asian countries, the college you go to and the major you study are determined by the single numerical score of the *gaokao*, the nationwide general subjects test held every year for three days beginning June 7. There are two variants of the test, one for the sciences (*like*, or quantitative fields) and the other for arts (*wenke*, humanities), toward which students are tracked by high school.[26] Within these two general fields of distinction, every department in every university can be ranked by its relative score requirements. The *gaokao* ranks students, schools, and fields of study numerically, in a unifying hierarchy that appears objective. The minute distinctions of the education system drive middle-class anxieties and families' educational calculations. Students can choose three department/school combinations prior to taking the test; their scores determine which if any of these schools they can attend, and majors are very difficult to change. This

FIGURE 3.4 Parents talking after dropping their children off at the testing site.

system has been in place since 1978, when the *gaokao* was reinstated and colleges reopened after the end of the Cultural Revolution.[27] Over the past few decades, the pressure to get one's child into college has grown. In the eighties and nineties, college admittance was vastly more difficult to attain than it is now, because there were so many fewer schools, and they were much smaller than they are now. In the eighties the Central Academy of Fine Arts had only a few hundred students, whereas now it has over ten thousand. Back then many parents (members of the "lost generation," themselves denied a chance at higher education by the long Cultural Revolution) viewed college entrance as an ideal, and many made testing into college a top family priority. However, the system of test preparation was not nearly so elaborate as it is now, and families were never sure that their children would go to college, even if they hoped they might (see figure 3.4).

The 2005 movie *Sunflowers* (*Xiangrikui*, directed by Yang Zhang) describes the life of an art student born in the sixties. The movie begins with the birth of Xiangyang ("facing the sun"), and with his traditional first birthday ceremony, in which he picks up his artist father's paint brushes, suggesting to his watching family that he has a proclivity for painting. It then cuts to 1976, the end of the Cultural Revolution, when Xiangyang's father

returns after six years of internment in a labor camp, where his hands were crushed by Red Guards. He decides to teach Xiangyang to paint, to keep him from running wild with the other boys while the schools are closed. The father forces his unwilling son to draw and paint in their yard all day long. He spends his childhood drawing at home, envying other children's freedom to play. By his teenage years in the late 1980s, Xiangyang is training in Soviet-style socialist realism: *sumiao* (chiaroscuro portraits), *suxie* (sketches), *xiesheng* (drawing out of doors), and *secai* (impressionist still life). Xiangyang has been enrolled in a test prep class at the local state-run cultural center, as private classes are then rare. His father, who is still forcing him to study drawing, dragging him back when he tries to run away, is now focused on drawing as a path to college. Xiangyang's skill means he has *chuxi*, future prospects, because he might be able to attend college. And indeed Xiangyang does gain admittance and becomes a great painter. In 2006 he is shown unveiling an exhibition of paintings—actually the famous "Bloodlines" series by the artist Zhang Xiaogang, here cinematically re-entextualized as sentimental reflections on the son's filial debt to his parents—that in their greatness confirm his father's hopes and justify his methods.

Twenty-some years later, college test success rates have gone up, due to the massive expansion of tertiary education around the country that began in 1997, and to the population control that began to be enforced in the early 1980s. But the sense that competition is impossibly intense seems only to have grown, as more and more people compete for entrance into the best colleges. If anything, the battle between Xiangyang and his father is more common now than it was in the eighties. The stress that families endure in the preparation for the *gaokao* has become part of the expected life-course of most Chinese people. In *Sunflowers*, Xiangyang is the only child in the neighborhood whose father forces him to study, but this sort of pressure is now entirely normal, beginning as early as first grade and continuing all the way to the college entrance examination.[28] It has become common in middle-class families for one parent to take anywhere from several months to a year off of work to oversee their child's test preparation and test taking. Publicity about the plight of unemployed college graduates has not reduced the importance of the college examination to contemporary Chinese families.[29]

In February 2008, I met with an artist named Lin and his eighteen-year-old son Lin Xu at the gates of the test registration site in Qingdao, Shandong, among the milling crowds of kids, parents, taxis, and drivers for "art test shuttle buses" run by hotels. Lin teaches graphic design at a technical

high school in Zibo (a small city in Shandong), and has recently begun to have success with his abstract ink paintings, getting exhibits in Beijing and Australia. Father and son were in Qingdao so the boy could take three art school entrance tests. They had already been to another city, Weifang, and after that would take the train to Zhengzhou in Henan province, and then to Beijing. Every night, Lin drilled his son, giving him practice drawing tests in their hotel room. At lunch, I asked Lin Xu where he wanted to go to school. He said of course he wanted to go to the Central Academy of Fine Arts (CAFA) in Beijing. "To major in oil painting?" I asked, and he responded, "No, that would be too hard" (oil painting departments are thought to be the most competitive in any art school, and CAFA is thought to be the most competitive school in the country) "and anyway, I don't like art." I looked at his father, who smiled wryly. The young man mentioned a few possible majors—animation, graphic design—then said he also wanted to take the test for the Beijing Academy of Fashion Design. I looked at his practical yellow windbreaker and crew cut, which stood in contrast to his father's ostentatious green army fatigues and shaved head (the vogue among forty-something artists in Beijing), and to the more conventionally stylish ripped jeans and spiky haircuts of the other teenagers around us. "Why?" "Because their score requirements are the lowest." "What's your favorite subject?" I asked him. "Math," he said.

Lin Xu was not considering testing for the Fashion Academy out of desire to become a fashion designer. His "choice" (guided by his father, and by his teachers at the test prep school where his father had placed him) was focused on the metrics of college entrance: academic and painting score requirements calculated against admissions numbers and prestige. When I asked Lin Xu his favorite subject, I was following the convention of bourgeois American adults making conversation with other people's children. This question is usually followed with some variant of "what do you want to be when you grow up?" These questions are a ritual enactment of the ideology of personal calling.[30] People in China do not generally make a habit of asking other people's children these questions. When people ask children about school or parents about their children, they most often ask about performance, not preference. The quantitative and probabilistic talk of scores and potentials extends beyond the nuclear family, so that extended family members and family friends often casually discuss a child's various test scores and the implications of these numbers for his or her future. The specific features of the Chinese test system shape these numerological discursive practices. The *gaokao* does not (like the SAT) divide scores by subject, so

it doesn't matter which subject you like best. And because majors in college are decided by the same scores that determine college admission, there is a general understanding that what you like may not influence what you study in college, let alone what you do for a living after you graduate.

Although a student's exact score potential is not clear until very shortly before the test, worries about it begin a very long time before then, as early as elementary school. In primary school, teachers and school officials whose salaries and career advancement depend on students' achievements are often as concerned as parents about tracking students into those classes most likely to deposit them safely in college. Students are tracked by their school teachers toward math or humanities according to their predicted score potentials. In elementary and middle school a smaller number are tracked toward preparation for one of the specialized tests—art, music, or sports—programs with less demanding academic requirements. In these early stages, parents and teachers work to encourage, guide, cajole, and sometimes force hundreds of thousands of kids whose grades fall short of stellar to study painting, just as other parents compel their children to prepare for the academic tests.[31]

Because of teachers' personal interest in students' educational achievements, they are at some crucial moments positioned as self-interested strategists working within the terms established by state policies, rather than agents of a state educational project, and so as potential allies of students. On the other hand, state school teachers are much more "risk averse" than parents, who are usually trying to push for the highest achievement possible, in a world where achievements are like schools minutely ranked and numbered, and global modernist discourses about college intersect with idioms of success that developed over centuries of imperial examinations. Even in primary school the basic tensions between families and the education system, and between parents and children, are already in place.

Art schools (like music and sports schools) require students to take the academic *gaokao*, but the scores required for entrance are much lower for an art school or art department than for an academic school or a major such as business or philosophy. These lower requirements reflect the belief that art and performance students earn lower grades. Art training is popular because it doesn't take as long as music (three years of nearly full-time study is sufficient for a good shot at a good school), and because art supplies are cheaper than musical instruments. Unlike performing arts, which is associated with low-status sex work,[32] certain kinds of painting have a historical status as an elite pursuit in China, and many parents believe that the visual arts offer the possibility of entrance into a range of relatively respectable careers, such as interior design, advertising, and fashion.

However, the more energy students invest in preparing for the art test, the less time they have for the academic tests. This practical possibility is regimented through a policy that any student who fails at the art test (held in February) is not allowed to register for any "first-tier" universities in the academic test (held in June). In practice, studying art often means giving up on the possibility of testing for anything else, and this decision is frequently made by parents or teachers while the student is still in elementary school or junior high school. Many children start drawing training in early childhood.

Despite the fact that it can be difficult to go into a field unrelated to your college major, families spend relatively little time talking about how any particular educational track will lead into a profession. As in Lin Xu's case, where there was no discussion of how a degree in fashion would lead to a career, what matters is to test into college (*kaoshang daxue*), and what happens after college will be determined later (*yihou zaishuo*, talk about it later). Many students decide which schools to register for at the registration site; registration procedures can be bewildering. In Shandong in 2008 and 2009, test registration sites in Jinan and Qingdao were full of parents leading their children, asking at the booths, checking notebooks full of numbers, lists of departments, score requirements, projected enrollments from each province, testing dates and times, new and constantly shifting test regulations downloaded from the Internet, and so on.[33] Other students came alone or with friends (sometimes having an unprecedented adventure staying in tiny rooms in cheap hotels), and still others with uneducated parents, who stood by carrying bags and snacks, funding the process but unable to help with decisions. After months or years of preparation in drawing test prep schools, arduously learning a highly stylized form of realist drawing and painting in order to pass these tests, many kids would end up registering for whichever school had the lowest tuition and was choosing the largest projected entrance numbers, or for the school that had the most talkative agents and the most attractive flyers.

The Chinese college entrance system gives rise to a mode of educational planning that is very different from the orientation to narrativized pasts and imagined futures that characterize American college entrance. In the United States, college entrance regimes require test scores above a certain limit, but focus on textual narratives of distant pasts and distant futures: childhood interests or influences, difficulties overcome, inspiring experiences, and imagined professional futures. But none of these narrative texts are involved in college entrance in China. Reformers have considered how to integrate such documents into the college entrance system, but in addition to the practical

difficulty given the huge numbers of applicants, and the problem of retraining students and teachers, essays and letters are regarded with suspicion by parents, who fear that these more personal documents would open doors for cheating.

The chronotope of Chinese college preparation goes from "now" up to the moment of the test, followed by a general future possibility that college entrance is thought to offer. The time before college entrance is filled with highly specific and anxious temporal sequences; the time after is not usually given any very specific narrative—just as in *Sunflowers*, Xiangyang's father is focused on college as an emblem of *chuxi* ("potential"), without ever expressing any specific hope that his son become a painter. Although the skills learned in the *huaban* are highly particular and even quixotic in a time where images are mostly produced with cameras and computers, the students are actually engaged in a project that has nothing to do with those skills or the images they produce: the project of "college." Like the parents and students I met in the *huaban*, Xiangyang's father speaks of college (*daxue*), not art school (*meiyuan*). When asked what they wanted to major in, what school they wanted to go to, or what they wanted to be when they grew up, high school students in the test prep schools where I conducted research almost always said they didn't know, they hadn't thought about it. Students who had been preparing for art tests for years did not know which schools or majors they would register for until the week before the test. Their goal was "college," and while they were intensely interested in whether they would achieve a level of manual dexterity sufficient to get into college, they were by and large entirely uninterested in the drawing itself.

Throughout the course of my research, during interviews and casual conversations in classrooms and coffee shops, painting teachers and art school professors (as well as some parents and students) said that these students and the parents and high school administrators guiding their studies were "blind" (*mangmu*), or "in the dark" (*mangran*): confused, lost, without purpose. Over and over, teachers and art professionals in their thirties to sixties (including those with children preparing for the test, such as Lin Xu) compared this generation of art students unfavorably with themselves, saying that children born in the 1980s and 1990s lack the "interest" and "passion" that they themselves allegedly had as kids. They frequently blamed this "blindness" on China's new wealth, comparing the piles of books and dozens of websites kids today use and discard with their own very limited and preciously hoarded resources back in the 1970s and 1980s, suggesting that as images have become more accessible they have become disenchanted: less valuable as objects, and less meaningful as signs.

Middle-aged informants also attributed this "blindness" to education re-form, the expansion of higher education that began in 1997 and produced the "fever," by making everyone feel that their children had to go to col-lege, and gradually devalued the college degree. But at the same time, teach-ers sympathized with parents' anxieties about their children's fates in the competition for scores and jobs. More common even than the discourse of blindness was the discourse of population, the insistence on the impossibil-ity of resisting or reforming the test system, because "there are too many people" (*ren taiduo*).

Although I encountered very few aspirational narratives tracing the paths to be opened by educational choices among adolescents and parents of teen-agers preparing for the test, the professional trajectories of the college grad-uates I met were mostly shaped by their school, major, and even primary advisor. It is rare in China to meet a college graduate who changed majors, transferred to another school, or switched majors between undergraduate and graduate studies. With the exception of one self-trained photographer, everyone under the age of forty-five working in visual culture fields whom I met—artists, logo designers, Photoshop grunts, theatrical designers, tele-vision commercial directors—had studied drawing in a *huaban* (or private tutorial), and studied art or design in school. A school may be selected through a "blind" gamble on a shifting set of probabilities, but it usually be-comes the basis for the graduate's professional and social networks well into the twenties and beyond.

The story of Wang Xi, in 2007 a twenty-six-year-old graduate of Qingdao University's Art Department, is typical, but also, from the point of view of many parents, ideal. He was in the second year of middle school in the local county seat when the school principal took him into his office to discuss his bad grades, and told him he could choose: art or music. He was never talented at drawing, he claimed, so he tested for the design major, rather than for the more difficult major of art (at the time, *Qingda*'s art school had only those two departments, but it has since expanded to many specialized majors). After graduating he worked in a graphic design business run by one of his teachers, and now he runs his own small business with a staff of four *shimei* and *shidi* (younger students from the same school), printing glossy folders, posters, and promotional literature for small businesses and local government events. He let me leaf through the sample posters with some embarrassment, saying, "this has nothing to do with art," because he knew I was interested in art education, and because he had been deputized to host me by his former teacher and employer. Teacher Wu made his living partly by selling abstracted paintings of the sea. He frequented galleries in Beijing,

and deported himself in a bohemian, "artistic" way, for example wearing semitraditional linen clothing and a mustache appropriate for a Chinese ink (*guohua*) painter. Wang Xi did not aspire to be an artist like his teacher, but through his teacher he had achieved the dream of upward mobility to which many parents and adolescents aspire. He was called "boss" by several people, had built his parents a new house in their village, and had an apartment in Qingdao, a car, and a pregnant wife. Wang Xi's story suggests that the calculations of such parents and teachers were not "blind" or "purposeless," but extremely goal-oriented, and often successful. But their purposes had nothing to do with art.

There is a neo-Confucian moral order underlying the logic of art test fever and other forms of test preparation in China, insofar as the success of the student is publicly recognized as a family affair, and the test as a family ritual: witness the crowds of parents standing anxiously outside the gates of every school that serves as a testing ground. As the stories of Xiangyang, Lin Xu, and Wang Xi suggest, the purpose of drawing training is not artistic fulfillment or self-realization, but realizing *chuxi*, for which professional and familial commitments are inseparable.

The sublimation of individual success into family success appears repeatedly in *Sunflowers*, which posits art test prep as a nexus for the tensions of the new Chinese "three mouth" (*sankou*) family, rather than the pursuit of individual artistic fulfillment. The movie's climax is Xiangyang's big art exhibit in Beijing's 798 gallery district, displaying a series of paintings; as noted above, these are actually Zhang Xiaogang's "Bloodlines" series, abstracted versions of socialist-era family photographs in which people in Mao-suits with serious, childlike expressions stare straight at the viewer, with hair-thin red lines weaving between them. In the movie, these paintings are reinterpreted as being based on childhood photos of Xiangyang with his parents. In a touching scene, the father goes by himself to Xiangyang's exhibit to see the paintings he has never before been allowed to see. He is moved by the aesthetic and artistic quality of his son's work. The fictitious Xiangyang's paintings (laminated onto the real Zhang Xiaogang's "Bloodlines" series) are thereby entextualized as a public testament to the father's parental efforts, a message of gratitude that could not be expressed verbally by these taciturn men. But the movie does not end there; Xiangyang's father is still not satisfied with his son, because Xiangyang refuses to have a baby, and repeatedly forces his wife to abort. Xiangyang tells his wife that he doesn't want to have a child because he resents his father's efforts to control his life, but then decides a second time to accede to his father's wishes. The movie ends with

Xiangyang's wife in labor, replicating the scene of Xiangyang's birth with which it began, and affirming the cycle of family reproduction.

Unlike the grown-up Xiangyang in *Sunflowers*, who becomes a contemporary artist, Lin Xu and Wang Xi were both disaffected about the aesthetic, had little interest in "art" and fashionable self-presentation, and were indifferent to images. This is the attitude many artists and art teachers labeled "blindness," contrasting it with their own remembered and recounted adolescent love for painting. Wang Xi disavowed any personal connection with "art"; Lin Xu claimed that no one likes art, pointedly declining to adopt his father's carefully narrated lifelong love.[34] Both of these young men regarded the hard-won ability to produce highly detailed realist drawings and paintings as unrelated to anything but the purpose of art test preparation. They do not even regard drawing as a useful skill. In the 1980s and 1990s many artists could use their drawing skills to earn money, by painting pictures, decorating curios, or drafting plans. But while some of the students studying in some *huaban* ended up painting oil reproductions for the export market,[35] most of those I met did not regard drawing by hand itself as a marketable skill. If they thought of earning money with this talent, it was by getting into the test prep business themselves, as many students at CAFA did in their very first year of school (a vicious circle, as many informants admitted).

When the journalist Peter Hessler wrote an account of the oil-painting export business in Lishui, he was continuously perplexed by the ambivalent "pragmatism" of one of his main informants, Chen Meizi, a young woman who, having learned to paint at "art school" (probably first at a *huaban* or *zhongzhuan* state-run school), was painting oil landscapes to order for European and American buyers. Hessler stated, "I asked her which of her pictures she liked the most, and she said, 'I don't like any of them.' She didn't have a favorite painter; there wasn't any particular artistic period that had influenced her. 'That kind of art has no connection at all with what we do,' she said."[36] Chen Meizi defied all his attempts to uncover an artistic sensibility, refusing to claim any talent, interest in art, or even any liking for it.[37] Hessler attributed her diffidence on the one hand to a "strong tradition of humility as well as pragmatism," that he claims is "typical" of rural migrants, and on the other hand to a pragmatic personality. But given the similarity of Chen Meizi's responses to those of Lin Xu and many other of my informants who are middle-class, urban and college-bound, her responses cannot be understood in terms of rurality or personality alone. Her "pragmatism" about painting is a discursive style structured by the discursive

practices surrounding educational planning in China, and by the particular conditions of training in the *huaban*, where oil painting is understood as a technical skill that is oriented to college admission (or, in Lishui, to commercial painting) and rarely or never anchored to art history or individual artistic calling. (In contrast, Winnie Wong's informants in the famous contract-painting town of Dafen, subject of significant attention from both Chinese cultural bureaucrats and Western artists and art historians, attempted to position themselves as artists in relation to art world interlocutors, while at the same time constructing strategies of production-line painting to produce a standardized, replicable style for Walmart.)[38]

The calculations that drive art test prep thus compel potential students to invest the long hours of study necessary to develop drawing skills with both intense significance and existential vacuity. To listen to many students and parents preparing for the test, realist painting is a meaningless hoop that they will spend almost any amount of money and time to jump through. This leads to a peculiar fact: although almost everyone involved in the visual culture industries—all landscape architects, graphic designers, industrial designers, video producers, advertisers, contemporary artists, photographers, etc.—passed a test in realist painting and drawing in order to get into art school, where many kept on studying realist painting for one or two years, and basically everyone in the visual culture industries under the age of forty-five went to some form of *huaban* to prepare for these tests, no one talks about these genres of painting except in reference to the test. For the vast majority of *huaban* students who do not go on as painters, *sumiao* and *secai* are regarded as nothing more than a technique learned for a test and then forgotten, like calculus for the average college student in America. Despite this ambivalence, students manage to achieve an extremely high level of proficiency in very detailed genres of realism: most university-level art students in the United States could not produce the images that even average *huaban* students do, and many Chinese art school students go on to learn techniques that have all but disappeared in Western countries.[39]

DECENTRALIZING DISCIPLINE

In September 2007, I met Lin Xu's father on an eight-lane highway (an average street in Beijing) behind CAFA and not far from IKEA. Tucked between a gas station and a breakfast snack stand was a large steel gate, painted gold and padlocked. On the wall next to it was a fading billboard: a collage of photographs of masterfully shaded pencil drawings, photos of students crouching in front of easels, a still life with flowers, plaster busts of Michelangelo's

David. Lin told a girl disposing of pencil shavings in the yard to call a teacher to unlock the door; the teacher let us into Xiaoze Huashi, the *huaban* where Lin Xu was preparing for the art school entrance test.

The first floor was a large room crowded with dozens of students bundled up against the cold, sitting on folding stools with their drawing boards clutched between their knees, drawing little arrangements of objects, or copying from copybooks. On the second floor students were drawing plaster copies of Roman and Soviet sculpture. We went into the manager's office, its carpet and walls gray from the pencil dust that is always in the air; there were piles of discarded drawings on the floor. Mr. Lin, who doesn't smoke, pulled a pack of cigarettes from his pocket, ripped off the cellophane, and offered one to the manager: a surprising gesture of deference, given the age difference between them.[40]

Manager Zhang, a skinny man in his twenties, was wearing a black zip-up bomber jacket with a fur collar, the jacket that businessmen in China wear, the sort of jacket General Secretary Hu Jintao wears. Manager Zhang graduated from the Beijing Academy of Fashion Design, BAFD, the nation's most prominent fashion design school.[41] But Manager Zhang was not an artist or a fashion designer. He opened this school right after graduating from college, starting with one room, and as it grew along with art test fever, he hired a few younger classmates still in school as teachers. Of the dozens of test prep schools in the Wangjing neighborhood, this one is (according to Lin) relatively prestigious and expensive, though by no means the top. Tuition is 2,300 yuan a month for a brush-up class, 38,800 for a full seven-month advanced class, and 48,800 for a full beginning class. (Tuition does not include the fees for living in the school's attached no-frill dormitories—rooms crammed with dozens of bunk beds, divided by gender—or for the food cooked by the live-in *ayi* who watches the dorms.) By comparison, a year's tuition at a first-rate college is 10,500 yuan.

Xiaoze Huashi commands these prices in large part because of its proximity to CAFA. Most of the teachers at the school are first- or second-year undergraduate students at CAFA, many cutting classes to make money. The school's promotional flyer lists its successes: names and birth cities of students who made it into CAFA, BAFD, and Tsinghua's Academy of Art and Design. The flyer also promises results: if full-class students do not get into the college on which the school and the students have agreed as their target, the school will return half of the tuition, or allow the student to continue to study for another year. These contractual guarantees are the reason why the gate to Xiaoze is chained shut. The padlock is not there to keep people out; as Mr. Lin said to me on our way out, with evident parental satisfaction,

it is there to keep students in, to make sure that they (unlike their teachers) do not play hooky.

Prior to taking the test, most students have completed at least three and often five years of training in drawing techniques: summers and weekends beginning in middle or high school, and at least one full year of twelve-hour days across six-day weeks in a *huaban* or *huashi*.[42] Students spend years developing skills in realist drawing and painting, progressing through a highly regimented curriculum of plaster cubes, cones and classical busts (drawn in pencil), glass bottles, cloth, rubber fruit (painted in color). They copy paintings from copybooks, sketch models, and eventually learn how to draw standardized "realist" imagery from memory (see figure 3.4).

Even if they succeed in getting into an art or design academy, such extremely refined drawing skills will almost certainly be irrelevant to their future careers, since most designers do not draw with their hands. These days, very detailed realist painting is rarely exhibited outside of official museum exhibits, often held in celebration of state events such as the sixtieth anniversary of the PRC. Perhaps as a result, most students have little or no aesthetic appreciation for the images they are learning to produce, preferring to draw images from anime or other more contemporary genres when they have the chance (the walls of a small school I frequently visited in Jinan City were scrawled with cartoons), though *huaban* students are impressed by displays of realist technique. Expressions of disdain for the tedium and difficulty of realist training are common: one girl at a school in Jinan raised hilarious laughter from her classmates by telling me how much she *loved* mixing colors.

The third year of high school in China has no full curriculum: students spend their time preparing for college entrance exams, brushing up on academic subjects, or attending various test prep schools. Where they go depends on where they are from and where they hope to end up. A student from a village or small town in Shandong who is trying to get into a provincial-level school might start in a local school, and then go to a *huaban* in Jinan or Qingdao. A student from Jinan or Qingdao who is trying to get into CAFA might start in a Jinan school, and then go to a *huaban* in Beijing. Some attend big schools like Xiaoze, which are advertised by flyers and billboards, others small one-room schools where teachers find their students by word of mouth, often through relatives in their hometowns.

These latter *huaban* are usually just apartments: a room or two to serve as classrooms, a little kitchen, a bathroom. Sometimes the classrooms are in the teacher's apartment (who keeps one room for himself or herself), and other times they are in a separate apartment where two bedrooms serve as

segregated dormitories for the genders. *Huashi* are usually clustered together in neighborhoods near an art institute or museum, along with the art supply stores and bookstores where students buy supplies and copybooks, and teachers purchase the highly standardized objects: plaster or plastic busts and heads based on neoclassical sculpture, plaster geometric objects, plastic grapes, wine bottles, ceramic jugs. The walls of the *huaban* are often hung with delicately rendered drawings of these objects by the teacher and by especially accomplished students. These drawings, which look exactly like the images in the copybooks (which serve as the standard of realism), prove that the teacher is capable of producing and teaching others to produce such images. The teacher does not need any teaching certification or evidence of training in pedagogy. Few people would want an art education major for a drawing teacher, as they are thought to lack technique. Prep school teachers teach primarily by example (*mofang*), rather than explanation, and the best certification for young teachers is having graduated from a prestigious art school; for older teachers, it is most important to have had many students who matriculated at prestigious art schools.

Every year during the Chinese New Year's vacation, when workers and students in cities across China crush into trains packed like subway cars for the journey home, tens of thousands of teenagers travel to the cities to take art school entrance tests administered in the colleges emptied for the holiday. In art test season, across every major city, at the hotels and train stations, at college gates and the registration or test sites behind them, there appear sudden crowds of adolescents, some with their parents, others alone, small groups at first, then dozens, hundreds, and then thousands: all consulting maps, carrying gray tackle boxes and black backpacks the size of coffee tables, dragging rolling suitcases, packed with clothes and toiletries for the days or weeks they must spend on the road.

The backpacks that mark these adolescents as art students hold drawing boards (but no paper, for fear of cheating), folding stools, and collapsible water buckets. The tackle boxes have two compartments: the shallow upper compartment contains rubber and gum arabic erasers, chamois cloths, razor blades and dozens of pencils, leads carefully sharpened into inch-long needles as brittle as porcelain, used for the light strokes that make up shadows and textures in the *sumiao* (chiaroscuro) test in highly detailed realistic pencil portraiture. The lower compartment contains brushes and jars of an impermanent, quick-drying powdered pastel called *shuifen*, used for the *secai* (color) test in impressionistic still-lives and tableaux. Many students have complete art test sets from Maries, the most popular art supply brand in China. These uniquely Chinese art test backpacks are the most

condensed and portable form of the disciplinary system that developed out of nineteenth-century French painting training in the Soviet Union and was imported to China early in the twentieth century via Japan, in the thirties from France, and in the fifties from the Soviet Union. The system was suppressed during the Cultural Revolution, revived in the 1980s, and has flourished in the first decade of the twenty-first century (see chapter 4 for more detailed history).

In "The Means of Correct Training" Foucault offers an analysis of the disciplinary system and the examination, which could well describe Soviet-style realist drawing training and the contemporary art school entrance test that developed from it.[43] Drawing training divides objects into a series of component parts, through which students must progress in a series of stages embodied in a series of plaster objects: from spheres and cubes to angular, abstracted parts of lips, noses and ears, chunky, oversimplified plaster faces, and casts of Roman sculpture. Students progress from drawing these plaster objects to copying images of real faces, drawing real faces from life, and then memorizing the patterns of faces, to be able to draw them from memory without any object of representation. Copybooks for *sumiao* contain series of eyes, noses, and ears, then series of images of portraits-in-progress, so that there is an iconicity between the structure of training in the *huaban* and the books used there. These serial structures are replicated in the course of each particular drawing, as it is laid out on the page in lines and planes, and then shadows, and finally details. Copybooks for life sketching (*suxie* and *xiesheng*) provide series of hands, feet, shoes, legs, heads, at various angles, to be memorized and fit together to approximate a living or imagined model. Test examiners employ an equally standardized model of ideal realism to evaluate and judge, giving quantified scores and definite rankings to thousands of drawings of the exact same subject (see figure 3.5).

The *huaban* deploys the disciplinary system of Soviet drawing training, using what Foucault identifies as the "arts of distribution" in their most basic forms, and modeling the disciplinary techniques that are also used by the state-run school. Consider, for example, the "distribution of space": even in a very small school of only ten students, students are divided into groups by skill level, gathered around separate models; one-room "dorms" are divided by gender. Students sit on little stools, which are arranged around the room in a way that allows the teacher to walk through a central path and panoptically observe their drawings. Each morning and each afternoon, the teacher (usually though not always male) gives students an assignment that takes several hours. When he sees a problem with a student's progress, he interrupts the student, sits down on the student's stool, and redraws

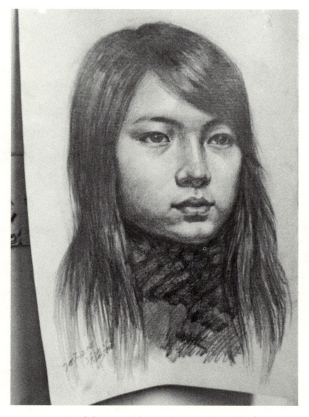

FIGURE 3.5 Model portrait by teacher on the wall of a test prep school, Jinan, Shandong, 2007.

the incorrect portion while the student stands and watches. Oftentimes, other students will get up from their drawings to watch a teacher *gaihua* (fix paintings).

Painting teachers practice what Foucault calls "exhaustive use," requiring students to draw for ten to twelve hours a day, six days a week, in poor conditions. Sixty-year-old Teacher Wu has run a *huaban* out of his own comfortable, well-lit living room since the early 1990s. During the years of art test fever, he rented a second, unfurnished apartment for the out-of-town students, mostly from smaller towns or even rural villages.[44] (Students slept in a dorm shared with other *huaban* in the neighborhood, and ate fast food in the neighborhood.) This apartment was gray with pencil dust, with no kitchen, windows that let in no light, a concrete floor, and a broken squat

FIGURE 3.6 Drawing model heads outside an art supply shop, Jinan, Shandong, 2007.

toilet; the temperature was kept at sixty degrees in the winter time, so students had to draw wearing their down coats. In the winter months before the test, after sitting for a short while, fingers go cold and stiff. In these temperatures students drew twelve hours a day, seven days a week. As in many other small *huaban*, these students lacked easels; they sat on short stools and grasped the eighteen- by thirty-inch drawing boards between their legs, nestled under their knees and digging into their calves, all day long (see figure 3.6).[45]

This form of drawing requires what Foucault calls "body-object articulation": the skill to sharpen a pencil point to an inch-long needle with a razor blade, and the lightness of touch to be able to use it without breaking it, holding it in one of two positions, both parallel to the wrist: "like a sword, or like a brush"; the ability to clutch the drawing board between the knees for hours at a time, and hold it at the proper angle to one's own head so that the drawing comes out even, not skewed; the ability to hold one's head in the right position and move one's eyes from the object to the page without losing point of view. Drawing training "constitutes a . . . body-tool complex," designed to produce very particular genres of realist drawing.

But unlike the disciplinary systems Foucault describes, *huaban* are not alienating or authoritarian. Relationships between teachers and students in the *huaban* are intimate and familial, more so than in either high school or college, and this intimacy is a product of and essential to their role in mediating between parents and the test system, on the one hand, and between parents and students, on the other. This intimacy is also essential to the *huaban*'s mode of pedagogy, the kind of compulsive power deployed there, which contrasts with the modes of education that take place in state-run schools.

Relations between students and teachers are often grounded in localism and kinship. At smaller studios, the teachers are often older cousins, or friends of cousins from the same village, because people follow recommendations from kin and friends to find *huashi*. The intimacy of these local ties is compounded by the students' estrangement from the cities where they go to study in *huashi*. I conducted interviews in three such studios in Beijing; in each case, none of the students were from Beijing, and nearly all were from the same province and city or township as the teacher. As *laoxiang* (people from the same "place"), even students who studied in *huaban* far from home can maintain ties to one another through home connections for many years.[46] The real local and familial ties in the *huaban* pedagogy are compounded by interactional modes modeled on kin relationships. At *huaban* with multiple teachers, the teachers are almost all new graduates or current students at art schools, only a few years older than their students; but even at small studios with much older teachers, students do not treat their painting teachers as figures of authority. Teachers and students joke and teachers frequently call students by their nicknames, used by friends and family. Teacher Wu often gave his students nicknames that referred to particular foibles or characteristics. Students at a small school in Beijing called their young teacher *jie* (an informal version of the title "older sister," used to address cousins and other intimates).

In the *huaban* the teacher rarely speaks in his formal capacity as a teacher. Most of the time, students are chatting with each other while painting, about things such as favorite delicacies particular to their towns and differences in cuisine between different parts of their (common) province. When the teacher does talk, her tone is often more friendly than pedagogical. When she sits down and corrects a painting, there is some explicit talk about the drawing, but it is conducted briefly and in a joking voice. Most of the talk is irrelevant to the lesson, and the instruction happens primarily on the page, with her hand. Copybooks and websites display only test drawings or

models thereof, offering little history and less aesthetic discourse. Likewise, the *huaban* teacher refrains from justifying the tests' evaluative regimes. These requirements are presented as facts that do not require aesthetic commitment.

Huaban teachers not only speak in the voice of but also communicate through the media used by peers or friends; teachers use online games and social networking sites to keep in touch with their current and former students. When students have conflicts with their parents, usually about the pressure involved in test preparation and the student's desire to engage in other pursuits, teachers often intervene.[47] Romantic flirtations in the *huaban* are common, most often between students, but sometimes involving teachers. Many young female art students I knew had been involved in romantic relationships with their teachers. One friend had her first romance with a young female *huaban* teacher who favored her. After the students had all gone to lunch, the teacher would remain in the classroom, ignoring her own lunch, smoking and staring at the student's painting. (This was the only case I knew of where test prep paintings were described as being appreciated in an aesthetic and not technical way.) This friend explained that because of discomfort with this relationship she did not test for the more prestigious oil painting department where the teacher herself had studied, but instead entered another field of design. Teacher Wu continued to have relationships with young students well into his sixties, including one who, after a brief, failed attempt to study drawing, had graduated from veterinary school; in 2008, unable to find work as a veterinarian, she lived in his apartment during the off-season, cooking his meals.[48]

Smaller *huaban* are often run by older teachers who have been doing test preparation work for over a decade. In these studios, the (usually male) teachers take on paternal roles, complemented by the maternal *ayis* (aunties) who watch over the dorms—a central part of the experience of studying in *huaban*. A twenty-two-year-old undergraduate at CAFA who has been bunking in dorms of four to twenty girls and eating in cafeterias since she was nine years old is not unusual. Most students in China spend their teenage years away from their families. Kids from villages and small towns almost without exception live in dormitories in middle school and high school, and sometimes leave home for school as early as elementary school; urban students leave home for college preparation. Rural and suburban students may easily spend more of their adolescence with the teachers than with their parents.

Consequently, the *huaban* teacher can stand in for and speak in the voice of the parent. For example, one evening at a Beijing *huaban*, Teacher Xu,

the aunty, and their ten students (most, like the teacher and aunty, from Dongbei) were gathered to celebrate one girl's birthday. After cake was finished Teacher Xu solemnly lectured the students on their parents' investment, the gravity of their obligation to study hard and test well. The aunty drew on her intimate knowledge of their lifestyles to criticize, correct, and encourage them. Together they picked out one student, a habitual oversleeper, as a negative model for the others: the aunty citing his habits at home, the teacher his habits in class, both of them continually returning to the theme of the sacrifice his parents had made for his tuition and his consequent responsibility to his family. Unlike a *banzhuren* or class monitor in a state-run school dormitory, who physically forces students to get up and get to school on time, both the teacher and the *ayi* (like parents in a family) allowed him to sleep late, but then ritually censured him for his laziness.

The teacher acts as an agent of the student's family, paid by his parents to conduct what might otherwise be a parent's job. In some cases the teacher is the parent, since all *huaban* teachers I met with grown children of their own had trained them in their own classes, and nearly every art educator's child had undergone the art test. (In *Sunflowers*, when Xiangyang starts cutting classes at his test prep painting school to sell paintings on the street at Houhai, his mother berates him, "Do you know how much the family spent on you?" and his father tells him "I'll start my own *huashi* for you," after which he is brought to his father's workshop every day to paint.) The *huaban* does not appear as an extension of the state-run disciplinary system of education, much less a tool of indoctrination into socialist visual culture; rather it is a direct extension of the modes of educational planning and test preparation practiced at home. And yet it is a necessary extension, given the increasingly exacting standards of the test: no one, not even children of artists and art teachers, can get into an art school without attending a *huaban*.

Parents are often on close terms with their children's teachers or the school managers, feeling free to go in and talk with their child's teacher in the way they would with a business associate: they bring cigarettes or liquor, or take the teacher to dinner.[49] Very few parents would dare approach a college professor this way. Perhaps because of the standardization and rationalization of the test system and the expansion of colleges, the personal relationships contracted through the *huaban* are more important than ever. As one parent in Qingdao told me, "The difference between the eighties and the present is that in the eighties, if you wanted to go to college, you

gave a little something, something nice. Today, you give money, and they'll still say it's not enough!" In the competitive environment of the college entrance system, the *huaban* teacher is a consociate available for making connections.

The disciplinary training of the *huaban* is significantly more intimate than the alienating classroom experiences that follow in college. Though students describe the college curriculum as relatively "free" (*ziyou*), and the types of imagery and objects produced in those classes more to their tastes, relations between the teachers and students in universities have become increasingly distant as schools have grown and class sizes increased. The *huaban* teacher is personally invested in the students, contractually, emotionally, and financially obligated to try to ensure their success. But college teachers derive most of their income and prestige from "projects" (*xiangmu*) outside of the university, and teaching can seem like a chore. At least for undergraduates, professors are absent or unapproachable, appearing only at the beginning and end of the class, always addressed in formal terms. This is especially true in the new "college cities" (*daxue cheng*), where students live on campuses far away from the center of the city, which teachers visit briefly during the day. Attending classes ranging in size from forty to one hundred, students must compete to attract the attention of the teacher, whose unwritten, personal standards of evaluation can seem confusing and unpredictable.

Although the *huaban* is independent of the state-run education system, it has become an intrinsic part of the art test system in the three decades since it was reinstated. *Huaban* are positioned between the state-run public secondary school, where teachers frequently appear as agents of the state, and the state-run public art institute/university, where senior professors establish their own studios, with independent curricula and idiosyncratic standards of success. The *huaban* plays an essential role in passing students from one state education institution to another; at the same time, the internal competition between *huaban* relentlessly pushes the standardization of the test by increasing the number of qualified participants. Informal test prep training takes place in the breaks of formal secondary education: weekends, summers, evenings, and the last year of high school. The gaps in state-run education are explicitly represented by state education officials as attempts to give students free time. Schools are usually prohibited from running evening and weekend study sessions like those common in Taiwan and Korea, but parental anxieties cause *huaban* and other test industries to fill in this time with test preparation.[50] The *huaban* and the state-run educational institutions together form a total system, but one that is beyond the

FIGURE 3.7 Still life arrangement with teacher's model drawing, Jinan, Shandong, 2007.

control of the state. This understanding of the test system is expressed in phrases like "blindness" (*mangmu, mangran*), "fever" (*re*), "nothing can be done" (*meibanfa*). As a result of the understanding that art test fever is not a state project, the socialist realism reproduced in the *huaban* is not regarded as state propaganda, and the long political history of these artistic genres can be overlooked, if not entirely forgotten.

Given that state-run education is in practice almost as exclusively college-directed as private test prep, the two structures are in limited respects ideologically continuous: both frequently represent the test as the purpose of most primary and secondary education, and "college" as the ultimate goal. However, there is a fundamental opposition between the motives, practices, and discourses (which is to say, ideologies) of the family education system and those of the state system. The test system as a whole institutionalizes conflict at multiple levels, including conflicts between parents and children

and between education reformers and those they seek to reform. The dialogic relationship between these opposing systems has led to the massive reproduction of socialist realism, which neither the average Chinese family nor the Chinese education bureau (let alone the propaganda department or the Communist Party-state) would claim as a project (see figure 3.7).

In the first two sections of this chapter, I have examined the conflicts between families' aspirations and the system of the test, and considered how *huaban* mediate between the two. In the next and last section, I examine another kind of dialogic tension, between the values reproduced within the test system, and the dominant values outside of it.

BACKDOORS: VALUE TRANSFORMATIONS

Many teachers I met in the course of fieldwork suggested to me that poorer students from the countryside would do well on the test because they had to work hard, unlike wealthy urban students.[51] During multiple visits over several test seasons, in reference to multiple cohorts of students, Teacher Wu often complained about the laziness of rich students from the city—those with cell phones that cost more than two thousand yuan, as he described them, and this before the advent of the smartphone. These lazy students were more interested in playing video games at the Internet bar, dating each other, fiddling with their phones, and above all *talking*, than they were in drawing.

In Teacher Wu's unfurnished extra classroom, where most of the students were from poorer towns and villages around Shandong, a well-dressed boy from the city of Jinan strolled in late to class; when asked if he had finished his homework, he blandly replied in the negative. He sat in the corner of the classroom, and immediately began finishing his teacher's sentences, turning them into jokes to make the group of about five or six shy girls in class titter. These girls were mostly from working-class and rural backgrounds and wore arm covers of the kind used by manual workers and peasants to keep their jacket sleeves clean. When the class was over, they stayed behind to keep drawing, while the loud boy sauntered off with the prettiest and most stylish girl to get lunch and shop for pencils. Teacher Wu said that this student drew very badly, that he was lazy, just "liked to talk," and would not test well.

In the classroom Teacher Wu ran in his own much more comfortable apartment, a shy boy sat at the back of the class working at his drawing, and avoiding conversation the other students (again mostly girls, but this time urbane and well-dressed). When he did open his mouth he spoke with a thick rural accent. The girls were chatty and familiar with Teacher Wu. After

going out for lunch (while the boy sat eating a bun he'd brought with him) a female classmate called Xiaomao (little cat) wheedled the key to Teacher Wu's bedroom from him so that she and two friends could nap on his bed. When Teacher Wu complained that he would have nowhere to nap himself, she provocatively suggested he nap with them. When later (at our usual lunch) I asked Teacher Wu about these two, he said that Xiaomao was lazy, and would not test well, but the boy worked hard, and would test well.

Teacher Wu considered himself a friend to his diligent poor students; he repeatedly boasted that he would not take money from families that "sold grain to pay their fees," that is, farm families. He claimed to offer free instruction to students from rural backgrounds because they were good students. He claimed that although he had made a lot of money during art test fever, he would prefer not to teach students who were lazy and didn't care about drawing and wanted to teach only diligent (*nuli*) students, who had an interest (*xingchu*) in learning how to draw. But when I came to Jinan during the week of the tests in winter of 2008, Teacher Wu apologized that he could not invite me to lunch or dinner, as he usually did, because all his meals that week were booked by "parents," taking him out to dinner, looking for a way to "go through the back door" (*zou houmen*). He had been teaching in Jinan for so long, he explained, that he knew the test examiners at the various provincial capital art academies. Every year at test time parents would take him to dinner to give him money that he would in turn transmit to certain examiners. Teacher Wu virtuously gave poor students the skills to pass the test, by pushing them through physically and emotionally grueling months of training and preparation, praising their diligence, and criticizing the laziness of their more fortunate peers, only to turn around and arrange advantages for students whose families could afford to buy them (see figure 3.8).

Bourdieu describes the education system as a complicated system for delivering people to the positions they are already in, which is to say, a system for reproducing the dominant social order and its class hierarchies.[52] But the *gaokao* (like the Chinese imperial examination system and modern compulsory schooling systems around the world) is widely regarded by both parents and state education officials as a tool for promoting meritocracy and social mobility. For them, the *gaokao* is an equalizing force, which must be continuously remade to resist the powerful forces of social capital: class distinction, nepotism, and corruption. As a result, rural communities in China often strongly support the standardized test system, and regard creativity- and individuality-promoting reforms—such as the proposal to use letters of recommendation in college admissions—as a threat to this meritocracy.[53] As I have argued in

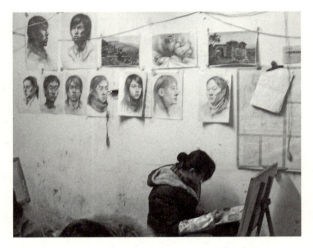

FIGURE 3.8 Student drawing in a test prep school, Jinan, Shandong, 2007.

this chapter, many of the disciplinary features that give the examination system its centripetal force, such as its unified standards, are figured as reactions to nepotism rather than ends in themselves. Policy is a reaction to strategy. Understanding this aspect of the Chinese test system (rather than merely dismissing it as false consciousness) requires a dialogic model of hierarchy and value. The conflicting ideologies of equality (on the one hand) and nepotism or familialism construct alternate hierarchies of students.[54]

The values reproduced by the test system are inversions of the values of the broader society. Teacher Wu's "diligent" students, whom he predicts will succeed, are (typically) shy, inarticulate, poorly dressed, with limited access to the commodities and entertainments that facilitate social relationships. But the students he calls "lazy" and predicts will fail are already developing skills essential to success in contemporary Chinese social life, skills that are significantly more useful than realist drawing: that is, chatting, flirting, shopping, gaming, hosting. Drawing silently is diligence (*nuli*), talking is laziness (*lan*); there is no relationship between verbal abilities (or mastery of standard Mandarin) and artistic or educational success. The backdoor practices Teacher Wu engages in are entirely routine in Chinese business: gifting money with expectations of special consideration. These transactions are called "commissions" and are widely accepted, though not lauded. But in relation to the *gaokao*, such transmissions are discussed less openly (attributed

to others more often than admitted directly), and are frequently exposed and punished as cheating (*zuobi*).[55]

Even in state-run academies, the moral order of *guanxi* can intersect with the moral order of meritocracy. Once I was sitting in a teacher's office at CAFA, watching two young art professors spend several hours addressing a series of first-year college students with extended and in some cases vicious monologues about improving their color and composition. Although they had been teaching this same class of students for months, they didn't know any of their names. Then, during a break, a well-dressed teenage girl came into the room. She was the daughter of a senior faculty member and had a bad reputation for repeatedly getting expelled from school (one of the teachers told me later that "no one knows how many school principals her father has had to suck up to"). She was about to "test" for entry to the school, and was there to pick up her test registration papers and instructions from her father's younger colleagues. Despite being reminded several times not to lose these papers, she promptly forgot them, and the younger of the two professors had to chase her down the hall. There was some awkward laughter, and then the critiques continued.

Like Teacher Wu, these young professors could address some students with the august authority of upholders of educational standards and relate to others from the intimate perspective of the parental consociate precisely because while nepotism is condemned within the institution *as* an educational institution, all the actors in it also participate in social spheres in which practices of reciprocity are normal and even moral.[56] Within the fields of activity organized by kin and professional networks, reciprocity has its own moral weight and its own compulsory power. It is an antiegalitarian ethical logic, used to correct the impersonal requirements of the test, even as the test is used to correct the inequalities of *guanxi*.

The educational system and its meritocratic values are implicitly understood as being in dialogic tension with another, broader social order. The predominance of women and people from lower- or middle-class backgrounds in higher education was frequently pointed out to me as evidence of the contrast between the values of the educational system and those of Chinese society.[57] The moral order in the school as school—according to which the proper work of teachers is to verbally abuse students for failing to learn skills they will never need, not to run after them with papers they have forgotten, and certainly not to help them get into school without learning those useless skills—is itself always potentially anachronistic. The norms of the school are not the dominant ones.

Chinese state-run schools and even universities are often explicitly political-ideological spaces, where Communist Party "thought" (*sixiang*) is promulgated and governmental rituals such as military training and contributions for national emergencies take place. Education policy is planned by the state according to projected "human resource" (*rencai*) requirements of the whole Chinese nation. The *huaban*, on the other hand, appears as an extension of the family, with no orientation to the organization of the whole society or the future of the nation; it is a strategy by which each family seeks to beat the test. But the line between the two sides is not sharp. The egalitarian values institutionalized in the state-run education system can trickle down into the *huaban* ("policy above and strategy below"), as when Teacher Wu offers free tuition to students whose families "grow grain," thereby replicating the state policy of offering free school tuition to rural residents. And the neo-Confucian values of the family and the clientelist values of the network can also bubble "up" in the school, as when the CAFA professors help their senior colleague's irresponsible daughter get into school. The *gaokao* is a dialogic system, where policy and strategy, above and below, contest and reciprocally transform each other. Art test fever was one product of this relationship. So too was the institution of the *tongkao* (unified test) in 2008, which put a stop to the fever—at least temporarily.

CONCLUSION

In this chapter I have shown that while art test fever was never institutionalized as a project by the Chinese state—and was in fact regarded as a problem, which education officials tried to solve with the imposition of a further policy—the art test prep industry that emerged from this fever managed to reproduce the art most associated with the Chinese state, socialist realism, in the very period when it began to lose its influence over popular visual culture. At the same time, the art test prep industry managed to erase the genre's historical and political associations and purposes, reducing it to an apparently empty set of technical forms. The *huaban* emerged from the contest between families and the state educational system, and socialist realism was reproduced as a "body-tool apparatus," manual skills embodied in the thousands of young people who passed through art test prep—an unprecedented mass of people with the skills necessary to produce realist drawings and paintings and to teach others to do so—just as most other countries ceased to train students in realist drawing.

4

NEW SOCIALIST REALISMS

As the last chapter illustrated, since 1978, when the college entrance examination systems were reinstated at the end of the Cultural Revolution, most Chinese art and design workers have been rigorously trained in three specific realist genres: delicately shaded bust-length portraits of work-weary faces, called *sumiao*; vividly colored impressionist still lifes focused on a chunky materiality, called *secai*; and rough, choppy, outlined sketches of people sitting, squatting, and standing, called *suxie*. Art test realism (hereafter ATR) is no longer called "socialist realism," although its derivation from Soviet painting is widely acknowledged. ATR images, painstakingly produced and thoughtlessly discarded, do not appear to be particularly "socialist" and are not regarded as propaganda. The ideological "cotexts"—slogans, critical descriptions, titles—that once politicized realist imagery have been erased. As a result, ATR genres are regarded as contentless formal exercises. Nevertheless, the complex political history of realism in twentieth-century China is not entirely forgotten.

The prototypic genre of Maoist socialist realism was the "revolutionary romanticist" *nianhua* poster that decorated homes and other workplaces all the way to the mid-1980s: scenes of idealized workers, soldiers, and peasants, youthful bodies vibrating with excitement as they dig ditches, pull ropes, read bulletins, listen to announcements, or stand with chests thrust out, gazing forward, holding identifying objects such as sheaves of wheat, rifles, or industrial equipment.[1] After the Cultural Revolution, this genre expanded to include new industries, such as industrial design and science (see figure 4.1). In many cases these posters featured active poses similar to or even drawn directly from those of the eight model plays, the revolutionary operas that

新花怒放

FIGURE 4.1 *New Flowers Bloom Gloriously*. Source: Wolf 2011: 203. Courtesy of Michael Wolf and Redux Pictures.

became a dominant cultural form during the Cultural Revolution. Many posters also prominently included famous works of art—portraits of Mao, posters hanging on the wall—or slogans and texts (represented as banners, books, and posters).

The most prominent genre of ATR, on the other hand, is *sumiao*, a softly shaded pencil portrait of a working person with a creased or rugged face, with eyes gazing off into the distance in an expression that can be described as weary, resigned, stoic, or detached. In *suxie* sketches, the bodies are always slumping, slouching, leaning. In revolutionary romanticism various categories of working people were indexed by their activities and the tools in their hands, but the people depicted in ATR are marked as workers only by their creased, dark faces, rough hands, and cheap clothes. In ATR there are never

images, slogans, or books to guide interpretation. The bright smiles, moving bodies, and bold slogans of fifties propaganda have moved into other genres, especially street billboards depicting the contented beneficiaries of technocracy—billboards that continue to depict the same themes and use many of the same compositions used in the 1980s. Moving bodies now appear in televised song-and-dance extravaganzas, especially those staged for Communist Party and military leaders, and for the New Year's holiday. But the moving bodies and smiling faces in these performances and billboards are not icons of labor.

This chapter explains this shift by putting ATR in the broader context of a new socialist realism, built around icons of migrant laborers, of the *nongmingong* (peasant-laborers) or *beipiao* (northward drifters).[2] There are parallels to ATR representations of workers in an array of genres, including both the official genres labeled "mainstream" by the Chinese cultural bureaucracy and the avant-garde new realism of artists like Liu Xiaodong and Jia Zhangke.[3] By comparing these genres, this chapter shows how they map contemporary Chinese social orders.[4] Placing these images in the history of Chinese political art shows how ideologies of realism transcend genres and styles. The transition from moving bodies to passive faces reveals a shift in models of history, from Marxism-Leninism-Maoism to Deng-Jiang-Hu's developmentalist socialism—models of history in which labor and the role of the worker have profound (and profoundly different) significance.

THE AESTHETICS OF PASSIVITY

In art schools and *huaban*, the historical shift from an aesthetic of moving bodies to still bodies, and from smiles to pensive frowns, is often attributed to the increasing competition for admission to art schools and the resulting increasingly technical requirements of the entrance exams. In the 1950s and 1960s, *suxie* (sketches of people in action) was an important genre for art students learning to produce socialist realist images in which active bodies moving were the focus. But over the course of art test fever, as the emphasis on highly detailed realism increased and the number of test takers grew, *suxie* was eclipsed in importance by *sumiao* (highly technical chiaroscuro bust-length portraits) and *secai* (impressionist still-lives). Most schools now administer only two tests, not the three or four they used to. If students draw *suxie* at all, they draw images of one another standing, sitting, and squatting (for that is also what they will draw during the test, if they are asked to draw *suxie*). The range of bodily gesture and expression that students are trained to produce is now limited to stationary poses.

Sumiao portraits typically take the accomplished student three hours to produce, the same period of time given to students in art school entrance tests. Short poses are three hours long; long poses may be anywhere from three days to two weeks (with breaks, of course). In the first two years of art school, the emphasis in life-drawing classes is overwhelmingly on long poses (four hours, two days, or even two weeks) no matter the medium being used, so that models are almost always depicted sitting, reclining, or lying prone.[5]

When I asked art teachers why the poses were so long, they said it was because of the demand for detail: models must stay still so that students can accurately depict them. As competition has increased, the standards of technical facility required to pass the examination have risen, and as a result the poses have become increasingly passive. These informants also suggested to me that ATR so frequently depicts *workers*, especially adolescent boys and older men, because of the economics of modeling. The models in *huaban* are usually migrant laborers or (at CAFA) retirees. According to this utilitarian analysis, the models' working-class faces and the long poses required by the demand for photorealistic detail give rise to a type of image that has become definitive of the *sumiao* genre: a worker's face, in a blank expression that might appear resigned, or stoic (see figure 4.2).

However, the same slack poses are used in classes that are not focused on realist technique, such as graduate classes in the Materials Workshop at the Central Academy of Fine Arts, where students' paintings can hardly be recognized as figure drawings. These poses are not merely an effect of the demand for technical accuracy but rather belong to a culture of modeling and image making that is informed by an aesthetic of immobility. These blank faces and slack poses are strikingly similar to faces and poses that appear in a wide range of visual culture forms, from high art films to popular music videos, from documentary photography to fashion magazines, all of which depend on a somber palette of grays, ochres, and umbers.

As for the economic explanation for the depiction of laboring people, students spend very little time drawing models, and most of their time drawing from copybooks. Workers can be models because *they look like the copybook drawings*, not the other way around. None of the classes I visited hired the many beautiful students of theater and dance schools as models, even though these schools are frequently located close to art schools and *huaban*. There is an aesthetic that organizes the selection of models, informed in part by depictions of laborers in socialist realism, and in part by contemporary Chinese visual cultures, both official and avant-garde.

ATR is frequently represented as an apolitical genre with its own logic, a logic moving in the opposite directions from those of Chinese visual cul-

FIGURE 4.2 Model image from China Art Test Web, a popular test prep website.

tures. The naturalizing explanations given to me by many informants—
that long poses result from the competition to prove technical skill, and
working-class faces result from the economics of modeling—represent re-
alism (*xieshi*) as a contentless, technical procedure, whose aesthetic features
are mere by-products of its material conditions of production. However,
comparing ATR to other genres of visual culture shows that the new faces
of *sumiao* are not mere technical exercises. In fact, ATR participates in a
broader political and ideological transformation.

In the years between 2005 and 2010, images of workers dominated official
exhibitions. Portraits of working people formed one of the core genres of
the official art exhibitions held in every art museum around the country to
celebrate the sixtieth anniversary of the PRC (such as the 2009 exhibition at
the Art Museum of Wuhan).[6] Pictures of blank-faced laborers and students

sitting idly also dominated many graduate student exhibitions, including one held in 2008 at the Shandong Academy of Art and Design near the military center and provincial capital, Jinan. This school, one of the central field sites in my research, is an extremely conservative place, where most faculty and many graduate students have ties to both the military and civilian bureaucracies. The vague expressions and bodily slackness that appear in ATR also characterize the genres of realist painting made by art teachers in China, which win the awards sponsored by the national and provincial cultural bureaus—the kind of art featured in a 2010 exhibition called "Trans-realism."[7] This exhibition was a collaboration between Christie's auction house and the Chinese Ministry of Culture, organized to assuage tensions resulting from Christie's sale of bronzes looted from the Summer Palace by the British and French in 1860. The exhibition displayed realist paintings that the curators described as "the mainstream art that Chinese favor," "more representative" than the "art favoring political themes" that has been so popular with Euro-American collectors and so profitable for auction houses like Christie's.[8]

In all these venues, the cultural bureaucracy of the Party-state has attempted to promote as mainstream a kind of realist oil painting based on ATR. In this context, the aesthetic of blank expressions takes on a political connotation of contentment, resilience, fortitude. Looking at contemporary official and academic genres of realism, art test prep training no longer seems so much like an unexpected, anomalous product of the market in technical training: rather, it seems like a massive system for indoctrinating future artists, designers, and elementary school art teachers into a state-sponsored politically conservative aesthetic, focused on representing workers as satisfied subjects.

On the other hand, images of work-worn laborers with passive, blank faces very similar to those featured in ATR have also played a special role in recent Chinese contemporary and avant-garde art, especially in the kinds of "political" art popular with foreign buyers mentioned above. Take for example Liu Xiaodong's "Three Gorges" paintings, among the most famous and highest-priced pieces of Chinese contemporary art ever sold at auction. In this series, Liu uses a thick-brushed style to paint several large group portraits of the people displaced by the Three Gorges Dam. In one sequence, called *Hotbed*, men stripped to their underwear play cards on a discarded mattress. In another set of images from the same series, a group of men carry an impossibly long piece of rebar; in another, young and old people stand and squat on the banks of the rising reservoir, faces impassive, arms crossed, hands in pockets. They stare out. The painting of the dam draws

directly on 1950s-era epic socialist industrial landscapes. The soon-to-be-displaced men and boys look like the migrant laborers often hired to pose in art test prep schools. The images are painted in the same color range and with the same thick pasty brushstrokes that art students use in *secai*. Only the nightmarish sex workers in the upper right-hand corner and the contorting ducks in the middle would be out of place in an art test painting.

Similar figures appear in Jia Zhangke's movies, in particular *Sanxia Haoren* (*The Good Person of Three Gorges*). The title is a reference to Bertolt Brecht's play *The Good Person of Sichuan* (*Sichuan Haoren*), the 1943 socialist classic dramatizing the impossibility of maintaining a moral compass in a capitalist system. Jia Zhangke's movie was distributed in the West as *Still Life*, an apt title for Jia's filmic aesthetic, which features numerous, extended shots of mostly working-class people looking pensive, the passive faces contrasted with gritty but rapidly changing semiurban environments. These long shots play with figure-ground relations, as the background gradually becomes the focus of attention. In *The Good Person of Three Gorges*, the background which becomes the figure is the group of houses along the banks of the dam which are being torn apart as the water rises; in another of Jia's movies, *24 City*, it is an outmoded factory, once the social center for all its employees and a world unto itself, now being dismantled. Both movies feature dozens of long, portrait-like shots of working people staring at the camera as if having their pictures taken, but with somber expressions not at all appropriate for social photography (hence the English title *Still Life*).

ATR and other highly technical forms of realist image production are called *xieshizhuyi* (artistic/literary realism; lit. "write-truth-ism"). The work of Liu and Jia is often described as *xianshizhuyi* ("factism," which can also mean pragmatism, realpolitik, a willingness to confront hard facts). The *xianshi* or hard facts they seek to depict in this case are what Ai Weiwei, describing Liu Xiaodong's paintings, calls the "human costs" of development: worn hands, tired faces, displaced people, the soon-to-be migrant laborers, the laid-off factory workers. These "avant-garde" artworks are often regarded by Western art critics and viewers as forms of antigovernment social critique.

The art critic Jeff Kelley cowrote a book about Liu Xiaodong's Three Gorges Project in which he and his two (also Western) coauthors accompanied the artist to the dam to watch as he painted the group of men playing cards on an abandoned mattress, with the rising reservoir behind them. In this book, Kelley writes, "The pedestrian faces and prosaic pictures of Liu's subjects . . . testify to a China filled with hope, ambition, cunning, bewilderment, anger, indifference, longing and despair. They are the old faces

of the new China, and they embody the weary countenance of history."⁹
Kelley regards Liu's work as "an epic narrative about loss," a kind of private/
public complaint, bridging the categories of *suku* (complaint to the govern-
ment) and *baoyuan* (private complaint). He describes these paintings as an
art conceived in opposition to the optimism of socialist realism, not just as
a critique of the Three Gorges Dam, but as a critique of the Communist
Party, and of the condition of China. In Kelley's analysis, even the brush-
work is political: "This anti-heroic approach extends beyond Liu's choice
and depiction of subjects to his handling of paint. His hand is confident
and deft, his brushwork brushy, quick, fluid, almost sketchy. One feels in
his manner neither painterly flourish nor party-line discipline: his brush-
strokes neither express themselves nor stand at attention. Rather, they con-
vey a hands-in-pockets informality, while evincing a sense of the mineral
weight and moral gravity that tugs at realist painting."¹⁰ Here, Kelley takes
Liu Xiaodong's brushwork as icons of a stance of helpless opposition. He
identifies the artist through an indexical icon of the painter's brushwork:
an expressionless character, resistant to discipline, but with a moral gravity,
standing around with his hands in his pockets—he could well be describing
the picture of Liu that appears in his book. Kelley regards Liu Xiaodong's
visual style as a unique artistic strategy, directly in opposition to the "aca-
demic orthodoxy" of Party-state technocracy.

In the West, Liu Xiaodong's Three Gorges Project, like Jia Zhangke's *Still
Life*, is frequently viewed not just as a critique of the Three Gorges Dam,
but also as a critique of the party and of China itself: as a dark "vision"
antithetical to the optimism of the Party-state. This implied oppositional
politics has given these artists global cachet. But in China, representations
of laborers that are very similar to those of Liu Xiaodong and Jia Zhangke
are reproduced on a massive scale as a condition of entry to Chinese state-
run art schools. They are displayed in official art exhibitions organized by
the party, and win prizes in state-run exhibitions. Liu Xiaodong's handling
of paint and his choice and depiction of subjects are all deeply connected
with ATR, perhaps the most orthodox and academic (and certainly the
most widely reproduced) genre of painting in China. As a former student
(BA 1988) and chair of the oil painting department at the Central Academy
of Fine Arts, the apex of the art education system, Liu occupies a central
position in the institutions that reproduce ATR. Likewise, Jia Zhangke has
returned to CAFA as head of the Intermedia Studies Department.

ATR, new realism, and official realism all represent the figure of the
worker in terms of stoic patience, or weary resignation: bearing the marks
of labor, but not doing anything. If the politics of images are embedded in

their modes of address and interpolation—the social relations indexed in and generated through images—then understanding the politics of these varieties of realism requires an analysis of these forms of indexicality: a semiotics of "vision."

THE SEMIOTICS OF VISION AND THE
AESTHETICS OF RECOGNITION

As Alla Efimova argues in relation to Soviet socialist realism, most histories of socialist art focus on how art was controlled by the state, and fail to engage with "the relationship of the artist with the viewer, the mechanisms of reception, and the mode of the artwork's address."[11] This omission is particularly regrettable because, as Efimova argues, socialist realist art was precisely concerned with "stimulating the viewer's response, producing affect." Analyzing the modes of address entailed by ATR/realism shows that these blank expressions too participate in a politics of affect, calling on a particular emotional response from the viewer, a response framed by the fraught class relations and complex ideological hybridizations of Chinese postsocialism. These icons of the worker (*gongren*) are not oriented toward the liberal politics of recognition described by Elizabeth Povinelli, which has an ethics of "decreased harm through increased mutual understanding of social and cultural differences."[12] Instead, these images serve as unidirectional recognition of the sacrifices of the laboring classes by those who do not labor. This recognition is quite unlike the "identification" between working people and cultural producers promoted by Maoist campaigns sending artists and writers "down" to the countryside or making students work in factories to the *nian-hua* posters described above. Nevertheless the ATR-style realist aesthetics of recognition is profoundly influenced by a particular kind of socialist ethics: a labor theory of value, highlighting the centrality of labor in producing all the bourgeois values enjoyed by the middle classes.

Revolutionary romanticism purveyed images of proud model workers, soldiers, and farmers as social categories (which later came to include intellectuals, businessmen and cadres) into which viewers were invited to project themselves. By contrast, ATR images of generalized *nongmingong*, with no specific markers for agriculture, industry, service, or construction, are not "models" but icons of weariness and suffering, literally "bitterness." They appear to viewers as images of others, recruiting viewers to roles of sympathetic objectification rather than empathetic identification.

In linguistic anthropology, the concept of "voice" is used to analyze social positioning in language: certain "voices" or ways of talking indicate "who" is

talking, and to whom—for certain listeners. As Asif Agha notes, the concepts of "register" and "voice" that have been so productively used to analyze social positioning in language are too specifically linked to the vocal apparatus and the grammatical and syntactic features of language to be applied to other forms of semiosis.[13] I propose the concept of "vision" as a way to analyze some processes of social indexicality in visual media, in particular to distinguish between the figures depicted in images and those indexed by them.

"Vision" is a way of thinking about the indexicality of images. A picture, film, or painting almost always suggests both an authorial persona, (who might be very different from the actual person who made the thing in question), and an intended viewer or addressee. Just as *registers* and *voices* are associated with *speakers* or social personae, *visions* are associated with *envisioners*. There are personal visions, authoritative visions, revolutionary visions, critical visions. Envisioners are personified "interpretants," social figures that should not be confused with individual human image producers. Envisioners, like the speakers associated with voices and registers, should be regarded not as biological people but as abstractions.[14] Likewise, the addressees, or implied viewers (in this case, sympathetic witnesses to suffering), are another social type, not reducible to the actual people who end up looking at the picture.[15] The envisioners indexed by an image may have a variety of relationships with the social figures depicted in that image, and with the implied viewers addressed by it.

Identifying a "vision" shared between the objects these actors produce allows us to ask not "who made these pictures?" but "what kind of envisioner is indexed by these pictures?"[16] In contemporary China, images corresponding to authoritative visions are produced in a variety of contexts: in government propaganda bureaus by propaganda workers under the direction of cadres, in private artworks by patriotic or ideologically inclined amateurs, in the works of academic artists attempting to win prizes in official exhibitions, and in private works created for the "gift market," to be used as gifts between government cadres. Visions transcend genres and subcultures.

This concept of vision is applicable to a variety of visual cultures, including capitalist and liberal ones; but the particular semiotic ideologies and practices of socialist realist visual cultures may allow the phenomenon of vision to appear more distinctly. As Greg Carleton has argued in his analysis of Soviet socialist realist literary criticism, socialist realism was "thematically centrifugal" but "stylistically centripetal": the same political themes were presented in novels, plays, history, and sociology, all of which were described as representations, "showing how" class consciousness developed, how the landlord class was overturned, and so forth.[17] Similarly, Chinese

socialist realist visual cultures have long been characterized by metageneric coherences, and consequently socialist and postsocialist visual cultures are particularly fruitful starting places for examining the indexicalities of vision.

Just as voices are indexed by vocal qualities, visions are indexed by a variety of formal qualities such as palette, composition, and iconography (including types of people, places, and things depicted). Like voices, visions can be parodied, as the Chinese political pop art of the 1990s parodied classic socialist aesthetics. But "voicing" or speaking in the register of another is not always parody, and not every reproduction of a vision is parody. Just as registers can have a hegemonic power and impose themselves on discourse, so too can visions impose themselves on art and other visual media. Distinguishing parody from other types of revisioning—which is to say, identifying the politics of an image—involves mapping the social positionings indexed by that vision, and the relations it posits between envisioner, envisioned, and addressee.

In modes of image production that involve a face-to-face interaction for the purpose of letting one person represent another (artists and models, photographers or filmmakers and subjects), the interactions between image subjects and image producers can in turn model relations between the "envisioner" and the "envisioned." The three genres of contemporary Chinese realism that I have discussed here—ATR, official realism, and avant-garde realism—are all produced through moments of face-to-face interaction between people on opposite sides of a class divide, and in many cases these interactions are awkward. The production of all of these images involves the inspection and examination of the faces and bodies of real migrant workers, who are paid to sit, stand, and squat, modeling the characterological role of "workers" not through action but inaction.

Jeff Kelley's book includes photographs of Liu Xiaodong and his subjects working on the Three Gorges Project. The men sitting in their underwear on the mattress under the eyes of Jia Zhangke's film crew, with Liu Xiaodong in front of them painting away at his giant canvas, a crew of observers behind them, are laughing with each other, but in the paintings they are blank-faced. In a snapshot, the children are smiling sweetly, but in the painting they are grimacing. Similar disjunctures appear in many of Jia Zhangke's movies, as subjects struggle to maintain the stoic expression that characterizes his art, and sometimes a shot ends when a bit of a smile slips through. It is clear that Jia has asked his subjects to perform the envisioned character of the passive, expressionless worker, and edited the film so that we can see the cracks in the performance. Both *Still Life* and *24 City* feature

sequences of apparent interviews, in which the interviewer never appears, some with "real" people, others with well-known actors. The presence of television and film stars such as Joan Chen breaks up the overall documentary effect, in a reverse of the classic Brechtian break of the "fourth wall": in this case, the denaturalized, denarrativized documentary scene breaks into the filmic world of illusion. It is never entirely clear how much the director has orchestrated the scene.

In another "political" artwork popular with Western collectors, the famous photograph by Zhang Huan, *To Raise the Water Level in a Fishpond*, forty migrant men stand naked up to their chests in the water. Even the small boy riding on a man's shoulders is blank-faced. For Zhang, it was very important that these subjects be migrant laborers "from the bottom of society," as he says in his artist statement. But in the much less famous videos of this performance shown at the PACE gallery in Beijing in the fall of 2010, it is clear that as the men stripped to their underwear and walked into the water, they were laughing and chatting with each other, but not with the artists managing, observing, and photographing them (who might not be able to understand what they were saying, anyhow). The social distance between the artists and the "laborers from the bottom of society" they choose to depict is painfully obvious.

These awkward situations can best be understood in terms of the politics of "recognition." Povinelli describes recognition as "at once a formal reconnaissance of a subaltern group's *being* and of its *being worthy* of national recognition, and at the same time, a formal moment of being inspected, examined and investigated."[18] In Jia Zhangke's movies, in Liu Xiaodong's life paintings, and even in *huaban* where art students gather around a laborer sitting on a pedestal to learn how to draw him, actual migrant laborers are paid to represent the characterological role of the worker, to provide passive bodies and blank expressions, for a representer who is thereby indexed as a *recognizer*, with the class consciousness of those who do not have to labor.

The *addressee* indexed by these images shares this privileged class consciousness. ATR-like images of passive workers recruit their viewers to roles of sympathetic objectification rather than empathetic identification. Where revolutionary romanticism invited viewers to project themselves into images of *gongren*, these new socialist realist images of *nongmingong* are images of others. In recognizing the figures in these images as migrant laborers, image producers and their implied audiences perform "middle-class" recognition of the role of the laboring classes in producing the wealth of the new China.

The stylistic shift from smiling faces to blank ones represents an ideological shift from glorifying monumentalization of the working class to recognition of human costs. Unlike the Maoist propaganda posters that were supposed to embody the ideology of a classless society, *recognition* implies an unequal relationship, not just between the characters depicted in the image and the audience, but also between the characterological roles depicted in the images and the envisioner indexed by it, regardless of the actual class background of the artist. Rather than attempting to overcome class difference and create identification between cultural producers and laboring people, this vision reproduces a relationship of inequality, of beneficiary to sacrificer. And yet, despite its radical departure from the history of Maoist class relations, the ATR-style realist aesthetics of recognition is not a liberal one. Rather, it represents a particular kind of socialist ethics, a modified labor theory of value for developmentalist socialism. It is a recognition that laborers produce all the bourgeois value that middle-class people enjoy, or what Wen Jiabao called *weida nongmingong de juda gongxian*, "the enormous contributions of the great peasant/laborer class."[19]

In China, Marx's "labor theory of value" is still taught in every middle and high school. According to this theory, labor is not just another commodity but the source of all value, and labor is taken to mean hard, physical, backbreaking work, the kinds of work that farmers and migrant laborers do. As a result, depicting laborers cannot be regarded as an inherently politically contrarian aesthetic move, as it is in the West. Liu Xiaodong and Jia Zhangke's illustrations of what Ai Weiwei calls "the human costs" of development represent a darker, more cynical version of the official vision, an indirect representation of the concept of *the value of labor*, which is basic to contemporary Chinese models of development and class relationship. The aesthetic of weary, work-worn faces that characterizes this realism stands in stark contrast to the consumer economy of the smile, the smile that is the basic currency of China's now vast service economy and of market socialism more broadly. However, the aesthetic of the passive face belongs to an authoritative vision of class relations in contemporary China, a vision shared between ATR, official realism, and avant-garde realism.

This leads to the problem of the relationship between vision and reality, or the problem of representation. The interpretive norms of socialist realism emphasize denotation or description as opposed to metaphor or allegory, which is to say they naturalize interpretation. Realist visions are presented as representations of the world as it is, or as it was. In the next section I look at the semiotics of Chinese socialist realism through a brief political history

of the interrelations of two ideologically inflected models of realism, the physical and the social: *xieshizhuyi* and *xianshizhuyi*.

REALIST VISION IN TWENTIETH-CENTURY CHINA

As mentioned above, ATR consists of three genres, *sumiao*, *secai*, and *suxie*, each of which is used to teach a different mode of realist image production, and each of which focuses on a different aspect of physical (or "natural") reality. *Sumiao* portraiture is "real" insofar as it captures light and shadow, and insofar as it achieves physiognomic accuracy or believability, such that even an imagined, composite face looks like it belongs to a "real" individual.[20] *Secai* still life is "real" insofar as it captures or convincingly approximates the way that light and shade interact with surfaces to project color. *Suxie* sketching is "real" insofar as it approximates the positions of bodies in spaces, abstracting them into outlines. Together, these three techniques of image production are taken by the art school entrance tests and first-year foundation (*jichu*) classes to represent a comprehensive mastery of physical materiality—light, color and space, physiognomy and anatomy—that is, the "foundation" for all other forms of image production.[21] All participants in all visual culture industries are de facto required by the art school entrance tests to have achieved a high level of technical mastery at depicting the physical world, which is called *xieshizhuyi*.

In the twentieth century, two concepts of realism, each associated with different kinds of interpretive norms, have played central roles in Chinese visual cultures. One is *xieshizhuyi* (technical realism), described above; the other is *xianshizhuyi* (social realism), which in some cases means realpolitik or pragmatism, and in other cases means the accurate or appropriate representation of human history and society, described in the previous section. Technical realism was treated as a problem of form; social realism was treated as a problem of content, especially political content. But as Julia Andrews has argued, during the early twentieth century and throughout the Maoist era, standards of social realism were naturalized in terms of technical realism, so that failure to depict the right social types was interpreted as a failure in depicting bodies, and failure to express the right political attitude was often interpreted as a failure to manage color and light. As a result, realist techniques were as much a focus of political contentions over visual culture as image contents.

The complex political history of twentieth-century Chinese visual culture has at times been told as a war of genres associated with famous figures, such as the educators Xu Beihong and Jiang Feng, and the Gang of Four

leader Jiang Qing. There is a tendency to map what Bakhtin called "the fates of genres" onto the political fates of their advocates. But separating the analysis of genres from the bitter struggles of the socialist period reveals substantial formal and ideological continuities between "contesting" aesthetic genres. For example, while *guohua* ("national painting," or Chinese-style ink paintings) has been rhetorically and institutionally contrasted with *youhua* (Western-style oil painting) since the nineteenth century, and this division was the basis of many political struggles in the fifties and sixties, hybridizations of ink and oil painting traditions have been central to Chinese modernist visual cultures since the early twentieth-century Republican period, and continue to be central to contemporary official visual cultures. *Guohua* and *youhua* painters in China were committed to the same general project of "realist" representation and the same authoritative visions framed by that project throughout the twentieth century.

Authoritative visions operate at the level of content—social types and topics—as well as at the level of aesthetic forms and color ranges or palettes. Figures of people and land, in particular, transcend genre. Over the twentieth and early twenty-first centuries *guohua* and *youhua* portraiture have shared preferences for certain types of physiognomy and anatomy; *guohua* and *youhua* landscape have shared ways of depicting space and preference for types of geography. These preferences have systematically shifted together. The same is true of the topics or *ticai* (such as natural disasters, wars, and technological victories) that were used in Soviet-style history painting starting in the early fifties, which are still used by academic painters today.

Western-style realist techniques like those used in ATR were imported to China from France and other European countries and Japan in the late nineteenth and early twentieth centuries by students returning home from abroad and by foreign painting teachers at missionary schools. In the first half of the twentieth century, these techniques were rapidly incorporated into and disseminated through the developing Nationalist-era education system, in accordance with Beijing University director Cai Yuanpei's theories of "aesthetic education." Western-style realism was promoted as a tool of scientific modernization by both liberal modernizers and radical communists, though with different aesthetic and political emphases.

The most famous of the modernizing academic painters was Xu Beihong, the *guohua* painter and friend of Cai Yuanpei. He had studied in France at the turn of the twentieth century and became the director of the Nanjing Academy of Fine Arts in the Nationalist period. Most moderate artists and intellectuals fled to Taiwan before the Communist Party came to power, but

Xu stayed behind to become the director of the Central Academy of Fine Arts (allegedly, he was able to maintain this position through his friendship with Zhou Enlai). Xu died only four years after Liberation. Since the end of the Cultural Revolution, he and his approach to realist painting have been historically rehabilitated, and he is now regarded as "the foundation layer of Chinese modern art . . . whose painting melted ancient, modern, Chinese and foreign (*gujinzhongwai*) in a single fire, who had a strong sense of the age, and who served a great purpose in our country's art history by inheriting the past and ushering in the future (*chengqianqihou*), carrying forward the revolutionary cause and forging ahead (*jiwangkailai*)."[22] Xu supported the establishment of highly technical training systems like those used in ATR during the prerevolutionary period and during his brief tenure as chair of CAFA. His charming syntheses of Chinese and Western painting include Chinese-style ink paintings of horses and eagles, and portraits in which the figures occupy most of the frame, the faces are delicately shaded according to Western conventions, and the partially indicated bodies are painted in ink outlines derived from Chinese portraiture, but with Western-style "realist" anatomy and perspective: combining *guohua* techniques with Western anatomy, physiognomy, light and color. Xu participated in the movement that re-valued *guohua* in the terms of referentialist interpretive norms, so that a pine was just a tree, a sparrow just a bird, not an allegory for anything else. Xu Beihong's aesthetic is the most recognizable basis of the "authoritative visions" that shape the now dominant genres of official and academic painting and his writings are quoted in most art histories and art education textbooks.

Xu's posthumous success in the postsocialist period is interesting because during the early years of Communism his apolitical, romantic style was totally rejected by hard-line Communists and political radicals like Ai Qing and Jiang Feng, the underground activist and *youhua* proponent who became the real force behind Communist Party artistic policy in the early years after Liberation (1949). Throughout the Maoist period, *guohua* and *youhua* painters fought over issues of form and content, style and topic, despite the fact that both shared a belief in the modernizing powers of the very same *xieshizhuyi* techniques, and a commitment to the same referential interpretive norms.

In the 1930s, Jiang Feng and his radical comrades learned printmaking from a Japanese teacher at a workshop organized by the author Lu Xun. Inspired by the works of Kathe Kollwitz and under Lu Xun's direction, Jiang Feng took up printing as a means of mobilizing the masses. At Yan'an in the late 1930s and early 1940s, Jiang Feng helped to develop the Communist

Party's first successful propaganda campaigns, with newly politicized versions of traditional New Year's folk prints or *nianhua*.[23] Jiang Feng later developed a new style of *nianhua* incorporating chiaroscuro, based on the Shanghai cigarette girl posters, which became one of the most popular art forms of the Maoist era. After Liberation, Jiang Feng became the head of the Lu Xun Art Academy and the acting director of the Central Academy of Fine Arts. He supported the development of several key genres of Chinese socialist realism: colored posters depicting workers engaged in "everyday" activities, industrialized oil landscapes of factories and busy shipping ports, and Soviet-style monumental "history painting" (tragic scenes of peasants suffering under feudalism, exciting scenes of revolutionary military action, and great scenes of postrevolutionary development).

Jiang was committed to the Stalinist model of popular socialist realism. He opposed both traditional Chinese ink painting and Western avant-garde modernism as bourgeois; he supported the Soviet-style use of shade and color to model forms, against what he considered insufficiently realistic traditional techniques such as the "black outline and flat-color" painting style. (On the other hand, he supported the development of new black-and-white outline versions of *lianhuanhua* serial graphic novels, perhaps the most popular and influential genre of visual culture in Maoist China.) In the mid-1950s, the period when Soviet experts in every field arrived to help China establish industrial socialism, Jiang invited the Soviet portrait painter Konstantin Maksimov to CAFA. Maksimov's two-year course (1955–57) produced an enormously influential cohort of realist painters; they took his highly formalized painting pedagogy—which is still widely recognized as the model on which ATR training is based—to art schools around China.

For radical artists in the 1940s and 1950s, such as Jiang Feng and Ai Qing, central figures in art and literature in the early Communist era, "realism" (*xianshizhuyi*) meant the use of chiaroscuro, three-point perspective, and scientific anatomy to depict contemporary events and places. For them, realism was not just a tool of propaganda but the highest aspiration of a political aesthetic. As the critic Chen Yifan wrote of the woodblock movement led by Lu Xun, in which Jiang Feng and other young radicals participated before the revolution, "It is the prime need of China and her millions to be able to see and feel and visualize things realistically, to orient themselves correctly on the basis of true facts (*xianshi*). And in art only realism can do this. In the creation of a realist art the artist completely fulfills his social and political duties."[24] Chen associates *xianshi* and *xianshizhuyi* with the ability to "see and visualize realistically." "Seeing and visualizing realistically" means accurately representing the contours and textures of objects

close at hand; but in accurately representing the physical, the artist will also accurately represent the social, and allow viewers to also see realistically. As the poet Ai Qing (father of Ai Weiwei) wrote, paintings of imaginary landscapes and figures, "with no body under their clothing," or of beauties "who cannot be seen in the park or on the street" are "lies." Ai Qing wrote, "We must substitute depiction of real objects for copying [old paintings] as the fundamental curriculum for the study of Chinese painting. . . . We need scientific realism as our standard in criticizing and evaluating our art. The excellence or poorness of a painting must be seen first in whether it accords with social reality and natural reality."[25] Eventually, Jiang Feng and Ai Qing's opposition to "bourgeois" Chinese ink painting won them enemies, who reportedly wooed central party figures with gifts of paintings. In the late fifties, as relations with the Soviets broke down, party leaders put a new emphasis on "national forms" and "anti-imperialism."[26] By the 1960s Jiang Feng had been stripped of his position and his "internationalist" version of realism repudiated, as a realist *guohua* based on painting from life, in formal respects similar to the work of Xu Beihong but with more overt political content, came to prominence within the academy. Jiang's fall had no effect on the popularity or continued production of the genres he brought to prominence, from *nianhua* posters to *lianhuanhua* comic books to monumental history painting, but it did lead to the rise of several new genres of realist *guohua*.

The genres of *guohua* portraiture, bird and flower painting, history painting, and mural-scale Chinese *shanshui* landscape developed in this era became the fundamental official genres of painting in the PRC. These genres survived the Cultural Revolution and *gaigekaifang* and are still in use today. They are displayed in Communist Party buildings and offices of state, and often dominate official exhibitions. The most important of all these genres is the hybrid landscape that manages to fit together entirely opposed Chinese and Western-style landscape conventions (most famously the 1959 classic *This Land So Rich in Beauty* by Fu Baoshi and Guan Shanyue) to present a vision of epic landscape, representing "the nation" through the figure of the land. These images continue to serve as backdrops for televised state meetings; a seemingly endless landscape of the Great Wall in this style hangs behind the customs desks at the old Beijing airport, and for decades was the first thing to greet visitors to China.

Despite the conflicts of the first twenty years of socialism and the diversity of genres that "flowered" during this period, the interpretive norms and representational strategies used by all these genres were fundamentally con-

tinuous. They were all committed to a basically modernist and referential-ist conception of realism, as a practice of representation in which "social reality and natural reality" come together, and in which social reality be-comes available for observation through a privileged mode of representa-tion of natural reality.

Things changed, however, during the Cultural Revolution. At the start of the Cultural Revolution, high-level cadres denounced both *guohua* ink paintings in the style of Xu Beihong and *youhua* impressionism in the style of Maksimov. The cadres in charge of art education and cultural affairs were replaced. The universities were shut down by the squads of adolescent Red Guards from all over the country. In response to Mao's big character poster "Bombard the Headquarters," Red Guards occupied art schools including the Central Academy of Fine Arts.[27] As factions of Red Guards fought, many artists were tortured in public "struggle sessions," sent to prison or labor camps, or forced into suicide, and a great deal of art was destroyed, often by artists themselves, for fear of being discovered.

"Red line" visual culture turned away from "realism" and toward "rev-olutionary romanticism" (another concept from Mao): "Life as reflected in works of literature and art can and ought to be on a higher plane, more in-tense, more concentrated, more typical, nearer the ideal, and therefore more universal than actual everyday life."[28] Interpretive norms shifted from refer-entialism to a kind of total symbolism and allegory. A new way of reading paintings, interdiscursive with the hermeneutics that surrounded imperial era-bird and flower painting,[29] came into political use. In this paranoiac her-meneutics seemingly banal objects such as flowers, trees, bugs, and birds could be interpreted as political allegories.[30] Color symbolism became a central focus in many political battles. "Black exhibitions" were held to denounce counterrevolutionary "black" artists, some of whom were called black because they used too much black pigment, which was to be avoided in favor of red. Black could be used only in the black outlines that were said to make images more legible and less bourgeois. The most important work was the production of large portraits/icons of Mao and other lead-ers and model figures (including Lei Feng), to be hung in public buildings and private homes for ritual worship. In these paintings, according to rules disseminated to painters, Mao's face was to be "red, smooth and lumines-cent . . . cool colors were to be avoided . . . conspicuous displays of brushwork should not be seen. . . . The entire composition should be bright, and should be illuminated in such a way as to imply that Mao himself was the primary source of light."[31] This vision of superhuman power, expressed through an

antinaturalist (theatrical) use of light and a symbolic approach to color, was so influential and so central to the time that it dominates memories of the Cultural Revolution and remained the object of parody for thirty years.

And yet, even these "revolutionary romantic" visions were informed by certain understandings of realism, both *xieshizhuyi* and *xianshizhuyi*. Throughout the Cultural Revolution, despite the emphasis on color symbolism and the theatrical use of light, propaganda images were nevertheless held to technical standards in three-point perspective, modeling, and anatomical and physiognomic plausibility. Because of these unspoken standards, technically incompetent but politically sound works by amateurs from good working-class backgrounds were always repainted by trained artists before display. The rough, childlike paintings produced by untrained peasants under the direction of artists sent down to the countryside, such as the famous collection "Peasant Paintings of Huaxian County," widely reproduced overseas, were not popular in China. In less chaotic years there were official exhibitions of monumental *guohua* landscapes, state-commissioned *youhua* history paintings, and smaller paintings of various forms of typical socialist activity.

Moreover, a semiotic ideology of referential accuracy continued to organize the conditions of art making (and thus the relationships between artists and their proletarian subjects) throughout the Cultural Revolution. Following Mao's directive that "artists and writers . . . must go among the masses of workers, peasants and soldiers . . . to observe, experience, study and analyze all the different kinds of people, all the classes, all the masses, all the vivid patterns of life and struggle, all the new materials of literature and art."[32] Over the course of the early socialist period under Jiang Feng, this directive had been incorporated into art pedagogy through the institution of *xiaxiang* (going down to the villages to labor) and also *xiesheng* (painting outdoors). During the Cultural Revolution, however, this was increasingly taken to mean that paintings ought to be based on artists' own experiences as laborers in the villages or industrial factories to which they were sent after the closing of the universities and art institutes. During this period many posters focused on rural production teams, minority peasants, industrial worksites, and military posts. Painting became a collaborative form, with teams of trained painters working under the oversight of committees of workers and cadres.

Such projects were driven by a political ethic of equality between artists and workers, but they were also organized by a semiotic ideology of referential accuracy. The point was as much to produce "real" images of socialism as

to transform class relationships. Of course, to viewers accustomed to a different model of realism, this version appears to be too stylized.[33] Judith Farquhar recounts how American students in her classes could not accept Chinese *nianhua* posters as "realism," but the Chinese students who had themselves experienced the Cultural Revolution saw such posters as valid representations of their memories.[34] These students focused on the recognizable details, the pieces of material culture from the 1970s scattered around the image; they also suggested that these pictures depicted the real emotional experience of the Cultural Revolution, the spirit of the age. Despite the theatricality, the obviously constructed character of revolutionary romantic images, they maintained a commitment to referential accuracy. Moreover, they aimed at a comprehensive documentation of the world, which contemporary genres of realism do not.[35]

As a result, despite the violence and destruction of the Cultural Revolution, a realist approach to image-making survived. It seems possible that despite the closure of the art schools, the popularization (*puji*) projects of the Cultural Revolution, including amateur art classes at the *wenhuabu* (Culture Office) and the continued mass production of popular art forms such as *lianhuahua* graphic novels and *nianhua* posters, actually expanded the numbers of people with experience in realist painting and drawing. Perhaps a result, in 1978 when the college entrance examinations were restored after more than ten years, there were thousands of young people ready to take art examinations and the competition was intense.

When the art academies reopened, Western-style oil painting became the dominant discipline of the "fine arts" (*meishu*). Oil painting departments became the most prestigious departments in the fine art schools, and the primary institutions determining the criteria used in art school entrance, which is to say, the institutions that defined ATR.[36] At CAFA and other schools the plaster casts of famous Greek, Roman, Italian, and French sculptures destroyed during the Cultural Revolution were replaced. Students ceased to go into villages and factories to labor, although they still went to rural places every spring for *xiesheng* (open air painting) field trips, which were (and are) still called by the Maoist term *xiashang* (going down to the villages). The Chiastakov drawing training system and the techniques of the "Soviet expert" Maksimov were restored as a foundation curriculum.

The resumption of a Soviet tradition, largely through the influence of former Maksimov students in the new administration of the Central Academy of Fine Arts, was part of a broader return to Soviet-style technical expertise after the populist movements of the Cultural Revolution. It was part

of a broader return to "elite" (*jingying*) education, aimed at producing a small class of highly trained experts. Over the course of the 1980s, muted Soviet palettes and thick, pasty brushstrokes came to signify the technical skill (*jishu*) that was the basis of an academic painter's status. While *nianhua* and *lianhuanhua* were still produced during the 1980s, smooth, bright colors and black outlines of poster art associated with Cultural Revolution–style populism came to be marked as *gongyi* (industrial art).

In the early 1980s, as new art books began to trickle into mainland China from Hong Kong and Taiwan, expressionist (*biaoxianzhuyi*) and impressionist (*yinxiangzhuyi*) painting styles became increasingly popular in the academies and in critical circles. Various avant-garde scenes developed, with members who often worked assigned jobs at art academies, but painted outside of academic genres. Over the course of the 1980s, visual culture styles proliferated and the New Wave art and literature movements grew in influence. As alternative visions came to prominence, the authoritative genres of official visual art and propaganda became increasingly recognizable as a hegemonic vision, as a "governmental" (*zhengzhi*) style. At the same time, the range of formal approaches to the concept of the real acceptable in official painting expanded. Landscape, portraiture, and history painting became more "real" in the sense of being less "idealized"; and as these images became more real, bodily and facial expressions became more passive, and seated portraits became more common than moving figures.

When Deng Xiaoping's reforms began in 1978, the *laoshi* (honest, guileless) rugged older working men, brawny young handsome men, and ruddy-faced sturdy women that used to march through all the varieties of Maoist visual culture did not disappear. They remained common in posters, billboards, films, and spectacles. These days, versions of the these characters still appear in television serials about rural people and revolutionary heroes such as *Village Love* and *Sister Jiang*, and the comedy sketches performed for New Year's TV programs. But starting in the 1980s these active people were joined by other figures, including pale, slender beauties, pretty white-faced boys, and sly men with "no bodies in their clothes." As the reforms that began under Deng Xiaoping continued under Jiang Zemin, a variety of new character types came slouching through a variety of genres of popular film, television serials, academic painting, and avant-garde imagery. At the same time, active scenes of people working appeared less frequently, and the triumvirate of basic socialist identities (workers, peasants, and soldiers) disappeared. In the age of Hu Jintao's "Harmonious Society" and Xi Jinping's "Chinese Dream," most of the figures in propaganda and advertisement are nondescript: vaguely white-collar and indistinguishably middle-class.

Class (*jieji*) is no longer an official identity category marked in one's registration book as it was during the Maoist era. But the erasure of class has accompanied the escalation of distinction: social level (*jieceng*) is more important than ever. The category of the "worker" (*gongren*) has been reduced to *dagongde*: those who labor for money, those who sell their bodies' labor power. In this context, a college education has become the most basic line of distinction between the middle and the lower classes.[37] Just as the painters who were sent down to the countryside in the 1960s to learn from the peasants by shoveling manure experienced an ideologically significant form of cross-class engagement, the *huaban* students of today, sent into the *huaban* to learn painting by their parents and teachers in the hopes that they will get into college, are also engaged in a socially and ideologically significant form of *recognition* when they draw the faces of migrant laborers. For art students who are middle-class and outfitted with expensive commodities, especially those at the more prestigious *huaban*, drawing models are figures of a specific class other, not just of a generic human physiognomy. Less well-off students, and even the children of farmers and migrant laborers, participate in the *huaban* as aspiring college students, and the act of drawing the model puts them in a different class from the migrant laborer (*nongmingong*) models who almost without exception did not finish high school.

In ATR, art students learn to draw by drawing workers' faces. Through the subtle conventions of the *sumiao* genre, they also learn to emphasis the "workerness" of these faces: how they are tanned or wrinkled, how their clothes are cheap. These recognitions are underlined by an explicit ideology of technical realism (*xieshizhuyi*), but also by implicit latter-day versions of socialist political realism (*xianshizhuyi*). In ATR, *xieshizhuyi* and *xianshizhuyi* are drawn together, just as they have been in every genre of Chinese realism since Jiang Qing.

Contesting political visions in twentieth-century China were shaped by the linked ideologies of *xieshizhuyi* and *xianshizhuyi*. The idea that by representing physical reality one can reveal social truth had a deep influence on Chinese visual arts throughout the twentieth century and continues to influence ATR and other genres of realism today. As China has in the past sixty years experienced a series of distinct historical stages, each in its own way focused on creating the future, Chinese visions of the "real" have been constantly rearticulated in terms of changing chronotopes of development. In this chapter's next and final section, I look at the semiotics of contemporaneity and futurity in the visions of revolutionary romanticism, high modernist abstraction, and ATR.

CHRONOTOPES OF REALISM

> In the past, [the painter] served a small number of idle
> people, but now he serves the billions who are creating a
> new world. In the past, because we wished to satisfy the
> tastes of those half-dead people, our painting became half-
> dead. Now we must satisfy the demands of billions of peo-
> ple bursting with energy. Our painting must be filled with
> vigor, its vitality extraordinarily exuberant, a thing that ex-
> cites those who see it.
>
> —AI QING

Ai's quote aptly summarizes the chronotope of classic socialist realism.[38] It was a realist art devoted to depicting the unfolding of the future. The activities of the figures in classic *nianhua* and history paintings indexed not just their characterological roles but also the "new world" they were creating through their work. These figures were depicted in the act of creating a world with news industrial and military implements, new kinds of social relationships, new kinds of people, and new "visions." The rapidly moving bodies of revolutionary romanticism were indexical icons of experiences of being in time: a specific historical stage that through the action depicted in the image was being transformed into the next stage. Socialist realism offered a "better world, highly recognizable but always ever so slightly deferred": a world that contained the padded coats, metal thermoses, propaganda posters, and production team meetings familiar to viewers then, but also the endless bumper crops and boundless joy that they hoped someday to enjoy.[39] In reform and opening up, revolutionary romanticism was replaced by modernist genres focused on recording the minute details of the recent past, including the "scar" literature of the 1980s and the television dramas of the early 1990s. Both genres depict reality by focusing on material culture, referring to events and practices situated in a specific moment. The socialist future and the postsocialist past establish a chronotope (timespace) through mundane details such as hairstyles and furnishings.[40]

ATR, on the other hand, is unperiodized. It is an image of timeless detachment from the world. The blank faces and calloused hands depicted in test prep portraits, the little arrangements of wine bottles and fruit depicted in test prep still-lives, are as temporally unspecific as the traditional art materials they are painted in. Pencils and oil pastels may have come to being

in a historical moment but are now fixed as world-historical traditions; they index timelessness.

Compare these temporally blank images to modern nonrealist art and literature, such as the successive movements of expressionism, abstract expressionism, minimalism, and conceptualism that occupied the fine arts in the capitalist West for most of the Cold War.[41] These forms of art and literature placed themselves in time only by indexing their novelty relative to earlier forms in the same genre—through systematic transformations of generic constraints, rather than (iconic) reference to the changing circumstances of the world. In a more rapid and perhaps more self-conscious version of the stylistic shifts that art historians and archaeologists use to date ancient pottery, Barnett Newman's stripe paintings can (given certain expert knowledge) be recognized as belonging to a time after Pollock's drips. ATR does not even have these sorts of temporal indexicality. There is no professionally recognized history of systematic generic change; to the extent that ATR genres have changed over the past fifteen years, under the influence of art test fever, they have become only increasingly standardized.

The blank expressions in ATR pictures are iconic of an experience of timelessness: waiting, sitting, stillness. Likewise, official realist portrait genres almost always seem to show people waiting, just as avant-garde "New Realist" portrait genres, including but by no means limited to work like that of Liu Xiaodong and Jia Zhangke. In all these genres, there is no movement, no direction (see figure 4.3). This passivity and timelessness might seem to fit awkwardly into the chronotopes or temporal narratives of postreform Chinese development, *fazhan*. Throughout the tenures of Deng Xiaoping in the eighties, Jiang Zemin in the nineties, and Hu Jintao and Xi Jinping, much rhetoric and propaganda have focused on the construction of a new, more modern, more sophisticated, and wealthier China. Provincial and local officials are required to demonstrate perpetual growth in GDP, to give evidence of (and encouragement to) this development.[42] From the Four Modernizations campaign of the early eighties to the "New Olympics, New Beijing" slogans that accompanied the massive building (and demolition) projects accompanying the Olympics, the future is always in view. There is an authoritative vision of the chronotope of a future-that-is-just-coming-into-being that appears in many media. One ad spot that played regularly on CCTV in 2010 showed a puff of smoke that started as a dragon and turned into a sword dancer, then the Olympic Stadium, the Rem Koolhaas CCTV building in Beijing, and finally a high-speed train racing across the screen (just as the new high-speed trains are "racing" to connect China's

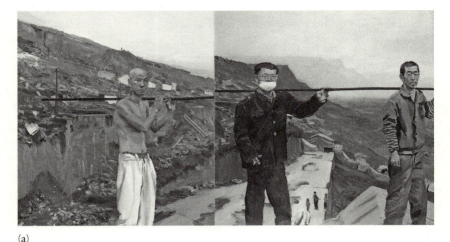

(a)

FIGURE 4.3 (a) Liu Xiaodong, *Three Gorges: Displaced People*. Source: Kelley 2006: 22–23.

major cities). However, there are few if any representations of *the future as such* in postreform official or semiofficial popular cultures. On the contrary, many CCTV-produced documentaries and nonfiction television shows, like fictional television serials, blockbuster movies, and popular books, focus on the past. In the postreform era, the past, from ancient history to Japanese colonization to memories of the 1980s, appears in many official, semiofficial, and unofficial media precisely as an allegory around which the nation *can* congeal.

What does the vision of resigned, stoic, weary, patient, passive workers mean in this context? How does a chronotope of patience fit between those of high-speed development on the one hand and endless memory on the other? I would suggest that the chronotope of inaction conveyed by these images, whether interpreted as waiting, passivity, complacence, resignation, or patience, must always appear in contrast to the "activism" of the past.[43] This resistance to *activism* aligns well with the paternalist state and the politics of stability (*wending*). In the vision of "Harmonious Society" promoted by Hu Jintao, and the vision of "Chinese Dream" promoted by Xi Jinping, citizens are called upon to act privately (economically), but not publicly (politically). Bureaucratic speech routinely contrasts the rapid pace of economic change with the government's slow, continuous work of reform, which was represented as being at every step obstructed by the complexity of solutions to fundamental problems. The momentum of scale

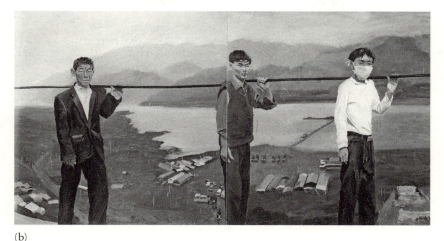

(b)

FIGURE 4.3 (*continued*). (b) Liu Xiaodong, *Three Gorges: Displaced People.* Source: Kelley 2006: 22–23.

made possible by the population that generated China's economic power is represented as precisely the source of the inertia that makes change so difficult. I would argue that this understanding of *nongmingong*, as both a powerful force for change and a massive obstacle to reform, underlies the vision of passive, complacent, resigned, patient working-class faces: the vision that unites the disparate genres of ATR, official realism, and avant-garde realism.

Despite my emphasis on the contrast between revolutionary romanticism and what I call the new socialist realism, this is not a history of rupture.[44] Certainly, *gaigekaifang* expanded the field of aesthetic production and led to the development of new, aesthetically radical communities of Chinese avant-garde artists oriented to Euro-American modern and contemporary art. Most English-language art histories of recent Chinese art have focused on these communities. But the dominant genres in Chinese visual culture all display aesthetic continuities with those of the socialist eras: from official art (the Chinese ink and watercolor paintings that are hung on the walls of major state buildings, meeting rooms, and officials' and administrators' offices) to academic art (the oil paintings, prints, sculptures, and photographs made by administrators and professors at state art schools, that often take awards at state exhibitions) and propaganda (on billboards, signs posted in hospitals, schools, and apartment complexes, on the walls around construction sites of major state venues, in magazines and televisions commercials).

There are still socialist-era massive landscapes hung prominently in national meeting rooms, and visible every night on the news, just as there have been since the mid-fifties; there are still Soviet-style history paintings displayed in national exhibitions at national art galleries around the country, with heroic figures of revolutionary history and great moments in the history of reform; and there are still posters, billboards, and television commercials with smiling, idealized socialist person types—including workers, soldiers, and "minority peoples"—displayed against composite landscapes of development. But today these composites are constructed in Photoshop. So this chapter is a history not of rupture but of shifts: generic shifts, as themes or tropes from one genre shift into others; stylistic shifts, as forms and contents change; and chronotopic shifts, changes in conceptualizations of time and people's relation to it.

CONCLUSION: RECOGNITION

In contemporary China there is a continuum of closely related "visions" of labor power, from ATR to the New Realists of the Sixth Generation to official propaganda. In Liu Xiaodong's work, as in Jia Zhangke's movies, workers' faces and bodies are contrasted with skyscrapers under construction and enormous flagship development projects. This is a way of organizing images that was frequently used in propaganda posters throughout the socialist era; it is a vision that links the visible evidence of development to the invisible *laborers* that built them. Similar images appear in official painting exhibitions and *xuanchuan* (propaganda). These images express a labor theory of value, according to which labor is not just another commodity but the source of all value—where labor means hard, physical, backbreaking work. These images offer "recognition" of the costs paid by laborers to building China's new wealth, a recognition that reinforces all the inequalities between *nongmingong*, artists and art audiences, between "envisioned," "envisioner," and "addressee," which that wealth has created.

Recognizing the long political history and contemporary political significance of ATR, it becomes clear that this highly technical form of drawing, studied by hundreds of thousands of adolescents, and used as a condition of entry into all of the visual culture industries from fine art to advertising, fashion to architecture, is not meaningless. Practicing this form of drawing positions these aspiring art students—some of whom come from poor rural backgrounds—as an already advantaged class, distinguishing them from the uneducated peasant-laborers who go to work, rather than test for college. However, this first stage of technical realist training—which contin-

ues on in the first two years of instruction at the art academy, as "foundation classes"—does not yet endow them with the authorial power of artists and designers. For that, they need to leave behind anxious calculations about the *gaokao*, and realist training, for narratives of personal development, self-discovery, and calling: they need creativity class.

5

SELF-STYLING

Since the 1990s, "creativity" (*chuangzaoli*) has been a keyword for Chinese education system reform projects, as well as for independent educational reformers and in popular parenting discourses. The idea that East Asian test-oriented systems of education suppress individual creativity—a central theme of the Chinese modernization movements of the late nineteenth and early twentieth centuries[1]—has been given new significance by the Communist Party's push to develop a "creativity industry" and propel China's transition from an economy based on low-wage industrial production to a knowledge economy founded on the work of high-earning "creative individuals." This chapter examines how Chinese art institutes—universities where most students are in their early twenties—teach their students to practice creativity, develop individual styles, and in the process "find themselves" (*zhaodao ziji*). All these skills are introduced at the end of the second year of art school, in the "creativity classes" (*chuangzuo* or *chuangzao ke*) that are a key part of art and design curriculum.

The words *chuangzuo* and *chuangzao* both have a double sense of "produce" and "create," the former referring exclusively to artistic and authorial production, the latter used in a more general sense for intellectual work. Neither is used for industrial production.[2] Though *chuangzuo* or *chuangzao ke* could be translated as "art making class" instead of "creativity class," such a translation would ignore the tense discursive field into which these classes intervene, in which innovation (*chuangxin, chuangyi*) and creativity (*chuangzaoli*) are constantly foregrounded as crucial embodied values and capacities, which the students in these classes often assume themselves to lack. They regard these classes as a radical departure from the technical founda-

tion courses that precede them precisely because in these classes they are for the first time invited to take on the role of creative individuals—producing new styles, rather than meeting standards—with the understanding that most of them are not prepared to do so, and will fail.

Chinese "creativity education" programs began in tandem with the "quality education" (*suzhi jiaoyu*) campaign that began in the 1990s, which aimed at producing a broad mass of "civilized" (*wenming*) citizens, with "high" *suzhi* or value—the qualities of being that characterize educated, urban, middle-class subjects. However, unlike *suzhi jiaoyu*, creative education aims at developing a particular authorial power and form of subjectivity. As argued in the first chapter, creativity education is supposed to produce a special kind of human capital (*rencai*), people who could make "a Chinese wind blow around the world": fashion designers, television directors, artists, pop music stars, media entrepreneurs. In this respect creativity-cultivating projects evoke the "expert" model (*jingying jiaoyu*) that organized college education throughout the 1980s.

In Chinese institutes of art and design, "creativity classes" are explicitly described as working to reverse the allegedly self-stifling effects of the Chinese education system. As one CAFA teacher said to a student, "Shandong [province] is nothing but test prep schools; you Shandong students are like steamed bread—one after another, you're all alike." Standardized art school entrance tests make students the same. The purpose of creativity classes is to allow them to become different, by "finding themselves": to convert a mass of realist painters into a network of stylish individuals. *Chuangzuo ke* mark the completion of the first-year foundational courses focused on realist technique, in which students learn to apply the basic techniques they learned preparing for the art school entrance tests described in chapters 3 and 4 to a broader range of materials, styles, and themes such as watercolors and nude life drawing. But *chuangzuo ke* are also considered distinct from the foundational courses: they are explicitly described by teachers and experienced by students as a departure from the prior education frameworks to which they have been exposed, from their years of high-pressure, test-oriented cramming. As a result of these years of training, "lots of *tongxue* [classmates/students] can't find themselves; they don't know what to paint." Teachers represent creativity classes as a space for free imagination, self-cultivation, and the discovery of one's own personality and style (see figure 5.1). Creativity is associated with "thought" (*sixiang* or *siwei*), just as technical foundation is associated with the body (as a manual skill), and creativity class marks a transition from the manual to the mental. Fittingly enough, the course on which this chapter focuses, held in the spring of 2008 at the

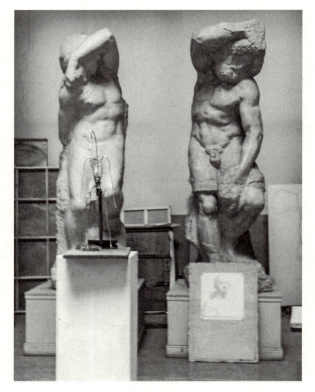

FIGURE 5.1 Drawing model sculptures, CAFA, 2008.

Central Academy of Fine Arts, was subtitled "Thought Transformation" (*sixiang zhuanbian*).

In most schools, *chuangzao ke* also coincide with the transition from general classes to major-specific coursework. There are distinct creativity classes for those majoring in oil painting, printmaking, sculpture, new media, and so on. *Chuangzao ke* are immediately followed by the division of the *ban* (cohort), as students join the various *gongzuoshi* (studios) led by prominent professors in the department, studios distinguished in part by style, media, and aesthetics, as well as by their "personality types." Consequently, *chuangzao ke* mark a radical transition from general and standardized technical training to self-directed professionalization; the individuation of students by style through the discursive marking of aesthetic and stylistic differences, including speech styles; and also the beginning of their socialization to distinct aesthetic communities. In these classes students are asked to rapidly develop a range of new discursive and aesthetic practices, new allegiances,

and new self-positionings, as teachers urge them to "find yourself" and "find what you like." Many students find this experience more stressful than liberating, precisely because of the ideological weight placed on the problem of creativity, individual personality (*gexing, xingge*) and style in contemporary China, especially in the visual culture industries. They find themselves worrying that, in the words of one girl starting the class, "I don't know what I like. I don't have a lot of personality."

Just as in the web dialogues cited above, in these classes, creativity is frequently described in terms of modes of thought and practice that are identified as foreign. Teachers at CAFA claim to have modeled their pedagogy on European or American art classes, and spent a considerable amount of class time describing their experiences attending European or American art schools or engaging with foreign artists, while also asserting the difference between technically focused, test-based Chinese art education and allegedly "creative" pedagogy in the West. The individual problem of locating a style is consistently laminated onto the national problem of developing identity and influence: in the words of one adolescent art test taker, "None of us have our own style (*fengge*), we all paint the same."

The ideas of individuality and selfhood are constitutive elements of liberalism, in both its classical and neoliberal varieties.[3] The liberal individual who participates in the market as a consumer, choosing commodities with which to perform a distinctive individuality, is the basic unit of liberal society (provoking sociological anxieties about isolation and anomie in those who study societies of selves). As many anthropologists have argued, this kind of self is often developed through practices of self-narration and self-expression.[4] It might seem that in creativity class we have an example of an even more foundational form of neoliberal agency, insofar as these young artists and designers are being trained to produce the forms and styles that are sold as commodities, through which ordinary people experience and perform selfhood. These design students will participate in metamarkets, selling the packaging and media that are used to sell other things. In these classes, everyone is implicitly aware that developing a creative self is the first step toward participating in aesthetic markets, that creative personality is a commodity-producing structure. Nevertheless, the fact remains that all this work at producing prototypic liberal individuals is taking place in institutions managed and operated by an illiberal state, with students who are also enrolled in state-mandated "government" (*zhengzhi*) classes where they learn about Marxism and Deng-Jiang-Hu thought. At CAFA, the curriculum is directly approved by the central government. They are trained to become liberal selves for an illiberal society.

The first part of this chapter looks at how language is used in creativity class, both in particular forms of speech, narrative, and multimodal semiotic performance, and as a metaphor for metasemiotic discussions of meaning and expression. The second part of the chapter considers how the cultivation of these discursive capacities fits into a broader social transformation, as students move into a stage of isolating individualism—the pursuit of self and personality—that is also the beginning of their socialization into diverse aesthetic communities. The last part of the chapter examines the politics of creativity and its associated speech genres, by reflecting on various political projects aimed at its suppression or cultivation, and on the implications of the institutional reproduction of practices of creativity in contemporary China for a politics of aesthetic personality.

PART I: WHAT ARE YOU TRYING TO SAY? TRYING AND FAILING TO SPEAK WITH THINGS

In Chinese art schools, creativity class is generally a critique class. In these classes, students take turns bringing their work to the front of the classroom, opening the discussion by describing their ideas, material selection, inspirations, answering questions from the teacher, and then listening to commentaries from both the teacher and fellow students.[5] Students learn to enact creativity not only by narrating a self but also by learning to make objects perform, or speak, for them: discursively laying the ground for a metonymic identification between self and object, or what Geoffrey Pullum calls "creative work metonymy."[6] According to participants, these classes use discussion to improve student artwork. No one says that students come to critique class to learn how to talk about art.

In critique (a transnational model of contemporary art pedagogy) the work is laid on the floor, pinned to the wall, or set on a table, in ways that nod to genres of art presentation, suggesting how a piece might be presented in an actual gallery, but without adhering to the formal conventions of professional display. Critique class is an example of what Goffman called a "nonlinguistic event having the floor,"[7] serving as a "participant" in the interaction. Agency is projected onto the object through what Teri Silvio calls "animation," or what Marx called fetishism.[8] When objects such as paintings, assemblages, sculptures, videos, and installations participate in critique class, there is a fundamental ambiguity. The art object is at times described as a kind of speech, a bit of talk in a visual channel, emanating from the artist-as-speaker, and at other times treated as a speaker in its own right. Moreover, over the course of a discussion about an art object, as the student, teacher, and classmates

engage in critique, the production role of the object also shifts: at times it is posited as the "animator" of the artist's thought, at other times treated as a "principal," having its own logic, about which the artist might well be ignorant, and about which fellow students, teachers, critics, and other viewers are authorized to speculate. These ambiguities or slippages in the participant role of the art object are not accidental, but rather fundamental to the ways that art objects and design forms come to have meanings; proper management of this ambiguity through proficiency in certain sorts of talk is exactly what art students have to learn, in order to begin developing a personal style that is both recognizably their own and also available to others, and thus appropriately able to circulate independent of them, to engage audiences and produce affect.

Art students must learn to take up visual elements such as red lines, black grids, a shade of blue, a kind of figure, or a material theme like taxidermied animals, to entextualize and (gradually) enregister these elements, in a "style" that indexes not a generic social role but rather a unique self. Clusters of phrases and forms, repeated and reproduced, constitute a style. The process through which simple visual elements become recognizable as belonging to a particular artist is also often analogized to branding.[9] But to do this, students must become adept at using nonvisual metalanguages in highly genred ways. To teach them how to do this, teachers deliver a stream of commentary, and work to elicit similar commentary from students, through formulaic dialogues. In the process, students "find themselves" in a style, and also learn the important professional skill of participating in a dialogic process of meaning making with a client or critic.

Interweavings of image and text—from art made of words to the words that travel with art—have fascinated several generations of art theorists and historians. However, less attention has been paid to the way that juxtapositions of image and text are related to *verbal interactions* around objects. This part of the chapter shows how visual languages are developed through verbal interactions, the processes of meaning making that Webb Keane, following Stanley Tambiah, has analyzed in terms of the "articulations" of words and objects.[10]

Art teachers often base their explanations of the meaningfulness of visual form on analogies to language (at least in the sense of language as code), and in particular on the concept of "visual language." Art and design teachers, critics, and historians speak of an artist or designer's own "visual language": particular, repeated combinations of formal elements that over time come to identify an individual artist's style.[11] Styles are private languages, or idiolects, created and used by a single person. To be regarded as creative,

these languages must be considered anachronistic or unconventional—in contrast to the conventional iconographies that Gombrich and art historians regard as belonging to cultures or time periods.[12] The idea of a visual language is a language ideology—a theory or belief about language that reflexively shapes how it is used—as well as a semiotic ideology about the meaning of images.[13] Insofar as a sculpture, painting, or assemblage is regarded as a message, it is interpreted as being a kind of speech; insofar as such objects are regarded as possessing a communicative capacity, they are regarded as speakers.[14] The concept of visual language treats visual form as a kind of message that can participate in human conversations.

My examples here are drawn from a 2008 class at the Central Academy of Fine Arts in Beijing, called "Creativity: Thought Transformation," taught by Professor Li Fan (his real name) and Teaching Assistant Jiang a pseydonym. This was the second-year printmaking students' first encounter with an art class in which the assignments came solely in the form of concepts such as "make it big" (*fangda*), as opposed to objects, bodies, or nouns. Student responses to these concepts could take the form of installations, sculptures, video, paintings, animation, assemblages, collages, or digital photography. It was the first time that neither the class nor the assignment had dictated the media to be used, the first time they were (implicitly) called on to experiment with nontraditional media, and also their first encounter with critique. While the class was oriented to the generic constraints of contemporary art, and the teachers said that their goal was "to make you into artists" (*rang nimen cheng yishujia*), the class was not really about contemporary art. The teacher and teaching assistant had both worked in graphic design as well as contemporary art, and many of the student works were oriented to other genres of visual culture, including videography and graphic design. Given the diverse professional trajectories of the graduates of the printmaking department, it was clear that the cultivation and embodiment of personal creativity and the ability to say things in a visual language, two constant themes of the teacher's commentary, were much more important in these classes than the reproduction of any particular genre or profession. The central project was the inculcation of a certain attitude toward and understanding of meaning and how it is situated in and communicated through an object, which is to say a semiotic ideology. As Professor Li said, "We are talking about *meaning*—not intentions, and not reasons" (*Women zai tan yisi; bushi neihan, ye bushi liyou*) (see figure 5.2).

Professor Li's first properly pedagogical act was to show students his personal scrapbook/sketchbook filled with drawings and images from his travels in Europe and America and his readings, surrounded by notes and *xiangfa*

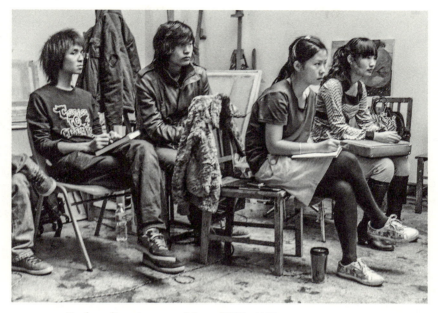

FIGURE 5.2 Students listening to a critique, CAFA, 2008.

(ideas); he encouraged the students to begin collecting and annotating im-
ages as a means of developing their own visual language. Professor Li's note-
book was in itself a good example of the ways that a private visual language
is developed in dialogic relation to a nonprivate language, or several of them
(in this case, Chinese, English, and French).

In this creativity class, as in many critique classes in the United States and
some in China, there was an ethic of open discussion that implied relative
equality between participants, so that presenters were encouraged to respond
to and even to disagree with the teacher's questions and evaluations. Class-
mates were encouraged to criticize or interrogate the presenter and offer their
own interpretations. Professor Li, who had spent several months as a visiting
artist in the United States, described this interactional mode as being Ameri-
can, and frequently suggested (both to me and to his students) that this class
was different from classes taught by other teachers in the department and the
school, or at other Chinese art schools. At one point late in the class, when
a student spontaneously broke into performance art, Professor Li said, "This
class is really too American!" In conversations with myself and others, Pro-
fessor Li represented himself as an outsider in the department. He said that
the other faculty did not understand his way of thinking (*sixiang*). It is true

that his enormous watercolor paintings of twisted lumpy couples in graphic situations could not be exhibited in the school.

Students agreed that Professor Li's pedagogy was different from other teachers: it was a difference they had often been *warned* of in advance by older students. Despite Professor Li's popularity and wit, creativity class was experienced not as a relaxing liberation from rigid hierarchy or formality, but as an often intimidating and frustrating confrontation with new and unfamiliar expectations, befitting the title "Thought Transformation." The students' anxiety of course reflected the fact that discussion was not entirely "open" (*kaifang*) or free, despite Professor Li's attempts to make it so. Although he regularly said things like "these are all just suggestions, think your own thoughts," "don't do things for me, do what you like," and "do what you want to do, don't let my voice be in your head," the hierarchy of authority was manifested in many little ways familiar to readers of Goffman. Professor Li and the TA sat at the head of the classroom, drinking coffee from a thermos delivered every morning by a female student, and they smoked during class, which students did not; male students did smoke in the hallways during breaks.[15] Students were evidently not authorized to begin the discussion, as they never did; authorization to speak went first to the teacher, second to the teaching assistant, and finally to the students. The teacher was, unlike everyone else, authorized to leave the room to answer his cell phone.[16] Despite sporadic attempts to break up these habits, such as the day when the teachers moved to sit with the students, saying, "Today we are all one status (*shenfen*), whoever is standing up (presenting work) is the student, all the rest of us are teachers," both students and teachers had difficulty maintaining equality; even on that day, Professor Li gradually stood up and migrated to the front of the room.

More importantly, though class evaluation ostensibly focused on the objects students produced, for the first time in the students' educational history, the evaluation these objects received in fact depended on the students' ability to entextualize the objects by talking about them and by performing a kind of personality. Likewise, evaluation came subtly, in little comments throughout the conversation, rather than in a score or a grade. The standards to which students were expected to aspire in this class were never clearly stated, and neither expectations nor evaluations were ever quantified or formalized (again in sharp contrast to all their previous educational experiences) though reactions were usually legible in the teachers' facial expressions.

Perhaps understandably, then, classmates were initially hesitant to speak; the conversation was frequently dyadic or triadic, between teacher and stu-

dent (or teacher, teaching assistant, and student) performed in front of the audience of classmates. As the weeks went on, some classmates began to speak more "freely" as they became socialized to the mode of discussion, and accumulated enough instances of Professor Li's speech to more fluently voice him. Classmates' speech tended to follow the general stance and style of the teacher, though usually without explicitly parroting his opinions. Speaking well in critique was partly a matter of voicing the teacher without seeming too obviously to voice him, which meant embedding elements of his speech into one's, preferably sometime after these elements were first performed. (The same was true for the teaching assistant Jiang, who was of course also learning to voice Professor Li, not always successfully.)

At the same time, some of Professor Li's most common phrases became recognizable objects of commentary in themselves, which were quoted and repeated until they became slogans.[17] In this class, one phrase often uttered by Professor Li became a kind of slogan, memorialized in the form *ni xiang shuo shenme?* (what are you trying to say?). This question posits the artwork as a form of speech, the student as speaker. Professor Li and the teaching assistant would often introduce variations on this question with the phrase "as I always say." It was even used as an epigraph for several of the books students put together at the end of the class. However, over the eight weeks of the course, this phrase actually appeared in several forms, and these different forms illustrate the ambiguity of participant roles in the critique class presentations.

The first time Professor Li asked this question was the first day of class. A student put down a small box frame recognizable as having been purchased from IKEA, inside of which hung several cut-out fluorescent sheets of paper and clear plastic, tracing images of her own face, creating a kind of layering when viewed from the front. Following the teacher and teaching assistant, all the students and myself stood up and went to look at the piece, to examine it closely, and take pictures of it with their digital cameras. When everyone had settled back in their seats, Professor Li looked pensive, and asked the student who had made the piece, who was still standing at the side of the room, *ni zhege xiang shuo shenme?* (literal translation: you this thinking say what?) (see figure 5.3).

There are two ways to translate this question into English. The phrase *ni zhege* (you this) is often used to refer to significant action by a person.[18] Interpreted in this way, the question *ni zhege xiang shuo shenme?* posits the art object as a communicative action by the student, a kind of speech, and asks for explanation. On the other hand, the form "you this" also follows the pattern of dropping the marker for possession between a pronoun and

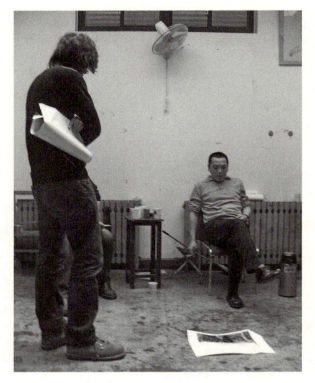

FIGURE 5.3 Student being critiqued, CAFA, 2008.

a noun, which is used to express intimate relationships, as in *ni ma* ("you mother").[19] In this sense the question is asking, "what is *your thing* trying to say?"—that is, positing the object as a speaker, and asking the student to interpret for the object, to translate for it. Indeed, in later classes, Professor Li often asked the question in the form *zhege zuopin xiang shuo shenme?* ("what is this artwork trying/intending to say?"), explicitly framing the object as a speaker.[20]

By asking these questions, Professor Li suggested that the artwork was either a form of speech or in itself capable of speech. He would often say that the object was *bu qingchu* (unclear, meaning it had failed to communicate); equally often he would say that the student was *bu qingchu* (unclear, meaning lacking explicit intentions). An even greater failure would be failure to speak: Professor Li said to one student, "You've *done* a lot, but you haven't *said* anything." Of course, Professor Li did not always ask the students "What are you trying to say?" If the work was very good, or very obvious,

he would respond directly to the piece without asking for any clarification at all, reinforcing the sense that the artwork in that case served as a successful moment of speech, an initial pair part, that could be met with a verbal reply. The worst response a student could get from Professor Li was the question "how much did you spend (on this)?" This question, which refuses even to treat the object as speech or speaker, but addresses it as a lump of purchased material, was usually followed by embarrassed laughter from all class participants.

The artwork was often treated as or even explicitly referred to as a realization of the student's thought (*sixiang, siwei*) or ideas (*xiang fa*), in expressions like "express your ideas more clearly" (*geng zhengquede chuanda nide xiang fa*). However, the "thought" in question was not propositional. The proper response to a question about what an object was trying to say or what it meant was not an abstract claim or factual statement, or even an "idea." Rather, it was a particular kind of description of the experience and thought process from which the object had emerged.

The first student selected by Professor Li to undergo critique in the class was a fashionably dressed and confidant young woman, who, in response to the assignment "dot, plane, line," had dripped white wax in little piles and lines on a sheet of glass, which she laid on the floor. The girls—only the girls—went up to take a closer look. When they had settled back, Professor Li began the critique by asking the classmates, "Who thinks it looks good?" and then noting that most hands went up. "Who thinks it's ugly?" One male student raised his hand, to laughter. Professor Li then commented on his feelings (*ganjue*) about her choice of materials and their meaning, concluding his comments by saying, "materials have a language" (*cailiao shi you yu-yande*). The student responded obliquely, by telling a story about flying in an airplane looking at the buildings below, and describing the peace and stillness (*pingjing*) of the morning street in Milan, which she had seen on one of her travels.

In China in 2008, airplane travel was still a relatively elite experience, and international travel quite rare (albeit much more common at an elite institution like CAFA than a Jinan *huaban*). The student's description of a privileged experience she shared with her teacher and TA might have been less than explanatory for many of her classmates. But this kind of indexicality, linking a common material to a particular biographical experience, was exactly what the teacher was looking for, and he was evidently pleased. The TA commented that glass is connected to danger (in a general indexical way: glass has the property of fragility, so when we look at it we might think of it breaking); she demurred this interpretation, explaining that she

was interested in glass's clarity, like the clarity of the wax. Professor Li said, "your thought process is good" (*nide sixiang meiwenti*). He suggested a book, and she said she already knew it. Professor Li finished the critique by saying, "Even though you've studied drawing and painting, you can still do this!" (*Ni xue huahuade hai hui zuo zhege!*), commending the girl for her ability to overcome years of potentially creativity-suppressing technical training and succeed in a radically different form of practice. She had achieved uptake.

In this encounter, though Professor Li opened with what might have been interpreted as a mildly dismissive question, the student was successful at contextualizing the object, and was evaluated well. Professor Li focused the discussion on the theme of the materials, glass and wax, from early on. His first question ("does it look good?") directed the other students to focus on the aesthetic qualities of the material. Later he made this connection more explicit. In saying that materials have a language, he was asking her to gloss or translate that language. She answered with a story, which implicitly suggested that glass and wax mean vision (aerial views) and clarity, stillness, quiet (morning in Milan). The TA tried to offer an alternate interpretation of the meaning of glass based on a general rather than unique experience, and she defended her own interpretation by identifying the particular quality of both materials that anchored her interpretation: clarity. The student succeeded in positioning the object as an animator of her own thought, and developing a complex indexical and iconic association for the combination of glass and wax. With Professor Li's subtle guidance, this student had managed to make a first step toward developing a visual language. She linked the visible qualia of the work to a particular but not unique biographical experience, rather than a conventional symbolism or generic association (danger). Despite the inaccessibility of her experiences of airplane flight and European travel, the iconisms suggested by the interpretation (the clarity of glass is like a quiet morning; wax drips are like buildings viewed from above) were comprehensible. It helped, of course, that her references to airplanes and Milan positioned her not only as a privileged person in terms of socioeconomic class, but more importantly as someone who had engaged in a highly privileged form of subjectivity, face-to-face engagements with Western cultural monuments: the same kind of subjectivity suggested by Professor Li's notebook about his travels in Europe and America.

Her dramatic success at the critique form was made especially clear when, a few rounds of critique later, a less fashionably dressed girl presented an abstract piece made from a store-bought white picture frame and layers of painted glass. She laid it on the floor. Professor Li asked how much she'd spent, to general hilarity. She responded by telling how she had seen a store

in 798 (the gallery district) that "sells this kind of glass material, it's really nice-looking, and I went to buy it. I just wanted to use it. It was my first time using it." She was in effect doing what the first student had done, explaining her work by telling a story about how it had come into being, a story complete with references to an elite place, but the story was unsatisfactory to Professor Li. First, she said nothing but that the material "looked good" (the same phrase the teacher had used in framing his first question), and how she had acquired it, suggesting that what was lying on the ground in front of us was just a bunch of glass, not a competent speaker, or even a piece of speech. Similarly, her reference to 798 failed in part because she described the gallery district as a market for materials. He evidenced his displeasure with a scowl, and asked her what the meaning (*hanyi*) of the piece was. She replied, "If you make me explain, I can explain; if you don't make me explain, that's okay too," her tone suggesting that the latter option was much preferable. Professor Li moved on to the next student. This second student had failed in three respects: failed to pick up on at the conventional speech form of presentation that uses a narrative of personal experience or process to endow an object with meaning; failed to entextualize the aesthetic qualia of the object; and failed to engage in the kind of dialogic back-and-forth that generates uptake. On the other hand, Professor Li had to some degree set her up for this failure by asking how much she'd spent, focusing the conversation on the material from the beginning and then punishing her for being unable to turn it in another direction.

Part of the first student's success lay in her ability to emphasize the iconicity of glass and wax while avoiding any reliance on conventional symbolism. Conventional sign systems produce an easy public accessibility that is precisely opposed to the subtlety of signification that makes art interpretation and critique an interesting practice in itself. The semiotic ideologies common to contemporary art and design require an appearance novelty and idiosyncrasy that constitutes "creativity"; objects should not appear as tokens of types, and when they do, it is a problem.

This is a semiotic ideology that departs radically from the sorts of systems of typologized objects used in exchange around the world, which typically rely on conventional interpretations to narrow the potentially dangerous ambiguities of iconicity. In Webb Keane's description of Anakalang it is because everyone knows that horns and spears signify men and cloth signifies women that these objects can play a crucial role in tense marriage exchanges.[21] In contrast, at the Central Academy of Fine Arts ambiguity is crucial to creative practice. Two students tried to get away with painting eyes on the same day: one young woman painted a huge, lugubriously shiny

eye, and one young man painted a whole lot of eyes. The bo, who presented first, wouldn't explain, and was told, "You this (*ni zhege*) doesn't just have no explanation (*jieshi*), it has no meaning (*yiyi*)." The girl, knowing she was in trouble, said nervously, "eyes are the window to the soul," and was told, "don't give me that crap (*feihua*)." When one student put a coin inside a series of glass boxes, Professor Li called it a "symbol," and Jiang Laoshi said, "This coin is limiting the meaning. You should find something more complicated." The kind of visual signification required in these classes must be iconic or indexical in a way that does not appear conventional, and it must allow space for interpretation.

On the other hand, ambiguity can be pushed too far. A few weeks into the class, a nervous, fashionably dressed boy had made an extremely simple image, straight pencil lines on a large piece of paper. It was reminiscent of early minimalism, but without the high production values. After laying it on the floor, he talked at length in a high academic register about the philosophical foundations for his work, at one point claiming to be "an independent artist," to much back chatter, laughter, and grimacing. When he was done a fellow (female) student asked, "If you do an exhibition, and you can't talk so much, what will you do?" Professor Li smiled, evidencing his agreement. This young man had, perhaps more than other students, understood the subtext of the class: that part of what the class required was a performance, and performing the role of an artist involved learning to speak in a certain style. But he had selected the wrong register, a monologic, academic speech style associated with art criticism rather than art practice, which he might have picked up from reading art criticism or attending lectures. From this point on, Professor Li referred to this student as "the philosopher." The philosopher's failure shows that a crucial part of the artistic as opposed to critical voice is its personality, its recognizability as "one's own." More important even than his use of voice, however, was the problem that he had failed to use this performance to stage the basic semiotic act crucial to artistic narration: entextualizing the object and enregistering its qualities as elements of a private "visual language" that could communicate independently in a future exhibition. He attracted attention to his own performance, raising doubts that the object had any meaning outside of it. He had failed to position the object as a speaker.

In the first few weeks of the class many students, picking up on the idea of the object as speaker and the idea that meaning could be materially embedded in the art object, would take an obvious strategy: refusing Professor Li's demand for explication, in effect questioning why there should be so much talk about art. Occasionally in class, a student would take an extreme

version of this position, saying that the piece "means whatever you think it means." This stance was always rejected by Professor Li, as a kind of total failure to engage in entextualization much graver even than the excessive performativity of "the philosopher."

And yet Professor Li also made it clear that the meaning of the work could not or should not be entirely decided by the verbal performance of the student. At times he would reject a student's interpretation of his or her own work, suggesting that the student might have misunderstood the object, and offer his own interpretation. In these cases (as in many others) he would start this way: "this piece gives me a feeling (*ganjue*) of. . . ." When a student had trouble explicating a piece, Professor Li would ask, "what feeling does it give you?" (To a student who made a giant snowflake out of salt, he said, "What feeling does snow give you? I feel like it instantly changes the whole world.") According to Professor Li, a crucial aspect of the contemporary art is its tendency to give "a psychological feeling more than a visual feeling," also called its "effect" (*xiaoguo*). Following the teacher's lead, classmates gradually learned to "voice" one another's work by talking about *ganjue* ("snow gives me a feeling of fragility," "it makes me think of difficulty").

The discourse of *ganjue* is central to contemporary Chinese discourse about art and design. It is how people express responses to artworks in galleries or to images in magazines; "good feeling" (*ganjue hen hao*) is the most common form of praise for aesthetic objects. *Zhizuogan*, from the verb *zhizuo* (make/manufacture/create) and the noun *gan* (feeling), refers to a kind of overall effect coming from the made qualities of the work. What Americans refer to as "production values" is in China described as "an artwork feeling" (*zuopingan*) or "a completed feeling" (*wanchenggan*). In creativity class, this general discourse of feeling is linked to the discourse of visual language. While talking about feeling Professor Li would frequently ask, "what is this artwork trying to say?," suggesting that artwork communicated meaning by producing feelings in the viewer.[22]

Thus the participation role of the artwork in critique class was continuously shifting, from a principle with its own thought, to an animator of the artist's thought, to a reified message or bit of speech. These slippages—positing artwork on the one hand as a kind of talk, and on the other as a speaker; on the one hand as an animator of the artist's thought, and on the other as a principle with its own "meanings" and intentions—were not random. "That sense of confusion is precisely the 'message' the coin conveys."[23] The point of critique class is to teach students an aesthetic hermeneutics that makes forms recognizable *as visual language* by providing them with

indexical links to particular kinds of sensual experience and thought, but without ever turning them into symbol systems, without conclusively defining or delimiting these meanings, giving others room for interpretation. This is not just a hermeneutics rooted in an aesthetic ideology; it is also a professional practice, the practice of creativity. In order to be able to work as artists or designers, students have to learn how to entextualize art objects and enregister visual forms through a variety of fundamentally dialogic interactional genres, including the genres of conversation between artist and critic or designer and client on which critique class is based.

Despite his claims of difference from the mainstream, talking about art objects as if they are forms of speech is not a habit unique to Professor Li. This is the fundamental convention of the critique class in both China and the United States; it is a convention rooted in the semiotic ideology of the visual language. The various procedures of meaning making and interactional positionings described here (both successful and unsuccessful) were very familiar to me from my own experiences in U.S. art classes. This class was, from the very beginning, embedded in the practices, discourses, and ideologies of the global fields of contemporary art and design. Students' artwork and verbal modes of self-presentation suggested varying degrees of familiarity with conventions of "artist's statement" and interviews, gathered from interacting with students in higher grades, visiting galleries, and reading interviews with artists and designers in magazines. Even as Professor Li asked them to develop their own style, he directed them toward other professional models.

Art teachers and students generally regard critique (metalanguage) as a means to developing expressive capacities in the (target) *visual* language. The ideology of the private visual language suggests that objects can "speak" or at least successfully transmit meanings in themselves, and that the verbal explanations and interpretations that accompany these objects serve only to elucidate that visual language. Certainly, learning how to manipulate aesthetic forms is a difficult task in itself. But part of making meaningful visual forms is learning how to make visual forms meaningful: that is, by learning particular genres of talk. Over the course of this class the students became more proficient in contextualizing their pieces by describing chains of associations, their "thought" (*sixiang*) and "process" (*guocheng*). By the end of the class, many of them were already well on their way to developing "their own" visual languages, recognizable stylistic elements that had been more or less made recognizable as a personal style.

In the next section, I look at how this process of enregistering style is at the same time used as way of eliciting a particular kind of subjectivity:

self-styling. Evaluation regimes based on ideologies of creativity (as opposed to technique) demand that students cultivate a self (*ziji, zishen*). To enregister a personal style, students have to go beyond animating art objects or talking with things, to learn to anchor the aesthetic qualia of their work in a unique personality (*xingge*), an individuality (*gexing*). In the next section I examine the ways that the project of self-styling is pedagogically conveyed as a pursuit of self.

PART II: SHIFTING EVALUATION REGIMES AND THE LOCATION OF SELF

> Can you develop your personality (*fahui gexing*)? The most important thing about art is not art. It is *gexing*. What is *gexing*? That's exactly what we're talking about.
>
> —PROFESSOR LI

Creativity class functions institutionally (and is experienced by students) as a moment of radical transition from one evaluation regime to another. Students are transferred from a standardized training focused on mimesis and organized by ideologies of technical skill focused on the body, to a student-led dialogue focused on narrative and organized by ideologies about meaning and language. Students are asked to locate a "self" in their own bodies, memories, and feelings. They are asked to take up meaningful forms and make them their own, even though such forms are always embedded in other people's work, and other people's talk. This professionalizing education overtly individuates students by forcing them to focus on their "personalities" and "selves." Where the examination system held students to a unified standard, in "creativity class" students are asked to find themselves in an array of distinctions based on subtle correspondences between styles and personality types. These distinctions also carry over into the contrasts between the studios, with their different styles, network of connections, and professional trajectories, into which each cohort is divided immediately after school. At the same time, this process of developing "self" covertly (without ever acknowledging that this is what is going on) socializes students to various aesthetic communities, oriented to distinct metageneric styles (high modern, neoclassical, traditional Chinese, punk, high fashion, contemporary, etc.) corresponding to "personality types" and modes of aesthetic self-presentation.

Critique class replicates the evaluation situation that is a crucial part of work in many visual culture industries, in which an artist or designer presents an object to an evaluator (client, critic, curator, etc.) who evaluates the maker through the work and vice versa, in part by rhematizing the qualia of the work, positing aesthetic qualia as iconic indexes of the maker's personality. This kind of rhematization underlies the identification of authorial agent and product: creative work metonymy. Evaluation regimes based on personhood of the kind used in critique class are radically different from the standardizing and quantifying regimes used to evaluate students in the art school entrance tests.[24] This part of the chapter reflects on the difficulties students have shifting to the new evaluation regime, with its complex demands for multimodal forms of self-presentation.

The ideology of the personal visual language causes artists and art students to regard the semantics of form as personal (intellectual) property. But visual languages are never really private; in making artworks, students are always "speaking with other's words," using themes and styles that belong not just to other individuals but to a (sometimes nascent, sometimes established) community. Art objects get their communicative potential from a variety of "languages" (including dialects and registers), genres, and discourses. To "become artists" and be recognized as creative, art students have to learn how to hook into the chains of reference made possible by these languages. Just as speaking a particular language indexes the speaker's belonging to a language community oriented to norms of denotational code (a language), so too does using a kind of aesthetic form mark the artist's belonging to an aesthetic community oriented to norms of aesthetic code.[25]

A visual style identifies its maker's position within a complex field of stylistic distinctions; but students are not always fully aware of these distinctions until well after they have wandered into one aesthetic community or another. Consequently the process of socialization to aesthetic community is experienced (and metapragmatically described) as a process of "finding the self" and of "becoming different" from your classmates, rather than becoming the same. Self is routinely presented as a location: students are pressed to look for "things out of everyday life," things "close to them," and also to get "closer to themselves," to be "real." In this part of the chapter, I examine how students go about finding *gexing*, a personality, and at the same time begin to find their way to a community. In particular, I look at the problem of the locations in which students are told to seek self: in culture, history, memory, and even their own bodies.

At a postprofessional (*jinxiu*) MFA class in the "Materials Workshop" (*Cailiao gongzuoshi*) at CAFA, a visiting teacher named Gao walked around

the class watching as the students (many of them art teachers from provincial colleges, some of them with years of experience and others not yet begun teaching) painted abstract versions of a model, who was reclining naked on a platform. She had been in the same pose for two weeks. The visiting teacher, who had just moved back from New York, had floppy hair and dressed much more casually the professors at CAFA, in worn jeans and sneakers.[26] He stood over one man in his thirties, who was laying out polished, abstract, drip-and-pour compositions, and said, "This work is too decorative . . . the effect is too much like industrial art." Then, in clear earshot of all the other students, he added, "Actually, you are more clear (*qingchu*) than any of them, they are all painting human figures (*renti*). You are more clear, so your process (*guocheng*) is very important!" Then he proceeded to ask the student about how his materials worked, encouraging him to develop a narrative of process.

"Clarity" (*qingchu*) is the recognition of the imperative of stylistic difference. All the other students in class had (perhaps because of the provision of a nude model) continued to paint referentially, failing to grasp the new evaluation regime. For students who understand this imperative, the next step is developing a material language, taking care to choose materials and styles that will align them with the right professional community (contemporary art or industrial design), and a narrative of "process," of the kind that will figure in an artist's statement used in promotional materials.

At the break, three other students—all clearly anxious about the comment they'd heard—gathered around the teacher. He told them, "You all paint the same, your paintings look the same. You can't paint the same; that is failure. You can't paint the same, because you all have different personalities (*xingge*)." They asked him for advice and he said, "use a color that is connected to your memory, to your recollection," suggesting that style must be anchored in personal experience. But later, after the students had begun painting again, the professor went over to one of the students, who was painting in brown and white, and said, "this painting is *too* Inner Mongolia; it's too much like an Inner Mongolian's." Ethno-national orders of difference are not the object of the self-discovery orchestrated through critique class, and students who get marked as belonging to such "identities" are not usually the most successful.

Despite the de facto requirement that teachers at CAFA have studied abroad and the constant encouragement to look at the work of foreign artists, in Chinese critique classes the location of self is frequently circumscribed by an ethnonational boundary. When a girl in the class made a painting that looked like *Guernica*, Professor Li said, "Why use Picasso? He has no relation

to you." In the only assignment in which students in the class worked in groups, they were asked to take famous works of Western (*xifang*) art and translate them into a Chinese traditional style, "bringing them closer to themselves."[27] In another case, Professor Li told a student who was worried about her lack of a style to watch me and spend more time with me, so she could understand the difference "between us and them" (meaning the difference between Chinese and Western people). But the ethnonational limit was only imagined as a kind of boundary, within which students had to find themselves in their own uniquely personal experiences: not a categorical identity like being Inner Mongolian or hobby-based subculture like being a skateboarder, but something truly individual.

Art students have to find themselves through an indexical icon of the self, embodied in an aesthetic form. As a result, their first formal responses to the project of "finding themselves" are usually variations on the self-portrait: a classic realist self-portrait, a series of cut-out silhouettes, a collection of family photographs from birth the present. Gradually, they are asked to move beyond physiognomy and to a looser and more abstract approach to personal style, to find "themselves" outside of their own faces.

In Professor Li's class there was one young man who was missing a forearm; he usually kept his missing arm hidden inside a long sleeve. One day the teacher told him to stay after class. In the midst of a circle of students wanting to talk about their projects, Professor Li turned to the one-armed student and said, "What happened to your arm?" The boy said it had been amputated because of an infection when he was seven years old. Professor Li asked to see the stump, which was covered in red scars; he said, "That surgery must have made a big impression on you, left a lot of memories. Why don't you start from your body? You should use it as a subject. This is something that makes you different from everybody else. Use your merits (*youdian*)." Then he turned to the other students who had stayed behind and said, "and you, you so-called normal students, you have to find what's special in yourselves." Thus stigma and trauma were made available as a model for the project of selfhood. Everyone could see what made the one-armed boy unique; the other students would have to work to locate (that is, entextualize) the *gexing* that the teacher told them they already certainly had.

Professor Li believed that discursively drawing the self out of students through critique was not just a way of producing artists or creative individuals, but also a means to a kind of psychological healing, or mental health (*xinli jiankang*)—suggesting the ideological similarities between critique and the psychoanalytic process as discursive means of identifying the self.[28]

He believed that through developing a unique visual language, students could come to develop a healthy self-understanding, and in the interests of this healing he was not afraid of inquiring into and/or publicizing a student's most personal problems.[29] In some cases the psychological project of self-discovery became more important than the creative project of enregistering a personal style. Over the course of the class Professor Li met repeatedly with the one-armed student to encourage him to develop work about his disability. He made three pieces: a design for a video game controller he could use with one hand; a drawing of himself flying with feet enlarged as wings; and a large-scale digital photograph of himself, shirtless, with his stump upraised, and standing on the point of his stump was a small image of himself, arms spread out triumphantly, the exact opposite of his normal, art-concealing posture. Professor Li was very pleased with all these works as steps toward a "healthy" sense of self, and did not express any concern about the obvious symbolism.

For some other students, however, both teachers would demand that through self-awareness and self-discovery students move beyond self-portraiture and into a disciplined kind of stylistic self-projection, "becoming an artist" (*cheng yishujia*). In the following transcript of a critique, the student begins by talking about her thought process, much of which is concerned with visual effect. Professor Li (PL) responds by using her choice of subject to investigate her "self," in this case asking about religious faith, belief, and "feeling in the heart," while the TA encourages her to think about ways of modeling her self-presentation and discursive entextualization on those of established artists.

PL: Come, start.

(The student put up a picture of herself standing on a box wrapped in a sheet and holding all kinds of random objects, some of which are also tied to her head and body; she is blurry and the image is red, from the single, low-place light source which projects a large shadow behind her. The shadow, which is the focus of the image, looks like the Statue of Liberty (*ziyounvshen*).)

TA: This is you?
PL: Come, talk, say how you thought of it.
Stud: I think maybe that maybe, it was that artist, who uses garbage?
PL: Huh? What garbage?
Stud: He uses garbage and uh . . . it's really realistic (*xieshi*).
PL: Keep talking.

Stud: And then later I thought about theater, how sometimes maybe they have some strong shadows, and then I thought of the Goddess of Victory (*shengnvshen*),[30] but then I thought, maybe people wouldn't be able to see what it was, and then I thought what kind of thing is more symbolic (*biaozhixing*), that as soon as people see it they will know what it is, and then I thought of the Statue of Liberty.

PL: More recognizable.

Stud: Right, that Goddess of Victory is the one with the wings, *but it's not as recognizable as this one.* . . . So then I found a friend in the sculpture department to help me with the setup, and the friend from the oil painting department helped with getting the shape right. . . .

PL: What about the lights?

Stud: That was a friend from photography, he brought a spotlight . . . but anyway *my idea was to take a lot of things from daily life all on my body.* And then that book, well umm because it's the constitution, right, but it's the student handbook.

PL: Maybe this is too simple, but do you have faith, religious faith?

Stud: I believe in Buddha.

PL: You believe in Buddha.

Stud: But I don't go to pray all the time, just on New Year's.

PL: Oh you're that kind (all laugh). Because, see, I realized that a lot of people who have religion are really part-time (*gongyu*). This one time made a deep impression on me, in Europe, at Christmas I saw all these old ladies going into the church and so I went in and I saw this one woman, singing and (here he starts humming lazily and playing with his phone). *The feeling is that the heart's not in the play, you know? The heart doesn't have this thing.* I think belief is really easy. But I think (*xiang*), if you believe in Buddha, I think (*juede*), why are you thinking about the Statue of Liberty?

Stud: Actually at first I thought of (the Bodhisattva) Guanyin, haha.

PL: Right, so, I also think, so to speak, since you believe in Buddha, it's closer to you, right? You believe in (it). No matter what (it's) closer to you. . . . The Statue of Liberty, you haven't gone there, *she's really far away from you.* Why would you think of her?

Stud: Because she's free, and a goddess. (A play on the Chinese name *ziyounushen*, "Freedom Goddess." All except for Professor Li laugh.)

PL: Come on, that's not good enough. "Because she's free." Aren't goddesses all free?

Stud: *No, I mean, because her name is called Freedom Goddess, and I think it's like my personality. It's like my spirit made big.*[31]

PL: Oh, that's how you think. But then why do you believe in Buddha?

Stud: That's something from my family, ever since I was little my mom and dad took me to pray.

PL: Which is to say you don't actually believe. In your heart, does it have any comfort for you in your heart?

Stud: But compared to Christianity I believe Buddhism more.

PL: Right, so that's the question, why don't you choose the thing that you believe in. . . . I believe you really feel, if somebody has no money give him money, it's that kind of feeling, right? Something you have feeling for.[32]

TA: Right, so I think this direction is correct, the way you are using the light and everything, and the way you organized help from friends, an artist, as a kind of art, the feeling is right, as a direction. But now, the problem is the thread (*xiansuo*).[33] What are you trying to do? It's still that same question. Just, what relationship does the Statue of Liberty have to you? . . . Including your last piece, they were both really good, really stand out, but what you are trying to do, this still hasn't come through. Look, both the reactions were the same, even though the appearance was totally different. If you go look at some artist's book, look at his process and the outcome, you'll find a lot are the same as yours, because your methods and your process, are already right, but then you'll find, when he is slowly, slowly, slowly talking about his reasoning (*daoli*), it's different, that's when a lot of things come together.

Stud: You mean—

TA: Right, just, what is this doing, can you tell me? In one simple sentence? You can't just say, oh this is just a stupid thing (*wuliao de wanyir*). So you have to say, say that kind of meaning (*yiyi*). What relationship does this thing have to me? I think this is really important.

PL: This is requirement is really high, you've already succeeded in the homework, but can you reach a higher requirement, can you talk about your ideas. Everything you've done is good.

TA: But I really admire her attitude, the way she works, even if the idea isn't clear but she is still doing big things, really good.

PL: Do you have any questions?

Stud: But this, I mean isn't it always just to please the teacher, be-
 cause the teacher wants you to.

PL: No, of course not. You have to *think from your self-body* (*cong
 ni zishen xiang*). What relationship does the Statue of Liberty
 have to you? If she doesn't have a relationship to you then why
 do it? It's a matter of judgment. We can only give you sugges-
 tions. How can the result be closer to you? You say, I just want
 freedom, I just want whatever?

TA: Actually this makes me think of Yin Xiuzhen.

Stud: Yin Xiuzhen?

PL: A woman artist, Chinese. She was in the Venice Biennale. She
 made a giant car and when you look, it was made out of pots
 and pans, every kind of pot. And then she uses clothes, and all
 kinds of stuff, every kind of garbage. The *zhizuogan* was really
 great.[34]

Through this conversation, the student identifies a stylistic element or ar-
tistic strategy within the piece that the teachers wholeheartedly accept: ar-
rangements or accumulations of random, everyday objects, photographed to
make shadows. She begins by acknowledging that she drew this theme from
the work of another artist (the unnamed artist who uses "garbage . . . and it's
really realistic"), and yet still identifies it as her own idea ("my idea was to
take a lot of things from daily life all on my body," which she uses to shape
the shadow of the Statue of Liberty). Finally, the teachers link this stylistic
element up to the successful work of Yin Xiuzhen. They are suggesting—
but never explicitly claiming—that this "direction" is very fruitful: the art-
ists who use this theme participate in major international exhibitions, so by
using it she is already linking herself to a particularly successful aesthetic
community (and practice community).

Nevertheless, the overall emphasis of the critique is not on naming a
particular style for her to join, but on getting her to narrate a personal rela-
tionship to the work. Professor Li spends most of the critique talking about
religion, trying to draw out a genuine feeling of religious commitment "in
the heart," as opposed to the "part-time" practice of religious ritual. Profes-
sor Li suggests that the Statue of Liberty is "too far away" for her to have real
feeling about it, and asks why she didn't choose the religiously, ethnona-
tionally, and geographically more proximate Guanyin.[35] In this line of ques-
tioning, Professor Li uses religious faith as a model for the kind of feeling

and personal relationship that students should have toward the elements they use in their work: "the heart" has to "have this thing."

The student offers two justifications of her choice of subject matter, neither of which suggests any kind of feeling in the heart. First, she says that she chose the Statue of Liberty because it was a recognizable symbol (*biaozhixing de dongxi*), focusing her explanation in the wrong direction (on viewer response rather than individual feeling). Second, she quips that the "Freedom Goddess" is "like my personality . . . free, and a goddess," attempting a form of indexicality that rests specifically on language as such. Professor Li rejects both jokes out of hand, pushing her to develop a way of talking about the work that implies an introspective self-awareness.

Toward the end of the critique, the TA congratulates the student on her success in developing a creative process and aesthetic style, but directs her attention to the problem of discourse: "Can you say what you're doing in one sentence?" He instructs her to look not just at the work of other artists, but their process and discursive styles ("when he is slowly, slowly, slowly talking about his reasoning, that's when a lot of things come together"), to change her way of orienting toward and modeling herself on other artists—such as Yin Xiuzhen—by learning to pay attention to process and discourse.

Being a creative individual does not mean isolation or even necessarily uniqueness, but rather being able to take an aesthetic form that might well have been used by other artists and anchor it in the self, enregistering it. It means understanding the right way of inserting oneself in a situation, knowing how to copy without concealing it. Unlike the nervous boy from a poor family who, when pressed by his teachers about his repeated failure to finish any homework, said that he didn't make anything because "I had ideas, but they had already been done" (and was told, "you aren't like a CAFA student; you don't belong here"), this student was able to get praise precisely for doing things that had already been done. Developing a style that indexes self also becomes a way of making connections to other professionals, and of orienting to aesthetic community (and vice versa): not just to make things that look like the work of other artists but to find the right way to discursively participate in and compare oneself to those other professionals.

In this class, as in many other critique classes I have witnessed, the locations of "self" were always deeply private: the body and its stigmas, memory and its traumas, the heart and its feelings. Through the process of critique students learned to publicize the personal, to talk about their most private thoughts, uncover their stigmata. At the same time, they learned to personalize the public, to take something from another artist and "make it their

own." These discursive negotiations of public and private were organized through a kind of binary logic analogous to the distinctions between form and content, signifier and signified: the interior self with its thoughts and feelings, and the externalized art object that communicates by speaking and giving feeling to others.

The semiotic ideology of creativity class entirely ignores the economy of self-presentation that is so constitutive for identity formation in the visual culture industries and commodity capitalism more broadly. Fashion was never a topic of discussion; students were never told what to wear. And yet bodily ornamentation was obviously a focal concern for most of the students, especially the most successful ones, the students who went on to join the most prestigious studios. Their modes of dress and hairstyle were far more diverse than those of the older students in the MA programs CAFA, or those of students in the Shandong Academy of Fine Arts in Jinan, and were clearly used to signify persona and personality.

There were two students in Professor Li's class who were widely regarded by the other students as having the most "personality" and as having the potential to succeed in the class and make it into Professor Li's studio. Neither of them anchored their artwork in anything as concrete as a missing arm or as categorical as a religious faith; but both had a style of making work that was articulated with an unconventional or "anti-mainstream" (*feizhu-liu*) style of self-presentation. One was a student with long hair and fingernails,[36] who always wore the same paint-stained jeans and military jacket. He seemed engaged in the class but rarely spoke, and then only in a whisper; he constantly, obsessively rolled a coin back and forth across his knuckles; he had his own studio apartment, and was rumored to be from a very wealthy family. He spent most of the course working on one series, a sequence of digital images of obese figures in dark rooms with images projected against their skin. The other was a young woman who dressed in a butch style: military boots, short cropped hair, men's pants, black shirts and jackets, black frame glasses, elegant silver jewelry. Her work was often textual and borrowed from the work of the famous artist Xu Bing, who had also recently returned from the West to become director of CAFA's fine art division. Both of these individuals presented themselves in ways that challenged mainstream Chinese norms—in the one case, of gender presentation, in the other case, of personal grooming and polite communication. However, both of them actually made work that was thoroughly mainstream. The young man's work fit precisely into the aesthetic of gothic/vampire/science fiction that has developed into a global dominant paradigm in the early years of the twenty-first century, and the young woman's work fit into the most institutionally and

economically successful genres of Chinese contemporary art. Their articulations of self-presentation and artistic style managed to anchor an extremely public style in a seemingly private self. Because their clothes and hair seemed to express something private (a psychological condition, a sexuality), others were inclined to read their work as a direct expression of self, rather than a manifestation of a global aesthetic. Professor Li said of both of them that they "had a lot of ideas" and were very creative; both made it into his studio (two of a total of five chosen that year).

In critique, just as in negotiations with a client or buyer, the body of the artist or designer serves as a cotext for the work. Self-presentation can create a kind of mimetic identification between the person and the person's work, the kind of identification that underlies creative work metonymy: a girl with a bowl cut and cat-eye glasses, oversized T-shirts, skinny jeans, and bad posture draws cartoons of awkward animals with big heads and crooked, shriveled limbs. But difference or contrast can be equally effective in entextualizing the work. Professor Li dresses conservatively for an artist, and describes himself as living a sober, bourgeois lifestyle; he made a point of mentioning to me that he does not engage in the sexual entertainment practices that have become an accepted part of upper-middle-class Chinese men's lives.[37] This air of restraint and conservatism makes his paintings of nudes seem shockingly private, much more graphic than they might seem if his self-presentation were more libidinal.

It very quickly became evident to the students in critique class that clothes and haircuts—as well as voices and aesthetic styles—were part of the total semiotic package they were learning to produce through "self-styling." For some students this realization prompted anxious self-transformations. When I met Xia, a twenty-two-year-old student, in the last weeks of her foundation classes, before the start of creativity class, she wore the same thing every day: an old red sweater that her mother had knitted, jeans, and brown leather walking shoes. She told me proudly that she'd worn that one pair of shoes for years, out of sentiment rather than thrift; during the required military training at the start of college, she had been disciplined for wearing them. After the second day of creativity class, Xia told me she was worried that she didn't have enough personality, and that she didn't know what she liked, didn't have any real interests. Soon after that she began to buy new clothes, and by the end of the course she had developed a new style, mature and feminine: skirts, sharp jackets in gray and brown, and very high heels, totally unlike the girlish styles worn by most of her classmates. She also began to smoke secretively, and rented a cheap, windowless underground room (the kind of room in which migrant laborers live) to use as a painting studio.

The anxiety of self-presentation was heightened, of course, by the inevitability that some students would not be able to control how others saw them; that their "selves" would be located for them, in places they didn't necessarily want to see themselves. In one assignment students were grouped in pairs and told to make portraits of one another on the basis of long conversations, to help one another in the project of self-discovery. The quiet goth with "a lot of ideas" (Z) was paired with the shy young man from a poor family (W) who said that "everything had already been done." W made a video of Z's hand as he rolled a coin back and forth across his knuckles in his trademark display of dexterity. Z made a video in which he asked W to read out a list of characters displayed on the screen, so everyone could marvel at his thick Hunan accent. When the videos were played in class, Z watched his own hand with pleasure, but W turned his head aside in embarrassment at his own voice. Neither of these videos drew on any deep conversation about personality; each simply picked up and re-entextualized a notable aspect of the other's behavior in public. But W's video reinforced Z's self-styling (as Goffman would put it, the impression he was giving), while Z's video stigmatized W as someone unable to master a basic form of urbane self-presentation, fluency in standard Mandarin (what Goffman called the impression he was "giving off").

In this section I have examined the difficulties that students face in "finding themselves" as they are shifted from the standardized evaluation regime of traditional realist painting classes to the individuated evaluation regime of the critique. They are told to look for "self" in their memories, their traumas, their hearts, and their bodies; but they must also find a way to discursively embed this self in particular, recognizable, stylistic elements of their artworks, and at the same time to use these stylistic elements to link themselves to other artists and designers. Simultaneously they must develop a form of self-presentation that can serve as an appropriate cotext (or paratext) for their work, a personal style that can mediate between their interior self and their externalized work.

Examining the evaluation regimes used in creativity class shows that creativity is a highly complex set of multimodal discursive practices. Practicing creativity means learning not just how to "make things" but also to think, feel, talk, dress, and stand in particular, individuated ways, and to make these various forms of practice work together semiotically. That so many students in Professor Li's class were able to meet this challenge and produce sensitive, subtle, and bold works of art in a variety of media so soon after starting his class and after so many years under an allegedly creativity-crushing regime of standardized technical training is a testament to their

resilience and imagination. It is also a testament to the effectiveness of Li's pedagogy, his techniques for helping students to "find themselves."

In the next and final section, I examine the political implications of these performances and the language ideologies that inform them. The conceptsof self, personality, and creativity at play in these classes have often been regarded as foundations for liberal self-determination—and yet they are being reproduced through central institutions of the illiberal Chinese Party-state.

PART III: BOURGEOIS CREATIVITY AND THE PROBLEM OF CHINESE POSTSOCIALISM

Liberals (proponents of democracy and freedom) and neoliberals (proponents of deregulation and opponents of state services) from John Dewey to Francis Fukuyama have long regarded the cultivation of "individualism" and "creativity" as central to their political and social aspirations. Because artistic creativity has been understood as an analogue of certain liberal genres of linguistic self-expression, it has also been regarded as one of the key, emblematic practices of liberalism: acting "publicly" by expressing what is "private," personal, individual, unique.

For much of the twentieth century antiliberals agreed that bourgeois individualism was the most insidious threat that capitalism could offer to the establishment of socialist equality. In order to build communism, the modes of self-expression and self-presentation that are so central to commodity capitalism—the forms of fashion and style used to index distinction and difference—had to be suppressed and eradicated, along with the kinds of "bourgeois creativity" that produced these forms. Socialism completely reorganized visual culture, switching it from the model of perpetual change and difference to a model of coherence and uniformity. In contrast to the Western suits and form-fitting, flowered *qipao* dresses that characterized Shanghai fashion under the Nationalists, Sun Yat-sen clothes (known in English as Mao suits) expressed neither self nor sexuality, but rather a deep equality and coevalness that transcended even gender. From the early days of revolutionary organizing all the way to the late 1980s, Chinese visual artists were called upon to go out to farms and factories to find "the people" and "the nation," rather than sitting in their own studios to find "themselves" in their own bodies, feelings, and memories. When Maoists used personal narratives to promote political transformation, for instance in "speaking bitterness" campaigns against former landowners, they presented personal experiences of suffering as representative cases of class experience.

In the post–Cold War period of desocialization, as former communist countries filled with markets, the logic of association between commodity capitalism and democracy led many critics inside and outside of China to suggest that individual self-expression would gradually lead to political transformation. But in the decades since, it has become clear that having a style does not necessarily mean having a claim to a particular kind of liberal political positioning with respect to the state. Generations of artists and designers, as well as other *feizhuliu* (anti-mainstream) individuals, have shown a general disdain for official and popular culture—just as Professor Li scorned the "Stars of the Academy" show of works by "outstanding" (*youxiu*) students at CAFA as too official, too conservative. However, these artists and designers have rarely shown antigovernment feeling or proclivity to active rebellion. Professor Li did not treat "thought transformation" as a political transformation, and these students did not seem to experience it as one. The forms of self-conscious subjectivity and dialogic, egalitarian communication modeled in critique are not fundamentally or inevitably political.

In an illiberal society "the political" is not the same kind of sphere of action and daily interaction that it is in a democracy. The root "politic" used in all major Western languages, which connotes contest and conflict, has no good translation in Chinese; the Chinese word *zhengzhi* would be better translated as "governance" or "government." In China, as in many other illiberal societies, there are no elections or contests to give drama to politics; people are not explicitly organized into factions. For most people there is no sense in which social life is organized by political affiliation. Government policies and corruption can be privately criticized, but organized and sustained political opposition is impossible (online memes get shut down; activists and organizers are arrested). Active dissent is functionally invisible.

If Chinese politics is limited to *zhengzhi*, then it can be understood only in terms of activities that operate at the level of nation. All students in Chinese schools and universities are required to take classes and pass examinations in government (*zhengzhi*), about which most students express cynicism. However, during my fieldwork at CAFA the only major public actions I saw students engage in were patriotic and nationalist, and in both cases the students seemed motivated by genuine emotion. One was the series of patriotic activities organized in response to the 2008 Sichuan earthquake; the campus of CAFA was transformed overnight into a series of installation-style memorials, including a tower painted with images from CCTV photo montages covering the disaster, with victims at the bottom, heroic soldiers living them up, and Wen Jiabao at the top, offering hope (see figure 5.4). The other was a series of nationalist student protests against the French supermarket

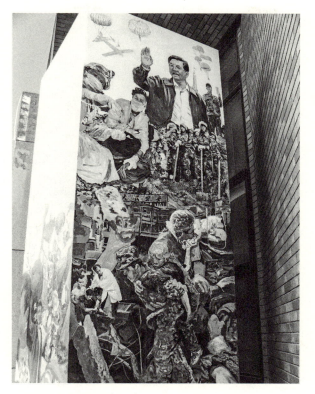

FIGURE 5.4 2008 earthquake commemoration monument
made by CAFA students.

chain Carrefour (Jialefu), in response to that organization's gift of money
to the Dalai Lama. Many students at CAFA and other universities went to
the doors of Jialefu stores around to city to protest Western interference in
China's internal affairs (protests that many people regarded as having been
surreptitiously organized by the government) (see figure 5.5).

Professor Li routinely made it clear to students that they should work only
on personal, not political, themes. He discouraged his students from going
to the protests at Carrefour. When potentially political (*zhengzhi*) themes
did appear in student artworks, he actively directed the conversation away
from the political and toward the personal. When a student made a car-
toon of Marx as a lion, Professor Li at first laughed and asked each student
how to say "Marx" in their own dialect. Then he turned to the student and
said, "You are doing this to try to challenge society. Your behavior is just
for other people to see; but how can you get closer to yourself?" When the

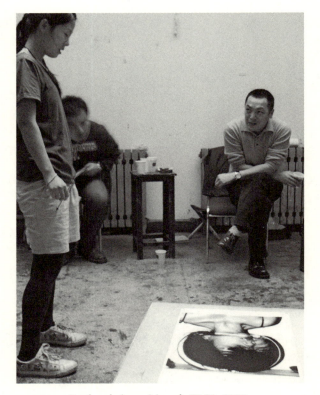

FIGURE 5.5 Student being critiqued, CAFA, 2008.

butch student made a series of text pieces based on Mao's writings, including the word "contradiction" (*maodun*), Professor Li asked her, "What does this have to do with you? You weren't even born then."

Should this pedagogical pressure be understood as an instance of internalized governmental suppression of dissent—an enforcement of political silence? Or is it part of a broader strategy of ceding the political and opening the private as a kind of alternate sphere of action?[38] Certainly, in both these cases the students were aware that bringing Marx and Mao into their work would automatically make it *zhengzhi*. But neither had any political perspective to express through their work; it is not clear what the depiction of Marx as a lion had to say, other than that Marx had a big bushy beard, and the piece about Mao's calligraphy, while referencing Mao's book "On contradiction," did not make reference to any social contradictions in particular. Unlike Professor Li's own work, which explicitly pushed a boundary

of visual representation set by the censors,[39] neither of these pieces expressed any controversial position.

The Statue of Liberty piece that I discussed above was different. For this student and most of her classmates, this piece did not appear to be *zheng-zhi*. For myself and Professor Li, who was a student at CAFA during the 1989 protests, however, her self-portrait as the Statue of Liberty immediately called to mind another Freedom Goddess, the giant sculpture made by CAFA students that occupied a central place in Tiananmen Square and was destroyed by tanks. In Hong Kong, where newspapers can freely criticize the government and street protests are legal, this sculpture serves as an icon of resistance for the activists who commemorate the 1989 crackdown every year (starting on April 16 and culminating on June 4). In addition to draping the Central district in black banners, they wear T-shirts printed with the face of the CAFA Freedom Goddess and carry a full-scale replica of the sculpture to the local government office. In this context, Professor Li's persistent effort to get the student to focus on Guanyin or some other religious figure "closer to herself" might appear as a form of helpful redirection, if not censorship.

However, this student was, like most people her age in mainland China, completely unaware of that other Freedom Goddess, as I found when I asked her about it later—and as Professor Li told me he had automatically assumed.[40] She had never seen a picture of it, and had only inadvertently inserted herself into this political history. For her, the Statue of Liberty was not a symbol of political transformation but a "recognizable thing" (*biaozhixing de dongxi*). When she said that she herself was "free and a goddess," her use of the term *ziyou* did not have any political implications. She was not talking about freedom from the Communist Party, but rather a kind of personal freedom for which the Statue of Liberty serves as an engorged emblem: "like my personality made big."

What relationship does the kind of freedom that this young woman and many other "post-1990" (*jiushi hou*) young people see themselves as *already having* (as opposed to pursuing) bear on the liberal discourses of political freedom that have circulated around the real Statue of Liberty since 1886— the long history of which is implied by the sculpture's reference to the Roman goddess *Libertas*? She was not invoking the freedom from state oppression symbolized by the broken chain at the original statue's feet. In fact, she did not compare herself to the Statue of Liberty, but rather compared *ziyounushen* to herself, "free and a goddess." In making this quip, with a flirty laugh and a toss of her hair, she called upon postsocialist (and third-wave feminist) models of liberated femininity associated with hyper-consumption,

the models of freedom offered by shampoo advertisements. It is the same model of *kaifang* freedom offered by the endless sequence of party pictures that Liang Yuanwei displayed in the Homesickness exhibition discussed in chapter 2, and of personality (*gexing*) championed by the young rural women Yan Yunxiang has written about.[41] In China, of course, this twenty-first-century self-confident, fashionable, demanding woman stands in contrast to the history of sturdy, self-effacing, hardworking socialist women heroes.[42]

Ziyou is not a term frequently used in Chinese Party-state governmental discourses, but this discourse of *ziyou* is not antiauthoritarian. On the contrary, this version of freedom is homologous to and interdiscursively linked to the governmental discourse around creativity (*chuangzao, chuangzuo,* and *chuangxin*). This concept of *ziyou*—which I often heard young people of both genders call upon—is basically neoliberal. It is the freedom offered by the market economy, in which visual culture workers are fundamentally implicated: "free" individualized choices at the level of clothing, consumption, and entertainment. There is a very clear overlap between the kinds of subjectivity (and the characterological roles) that typify "freedom" and those that typify "creativity": both are concerned with an autonomous, desiring, acting "self." It is the kind of subjectivity that the education bureaucracy actively cultivates through institutionalized creativity classes.

As I have argued in this chapter, these intertwined discourses of creativity and freedom do not generally touch on political themes, except in the limited sense of global national competition suggested by Li Wuwei's slogan "Let a Chinese Wind Blow around the World" (and, for that matter, President Obama's slogan "Win the Future"). And yet, given the ideological weight placed on both "freedom" and "innovation" in the liberal polities that most frequently criticize China's government, these discourses seem to offer openings for a liberal (as opposed to neoliberal) politics.

Part of the reason that "creativity" figured so centrally in liberal models of education is that artistic creativity has been understood as an indexical icon of liberal practices of self-expression. Self-expression is often understood by democracy promoters to have a psychologically transformative and inherently liberating potential. The organization Oxfam Hong Kong has promoted a variety of narrative practices in mainland China under the auspices of a program called "developmental education," which seems at first to be wholly consistent with the bureaucratic push for creativity education, but conceals a goal of promoting political transformation through promoting group expression. In the group exercise "one person one story," a group of actors ask an audience member to come up and tell his story; when he

has finished, the actors use the methods of "living sculpture, improvisation and chorus" to act out the story. According to a participant cited in Oxfam's promotional magazine,

> The thing that left the greatest impression on me was the groups' (*tuanti*) experience of equality and cooperation. In this group, every person is equal, every person has the opportunity to publish (*fabiao*) his opinion. When a community (*qunti*) is full of love, it won't make any member lonely. No matter how estranged you are, or how cold/reserved you are, when you go into this group that insists on equality, trust and respect, you will inevitably feel satisfied. If this group became bigger and bigger, to include the majority of humanity, wouldn't it make everyone as satisfied as me? . . . If we all pursue freedom and equality, we should not treat theater as propaganda, we should not try to impose our perspectives and attitudes on other people. What we want is to display every problem to people, let people experience the existence of this problem, let them give their own opinions, their own solutions. What we want is mutual dialogue, through dialogue we will discover new perspectives on the problem, hear more ideas. Maybe people will accept our ideas, or maybe they will keep their own ideas; no matter what, through this dialogue, we can all achieve a more complete recognition.[43]

There are obvious ideological similarities between the practices of "one person one story" and the kinds of narrative self-cultivation practiced in Professor Li's creativity class: both attempt to project an internal self for a group through a semiotic intermediary (the art object, the actors), and provoke a dialogue around that intermediary, in order to generate "recognition." Just as Professor Li made frequent attempts to claim or establish discursive equality between teachers and students in critique, and repeatedly positioned his own critical comments as "merely my own opinion," Zhang Qinggang claims that "one person one story" creates an atmosphere of "equality and cooperation," which makes possible a free exchange of ideas (the subtle analogies to the market, in which people can accept your products, or reject them, should not be missed here). But Zhang Qinggang (and by extension Oxfam Hong Kong) subtly posits self-recognition as a step in a broader process of social transformation, a move away from "propaganda" and toward an environment of "free expression."[44] Professor Li, by contrast, pushes students away from even inchoate "postpolitical" references; the self is its own world.[45]

AESTHETIC COMMUNITY

Wo xiang gao chun yishu! I want to do pure art!
Chun yishu xiang gao ni, ma? Does pure art want to do you?

If "to paint the same is failure," the work of being creative is in large part the work of manifesting difference. And yet it is obvious that much of the work done in the visual culture industries is the same. Artists and designers are always drawing from the works of others; works of art and design are described, appraised, and marketed in terms of genres and other categories, which is to say in terms of their similarities as much as in terms of their differences; and those generic and stylistic categories in turn index social categories that link and divide artists and curators, designers and clients, consumers and fans.

In contemporary art and design, there is a constant effort to manage a tension between opposing impulses to difference and similarity, between indexing unique individual creativity and indexing a membership in a recognizable genre and community. In China, the tension between the ideology of creative individuality and identification with a community frequently serves as a model for and manifestation of another kind of contrast: between the market (in which people are divided by pecuniary interests) and society (in which actors are linked by shared practices).[1] By describing events and locations in which artists and designers index community, this chapter shows how the aesthetic gestures that mark personal styles also mark associations and positions in relation to various imaginations of community (*qunti, shequ*) and society (*shehui*) in postsocialist China, imaginations that are in turn shaped by anxieties about capitalist individualism and its reconfigurations of public/private spheres.[2]

Even as objects and mediated images index aesthetic community, and the market in "commodity images" allows such communities to form and expand, the dialectics of creative community produce a double bind. Chinese creative subjects are caught between the discourse of utopian individuality and dystopian social uniformity on the one hand, and the discourse of utopian sociality and dystopian anomie on the other. As market conditions push culture workers into agonistic competition with one another, some of them attempt to create spaces of sociality to recuperate the good in socialism— spaces that are, nevertheless, both individualized (as projections of self) and commodified (and venues for value production). People are always operating in a field of contrasting styles or visions (registers) associated with social identities.[3] In some situations, registers are clearly demarcated as belonging to groups with discrete memberships, and most everyone recognizes the register.[4] But in many other situations, both registers and the communities indexed through them are less discrete or less perduring, and shibboleths are less consciously or less widely recognized. Categories overlap and binary distinctions fractally recur; there are registers within registers and communities within communities.[5]

As argued in chapter 1, practice communities are, like speech communities, defined by norms of interaction: bodies of knowledge, modes of exchange, ways of doing things. They are anchored in institutions, apparatuses, and "technologies" broadly construed. In the culture industries, these technologies include both media and genres at a very broad level of distinction: poetry, epic, novel; painting, sculpture, performance; film, sitcom, news. Within those categories are many subtle normative distinctions. Genres at this finer level of analysis frequently serve to index aesthetic communities, which are, like language communities, defined by orientation to norms of communication: systematically corelated iconographies, repertoires, and styles (as well as associated speech registers and modes of self-presentation).[6] Aesthetic communities are organized by genres as "historically specific conventions and ideals according to which authors compose discourse . . . and audiences receive it. In this view, genres consist of orienting frameworks, interpretive procedures, and sets of expectations."[7] They are oriented toward literacy, comprehension, proficiency, and preference, rather than professional practice. They include both classical musicians and classical music aficionados; soap opera writers and soap opera fans; modernist designers and people who like modernist stuff, whether or not they can afford to buy it. As intersubjective spacetimes, aesthetic communities can include both the living and the dead.[8]

Aesthetic and practice communities only rarely overlap neatly.[9] In most cases, there are multiple practice communities within an aesthetic community (modern design includes artists and designers in many fields) or multiple aesthetic communities within a practice community (contemporary art includes many contrasting styles). The tensions that can result from these overlaps—as when people who belong to the same practice community, but work in radically different styles, interact—provoke delicate dialectics of self-positioning, which highlight the complexity of broader imaginaries of groupness.

Communities are always projections of similarity that provoke identification—all of "us" who orient to this standard, or who do this kind of work—across gaps of time and space, facilitated by words, objects, and images. They are forms of "poetic worldmaking," like the publics and counterpublics constituted by particular aesthetic forms.[10] The formation of aesthetic communities, which is to say their emergence as categories that both give shape to and are used to interpret aesthetic forms or human behavior, is, like the emergence of ethnonational communities or any other kind of community, an ideological process. The diversity of aesthetic community seems to increase with the plurality of genres, because the same culture industries that proliferate genres also actively encourage the formation of self-recognizing aesthetic community, and also encourage internal distinctions and hierarchies.

In the culture industries, the boundaries of community are sometimes asserted by those claiming membership, denying it or asserting it of someone else. But more commonly aesthetic community is implied, suggested by attitudes, taste, receptivity to certain modes of address: "liking" and "disliking," understood not as mental states but as semiotic activities that reflexively serve to identify the actor as belonging (or not belonging) to a social category.[11] Aesthetic communities are socially powerful precisely because they are not explicit.[12]

The concepts of aesthetic and practice community together offer an alternative approach to the fields of cultural production. Bourdieu's analysis of the field emphasized the organization of power and the hierarchical positioning of actors within a field of practice, as well as their shared orientation to a kind of capital (cultural, economic, etc.) and to certain norms (*nomos*). This approach emphasizes the ways that the types of relationships that define communities (hierarchical, egalitarian, and otherwise) are immanent in moments of interaction in context: focusing on the play, rather than the "playing field." The flexibility of this analytical approach is particularly well suited to an analysis of the visual culture industries in contemporary China. Chinese visual culture industries are primarily composed of thousands of culture workers freelancing or operating companies with a handful of em-

ployees from offices located in apartments. Most of these workers have no licenses or professional association memberships. They are connected to one another only through informal networks, only some of which formed in school. They do not attend annual conventions. Certainly there are university departments and state-sponsored research academies in every "field" of art and design; but since most of the design departments were founded in the past ten years, key actors in the design fields were educated not in design but in fine art or industrial art schools. Most participants in most fields do not regard the academies as arbiters of taste or covet academic prizes. Even the trade publications are not objectively ranked: there are too many of them and they appeal to too wide a variety of aesthetic tendencies.

However, it must be emphasized that even in the absence of Weberian "organization," staging remains a crucial part of the play of making communities. Contexts (sites, locations, places, events) organize the imagination of community, without necessarily delimiting its boundaries. As Warner points out, "when an essay is read aloud as a lecture at a university, for example, the concrete audience of hearers understands itself as standing in for a more indefinite audience of readers."[13] Consequently this chapter focuses on a series of locations, describing moments in which a small group of individuals brought together in a specific place or through a particular object come to regard themselves as part of larger communities, and analyzing the implications of these identifications. In so doing it shows how aesthetic and professional identities index other identities, positions, and interests.[14]

The first part of the chapter contrasts two professional sites in which practice communities and aesthetic communities emerge: a giant art fair called Art Beijing, and a private meeting between a small group of young artists and a curator. The second part of the chapter examines the studios and cafés (*kafeiguan* or *jiuba*) in which artists and designers socialize,[15] while the third part of the chapter shows how communities expand spatiotemporally through objects and media. Throughout, the chapter considers fantasies of sociality provoked by anxieties about anomie: memories of the community around Yuanmingyuan that was torn down during the reconstruction of the city; attempts to build a community of artists and designers turned kung fu (*gongfu*) practitioners; and a fantasy of a public art library, imagined by a young photographer, which never came to be.

EXHIBITING COMMUNITY

Since 2006, the Agricultural Exhibition Center in Beijing has hosted a massive annual fair called Art Beijing. During the three days of the fair, the rear

hall of the center, built like a giant airplane hangar, is divided into around a hundred small booths, the vast majority of which are managed by art galleries. Along the right side are booths representing magazines and other publications; along the left are special, nongallery hosts; and at the back of the room are a series of relative large spaces for sponsors and design firms. The temporary walls are crammed with art: mostly paintings, but also video screens, sculptures on pedestals, and, in some booths, little cards and curiosities. Nearly everything is for sale, with prices ranging from highs around five million renminbi for some paintings and sculptures, averages around five hundred thousand, and lows under one hundred for magazines and prints. Art Beijing is billed in advertisements as a contemporary art fair. The "contemporary" refers both to the date of production and to a certain degree of detachment from official and academic genres, a relative liberality, a willingness to include the abstract (*chouxiang*) and the weird (*guai*). There are certainly many abstract paintings, weird sculptures, and avant-garde video works in the fair, but there are also a fair number of decorative paintings and realist portraits, and even some academic kitsch (i.e., romantic paintings of ethnic minority girls).

In this fair a large practice community coalesces: people who make art, people who sell art, people who buy art in order to sell it again later, and people who write, publish, and sell magazines about art. The fair also attracts a range of visitors from a variety of aesthetic communities: collectors, including celebrities and other rich people, journalists, artists and designers, art fans, and a lot of art students. Like participating in a professional conference or a rock music festival, participating in the fair is a way of enacting membership in the "art world"—especially if you have a VIP pass—or at least "liking" contemporary art. The first day of the fair, always a Friday, is VIP only, with the VIPs being mostly collectors, gallery directors, famous artists, their friends, and other important people, as well as the journalists whose presence gives these local insiders the sense that they belong to a larger practice community, the global art world. The second and third days, there is a separate VIP entrance, but non-VIPs are allowed in too, although they must buy tickets, which are not cheap. On the second day, many participants are still actively engaged in constructing a practice community, making sales, making connections, and so on. But by the third day, there are very few VIPs or gallery directors in attendance, and the people manning the booths have little interest in the crowds of people who've just come to look (or rather, the degree of deference and amount of attention they pay to visitors is inversely related to their own status within the gallery). By the third day, the gallerists have begun to treat the visitors as a public, rather than as members of a

community—ignoring them as they view the artworks. Many of the visitors understand themselves as belonging to a public, too, although others (especially art students, artists who are not included, and art lovers without the economic means to be collectors) experience their attendance at the fair as a way of participating in a community of practice.

Nearly every contemporary art gallery in China has a booth in this fair and all the other fairs held in China every year. Before each fair they send emails to their contact lists with their booth numbers, attempting to draw their clients and frequent visitors into the fair too. Like the annual "Black Friday" sales in the United States, the fairs convert institutions into events in order to attract a larger audience; they also gather the dozens and even hundreds of separate galleries into a single community. But Art Beijing (like the many other fairs held in China every year) is not just a bigger version of the gallery openings that happen every weekend.[16] It operates on a different model: it is basically uncurated. The booths are not placed in any stylistic order. Most galleries' booths display pieces from all the artists they represent, whatever happens to be available. The large industrial space crammed with rows of tiny booths offering different items brings to mind the massive markets (*shichang*) where working-class urban Chinese people buy food, clothes, shoes, toys, luggage, dishes, and appliances.

This mode of presentation disrupts the museum-based interpretive practices that are normally crucial to contemporary and modern art. As a result, in the art fair, even as the practice community is performatively constructed, it is also discursively deconstructed. In the temporary café outside the fair, on the way home, and in the days following, the fair frequently becomes a focus for complaints about commodification. Much of this talk is about "interests," attributing pecuniary interests to artists and gallery owners and criticizing them for caring about money rather than art.[17] The fair provokes such criticisms not just because of its similarity to a market, but because in highlighting both difference and sameness it expands the frame of reference for any particular artwork beyond the limits of the interpretive framework of authorial creativity. By juxtaposing different styles it makes evident the plurality of aesthetic communities within the practice community of "contemporary art," foregrounding the practice community, and drawing attention to the material and economic practices common to artists working in different styles. The difficulty that culture workers experience in indexically managing the dialectic of creativity and community increases with the scale of community gathered in a single place.

At the same time, by grouping together so many artists working in the same forms, the fair draws attention to the generic conventions that shape

style. The sheer quantity of items in the fair makes possible a level of categorization (another painting of a dissolute girl with a liquor bottle; another painting of a lost child in a dark forest; another lewd, oversized fiberglass figurine; another human-animal hybrid) that conflicts with the ideology of the unique personal style or personal vision. This is why the fair routinely provokes complaints about repetition, sameness, and the lack of creativity (the same complaints every year). Sameness and lack of creativity in turn come to index the financial interests of the artists and dealers involved, the suggestion being that they copy the work of other, more successful artists in order to make money. Where the commodity character of an artwork in a gallery is typically implicit, in the fair it is patently obvious that all the pieces are in their "commodity phase."[18] Some galleries even post prices next to pieces, and visitors react with humor to seeing a price tag of four and a half million renminbi (in 2008 the price of a reasonably sized apartment in Beijing) next to a piece of canvas.

The interpretive framework of creativity that is widely used in contemporary art depends on a carefully managed context, and a carefully restricted selection of cotexts, because it is not nearly as easy to essentialize to an individual as it is to essentialize to a social type. The interpretive framework of creativity is at odds with the projections of macro-social scale characteristic of most concepts of "community." Activists and patriots generally like to imagine the ethnonational or political communities they identify with as growing masses, but workers in the "creative industriess" do not. The conflict between the ideology of creativity and the very *idea* of the generic conventions, organizations, and institutions that define aesthetic and practice community is the reason that such concepts are only rarely explicitly articulated in the visual culture industries. And yet, there are many contexts in which the metapragmatic frameworks of community are essential to the practice of visual art, and many contexts in which personal style is itself cultivated through the discursive projection of aesthetic community.

In 2008, I attended a lunch hosted by a young artist and aspiring curator nicknamed "Pants," who was organizing an exhibition. At the restaurant, there were several other young artists and designers, most of whom did not know each other. There was a skinny young man recently returned from graduate training at an art school in England, who wore a long black pea coat, oversized glasses, too-short skinny jeans and sneakers, like a New Wave rocker from the 1980s; a photographer in her mid-twenties who had also studied in England, and wore a black blazer with padded shoulders, a bright red pleated skirt, blue tights and red pumps, effecting a 1980s Nancy Reagan look; and two elegant designers, a married couple, both dressed in

sleek, futuristic, androgynous, black clothes. Pants himself was a chubby guy with a shaved head who always wore the same dirty T-shirt and jeans, oversized and full of holes, and carried a large cloth bag with a sketchbook (during the 2008 scares over separatist terrorism, Pants was once stopped and questioned by a police officer who mistook him for a vagrant from the Uighur territory of Xinjiang, and he often told this story to much hilarity). The discussion at lunch ranged across various artists, exhibitions, and local indie rock musicians. Then we all got in cabs and went to a prominent gallery in the Grassland art district, a place called Platform China. We waited in the courtyard and continued chatting about the kinds of work we had done in the past and the projects we were working on now, as well as about economic limitations that made it difficult to get "experimental" forms of artwork exhibited.

Finally the director of the gallery and the curator of the exhibition came out to meet us. First, the director talked to each young artist, asking questions about the work they were doing, where they were from, where they went to school, which teachers they studied with. Next, the prominent British curator, who had lived in Beijing for many years and spoke excellent Mandarin, described how she met Pants and worked with him on a previous exhibition, and emphasized that she knew we were all friends of Pants. Then she explained the idea for the exhibition, provisionally called "Weimiao": when she was last in Europe hosting an exhibition of Chinese art, people had told her that it was just what they expected from Chinese art: always bold and brash, but not subtle. So she decided to have a show called "Subtle," but the standard translation for that term in Chinese (*weimiao*) has other connotations,[19] and she was looking for a better way to express the concept in Chinese. She talked about subtlety for a while, the kinds of feelings that she wanted to evoke in the exhibition, and the kinds of things that might not be appropriate, describing particular well-known styles without naming the artists who made them. She then said, "Pants has told me that all of you have proposals for work to include in the exhibition, so why don't we look at those proposals." The group dispersed to wander around the gallery, while Pants, the curator and the director looked at a series of computer-aided proposals on a laptop, with each artist in turn. When they were done, we said our goodbyes and then went to look around the other galleries in the Grassland complex, including a large exhibition of sculptures and installations by contemporary artists from Japan and Korea, held in a big gallery sponsored by a car company, before finally separating for the evening.

In this event—precisely the sort of evaluation ritual for which the critiques described in the last chapter are designed to prepare students—references

to aesthetic community were crucial to every step in the organization of an exhibition and to the construction of a practice community. The conversation we had at lunch before going to the gallery mapped a multimodal aesthetic community by establishing shared references and preferences, shared points of orientation. The conversation while waiting in the courtyard took this mapping a step further, placing each individual stylistically as a practitioner within this aesthetic community. The director's biographical questions situated each individual in a local practice community, depositing them within a map of institutions and networks. But everyone involved understood that he asked these questions from a position of expert knowledge of the practice community; it was implied that he was using institutional identifications to identify each individual aesthetically, too.

The curator began by identifying the few of us gathered there as a kind of cohesive group, all "friends of Pants," telling how she had mentioned this project to Pants and asked him to find some young artists to join the show. She then made reference to another, broader aesthetic community, that of Chinese contemporary artists in general, as viewed from the perspective European art viewers (who say that Chinese art is "brash and bold, but not subtle"). By framing the exhibition as a reply to this reported criticism, she offered these young Chinese artists an alternative frame of identification, an invitation to join an aesthetic community with those Europeans: a community drawn together by a vision of "subtlety," defined in opposition to the "bold and brash" Chinese (subtly deploying a familiar value hierarchy, of course: sophisticated versus crude, etc.). She then made these alternative frames of identification more explicit by pointing to appropriate kinds of "feeling" (*ganjue*) relevant to the show and to the inappropriate styles (recognizable even without any artist's names) that would not be accepted.

By making these remarks before looking at each artist's proposal, she offered them a framework for their pitches to her: although they were all unaware of the exhibition's guiding concept when they put their proposals together, in entextualizing their own work to her they were able to draw on this concept and emphasize certain aspects, while downplaying others, to discursively push the proposal in the direction of her aesthetic vision. Their "subtle" self-positionings were reinforced when the interviews were done and all the "friends of Pants" went to another gallery to appraise artworks together, examining and critiquing them; whether or not they were offended by the way the curator called up *weimiao* ethno-national tensions in framing the exhibition, through the process of critique they continued to articulate a shared aesthetic that in fact fit the requirements of the show.

This one event shows the many ways that references to aesthetic community are involved in the daily professional practices of artists and designers. The work of making communities of practice, which includes both social labor like shared meals and activities directly oriented to art, there are constant references to aesthetic norms, to registers, genres, and styles that index community. Sometimes this talk is focused on contrasting visions: the "subtle" versus the "bold and brash." But much of the time, these conversations articulate a series of distinct but connected, overlapping communities, describing a vision of aesthetic pluralism that itself indexes a higher-order aesthetic community.

Take for instance the distinct styles of clothing worn by the young artists. There were several points in this extended meeting when individuals complimented one another on their clothing. Despite the differences between their styles, there was a kind of "feeling" that linked them together. Compared to the mainstream (*zhuliu*) jeans, T-shirts, and shoes worn by the director of the gallery, there was a similar theatricality in the way the young artists wore their clothes, a self-conscious indexicality and iconicity (like an eighties New Wave rock star, like an eighties power-suit wearing woman, like an inhabitant of a future space colony, like an itinerant separatist from Xinjiang). This was precisely the kind of aesthetic difference in unity that curators usually strive to achieve in putting together an art exhibition. Each piece must be stylistically different, and yet they should together suggest a coherent theme (for instance, "subtlety," or in this case "eighties"). The right balance of coherence and disjuncture is achieved by organizing small groups of contrasting styles that index, a cohesive vision, at a higher order, and thus a higher-order aesthetic community, brought together by difference as well as similarity.

In contemporary art and design, aesthetic pluralism is a key aspect of the concept of the contemporary (*dangdai*; as opposed to the modern, *xiandai*), and efforts are made to achieve a kind of plurality, a difference in similarity, wherever objects of modern art and design are grouped, whether in an art exhibition or in a high-end shop. The difference between a small, curated exhibition at Platform and the huge, uncurated Art Beijing is not just the care with which this balance of unity and disjuncture is managed. Rather, the fair has a problem with scale and proximity: too much, too close. If the fair organizers solved the problem of disorderly juxtaposition in Art Beijing by putting like with like, it would only make the conventionality of the genres more obvious, and further threaten the artworks' claims to creativity based on personal vision—just as if you put all the artists and intellectuals who wear threadbare jeans in a room together, their clothes might start to look like a uniform.

Within the field of contemporary art, as in all other aesthetic communities committed to an ideology of creativity, the scale of community is frequently evoked by references to the global or international "art world," but only at a distance, from relatively confined locations, or in small selections. The most prominent "global" biennial exhibition in Venice is always tightly curated and also spatially extended; it has far fewer artworks than appear in the annual Art Beijing, and the artworks are installed in separate national pavilions. From a small courtyard in the northeastern corner of Beijing, no one in this group seemed to have any problem with positioning themselves as members of an aesthetic community oriented toward European art viewers; they might be less comfortable locating themselves in a multivolume "who's who" of international artists.[20]

Just as Pants facilitated the meeting described above, acting as intermediary between the curator and the young artists, the small-scale events in which aesthetic community is projected are often organized by relatively unimportant actors, people without positions of power and status. Practice communities in the visual culture industries are anchored not only in institutions like galleries, but also through small groups of friends, social circles, and social networks. In China, such networks have often been analyzed in terms of the local concepts of *guanxi* ("relationships"), which is produced through a complex range of exchange practices and forms of hospitality.[21] These relationships are cultivated in a site that is central to social life in the Chinese visual culture industries: the hospitality of the studio and the café. The next section examines moments in which such forms of hospitality are posited as alternative forms of sociality, and contrasted to those forms of entertainment that have come to be most emblematic of "market socialism."

THE SOCIAL LIFE

The communities of bohemian artists, poets, and rock musicians who lived, worked, and drank in tiny, ramshackle brick houses around Yuanmingyuan in the 1980s and 1990s, or around the northern rural suburb of *Huoying* in the early 2000s, are subjects of frequent obituary, especially in conversations in cafés and studios. These houses were all demolished, one after another, by the constant landscape development that has transformed Beijing in the past fifteen years.

Beginning in the early 2000s, hundreds of acres northeast of Beijing were converted into large studio developments, each housing dozens of semi-industrial, high-ceilinged, white-walled live-work spaces. These studio districts, which were all built by landscape developers, are recognized as rel-

atively bourgeois spaces, with little of the romance of the old artists' and musicians' neighborhoods.

Starting around 2005, when Chinese contemporary art became an extremely profitable commodity in Western art markets, large studios (*gong-zuoshi*, literally work rooms) with couches, massive coffee/tea tables, wet bars, artworks hanging on the walls, and some brushes or tools in a corner became requisite parts of an artist's professional apparatus. These studios are used primarily for the social side of artists' work, meeting with curators, showing work to clients, and hosting friends; many artists do their actual work in separate studios, next door or far away in less expensive locations, where no one other than their assistants would be bothered by the fumes or the dust. Studios are carefully arranged to facilitate this hospitality, with interior design and furnishings worthy of upscale hotels. One artist in his sixties has a bare, white studio, hung with his giant, monochrome paintings of the sea, with an enormous, beautiful antique hardwood table and benches at which he serves tea, elaborately, over a large porcelain *wenren* (literati) tea set; another, who wears nondescript clothes and paints big monochromatic abstractions, has a huge chrome coffee table surrounded by deep, angular, black leather sectional couches, with large photographs hanging on the walls, a chandelier made of fluorescent light tubes that hangs low over the table, and a wrought-iron bar holding bottles of bourbon and red wine.

During the same years, many galleries in the former studio district of 798 and whole blocks of the historical district at the center of the city around the Drum Tower were turned into cafés, many of which were owned and managed by culture workers, including photographers, filmmakers, designers, and musicians. In Chinese, cafés are called *kafeiguan* or *jiuba*, terms partly transliterated from English: *kafei-guan* (coffee place), *jiu-ba* (liquor bar). These markedly translingual terms reinforce the "imported" quality of these venues. Cafés are explicitly understood as being modeled on forms of sociality popular in the West; in addition to lattes and drip coffee they generally serve imported Western liquor (a full bar of mixed and neat drinks) and even Western-style food (ham sandwiches, spaghetti with marinara sauce, eggs and bacon). As a result, they appeal to Western tourists and expatriates, who are often to be found sitting around in them. And yet these cafés must be understood as something more than ventures in the tourist industry.

These little cafés are very rarely profitable given the rapid rent increases in the central city and especially in the arts districts in recent years. Cafés have many nontourist customers: couples on dates, friends meeting to chat, or people meeting to talk about their own business. However, there are so

many cafés that most of them are usually empty, and this is part of their appeal as places for socializing; they offer a privacy that their customers, their owners, and their owners' friends cannot get at home. Many cafés include a separate room or large table, frequently or constantly occupied by the owner and a core group of his friends or acquaintances. Often, this space is actually the owner's main interest in the café. One person I knew had opened a café that became very popular. There were too many people in his café, so he opened a second location, where no customers ever came, and there was always room for his friends. In another café belonging to a friend, the servers often sat in the kitchen. People who were not familiar with the place would leave when no one came out to take their orders, but acquaintances would just call the servers by name.

Like the studios, the cafés in Beijing that belong to culture workers are often aesthetically personalized, with unique furniture, knickknacks arranged on tables and windowsills, and art on the walls. Unlike chain coffee shops such as UBC, Dante, Starbucks, and McCafé, which serve a more mainstream clientele and are usually located in multistory office buildings, the cafés belonging to artists are usually one of a kind, and are located in older single-story brick buildings, with little courtyards and rooftops (hence, in the city center or in the gallery districts).

Cafés are not as private as studios, insofar as they are open to anyone who passes by. But both are places where groups of friends gather to drink (tea, coffee, beer, liquor) and talk. Both usually belong to men and serve as places in which those men can work and relax, play with their toys (i.e., computers and cameras), and host friends and colleagues. Studios and bars serve as semiprivate masculine spaces separate from the domestic sphere; unlike the "den" these spaces have the advantage of being actually physically separated from the home by at least a few kilometers. Like the courtyard of the gallery where Pants' friends met, such cafés and studios are constantly hosting conversations in which a variety of configurations of aesthetic and professional community are called upon. They are frequently sites for meetings similar to the one described in the last section, planning exhibitions or other projects.

These highly personalized and yet public spaces serve as locations in which categories of community are used to index positions in relationship to "the market," to the state, and to a variety of forms of sociality that are imagined as alternatives to those of contemporary Chinese market socialism. By examining the forms of hospitality conducted in these places, I contrast the work of making *guanxi* (which has been the focus of so many anthropologies of China) with the work of making communities and publics (a focus of so many anthropologies of the West), and show how café

sociality is sometimes figured precisely in terms of these contrasts. Cafés serve as sites for professional practice and for the emergence of aesthetic community; they also serve as sites in which such forms of community index stances in relation to problems of sociality in postsocialist China.

For most culture workers, the amount of money required to retrofit a studio or café is enormous, although it wouldn't be much to a landscape developer or Shaanxi coal boss. It helps that they don't have to pay interior design fees, since they have friends who will do it for them. But the cost of renovation is dwarfed by the rent, which in both studio and café districts doubled or tripled between 2006 and 2010, and by the cost of hiring waiters. A major part of the attraction of hosting friends in a café is the presence of servers, addressed by the diminutive *Xiao*,[22] who pour the drinks. Yet to many artists the cost is worth it. I knew two people who held on to their studios or cafés long after they could afford to, not paying their servers until they left to find other work, and not paying their landlords until they were evicted. The spaces didn't close, however: it seems there is also someone else ready to open a shop.

On the one hand, the rise of the studio and the café could be regarded as a new manifestations of the very old culture of pecuniary expenditure associated with *guanxi*, relationship making. The homosocial banqueting and hosting that facilitates business and other transactions in China is the organizing principle for many other parts of the urban hospitality industry: the restaurants with their private rooms, hotels with their lounges, karaoke bars with their brothels.

Certainly, there was a pecuniary aspect to the rapid expansion of studios and cafés in the space of a few short years. Having such a space became a matter of status and reputation in the visual culture industries (along with having a car; in 2006, very few of the artists and designers I knew owned cars; by 2009, all of them did). As one Chinese intellectual told me once, "Chinese people don't talk directly about money, that's not the style. They invite you back to their house so you can see what they have." The studio is particularly face-giving because it is strictly private and because it is separate from the house, indexing the means to keep two places. The café is face-giving for similar reasons, but also because it is transitive: many visual culture workers who don't have their own cafés conduct informal meetings and social appointments in the cafés of their closest friends, because there is a kind of face in knowing the owner; likewise, being host to other people's hosting is itself face-giving.

However, although many kinds of *guanxi* are transacted in and through studios and cafés, they are much less formal than dinners or karaoke singing.

Neither a banquet in a restaurant or a dinner at home is open; both require explicit invitations, whether as simple as a phone call or text message or as elaborate as a printed card. But people go uninvited to a friend's café or studio, and bring along who ever they happen to have with them. The owner or proprietor of the studio or café is there in his place nearly every afternoon; if you happen to pass by you can knock on the door or poke your head in. For people in the urban middle classes, only a very intimate relationship would allow the same kind of approach to another person's residence or place of work.

This openness allows the café in particular to serve as a locus for a rapidly expanding circle of acquaintances, a circle that is not defined by hierarchies of social role or position. Interactions in the café are notably informal. No one stands around the table arguing over who should sit where, as they might do in a restaurant. People don't engage in shows of polite respect, don't smile solicitously or stand on ceremony. They drink casually; they don't follow the formal practices of *quanjiu* (urging others to drink) or *jingjiu* (toasting or dedicating cups to other people), nor do they engage in the drinking games that encourage competitive inebriation (in all these practices, you never take a sip from your own cup out of turn). Also, far from fighting over the check, people who are familiar with the owner only sometimes pay for what they drink.

This air of informality is reinforced by the absence of strict gender roles in the studio and café. In contemporary Chinese bourgeois households, domestic hosting and restaurant dinners attended by couples are often characterized by formal gender roles; men and women sit together during dinner, but afterward the men remain sitting at the dinner table to talk, smoke, and drink alcohol, while the women go to sit and chat about their work and or their children in another area, usually on the couch, and drink water or juice.[23] Gender roles are even stricter in the business hosting (*yingchou*) that goes on in hotels, clubs, and KTVs (karaoke clubs). Often the only women who participate in such events are the professional hostesses and sex workers who provide companionship to facilitate masculine sociality.[24] Even banqueting in mixed-gender restaurants reflects this division of the domestic woman and the entertaining woman: before going out to dinner with their friends, many middle-aged male artists and designers will rack their cell phones to find "girls" to invite, but they never invite their own wives. They regard the young women (usually students) that they invite to dinner as playing a more chaste version of the social entertainment role played by hostesses in clubs.

In cafés and studios, on the other hand, while the spaces usually belong to men, there are always lots of women, and they are not positioned as en-

tertainers. They are classmates and friends, members of the same aesthetic and professional communities. The owner's wife or girlfriend may even go there frequently. In the café and studio, men and women sit, drink, and talk together. This relative gender equity is part of the reason that such spaces are increasingly popular as spaces for couples and women to socialize together. The café is now understood as an ideal space for socializing between couples and female friends, at least among urban elites. In television shows and movies depicting contemporary urban professionals, scenes of dyadic conversations between couples and female friends are very often filmed in cafés. (In this case, one kind of male homosociality actually facilitates another kind of female homosociality.) The café and the studio serve as key sites for three related projects: the emergence of communities of aesthetics and practice, critiques of and complaints about contemporary Chinese society, and imaginations of alternative forms of sociality.

Habermas argued that informal conversations in the salon were key to the formation of a "public sphere" in prerevolutionary France, and thus to a kind of liberating political community. And indeed, like the salons of prerevolutionary France, the studios and cafés of postsocialist Beijing are defined by a kind of informality that is manifestly contrasted to the deference and demeanor that emphasize roles and status in *guanxi* banqueting (or in the French case, "court society").[25] The informality of the café is also, at least in some moments, linked to its "global" character. Insofar as cafés are recognized as "Western-style" places, markedly traditional forms of politeness (*li*) might seem inappropriate in them. And there are times when imaginations of European-style enlightenment directly related to Habermasian theories of the salon are self-consciously referenced in the conversation in the café. In what follows, I describe two events in which conversations about art with Chinese visual culture workers shift rapidly to discussions of idealized forms of European sociality, which are posited as alternatives to those of postsocialist China. The first is a critique of marketization; the second is a critique of the political order.

One night in 2007, Nana (a young fashion designer turned painter and party organizer) and I went to Zheli (Here). It was the second of the café's three incarnations. The first place, called Nali (There), was near the old artists' neighborhood near Yuanmingyuan. Nali was torn down (along with what was left of the rest of the neighborhood) around 2005, for a development project. Zheli opened in 2006 on *Nanluoguxiang*, an alley in the central city that was just about to become trendy. The crowd from the "old place" or "original place" returned, often to reminisce about the past. But before long this place was surrounded by other coffee shops and bars;

the rent went up, too high for a place where only strangers ever paid bills, and in early 2008, the owner Lao Chen was forced to move to a small space in a side alley, which he remodeled with a courtyard, giant ceramic fish bowls, grape vines, and a rooftop patio. His wife opened a youth hostel across the alley. The youth hostel failed quickly, but Lao Chen held on to the café held until 2010, when he and his children moved into his former photography studio, collapsing the three spaces he had once maintained into one.

However, that night in 2007, Lao Chen, a photographer and painter, was there in his second coffee shop with his constant companion Li Yue, a film-maker who owned two coffee shops of his own. They were sitting with two men who were dressed a little more formally than most of the young designers who hung around that place, in button-down shirts and leather shoes, but with long, shaggy haircuts, which made it clear that they were some kind of creative workers. They had design magazines out on the table; it turned out they were graphic designers, associates of Li Yue's. When we got there, Li Yue was telling the younger of the two about the art impresario Ai Weiwei. That this designer had never heard of him made it doubly clear that he belonged to an aesthetic community separate from that of most of the designers who hung out at Zheli, all of whom were at least nominally familiar with contemporary art. Listening to Li Yue talk about Ai Weiwei's performance art, the guy with glasses said, "oh, I guess he's not very commercial (*shangyehua*)," and Li Yue disagreed, saying that actually Ai Weiwei really *is* commercial: "he is doing it for the money too" (*ta ye shi weile qian*).[26] Then Li Yue started telling the graphic designers about the older generation of expatriate artists who left during the 1980s and around 2007 began returning to China. He shifted from Ai Weiwei to Xu Bing, and Lao Chen spoke up to emphasize how much he liked Xu Bing's work. Li Yue, Lao Chen, and Nana talked about Xu Bing for a while, and then turn to a discussion of prices (indexing their shared familiarity with that world). At that point, the older designer, who had been sitting without saying anything the whole time, said, "The problem with China is that there's just one standard of value: money. Money is everything; people are judged according to how much they make and how much they spend. It's not like a Western value perspective (*jiazhiguan*) that values (*zhongshi*) every person's individuality."

A few nights later, in the early evening, I went to Zheli again. Lao Chen was alone there sketching plans for his next photography project. An acquaintance of Lao Chen's came in and greeted him. The man started asking questions about Lao Chen's project, and at first I thought he was a buyer

interested in Lao Chen's work, but then he pulled out his USB stick to show his own photographs. He was the editor in chief of a Shanghai paper. We looked at his photographs, including some of working-class people sleeping on grass mats laid out on a closed-off section of freeway in Shanghai. While we were looking at the pictures two more people showed up: a girl called "Winnie" who worked in an office, and a very thin fashion designer called Tiantian. Looking at the pictures, Winnie asked, "Why are they sleeping on the street?" The photographer said, "Because it's too hot inside," and the rest of us laughed, because we had assumed they were homeless or refugees from a disaster. He then turned to ask me where I was from, what I was doing there. I told him about my project and he asked me, "Are there any traces of socialism left here? What do you think of what the government says?" I then asked him what he thought of the West. He and Tiantian began to talk together, telling me that they both had been to Europe and really liked it. Neither had been to America, but they were sure they wouldn't like it as much. Tiantian said, "Europe is full of culture and history" (unlike the United States). She said she liked the orderliness of Europe, the respect that people have for each other, and their kindness to strangers. The photographer then spoke at length about the beauty of life in the youth hostels, where he stayed when he was traveling: all kinds of people living together, young and old, male and female.

In these two events, the conversation began with talk about art (in the first, about Ai Weiwei and Xu Bing; in the second, about photographs). In this art talk, various forms of aesthetic community were indexed, through both distinction (contrastive identity or alterity) and association (sharing points of reference, offering objects for mutual identification). Both conversations then featured a rather sudden shift from art talk to the problem of sociality.

In the first conversation, it was the theme of financial interests attributed to Ai Weiwei and other artists that provokes a critique of postsocialist Chinese society. The older man claimed that money has actually become the basic standard of value in China, that people only care about money and judge each other in terms of it (constructing hierarchies); he alleged that in this respect China differs from the West, in which each person is respected for her individuality (constructing a society of equals). This statement reframed the art talk that preceded it, in which Li Yue ascribed pecuniary interests to specific individuals, by attributing such interests to all Chinese people, including presumably those present. Even the café itself was potentially implicated in the monetary value system under critique. On the other hand, the Westernness of the café as a type of social venue positioned the speaker and his audience as potential sympathizers of those "Western" values.

In the second conversation, my presence served as the transition point between these two themes. The photographer shifted from talking about his own art to asking about me; he asked me about Chinese politics, and I asked him about the West. But the enthusiastic conversation on Europe that followed, with others joining in, again shifted to the problem of sociality. First, Tiantian commented on Europeans' "orderliness," their respect for each other, and their kindness to strangers. In choosing these three themes, she implicitly referenced three of the most common themes in the immorality tales about contemporary China that feature on the news and in everyday conversations. Most such tales focus on instances of "disorder" (disregard for laws and regulations), lack of respect (toward family members, older people, or poor people), and lack of regard for strangers (unwillingness to help when others are in trouble; willingness to sell fake, dangerous, or even poisonous items to make money). By indexing the discourse on the lack of sociality in postreform, marketized China in this context, Tiantian played on a conventional trope of contrast between China and Europe, the same trope deployed by the older man in the first conversation.

In this context, the photographer's comments on youth hostels (as places where people of all ages and genders live together and life is beautiful) are interesting. He followed on Tiantian's remarks as if making an extension of them, but actually framed a model of community that is completely orthogonal to the discourse of essentialized cultural contrast she had deployed, with its emphasis on values, norms, social roles, and ethical principles. The mode of sociality he described is obviously as much a departure from everyday norms of privacy and demeanor for the Europeans he shared it with as it was for him. It is not a way of life, so much as a *situation* or interactional context in which a kind of publicness has temporarily lifted certain social restrictions and anxieties. It is a private life in public, a kind of "public sphere."

The "beautiful life" of the hostel is in that regard much like the scene depicted in his photograph of the people sleeping on the street in Shanghai: old and young, men and women, all leave their private bedrooms to sleep on the street (if only because they are too hot). This image of a sociality that transcends distinctions of age and gender is potentially reminiscent of the lives of early communist revolutionaries during the Long March (at least as depicted in the television dramas that continue to dominate the airwaves, more than sixty years later) in which women and men, old and young, lived together in rough conditions in the mountains, or of people in Maoist-era work communes and work units, where everyone ate together in public. It is reminiscent of the bohemian lives of the artists and musicians

in the old days at Yuanmingyuan. And it is also potentially iconic of the café, where social distinctions of age and gender are self-consciously downplayed to create a convivial scene of community. That may be why, that night, his comments were so warmly received by all involved.

The café or studio is informal because it is in one sense private—*more private* than the domestic household, where there are spouses, children, parents, and in-laws with a range of demands and expectations. The same is true to some degree of the café, especially when it is empty of customers. On the other hand, such places are informal because they are public: open to friends, associates, and even strangers.

It is a predictable irony that the expansion of space and spatial divisions made possible by increasing wealth gives rise to romantic nostalgia about communal living. One frequent object of this nostalgia is the one-story brick house (*pingfang*), the kind of building in the old arts neighborhoods like those around Yuanmingyuan. These buildings were divided into small rooms, which served as bedrooms, kitchens, bathrooms, painting studios, living rooms, and entertainment venues (*julebu*) all in one. In an exhibition of photographs from that era held at a gallery in the Liquor Factory gallery district in 2006, the photographs that most impressed my middle-aged companion were those of a tiny room with little book-sized paintings and beer bottles piled next to the bed, a small courtyard with a little stove outside the door, and somebody sitting on a stool playing guitar next to the stove. In viewing this picture he spoke nostalgically about how in "those days" people went in and out of each other's rooms, "eating and drinking together." Many of the artists and designers I interviewed who waxed nostalgic about life in art school during the 1980s emphasized the same point, repeatedly noting that teachers and students used to eat and drink together (*yiqi chifan yiqi hejiu*), implying that this form of eating and drinking was different from what they now do in restaurants and bars nearly every night of the week.

Thus the studio and the café serve not only as face-giving sites for guanxi-related hosting, and private dens for homosocial play, but also as venues through which to recuperate the publicness or *lack* of privacy that they remember (or nostalgically fantasize). In old-style cinderblock houses, people dropped in on each other, to borrow things, offer food, or just to talk; they did things in public that are considered private in apartment buildings, such as brushing their teeth or washing their faces and hair in the courtyard at the communal spigot. If they ever experienced such a "beautiful life" in the past, whether as college students, bohemians, or just by living in undeveloped neighborhoods, they lost it when they became petit-bourgeois: got

married, had children, bought cars, and moved to apartments in high-rise buildings where almost no one ever speaks to their neighbors.[27] Insofar as the "drinking together" that goes on in the studio and the café is aligned with that of the old-style neighborhoods—and this association is implicit in the very architecture of the cafés and studios, which are always in one-story buildings in "older" neighborhoods, even if the buildings are brand-new—they are positioned as venues for an alternative form of sociality, specifically contrasted with the pecuniary work of producing *guanxi* or getting and giving face that goes on in restaurants and KTVs. Consequently, even as cafés and studios participate in the complex division of private space that is one of the major projects of bourgeois life, they are also figured against that project.

Of course, the ideas of "Western values" and "European sociality" articulated above are fictions (albeit potent ones), and they are more or less recognized as such. This is because they are always potentially in tension with the histories of Western imperialism and Chinese humiliations taught in school, and because such histories are all too often called up by the actual behaviors of actual Westerners in Beijing. One night not long after the two described above, there was an informal art show at Zheli. A French man showed up with some European friends of friends, and proceeded to get drunker than he already was. He began practicing his rudimentary vocabulary of Chinese on Lao Gu, a somewhat butch designer, who sat there seething, until he veered off into ethnic slurs; then she stood up to hit him. People rushed over to break off the fight; the Europeans gathered up their friend and took him out.

This designer, Lao Gu, herself kept a little studio attached to her apartment. She served no coffee, only Chinese tea, beer, and liquor. The studio was bohemian, in a little cinderblock building that had not been remodeled. The furniture was cheap and old, the table and stools were low to the ground like those used by farmers and working-class people. In her studio, where people often gathered to drink tea and chat, she frequently spoke of her own trips to Europe and of the many European artists with whose work she was familiar. But in making her critiques of commercialism, she would draw on China's history as a source for models of sociality that she explicitly contrasted to those of contemporary China. She would occasionally draw on socialist-era themes (for example, jokingly calling a businessman friend a "stinky capitalist"), but most often she talked about traditional Chinese writers and painters; she made explicit links between their values and modes of practice and her own life in her studio, with her notebooks, tea, and paintings.

Lao Gu was not unique in calling on these tropes. The idea of the traditional *wenren* (literati) and the tea-based mode of sociality appropriate to this characterological role have a great deal of cachet with Chinese intellectuals and culture workers. The widespread popularity of this multifaceted aesthetic, various aspects of which appeal to both marginal bohemians like Lao Gu and to bourgeois party members like the professors I interviewed in Shandong, sustains the practice communities of those involved in the traditional arts of calligraphy, ink painting, and Chinese classical music.

Despite the mainstream appeal of this aesthetic, like Lao Gu and many other visual culture workers in Beijing, those involved in the traditional arts often imagine themselves as being alienated from contemporary Chinese society. One group of advanced graduate students in Chinese painting (*guohua*) at the Shandong Academy of Art and Design shared a plain studio in an old building on the school's old city campus until it was torn down and often made reference to socialist ethics in positioning themselves, calling one another "comrade" (*tongzhi*); the women wore plain, unisex clothing, and the men painted landscapes in a genre of socialist *guohua* that first developed during the sixties. Another, younger group shared a large, bright studio in the main building of the new university campus, located far outside the city of Jinan, where they gathered to drink tea, chat about one another's paintings, and compare their small collections of ancient beads and jade items. Like the café patrons described above, they frequently engaged in conversations about the decline of ethics in contemporary society, attributing pecuniary interests to everyone else, with various individuals at various moments making reference to Confucianism, Daoism, Buddhism, and Christianity as possible alternative sources of value.

In 2008, this vision of a traditional alternative society was put into practice by one well-established contemporary *guohua* painter in Beijing (who has been very successful with his paintings of Rubenesque nudes in ink on paper, sold through a gallery in 798 that also sells other genres of contemporary art). He was a graduate of CAFA who often hung out at Li Yue and Lao Chen's coffee shops. He had practiced kung fu for years, and in 2008 he decided to create a *wuguan*, or martial arts studio. He rented a large space in a studio district, and remodeled it. It had heavy wooden doors; a giant practice studio, with a little artificial stream passing through it; an indoor koi pond, with a huge *guqin* or classical Chinese harp on an island at one end; burlwood tables for drinking tea; courtyards lined in bamboo; and a room with a long wooden table for eating and drinking.[28] He had two live-in apprentices (*tudi*), adolescent boys from the countryside who shaved their heads, wore black kung fu practice pants and cloth shoes, and in addition

to studying kung fu also made dinner and served beer to the friends who came to practice with him or just to watch and drink in the evenings. Many of his friends decided to study kung fu with him, and began calling him *shifu* or "master" with various degrees of seriousness. His solution to the problem of sociality was to create a new kind of "practice community," oriented to a completely different kind of practice, one entirely disconnected from the markets through which he and his friends made their livings.

UNSOCIABLE SOCIALISM WITH CHINESE CHARACTERISTICS

Formations of aesthetic and practice community in China are shaped by a series of postsocialist antinomies of the social. First, there are the usual problems attending cultural production in capitalism. There is the problem of difference and sameness: of articulating membership in an aesthetic community in a community of practice defined by an ideology of creativity. Professional norms of self-presentation and narration that emphasize creativity often make artists and designers reluctant to assert their own membership in an aesthetic community (though others are often willing to point out such associations). And there are the correlated problems of selling out and buying in. In the visual culture industries, professional norms of ambition for fame, wealth, and recognition contrast with an ideology of creative disinterest; the accessibility offered by the market contrasts with the idea of the privileged moment of authentic recognition. Reproduction erodes the aura of authenticity, but it also makes possible the spatiotemporal expansion necessary for both individual fame and the growth of community.[29] Selling out and buying in may be stigmatized, but they are also the basic processes through which aesthetic communities form and grow in a capitalist society.

Concerns about commodification and its threat to authenticity are widespread within the more bohemian and avant-garde corners of the culture industries, in China as in other countries. But in China there is also a broader concern about *sociality* that is in some respects unique to postsocialism. The discourse of the loss of society (*shehui*) suggests that the newly aestheticized self has displaced the socialist community (*qunti, shequ*). There is a sense that the greed of the market and the narcissism of self-styling have displaced the moral communion and altruism that socialism was supposed to produce.

Society was, at least in the theory, the central project of socialism, in China and other places. But since the early 1990s, many of the structures that once organized society (including the urban work units and village communes that used to manage every aspect of personal life from housing and food to marriage registration and family planning) have been dismantled or

have declined in scope, scale, and influence.[30] The liberalizations of *gaigekaifang* from the privatization of industry to the loss of the social safety net to the efflorescence of consumerism, it is often said, have given rise to a widespread individualism (*genrenzhuyi*), and a loss of public morals.[31]

The alleged decline in social conscience is narrated through immorality tales about fake food, toxic pollution, official corruption, adultery, matricide, passive bystanders to crime, and so on, which have recently become prominent genres of private conversation, television news, and journalistic social commentary. Immorality tales—in which selfish desires for money or pleasure or safety override moral concerns for family, community, the society, or the nation—have given renewed relevance to the project of building community through socialist organizations and campaigns, using a particular aesthetics of society.

The ethics of social conscience and the ideal of society was promoted in the years running up to 2008 by campaigns including Hu Jintao's "Harmonious Society," which focused on building social cohesion through progressive education, health care, and social welfare programs as well as infrastructure investments. Party-affiliated student government organizations starting in elementary school with the Young Pioneers (*shaoxiandui*), with their red scarves and stripes marking various levels of responsibility and achievement, still serve to regulate behavior and success, all the way to college. In multibuilding housing developments where most people have never met their neighbors, there are still neighborhood party committees that hang red slogan banners, install slogan plaques, and organize annual residence registrations and charity donations for national emergencies. Most of the slogans posted in such housing developments make reference to community (*shequ*, the society of the neighborhood) or civil society (*shimin*, urban citizens).[32]

At the end of the Hu Jintao era, there were even new propaganda campaigns about Lei Feng (1940–62), the Maoist model citizen-soldier, who in his relentless self-criticism and devotion to the revolution denied himself even a crust of rice. Lei Feng's face appeared in 2006 in a billboard over the technology district, and in 2011 in a chic office building in the Beijing city center, where signs in the elevator depicted Lei Feng's head floating in the clouds, smiling beneficently over a city of high rises, with text advising elevator passengers to "Study Lei Feng and build a Harmonious Society." In a song and dance number on the annual New Year's television extravaganza in 2008, a child performer (around six or seven years old) walked out on stage and looked up incredulously at a huge screen depicting a teen idol. She pushed it aside, only to reveal another star, and then another. She kept pushing the celebrities

aside until at last Lei Feng appeared; then a crowd of young children marched onto the stage with their red Young Pioneer scarves, singing the Lei Feng song.

This performance dramatized anxiety about the loss of socialist ethics by showing a young girl, born into the age of consumerism, rejecting the culture industries and their cults of personality in favor of the Communist Party and its "models." Lei Feng's altruism and asceticism, while plausible in the sixties, seem impossibly strict and even laughable to many people now. But by depicting "post-2000" (*2000 hou*) children singing the same songs and following the same models that all viewers under fifty sang when they themselves were children, this piece attempted to construct a vision of ethical continuity between the socialist past and the marketized present. It did so by directly contrasting the aesthetics of society with the aesthetics of self-styling.

The aesthetics of society represented in and through official campaigns is thoroughly mainstream; it is a recognizably authoritative discourse, which strikes most visual culture workers as cloying. And yet the *problem* of society is reflected in many less authoritative discourses, including academic discourses on civil society, and nostalgias for socialism that are often motivated at least in part by implicit critiques of the current political-economic system.[33] As a result there are also many nongovernmental versions of the aesthetics of society (for instance, the popularity of socialist-era material culture with stylish young people in Beijing, discussed below).

In this context, aesthetic communities frequently appear as possible locations for the recuperation of an alternative aesthetics of community. Culture workers talk about the ideal of creating a small, bohemian community of creative people; this fantasy and the many genuine efforts made toward realizing it are mobilized by an urge to re-create the social in a thoroughly marketized society.

Critiques of postsocialist Chinese society often focus on avarice, attributing pecuniary "interests" to others; but many of these criticisms are also framed by larger discourses about the breakdown of society and social relationships, as well as dissatisfactions with the privacy of bourgeois life, the alienating quiet of the apartment building. These critiques are almost always articulated through explicit and implicit contrasts with imagined alternative forms of sociality. I have described a few of these models of sociality here, including contemporary European youth hostels and Ming-dynasty Chinese *wuguan*, but there are many more; there are also musicians who "like" Jamaican Rastafarian culture and ethnic Han painters who identify with Tibetan and Mongolian herders. Like American Hare Krishnas, they seek an identity in something distant from the here and now (what

Agamben calls the tendency to "establish a peculiar relationship with other times").[34]

In the cases described above, such models of sociality are also frequently indexically linked to aesthetic communities that transcend distances of space and time. By positioning themselves in relation to European viewers of contemporary art, the people at Zheli and the artists and curator at Platform China posit an aesthetic community that transcends geography and language; those who position themselves in relation to traditional *wenren* or kung fu masters posit an aesthetic community that transcends time and history.[35] Far from "beginning to dream of a total destruction of society in the interest of unlimited freedom of personality"[36]—that is, pursuing anarchism as a natural extension of the bourgeois individualism that time in art school and work in the culture industries have encouraged—Chinese artists and intellectuals seem often to be working at reproducing the *shequ* and other socialist models of community through the mechanisms of the market: small service businesses. In the next section, I describe formations of community around and through commodities and publications: an army surplus shirt, a magazine called *Milk*, and some idle plans for a public/private art library.

MEDIATING COMMUNITY

In 2007 and 2008, there were a series of fads for socialist retro and folk styles among anti-mainstream (*feizhuliu*) college students, art musicians, and rock musicians in Beijing. These fads recuperated familiar objects and remade them into emblems of a certain kind of aesthetic community; aesthetic community was projected through them. The most emblematic objects were the blue- and white-striped navy surplus T-shirts and cheap white or blue-and-white sneakers of the kind widely worn in the 1980s. These shoes and shirts were secondhand or vintage, nor were they produced specifically for the "retro" market. Rather, they were still being made and used as cheap utilitarian clothing in 2008, and so they could be procured very cheaply; it was just that suddenly they became popular with stylish young elites, including designers, artists, rock musicians, and their fans.

For some of the young people who took up these shirts and shoes, they appeared as icons of an aesthetic community with an ethics opposed to consumerism and its vapid individualism, and in that respect, to self-styling. Like blue jeans for the beat generation in the United States, the blue-and-white shirt and shoes signified, for these young Chinese people, both working-class *pusu* (plainness, simplicity) and also the past (the 1970s and

1980s, which they dimly remembered, if at all). Despite their continued availability, they were definitely markedly past, out of style, and low-class, and people with more mainstream aesthetic tendencies would definitely notice that these shoes and shirts marked a kind of difference; most working-class young people wouldn't be caught dead wearing them (and there were many inexpensive items worn by working-class people that these white shoe wearers would not ever buy).

Part of the appeal of these items was that they were once nearly ubiquitous: *everyone* wore them. Every family album has pictures of people wearing either that kind of blue- and white-striped shirt or that sort of white cloth sneakers, and contemporary images of that period, whether in contemporary art or on television, regularly include them. Even as these items serve to mark the distinctive aesthetic of the anti-mainstream and the independent, they also index a history of all-encompassing socialist community; and this dialectic of difference and unity was explicitly referenced in discourse surrounding these objects. One day in 2007, just when the fad was taking off, Lao Chen gave blue- and white-striped T-shirts to all his friends and his wife, calling it a "team uniform" (*duifu*), the uniform of the "little socialist big family," a twist on the old Maoist phrase "the big family of socialism" (*shehuizhuyi dajiating*).

The folk-rock singer Wan Xiaoli, who in that same year became very popular with college students, also wore a blue-and-white T-shirt and white shoes. These clothes fit well with his songs, such as "I got laid off" (*Xiagang le*), which describes living in fear of the boss "like a mouse who's seen a cat" and finally being fired. The chorus to that song goes: "in this civilized society (*wenming shehui*), in this civilized society, you must have money." The lyrics describe a situation to which many young people working in small private businesses, including design firms, could well relate. But by using the word *xiagang*, which means to be "off post," instead of the more standard *cizhi*, *shiye*, referring to being fired in a private industry, the song also references the historic group of "laid-off workers" forced into early retirement in the 1990s as part of the transition from state to private industry (not his fans, but his fans' parents), suggesting a critique of capitalism from the perspective of those who never really joined it.

However, neither Wan Xiaoli nor the socialist retro style was immune to the forces of commodification. One night at a concert at the Star Live Club (a large music venue just north of the second ring road), Wan Xiaoli performed. Almost all of the several hundred young people inside were wearing blue-and-white shirts; there were actually people selling the shirts near the door, along with tapes of his music. (After that concert, the people

at Zheli stopped wearing their blue-and-white shirts; it seems they didn't enjoy being part of such a large socialist team.) The Wan Xiaoli concert was only one of the profitable opportunities for commodification offered by the reincarnation of these cheap and readily available items as objects of desire among elite youth. For the young shop owners who (mostly) belong to the same aesthetic community as their clients, it was easy to buy these shoes and shirts in the inexpensive markets catering to working-class people and resell them at triple the price in shops in stylish districts, including the 798 gallery district and the Drum Tower area in the center of the city. By 2010, when I returned to the city after some months away, the fad had become an established style, like long hair on middle-aged male painters—not mainstream, but definitely widely recognized. The discourse around it had also shifted from history to nation; the taxi magazine (which is in the back of every taxi in Beijing) featured a special on "Chinese style," with pictures of shops in the Drum Tower district selling those blue-and-white shirts, the white sneakers, and the old-style enamel cups and thermoses of socialism.

As William Mazzarella has shown, commodification is not just putting things up for sale; the transformation of objects into "commodity images" is a central part of the process.[37] This is true not only in advertisement but also in journalism (insofar as the two can be separated, given the latter's economic reliance on the former). And as Benedict Anderson has shown, print journalism has long been one of the primary technologies for the formation of large-scale community (that is, the nation) at a distance. To conclude this chapter I bring these two arguments together, showing how print journalism serves to facilitate the formation of aesthetic publics, in part by projecting the "commodity image" beyond the field of the commodity's physical availability.

In 2008 I spent some time at a small, public, art-focused technical high school (*zhongzhuan*) in Zibo, Shandong. The city of Zibo is famous for its ceramics industry, and many of the students in the school took ceramics classes to prepare for work; some had already begun to work in their teachers' studios, decorating teapots and vases, and painting inside of bottles. Many contemporary artists from Beijing came to Zibo to arrange to have their work made by its artisans. However, there were several dozen students in the school who were still practicing their *sumiao* in order to take the test for entrance to an art academy. There were also some who were interested in bypassing university education to join the visual culture industries as designers and artists. For these students, the bookshop down the road was a key venue for their efforts at integrating themselves into an aesthetic community beyond that of their teachers, most of whom painted conservative

guohua flower and bird paintings or decorated ceramic dishes in mainstream styles.

The bookshop was especially important because the school had few resources to offer these students. The graphic design class I sat in on went frequently to the library (located in a single classroom) to consult the magazine collection; but all the magazines—mostly professional publications— were five if not ten years old, as were the pictures of prints in the magazines used by the teacher in class. The collection of books was haphazard and small. Through the local bookshop, however, students with a little spending money could buy contemporary publications. In this (pre-smartphone) media environment, magazines were important not so much as modes of information transmission but rather as modes of aesthetic categorization: they curate the proliferation of form. For provincial students, print publications were not just catalogs of styles to study (*xue*) or model (*mofang*), but also maps of aesthetic community, identifying the centers (galleries, firms, and clubs in Beijing) toward which they should orient themselves and to which they planned to travel.

In this class, there was a girl who dressed in a punk style, and dreamed of going to Beijing; she knew the names of all the most popular Beijing music venues, bands, and art galleries. She had read about them through magazines such as *Milk*, which combined references to art, design, music, fashion, and film. She was a favorite of the teacher who brought me to the school, a painter who was also attempting to build connections to Beijing by renting a studio there. There was an earnest young Christian calligrapher from a peasant family, who paid for his own schooling by teaching children calligraphy, which he had taught himself by copying a series of traditional calligraphy books (likewise purchased at the bookstore). There was a young man who planned to open a design firm as soon as he graduated, who read about new trends in product design in magazines he bought at the local bookstore.

All three of these students were regular Internet users; the Internet café near the bookstore was another center for their lives. But these provincial teenagers used print publications as maps through which to orient themselves to aesthetic communities, and through which to orient their Internet searches. Like the gallery curator, the magazine editor condenses, clarifies, selects, and juxtaposes, figuring community and identifying its centers, its actors, its norms and styles. In manifesting the commodity image, the magazine facilitates the imagination of community, and so facilitates its growth. The process of commodification is a condition of possibility for aesthetic communities, and at least in the last years of postsocialism, print publications had a key role to play in that process.

In this context, Li Yue's fantasy of a small, public, but privately funded art library on Nanluoguxiang becomes comprehensible. In early 2008, when money was still flowing easily in art circles, Li Yue approached me with a plan, to apply for grants to create a little art library. His vision was a small, four-room building with rooftop and courtyard spaces for socializing, a quiet room for reading, a room for events such as poetry readings, music performances, and lectures, and an underground space for exhibitions. He hope that the library would serve as a meeting ground for multiple communities: the children and older people in the neighborhood (*shequ*), the artists and students who frequented the cafés, and the high school students from across the highway. The space Li Yue imagined and drew on napkins at multiple meetings resembled a café without anything for sale, and without any boss. The library was to be a place where aesthetic community would transcend the economics of self-styling and *guanxixue* and become a platform for the kinds of community building that were so central to the project of socialism—only this time the platform would be entirely independent of the state, and devoid of any specifically political ideology (neither complicit nor resistant). Unfortunately, the art market crashed, debts were called up, and paintings did not sell. Before the library project had even begun, Li Yue had to give up his cafés, sell his car, and *xiahai*, jump into the sea: he left Beijing and its artistic communities for Guangzhou, to try his hand at "business" (*shengyi*).

CONCLUSION
Masters of Culture?

> The function of the intelligentsia has always been con-
> fined, in the main, to embellishing the bored existence of
> the bourgeoisie, to consoling the rich in the trivial trou-
> bles of their life. The intelligentsia was the nurse of the
> capitalist class. . . . The comforters from among the intelli-
> gentsia, confined within this "vicious circle," are gradually
> losing their skill in offering comfort, and are in need of
> comfort themselves.
>
> —GORKY (1932)

The flat-screen TVs on Beijing's buses and subway cars are sometimes silent
and sometimes deafeningly loud, but they are always on. They play com-
mercials and propaganda in variable proportion, interspersed with CCTV
news programs.[1] Most subway riders ignore the videos just as they look over
and through the giant posters that line the train platforms, or the party slo-
gan banners that garland the streets. But commuters who have neglected to
bring their own entertainment systems stare up at the televisions to watch
both the programming and some of the propaganda, especially when it is
adjusted for a big story.

There were many big stories in the months running up to the 2008 Olym-
pics—a series of disasters, repeatedly interrupting the CCTV narrative
of Olympics preparation. First came the snowstorms; then the train wreck;
the "rioting" in Tibet; an outbreak of disease among young children in
Beijing; and then the earthquake in Wenzhou, Sichuan. For a week after
the earthquake, the TVs played only news of the disaster, before slowly re-
turning to their regular regimen of Olympics-preparation programming in-
terspersed with inspiring stories of earthquake relief.[2]

It was at the beginning of June, little more than two weeks after the earthquake, when the subway televisions' images of collapsed buildings had all but been replaced by footage of rebuilding efforts and of movie stars hosting charity donation events, that "Reunion" appeared. It was a short propaganda film with an unusually complex narrative structure and sophisticated cinematography, and it stood out starkly among the Olympics- and earthquake-related montages. It played for only a few weeks (in contrast to many Olympics montages, which played for months), and it was never in heavy rotation, but cycled frequently enough that I saw it three times during that period, twice on the bus and once on the subway.

"Reunion" begins with a slight, elderly woman in a flowered blouse, plain pants, and cloth shoes, practicing *taichi* in a park. She looks the way nice old ladies in China always (should) look: like the soul of *pusu*, simplicity. Across the busy street and through all the traffic, the camera closes in on the face of a female bus driver. Though she sits in the driver's seat, it takes the viewer a moment to recognize that she is a bus driver, because the actress is clearly not working-class (too pale, too skinny, too made-up). The putative bus driver looks first with budding recognition and then with fondness at the old woman; the light changes and she drives off. In the next scene, she is home in her putative small apartment, where her son is doing his homework. She pulls out an old photograph, ripped diagonally in two (seen only from the back) and smiles.

The next few scenes show messages arriving around Beijing. One letter passes hand-over-hand among the workmen building the Bird's Nest stadium for the Olympics, before arriving at the field desk of an architect. Another letter comes to an actress on break from a shoot. A letter is handed to a Beijing opera performer who is wiping off his heavy stage makeup. A cell phone rings for a photographer who is standing on the Great Wall taking pictures of white models vamping in miniskirts—his assistant takes the call. A letter is delivered to a curator wearing stylish black glasses and overseeing the installation of an art show in a contemporary art gallery. An email appears in the inbox of an author (played by a popular actor) sitting cross-legged at a low wooden table in a beautiful Zen garden, writing on his laptop. The last letter is brought by a friendly middle-aged neighbor lady to a Houhai Park rickshaw driver, resting in the shade between stints of driving tourists around one of Beijing's famous scenic lake parks. The rickshaw driver is also played by a famous actor, incongruously pudgy for this role (rickshaw driving is hard labor); he looks at the letter, tosses it away and goes back to sleep.

In the last scene, a door in an old Beijing alleyway (*hutong*) opens, to reveal the crowd of letter recipients standing holding flowers and gifts. The camera turns to show the elderly tai chi practitioner. "Do you remember us?" they shout. The gathered forty-somethings call out their names, one by one, and the recognition of her former students slowly dawns on the old woman's face. At that moment the rickshaw driver races up on his rickshaw, and the bus driver, holding together the two halves of the torn picture—as we might have guessed, an old, black-and-white elementary school class photo—points to a little round-faced boy. Cut to credits.[3]

In June 2008, as "Reunion" was aired, Beijing was stirring with stories (widely reported in the foreign media and also discussed, though with different emphasis, in local media) about how the Sichuan earthquake seemed to discriminate between rich and poor and, in particular, between rich and poor schools. Rural schools—attended by the children of the poor—collapsed in large numbers. Magnet schools, as well as civic buildings and the homes of the rich, survived the earthquake mostly intact. "Reunion" was planned and filmed long before the earthquake; it depicts a half-finished Bird's Nest, which had already been completed before the earthquake struck. But "Reunion" was broadcast into a context in which long-standing questions about disparities in education and power were percolating with particular emotional resonance into the public discourses of the news and propaganda, and into the discourse of rumor that backchannels at the media. In June 2008, the class photo at the heart of the "Reunion" could not help but bring to mind the photos of schoolchildren being dragged out of rubble. One month later, when these images had all but disappeared from the television and the newspaper, "Reunion" might have had a different resonance. But by then it was gone from the bus televisions, left only on the Internet.

"Reunion" offers an overt message of class unity, while expressing the class anxiety and alienation of cultural producers in an emerging service economy, especially those born in the 1960s and 1970s, who came to consciousness in the early years of the 1980s. Though schooled in the class categories of Maoist-Marxism, these artists, designers, writers, and others grew up alongside a post-Marxist, liberal class system framed in terms of educational opportunity and achievement. In its saccharine way, this bit of propaganda points to serious questions about culture and class in Beijing, and offers a neat way of approaching the links among class, education, and alienation.[4]

In the vulgar Marxist understanding of capitalism, there are two historically primary, manifestly unequal classes: the bourgeoisie and the proletariat, the exploiters and the exploited. In the Maoist and Stalinist understand-

ing of (the future, coming into being) communism, the mass of the people would be composed of a number of "equal" classes: workers, farmers, soldiers, experts. The depiction of social unity through a plurality of representative class types (farmer, factory worker, soldier, teacher, party cadre) was a staple of twentieth-century socialist visual culture. There is a stop on the Moscow subway in which each column is composed of male and female members of these class types, standing one across from the other, and all together holding up the subway "sky"; similarly, there is a series of sculptures installed at Tiananmen of workers, farmers, and soldiers, standing together on an equal plane. The class spectrum idealized in Maoist socialist realism was not the class hierarchy used to categorize individuals according to their pre-Liberation class identities (landlord, rich peasant, poor peasant). Instead, it was a set of "separate but equal" social roles, a plurality rather than a scale of opposition.

Like many great works of socialist realism, "Reunion" is manifestly intended to depict a kind of "separate but equal" class unity, through the conceit that all these people, in all these walks of life, came from the same elementary school, from the same teacher. However, in the course of depicting class unity, the film points to a binary split between classes. "Reunion" strives to represent multiplicity by shifting back and forth between "types" of people, but in the process it draws a clear line between two (postsocialist) classes: *not* proletarian labor sellers and bourgeois owners of the means of production, but people who receive orders, and people who give them. The bus driver, the rickshaw driver, and the cab driver are people who earn their livings by satisfying the demands of others, who go where others tell them to go. By contrast, many of the "professionals" are directing assistants when they receive their letters, a vivid indication of their status (with the exception of the writer, who sits alone with his computer, and the Beijing opera singer, who is wiping off his own makeup).[5] They may not own the means of production (any more than the cab, bus and rickshaw drivers own their own vehicles), but they decide in which direction the vehicles move, so to speak.

Interestingly, all the professionals depicted are what might once have been called *wenhua gongzuozhe* (cultural workers): a movie actress, a *jingju* actor, an author, a contemporary art dealer, a photographer. There are no businessmen, officials, professors, engineers, bankers; there are no scenes of corporate conference rooms, PowerPoint presentations, or specialists poring over statistics. Even the architect is busy building the Bird's Nest, an overgrown cultural symbol (its computer-generated image appeared in hundreds of advertisements and several works of contemporary art long before

it was completed; the building itself has seen very little use since the Olympics, because of the marginal status of sports spectatorship in China). All the nonprofessional letter recipients, and many of the auxiliary figures in the depictions of professional letter recipients, that is, assistants, are service workers; there are no farmers, no factory workers, no soldiers. The multiplicity of class types initially evoked by the rapid cuts between very different working environments thus flattens down to two twenty-first-century classes: *professional culture producers* and *nonprofessional service workers*.

The film was clearly intended to evoke equality and unity between classes, just as the hammer and sickle symbolized parity between workers and farmers. Likewise, the subaltern status of the service workers is visually played down: they do not have the strong bodies or tanned faces that typically mark (or stigmatize) a life of labor. The bus driver's room is much nicer than the rooms occupied by most of Beijing's working-class people. But the costumes and set dressing make it exceedingly obvious that it is the cultural producers (the photographer, actress, curator and writer), with their luxurious homes and workplaces, stylish clothes, laptops, assistants, and access to foreign babes, who are materially dominant.[6]

Missing from this commercial, however, are the clients. Like the actress and the opera singer, who are both shown on break (without an audience), the rickshaw driver is depicted taking an afternoon nap, not struggling to drag a pair of overweight foreign tourists around the hairpin turns of Houhai's back alleys. The architect, the photographer, and the curator are all hard at work in the process of cultural production. There is no sign of the bidding process, of consultations with clients, of customers or consumers. But in fact, visual culture workers in China spend a great deal of time working on relations with clients, relations that are both mediated by and made through provisions of service.

In Mandarin, just as in English, there is a distinction between "clients" and "customers." Professionals like designers have "clients" (*kehu*); service workers like waiters and taxi drivers have "customers" (*guke* or *chengke*). But there is a basic similarity between these relationships that dismays many designers. Culture workers in China often bemoan the service aspect of their work, the need to serve clients who always know exactly what they want, but usually want things that are, from the designers' perspective, in poor taste. They resent the control these businessmen and party cadres exercise over their work, and sometimes call them *nongmin* (peasants) for their lack of cultural sophistication.[7] At the same time, designers often despairingly compare themselves to prostitutes—the archetypal service workers. Bidding for a project is sometimes jokingly called *chutai* (going onstage), the

phrase used to describe prostitutes lining up to be picked by customers. Moreover, as in many businesses, designers must treat their clients to evenings in bars, drinking with hostesses, in order to secure contracts. In some cases, these clients make the designer's lowly status as service workers painfully obvious.

One designer told me the following story: on one occasion when he took a group of potential clients out to an expensive karaoke bar, the portly *mami* (madam) took a liking to him, and within earshot of his clients, offered him three thousand yuan (then about five hundred dollars) for a night. The clients found this proposition hilarious, and when the madam had gone back to work, they physically carried him up to her room and locked him inside. He had to call a friend to come to the bar, find the key, and set him free. "They were just playing around," he said, but he also admitted that they would never have done that to someone more powerful (nor, I might add, would the madam have propositioned his clients, even though he was the one paying the bill, and technically *her* client). With clients, a professional who is used to receiving services, has to be attentive, receptive, and forgiving, accepting their demands about the project, meeting their needs in a range of leisure activities, and accepting their attacks on his dignity.[8]

The analogy between culture work and prostitution is even more overt in the practice communities of entertainment: opera singers and movie stars, like performers (*xizi*) of all kinds, have long been reputed to be sexually available at the right price. In "Reunion," insofar as performers and visual cultural producers are shown in parallel to one another, they appear as art workers and cultural elites. In this charming piece of *xuanchuan*, the only glimpse of the erotics of cultural production appears in the blatantly sexual expressions of the Caucasian models posing on the Great Wall in high heels and miniskirts, their legs spread for the photographer and his long telephoto lens. The framing of the shot emphasizes the dominance of the culture worker in the scene.

Chinese *xuanchuan* is usually regarded by both Chinese people and foreign observers as representing the voice of the central government. The government speaks through the cultural workers who make the propaganda. But in this case, it is possible that "Reunion" is giving voice to its makers, to the self-imaginings of certain kinds of Beijing culture workers. In "Reunion," culture workers and service workers are, in first view, shown to be united; at another level, the culture workers are shown to be materially and interactionally dominant. However, given the counternarrative of the service character of cultural work described above, the distinction "Reunion" draws between service workers and cultural producers seem less clear. Perhaps this

film is, in spite of its superficial message of unity, struggling to shore up a dangerously flimsy distinction, a class line in danger of collapsing. In order to simplify the boundary, the film omits the elite classes (e.g., executives, officials, real estate developers) to whom culture workers provide services: "By being superimposed on people with whose living conditions and mental make-up it is no longer in accord, this middle-class 'ontology' assumes an increasingly authoritarian and at the same time hollow character."[9] "Reunion" points overtly to the *integrating* function of primary education—equality and unity; but it points secondarily to the *stratifying* function of secondary education, where competition separates the best from the rest, or the lucky from the ill-fated. In contemporary China, the most explicit vocabulary for describing and acknowledging contemporary class differences is the language of "cultural level" (*wenhua shuiping*), which refers explicitly to educational background (when people register their residence in Beijing at the neighborhood police station, and the officer asks for their cultural level, the appropriate answer is middle school, high school, or college).

Part of the reason that "Reunion" can depict class difference even as it strives to depict class unity is that the work of each character in "Reunion" implicitly describes an educational history, with a specific position in the educational hierarchy. The professionals belong to fields that demand very particular forms of college-level schooling. It is unthinkable to become a bus or rickshaw driver after going to college; it is likewise unthinkable to become an architect without studying architecture, or a designer without studying design, or an actress without studying acting, or a Beijing opera performer without studying Beijing opera. If you want to make it in the cultural fields in Beijing, it is best to have studied at a good school (which is to say a school in Beijing), and if not as an undergraduate, then as a student in a graduate program or one of the many (less competitive) advanced studies programs run by prestigious schools.

The people depicted in "Reunion," all seemingly in their early forties, would have been in elementary school thirty years ago, or at the end of the Cultural Revolution and the very beginning of Deng Xiaoping's reforms. They were among the first generations since Liberation (1949) for whom education would have such determinative power. For this generation, competition to enter college was exceedingly intense; many people took art school entrance exams for five to seven years before matriculating, and many people tested for years without getting in at all. As described in chapter 2, at that time, the Ministry of Education was still operating higher education on an "elite education" basis, and the number of college students was miniscule in comparison to their number after the late 1990s. A single depart-

ment in one of Beijing's prestigious art schools would take only a handful of students a year.

As argued in chapter 3, since the 1990s, the number of students accepted into art schools has expanded radically, but the number of people testing to get into them has also expanded, so the competition remains intense. Studying art (the first step toward entering any visual culture field) is often regarded as a way for students with suboptimal grades to get into university. The test is, in some ways, a method of instituting equality: everyone has to pass through it, and stories of smart youngsters from the countryside managing to test into the very best colleges are not rare. On the other hand, the correlation between class background and success on the *gaokao* is clear and obvious, and the availability of "back doors" to those with money or connections is a commonly known fact.

At the start of "Reunion," the classmates are estranged from one another and from their teacher. In real life, as described in chapters 2 and 6, the problem of alienation—the loss of intimacy that characterized the 1980s, as people were drawn apart by work, migration, and material inequity—is a theme of much art, literature, and private conversation. "Reunion" presents a narrative of healing the rifts caused by economic development: the old teacher is found by chance, appearing as a spot of calm in the hectic traffic of the city, and the bus driver manages to arrange a reunion in her honor. But this fictional reunion is possible only because both the teacher and her many students are Beijingers who still live in Beijing, a geographic immobility that is unusual in contemporary Beijing, and in many other Chinese cities.

Beijing remains a (if not the) center of most major cultural industries in China, from academia to advertising, and this piece of *xuanchuan* represents that. However, in order to represent a healing reunion between cultural producers and service workers, the film has to gloss over the presence of outsiders in Beijing, people whose elementary school teachers are somewhere else. The category of *liudongrenkou* ("floating population")—people from outside the city—is usually associated with semi- and unskilled labor, all the forms of employment called *dagong*. Construction workers, security guards, restaurant workers, shopgirls, hair cutters, and prostitutes compose the prototypical "floating" populations. In reality, however, migrants fill many professions and social roles in the contemporary Chinese city.

The rickshaw drivers who live and work in Houhai, figured in "Reunion" as a symbol of Beijing, are almost all from places such as the northeastern province of Heilongjiang, and their relations with their remaining Beijing-native

neighbors are often tense, since they are seen as having low *suzhi* ("quality"). In 2008 a rickshaw driver in the Houhai area killed a woman retiree who lived in the same yard by slashing her with a kitchen knife—a far cry from the tender scene of the letter delivery in "Reunion." The cab and bus drivers that figure prominently in the film are legally required to be Beijingers, but the vast majority of them come from areas which have only recently (in the last two to ten years) been incorporated into the city, as farmlands are razed to make way for the relentless march of the ring roads (numbers four, five, six, etc.), subdivisions, and boulevards.

Indeed, the vast majority of professionals in Beijing are also "floating," both in the sense that they are not registered as Beijingers (*liudong,* meaning mobile or flowing, but typically translated as "floating" in relation to population), and in the deeper sense of *piao* (a more poetic term for floating), a term young urban professionals often use to describe the experience of being unmoored, not tied down to a house or *danwei* (work unit). For them, residential status is only a problem once they have children, because without a Beijing *hukou* it is inordinately expensive (and increasingly difficult) to get children into school. As long as you have money and do not seem working-class, you are unlikely to be harassed by the subway police about your residential permit (something that happens on a regular basis to more scruffily dressed cultural producers such as musicians and street singers). If you have enough money, you can even get in car accidents without fear of the police hassling you about what you are doing in Beijing. For these professionals, Beijing has already become home; they do not plan ever to leave it, even if they complain about its traffic, pollution, and increasingly prominent regulatory apparatus. But they are disconnected, spatially and linguistically, from their hometowns—hometowns to which their children are increasingly relegated by the crackdown on school enrollment. Cell phones ring and they switch to dialect.

The little, torn, black-and-white school picture that forms the crux of "Reunion" depicts a group of forty-somethings at the moment of innocence, at the last age when schooling is primarily directed to unifying memorization, rather than competitive testing. People often fondly remember early elementary school, in which the whole class belted out poems and speeches in unison, as a time of play. Middle school and high school, by contrast, are often described as a time of exhausting test preparation and competitive ranking. But because the characters in "Reunion" are in their early forties, the torn photograph also depicts a moment in the life of the People's Republic of China, the exact moment when reforms began, a time now regarded nostalgically. The 1980s are here depicted as a time preceding contemporary class

divides, when there were no fancy karaoke bars, no *mami*, no *kehu*, no cabs, no galleries, no foreign models, and no assistants: a moment that, regarded from a certain perspective, was as innocent as elementary school.

This depiction of reunion offers a fleeting recovery of a long-lost unity, in stark contrast to the optimistic and stable unity depicted in classic socialist propaganda. This is the unity of a class of first-graders, all equal before their teacher, just as all these forty-somethings are equal before the *pusu* (simple) virtue and respectability of their elderly teacher. The teacher, as both a symbol of authority and a representative of the generation that grew up with Maoism, the generation that retired soon after the age of reforms, the generation that never participated in a market economy, stands entirely outside of contemporary class relations. In this context, the question this group of forty-somethings asks their old teacher—*Nin hai jide women ma?* (Do you remember us?)—can be read as a plaintive call for recognition from the past.

In 2008, no one declared the end of "reform and opening up," but the phrase was no longer used to describe the present. Instead, the preferred term for the goal of state policy in a market economy was "development" (*fazhan*). China had been "postsocialist" for as long as it had been socialist, and as described in chapter 2, reflections on that parity both inside and outside of China seemed to beg the question of the next stage of history. In conclusion I briefly consider the chronotopes of transition that coalesced around China in 2008, and attempt to frame the question of the possible futures of both postsocialism and self-styling in China in terms of a global political economy.[10]

In 2008 the global economic crisis caused by the American and European financial industries came to a head and provoked a critical awareness of capitalism as a form of political economy. Arguments between followers of Polanyi and Keynes on the one hand, and Hayek and Friedman on the other, came to the front stage of national and international media. In 2009 the *Financial Times* published a four-part series about "The Future of Capitalism." The first part, titled "Seeds of Its Own Destruction," opened with a striking graphic: Ronald Reagan, Margaret Thatcher, Alan Greenspan, and Deng Xiaoping, silkscreened in red and blue, as the four faces of "liberalization," with the following tagline: "Another ideological god has failed. The assumptions that ruled policy and politics over three decades suddenly look as outdated as revolutionary socialism."[11] The image posited Deng Xiaoping as a member of the core group of neoliberal leaders who orchestrated a global transition toward economic liberalization, deregulation, and privatization beginning in the early 1980s, aligning China's political/economic history with that of the West. The tagline, on the other

hand, framed Western economic history in terms of China's historical narrative: three decades of revolutionary socialism and three decades of getting gloriously rich (the style of the image made a similar point, with its vague likeness to Andy Warhol's prints of Mao).

Martin Wolf took it as a point of fact that China was able to weather the economic crisis because it never liberalized the way that Western countries did. In China the state continues to control all major industries, including finance, and was able to temper the effects of the financial crisis through a massive stimulus program, while Western governments fell one after the other into austerity measures, cutting basic social services and safety nets, while bailing out banks. In making this point, Wolf gestured ominously to "China's rise" and the eminent decline of Western civilization.[12] The future of liberalism seemed uncertain. America, the aging world power, was compared to Rome and the British Empire. Even Francis Fukuyama published a paper called "After Neoconservatism," condemning "benevolent hegemony" and retracting his former support for "democracy building."

Within China, 2008 was also frequently figured as marking China's apotheosis as a powerful country (*qiangguo*), a developed country (*fada guojia*), possessed of the economic, political, and military means to demand recognition from its former colonizers and resist American imperialism (*meidiguozhuyi*). The tropes of global friendship and harmony that framed the Olympics and the Shanghai World Fair in 2010 were figured against a long history of oppression and antagonism. In China, state and popular discourse made frequent reference to the idea that China was becoming an ethical world power, contrasting China's benevolent "soft power" (e.g., bringing economic development to Africa) to American imperialist interventions in the Middle East. State media took the success of the Chinese "stimulus" as a direct refutation of the theory that that centralized economies are "woefully inadequate in creating . . . post-industrial economies in which information and technological innovation play a much larger role."[13]

Vague predictions of a peaceful twenty-first-century transfer of power between the United States and China did not last long, however. In 2011, radical popular uprisings in the Middle East and North Africa brought a renewed enthusiasm to Western advocates of democracy. Scenes of protestors in the streets and violent military crackdowns brought frequent references to Tiananmen Square. U.S. encouragement of these uprisings included NATO air strikes in Libya, formerly one of China's allies and one of its sources of oil, a move that some suggested might have been deliberately orchestrated by AFRICOM in an effort to counter Chinese power in Africa. Thousands of Chinese workers had to be evacuated and brought home from

Libya at the start of what was there called "civil war" (*neizhan*). On Chinese state media, criticisms of American imperialism increased in frequency and intensity, including special biographical segments describing Libya's dictator Muammar Gaddafi and Osama bin Laden as heroic anti-American freedom fighters. In the West, China's crackdown on its critics in the wake of the Middle Eastern uprisings—including the arrest of the prominent artist Ai Weiwei—coupled with hints of popular dissatisfaction, including that expressed in strikes and the work of other artists and writers, as well as the idea of a "Jasmine Revolution" organized online by Chinese expatriates, led to suggestions that the Communist Party was neither as popular nor as hegemonic as previously thought. These events seemed to renew the faith of liberal commentators of many nationalities in the chronotope of unfolding democracy.

It is worth returning to the clearest expression of this chronotope: Fukuyama's Hegelian synthesis of the various strands of the liberal tradition. In 1992, after the breakup of the Soviet Union, Fukuyama had argued that in liberal democracy, "mankind had achieved a form of society that satisfied its deepest and most fundamental longings":

> Desire induces men to seek things outside themselves, while reason or calculation shows them the best way to get them. But in addition, human beings seek recognition of their own worth. . . . *The propensity to invest the self with a certain value, and to demand recognition for that value,* is what in today's popular language we could call "self-esteem" . . . *the striving for liberal democracy ultimately arises out of thymos, the part of the soul that demands recognition.* . . . As standards of living increase, as populations become more cosmopolitan and better educated, and as society as a whole achieves a greater equality of condition, people begin to demand not simply more wealth but recognition of their status.[14]

This is a political economy anchored in a psychology: when reason (manifested through economics) has satisfied the material desires of the body, *thymos* begins to press for the specifically political satisfaction of recognition. Fukuyama's teleological "end of history," which continues to organize the work of many NGOs and diplomats in China, is directly opposed to the cyclical chronotope of the rise and fall of empires through which many people on both sides of the Pacific viewed the financial crisis. It is also directly opposed to the pessimism about development shared by many people in China, both young and old, rich and poor: the view that wealth leads

inevitably to moral collapse (as in the saying that "when men get rich they turn bad; when women are bad they get rich"), and that as the country grows richer it only grows more corrupt.[15]

Through an ethnographic investigation of the "creative impulses" and practices of self-styling in postsocialist China, and critical readings of art-works and other text objects from this time period, this book has described some of the forms of "recognition, self-esteem and status" that mass higher education and high "standards of living" (which is to say, commodity con-sumption) have brought to the People's Republic of China. In the years from 2006 to 2008 practices of creativity and self-styling took many political guises, in Mao's terms: "feudal, bourgeois, petty bourgeois, liberal, individualistic, nihilistic, art-for-art's-sake, aristocratic, decadent, [and] pessimistic" as well as "of the people and the proletariat." What comes after postsocialism is not yet clear (late socialism? neoauthoritarianism?). Perhaps, rather than liberal recognition, it is "anti-mainstream" (*feizhuliu*) contemporaneity: "A singu-lar relationship to one's one time, which adheres to it and, at the same time, keeps a distance from it. More precisely, it is that relationship with time that adheres to it through a disjunction and an anachronism. Those who coincide too well with the epoch, those who are perfectly tied to it in every respect, are not contemporaries, precisely because they do not manage to see it."[16]

ACKNOWLEDGMENTS

First and foremost I owe thanks to the Department of Anthropology and the Division of Social Sciences at the University of Chicago, the Foreign Language Area Studies program, the Inter-University Chinese Language Program, the Wenner-Gren Foundation, the Federal Stafford Loan Program, and the Department of Media, Culture, and Communication at New York University. Thanks to Fred Appel, Juliana Fidler, Jenny Wolkowicki, and Joseph Dahm at Princeton University Press, who gave this book great care. Thanks as well to Alison Garforth and the two anonymous readers who generously saw its potential and offered many crucial suggestions for how to realize it.

Thanks to all the people in Beijing, Jinan, Qingdao, and Zibo who shared their work and their stories with me, including many teachers, administrators, and students at the Central Academy of Fine Arts in Beijing, the Shandong Academy of Art and Design, and the Zibo Art Technical High School. They showed me so much of what I write about here, and told me how to think about it; they gave me not just opportunities to observe but critical frameworks through which to see. Most of them are unnamed here, but I would like to acknowledge Chen Nong, Chen Xi, Chen Ruixue, Li Fan, Li Yue, Mi Rong, Julia Orell, Sun Bohan, Sun Rongfang, Wang Mingming, Zhang Xiaodong, and Zheng Xuewu.

Judith Farquhar, Michael Silverstein, and Susan Gal from the Department of Anthropology at the University of Chicago guided the project in its early stages. My debts to them are unrequitable. John Kelly, William Mazarella, Stephan Palmie, Jennifer Purtle, and Manuela Carneiro da Cunha commented on this project in its early stages, Julie Chu and Nancy Munn at the end. Like all graduates of the department, I owe enormous thanks to Anne Ch'ien. Early versions were presented at the Council on Advanced Studies workshops on Semiotics, Transregional Histories of East Asia, Art and Politics of East Asia. Many discussions in the Political Communication in Society Workshop inspired themes of this book. Thanks to the East

Asian Studies Dissertation Workshop at the University of Indiana, Bloomington, especially Nancy Abelmann, Heidi Ross, and Dan Wang.

Thanks to the editors of *Anthropological Theory* published by SAGE Publications, whose assistance with and comments on my 2013 article "Evaluation Regimes and the Qualia of Quality" (along with those of my coeditor Nicholas Harkness and the anonymous readers of the entire special issue on qualia) were invaluable for my conceptualization of this book. Some of the ethnographic descriptions from chapters 4 and 5 of this book were published in that article, with some changes. Thanks also to the editors of *Anthropological Quarterly* published by The George Washington University Institute for Ethnographic Research, for permission to use a short passage from chapter 6 published in that journal in 2016 under the title "Seeing Strange: Chinese Aesthetics in a Foreign World."

Many friends and colleagues have commented on earlier drafts of chapters, including Chen Chen, Amy Cooper, Kouross Esmaeli, Joseph Hankins, Nicholas Harkness, Diana Kamin, Lauren Keeler, Andrew Kipnis, Peter Koo, Lili Lai, Alaina Lemon, Kenneth McGill, Constantine Nakassis, Laurence Ralph, Michael Ralph, Gustavo Romero, Jonathan Rosa, Martin Scherzinger, Wang Jing, and Rihan Yeh. If they were all properly credited for their insights the notes would be twice as long; if I had properly addressed all their criticisms the book would be twice as good. Thanks in particular to my colleagues Lisa Gitelman, Ben Kafka, Erica Robles-Anderson, and Nicole Starosielski for extensive advice on the arts of publication.

I owe so much to Joan Holden and Daniel Chumley, whose political theater and collaborations in China were the seeds of this project. My mother took apart the first draft, and polished the last. Thanks also to my parents-in-law Huang Xiaoguang and Xue Lihui for many months of childcare and home-cooked meals in Beijing, Fuzhou, and New York. Thanks to Zillah, who shared her life with this project from birth to kindergarten, and to Seema, who oversaw the edits. Finally, this book owes most to Huang Yifan, who like all true cynics is an idealist at heart.

NOTES

CHAPTER I: CREATIVE HUMAN CAPITAL

1. The term "dreamworlds" comes from Susan Buck-Morss (2000), *Dreamworld and Catastrophe: The Passing of Mass Utopia in East and West*, a discussion of the end of Cold War dialectic socialist and liberal utopias (by way of Benjamin). However, it also evokes Xi Jinping's slogan "Chinese Dream," a synthesis of socialist and liberal utopias.
2. See Davis 2000 for a collection of essays examining this process at a pivotal moment.
3. See Barme 1999, Fraser 2000, Lu Hanlong 2000, Wang Jing 1996, Ying Zhu 2005, Lu Xinyu 2009, Rofel 1999, Zhao Yuezhi 2008.
4. See Pang 2012, Zhang Li 2010, Wang Jing 2009, Buckley 2008, Keane 2007, Dawson 2005, Wong 2001.
5. See Gao Minglu 1998 and 2005, Wu Hung 2000, Keane 2011, Andrews and Shen 2012, and Lü Peng 2012.
6. See Wong 2014.
7. See Keane 2011, Wang Jing 2009; see Lü Peng 2012: chapters 1 and 2 for a thorough history of the development of art spaces and institutions in recent decades.
8. Just as technical schools cultivated "patriotic professional" *rencai* for science and technology. See Hoffman 2010.
9. See Woronov 2008, Kipnis 2011, Hoffman 2010.
10. See Kong et al. 2006.
11. The Korean wave refers to the massive popularity of Korean television, cinema, fashion, pop music, and celebrities throughout Asia in the late 1990s and early 2000s. Note that Li Wuwei is here referring particularly to cultural industries. See Woronov 2008 for more instances of the "marketization" of creativity in governmental and education discourses.
12. Li Wuwei, "Fazhan Chuangyi Chanye, Rang Shijie Guaqi Zhongguo Feng," http://finance.people.com.cn/GB/71364/14119345.html. See also Li Wuwei, "Guanyu woguo Chuangyichanye fazhan de sikao," http://theory.people.com.cn/GB/10426655.html; and Li Wuwei 2011. The author is a policy maker, professor, and leader in Chinese governmental discourses on creative industries.
13. These terms translate as creative energy/power/ability (*chuangzaoli*), creative character (*chuangzaoxing*), creative spirit (*chuangzao jingshen*), creating the new (*chuangxin*), and creating ideas (*chuangyi*).

14. Ministry of Education statistics 2011 (http://www.moe.edu.cn). Art students were then outnumbered only by those in the fields of engineering, administration, medicine, and foreign languages.

15. Florida's (2002) theory of the creative class was addressed, at least in part, to urban development (and he has since admitted the failure of artistic gentrification to produce the results he expected). In China, creativity certainly implies urbanity, and many neighborhoods have been remade by artists, but the destruction and rebuilding of city centers has been primarily a problem for city administrators, not cultural workers. See Pang 2012: 60–63 for a critique of Florida and Keane 2011 for a relevant discussion of Chinese urbanity.

16. See Li Wuwei 2011.

17. Tsai 2007. See chapters 2, 3, and 6 of this book for more discussion of this problem.

18. On late nineteenth- and early twentieth-century radical, revolutionary, and reformist discourses contrasting Chinese tradition and Western innovation—both aesthetic and technological—see Levenson 1953, Duara 1995: chaps. 2–5, Cohen 1997: chap. 7, and Tang 2000.

19. Here the writer says *gankao*, or imperial examinations, as opposed to *gaokao*, making a reference to the long history of testing.

20. See Hulbert 2007, Pang 2012.

21. Carly Fiorina, self-financed political candidate and former HP CEO, was mocked by Jon Stewart as a racist when she said this in 2015, despite the fact that many other politicians—including President Obama—have made the same claim, albeit more subtly. Jon Stewart responded with the parody that "sure, the Chinese invented paper and moveable type, but only so they could take more standardized tests. . . . I, on the other hand, ran a famously innovative company [Hewlett-Packard] into the ground."

22. Justice 2012: 118. See Chumley 2014 for a discussion of Justice 2012.

23. Justice 2012: 10.

24. Wong 2014, Pang 2012, Nakassis 2013b, Luvaas 2010.

25. Liu Xin 2009: 51. Liu quotes President Jiang on a visit to Daliang, China: "Oh it is lovely, a truly pretty scene. Everything looks so handsome, it can almost be compared to San Francisco" (53).

26. Li Wuwei 2011, Keane 2011.

27. Wu Hung 1995, Gao Minglu 1998, 2005.

28. Ortiz 2013.

29. Harvey 1989.

30. McKenzie 2001, cited in Silvio 2010.

31. Pang 2012: chap. 1–3. "Critics tend to describe the age of creative economy and the space of flows created by late capitalist societal networks as postmodern. I would argue instead that this economy is not a breakaway from modernity, but it's most saturated manifestation, which therefore also contains the seeds of destruction. . . . In the development of modern Western culture, the divine creative power has been secularized into two human capacities: artistic creativity and epistemological knowledge. But the two are not simply dichotomized: the latter has manifested into a strong tendency to control the former, whereas artistic creativity retains some of the mythic components of divine creation.

The tensions and dynamics involved characterize, at least partly, the formation of modernity" (30). "The simultaneous embodiment of artistic and industrial logics in creative labor is potentially revolutionary, as we can see the value of creative labor in its ability to bring to crisis the inherent limitations of both logics. . . . The creative economy seems to have provided the infrastructure to realize the democracy of creativity . . . but the myth that everybody can be creative uncritically endorses the superiority of creative labor over other forms of labor, fulfilling the human-centered modernity project in a different way" (66).

32. Pang 2012: 30.
33. For example, President Obama's 2011 State of the Union speech urged Americans to "win the future," describing America as "the country of innovation."
34. Florida argues that the global, urban, "creative class" are not only the most important producers in the "new" economy, but also the ideal consumers, *and* the model urban residents and community members.
35. Even Laikwan Pang says, "We all know that it is very difficult to teach creativity" (2012: 6).
36. Goffman 1967, Hanks 1996.
37. For similar projects on education, see Mertz 2007 on law school, Ho 2008 on Princeton recruiting, Wilf 2014 on Jazz education, and Ruchti 2012 on nursing.
38. Irvine (2002: 21). As Eckert and Rickford put it, "style is the locus of the individual's internalization of broader social distributions of variation" (2002a: 1).
39. See Nakassis 2013a, Manning 2010 on branding; see Kripke 1980 on the "baptismal events" by which names come to index particular referents.
40. Silvio contrasts "animation," as the production of an external character, with "performance," as models for social behavior (2010). Animation emphasizes the capacity of the character to circulate independently (as opposed to social role, which most be embodied); it is thus more. See also Manning and Gershon (2013) for a further analysis of this concept in relation to mediation, and Nozawa (2013).
41. Self-styling is akin to, but not the same as, the concept of "self-making" developed by Nikolas Rose. "This ideal of the unified, coherent, self-centered subject was, perhaps, most often found in projects . . . whose very existence suggests that selfhood is more an aim or a norm than a natural given. . . . If our current regime of the self has a certain 'systematicity,' it is, perhaps, a relatively recent phenomenon, a resultant of all these diverse projects that have sought to know and govern humans *as if they were* selves of certain sorts" (Rose 1996: 4). As Althusser puts it, "The reproduction of labour power thus reveals as its sine qua non not only the reproduction of its 'skills' but also the reproduction of its subjection to the ruling ideology or of the 'practice' of that ideology" (2006: 88).
42. See Wang Jing 2009, Wang Ban 1997, Liu Kang 2000, Farquhar 2002, and Zhang Xudong 2002. Compare Tran 2015 for an argument demonstrating the complex translingual character of postsocialist discourses of "emotion" in Vietnam.
43. Irvine 2002, Bakhtin 1982.
44. Liu Xin 2002: 128–29.
45. Hebdige 1979.

46. This is a process known as enregisterment. See Silverstein 2003, Agha 2005.
47. Bourdieu and Passeron 1977; Bourdieu 1984, 1996a, 1996b.
48. See Kipnis 2001.
49. The Number Five line heads from the suburbs on the south side of the Fifth Ring Road, through the center, and up almost to the northern Sixth Ring Road, carrying office workers to the ever-more-distant developments where they buy apartments.
50. At a meeting I attended in 2012, a group of exceedingly stylish and individual Shanghai designers sat around discussing the design of a new and even more inexpensive paper bowl for instant noodles. These educated creative workers mostly ignored the consumer research their company had procured, and based their design decisions on their own assumptions about the colors and features that might attract young migrant laborers; their qualification to be in the room and make such decisions was their own self-styling.
51. Certainly there are many self-taught artists and designers with unique and unusual styles, as Winnie Wong has described in her book on contract painters—none of whom went to art academies. However, those without creative credentials often find it hard to achieve success in culture work, as indicated by the fraught desire for alternative credentialing (such as the Dafen training center, Wong 2014: 91). See chapter 3 of this book on test prep schooling.
52. See Becker 1982: chap. 2 on convention.
53. Hebdige 1979, Bourdieu 1993.
54. See Gumperz 1968, Silverstein 1997.
55. Gal and Irvine 1995. Compare this to nationalism or team loyalty, in which names and logos and identifying terms are foregrounded.
56. So even if the "self-styling" of students in a community is quite similar, those similarities will be systematically erased rather than enhanced or foregrounded. Gal and Irvine 1995. Compare this to the situation of brand "styling" of service labor, ensuring a uniform and consistent experience of interactions across service encounters described in Cameron 2000.
57. See Zhang Qing 2008 for an account of Beijing social divisions and tensions in a linguistic variable (rhotacization).
58. Lim 2014, Zhao Dingxin 2001, Calhoun 1994.
59. In most communities until the late 1980s, a woman could not wear fashionable, attractive clothing without attracting rumors and criticism, young people could not date or have premarital sex without facing censure, and a man could not engage in extramarital relationships without threatening his career.
60. Farquhar 2002, Karl 2010, MacFarquhar and Schoenhals 2006.
61. Farquhar 2002, Osburg 2013, Yan Yunxiang 2003, Zhang Li 2001, Liu Xin 2002.
62. Yan Yunxiang 2005, 2009.
63. E.g., Ong 2006a, 2006b, Ren Hai 2010a, 2010b.
64. Kipnis 2007, 2008, Zhang Li and Aiwha Ong 2008.
65. Hoffman 2010: 7. For a complete analysis of state control of media, see Zhao Yuezhi 2008; on state influence over art and cultural policy, see Keane 2011; for an example of the ongoing influence of socialist theory in the Communist Party bureaucracy, see Liu Xin 2009: chap. 4, "The Specter of Marx."
66. See Lü Peng 2012 for a history of the detachment of art from state control.

67. For example, Suzhou's massive Strawberry Music Festival was entirely cancelled in 2011, resulting from musician Zuoshao Zhuzhou's public demonstration of support for imprisoned artist Ai Weiwei at an earlier music festival.
68. Yang Guobin 2008.
69. See Farquhar 2002, Farquhar and Zhang 2005, Boyer and Yurchak 2010, Yurchak 2008a, 2008b.
70. Farquhar and Zhang 2005, Zhang Xudong 2002.
71. E.g., Mertz 1998, 2007, Ochs and Capps 1996.

CHAPTER 2: THIRTY YEARS OF REFORM

1. See Wang Jing 1996 and 2009 for analyses of this process over time.
2. Wang Jing 2009, Davis 2000, Yurchak 2008a, Humphreys 2002.
3. See, e.g., Zhao Yuezhi 2008, Wu Hung 2000 and 2009, Wang 2013, Lü Peng 2012, Chen Ruilin 2002.
4. Tang and Parish 2000, Hertz 1998, Tsai 2002. See also Susan Greenhalgh's 2008 book on population control, which demonstrates how a socialist biopolitics differed from a neoliberal one.
5. Zhang Xudong 2008: 15.
6. Granovetter 1973.
7. For more on this period, see Wu Hung 1995; it is also discussed in chapter 4.
8. Teachers' monthly salaries were then 100 yuan, and students could live on 20 or 30 yuan a month. Meals cost only a few mao (0.10 yuan).
9. Sometimes this led to questionable decisions: in one story I heard from an artist who had been a CAFA faculty member in the early eighties, as the (all male) faculty sat watching the test takers draw, they began complaining to each other that the female students were all unattractive. They decided to "let a pretty one in," and picked out one girl from Sichuan ("Ei, nage zenmeyang? bucuo, bucuo"). One teacher went to peek at her drawing in order to be able to recognize it when it was turned in. It almost went into the rejected pile, but luckily he saw it again; she was admitted, and later allegedly became a well-known artist.
10. Ai Weiwei 2002: 82.
11. Xiao Yu, quoted in Ai Weiwei 2002: 82 (my translation from the Chinese text rather than the English text).
12. 2008 CAFA catalogue.
13. As a result of these requirements, it seems likely that the Fine Arts Divisions of CAFA and many other art schools will become increasingly insular, and that the many faculty members in these departments who are linked (personally or by marriage) to the party apparatus are likely to increase in influence. On the other hand, the Design Divisions are only going to be increasingly oriented to "global" circuits and Western urban centers. It is tempting to speculate that this contrast reveals an underlying aesthetic ideology. Perhaps the Cultural Affairs Bureau regards the fine arts as having a potential for political communication that commercial design does not; as a result, the faculty in art departments are required to have a deeper training in (and willingness to affect allegiance to) state ideology, even as design faculty are encouraged to turn

"outward" and to direct their students toward global aesthetic communities (and global markets).

14. *Xuanchuan* lacks the negative associations of the English word "propaganda"; it might also be translated as "public service announcement." *Xuanchuan* comes in many forms, some of which descend from older forms of socialist propaganda (such as red banners bearing white slogans hung in the streets) and some of which derive from the visual forms associated with capitalism, such as full-color billboards and highly produced, short television commercials that rely more on visuals than text. Classic 1970s socialist propaganda posters have been reduced to historical kitsch, and China is full of all forms of commercial advertising; but while styles and media have changed, government-funded exhortative, expressive, encouraging, and cautionary messages continue to occupy a great deal of visual and sonic space in China. See Barmé 1999b.

15. The Public Security Bureau's response to this open criticism was predictable, if surprisingly slow. In May 2009 Ai Weiwei's blog was shut down; in August 2009 he was beaten to the point of cerebral hemorrhage; in November 2010 he was placed under house arrest; in January 2011 his studio in Shanghai was demolished; in April 2011 he and his wife and assistants were taken into custody.

16. As Judith Farquhar notes, "There is a very clear cohort effect in contemporary China. I need only ask a new acquaintance how old he or she is to receive, unsolicited, a brief litany of the key personal facts that place him or her in the official history of the People's Republic." Farquhar 2002: 16.

17. See, for example, the interviews in Ai Weiwei 2002.

18. In China, the past occupies a much greater portion of the narrative field than the present (let alone the future), from Taiwanese kung fu novels and Hong Kong kung fu movies to PRC drawing room comedies set in imperial courts, nostalgic telenovelas recounting 1960s romances, films depicting lives buffeted by national upheavals, and "avant-garde" artworks looking at the past. Movies and television series trace and retrace historical periods and material cultures, using the rapidly disappearing material ephemera of the socialist era and the early 1980s. Many of the artworks described here engage in this archaeology of the recent past, collecting, reframing, and annotating everyday objects.

19. Duara 1995: 9.

20. Many families in China have such pictures: they are an essential memento of the visit to Beijing that people from all over China, including poor farmers, expect to make at least once, a kind of national pilgrimage.

21. I translated this essay for Chen Xi and here present my translation from the unpublished text; it was also printed in an exhibition catalogue.

22. Chumley and Harkness 2013.

23. This phrase, which means beautifully dressed, is a complex metaphor: *huazhi* (flower on a branch) is a noun that can refer to a flower, a beautiful woman, or a squid; *zhaozhan* means to flutter or wave.

24. Her other paintings were not politically radical but were hardly conservative, either: one notable series depicted ruddy-faced, well-fed sex workers, covered in soap as if in the shower, standing on lively Beijing street corners: a sophisticated inversion of various tropes of gender and sexuality common in contem-

porary Chinese art (albeit very different than Liang Yuanwei's) and a lovely series of paintings.

25. Many of these *siheyuan* belonged to military leaders, as evidenced by their People's Liberation Army guards and chauffeurs and the military plates on their cars.

26. The word used here for "fireworks" is *lihua* ("celebration flowers").

27. A perhaps comparable treatment appeared in the "Homesickness" exhibit discussed below. In Li Wei's painting *women yiding yao . . .* (We have to . . .), a group of people in Mao suits walk in formation down a monochromatic street in which the only color is the cut-off slogan, painted on the wall; we don't know what they have to do, and though we can see that they are shouting, we can't hear any voice.

28. *Zhuyi anquan* ("pay attention to safety") is used in warning signs equivalent to the English "caution"; it can also be used as a reminder to "watch out."

29. Except, of course, to go backward (see Lim 2014). The injunction to forget those dark rooms—to leave aside the Cultural Revolution—has been the subject of many books and films, most recently Wang Xiaoshuai's 2014 *Red Amnesia*. The demand to "walk toward the future" takes many forms. When I spent a week in the hospital in 2007, in a shared room with older women having surgery, one roommate—blind and crippled by diabetes—repeatedly began weeping and narrating the story of her husband's murder in the early 1970s to no one in particular. The other roommates repeatedly told her, publicly, to be quiet and forget the past.

30. This led to the first Chinese space walk, a brief trip outside of a space shuttle, in the fall of 2008.

31. Chang E, the lady in the moon, was the wife of a tyrant emperor who sought the elixir of immortality; to save the people she took the elixir herself and fled to the moon, where she still lives, along with a rabbit. The rocket refers to fireworks, originally used for communicating ritually with heaven, now used for actual space travel.

32. At the end of 2007, auction prices had just peaked; the devastating crash in art prices that preceded the worldwide economic crisis was only just beginning.

33. T-Space 2008.

34. Ibid., 110.

35. This anthropomorphic quality was reinforced by the title, "Cakravada Mountain," a reference to cycles of reincarnation: gas tanks, like people, get used up and carted away, only to be refilled and brought back.

36. T-Space 2008: 126.

37. The combination of extreme wealth and crass consumption associated with the stereotype of the "coal boss." Shaanxi province coal mine owners are among the very richest people in China, and have thus become the stereotypic figure of the super-rich, associated with many stories of excess and arrogance. For example, a story with pictures posted around the Internet described a "Shaanxi coal boss" who ran up a twenty-thousand-yuan bill at a club and was told he could not pay with a card. So he called his assistants to bring the whole amount in one-yuan bills, and dumped the money out on the floor of the lobby, saying, "I can afford to pay it. Can you afford to count it?"

38. T-Space 2008: 184.
39. As Slavoj Žižek (1999: 4) says, "Havel also discerned the fraudulence of what I would call the 'interpassive socialism' of the Western academic Left. These left-ists aren't interested in activity—merely in 'authentic' experience. They allow themselves to pursue their well-paid academic careers in the West, while using the idealized Other (Cuba, Nicaragua, Tito's Yugoslavia) as the stuff of their ideological dreams."
40. Zhang Xudong 2008: 15. By contrast, Ai Weiwei who in 2008 began to criticize the Olympics as propaganda and was targeted by security forces for his efforts to record the names of Sichuan earthquake victims engaged in straightforward dissent.

CHAPTER 3: ART TEST FEVER

1. This chapter is based on two years of research in art test prep schools and art academies in Beijing and the cities of Jinan, Qingdao, and Zibo in Shandong province. Heartfelt thanks are due to the Wenner-Gren Foundation whose Doctoral Dissertation Research Grant made this project possible.
2. The *tongkao* apparently succeeded in raising the bar sufficiently high to make many families give up trying to use art school as a route to college. In 2009, the number of students at most of the test prep schools where I did my research had decreased by a third to a half, and the total number of test takers in Shandong province dropped precipitously to seventy thousand. The art test prep industry survives, but in the more modest niche that it occupied in the early 1990s.
3. Silverstein 2000, Woolard and Schieffelin 1994.
4. Many of these publishers are affiliated with the state in one way or another, but the production of *mofangshu* is nevertheless a profit-generating business rather than an educational service; see Zhao Yuezhi 2008 for more on the publishing industry in China and its particular economic form.
5. These are metapragmatic cotexts, see Silverstein 1993.
6. A decomposition is a series of partially completed images showing how the picture is constructed.
7. "Meaning" here should be understood as a cover term for pragmatic purposes in context, connotations, cotexts, etc. "Erasure" is used here in the specific sense introduced by Gal and Irvine 1995, Irvine and Gal 2000.
8. Rhodes and Slaughter 1997, Slaughter and Leslie 1997, Mok 1997, 2005.
9. Collier and Ong 2005: 13, as cited in relation to this topic by Kipnis 2008. See also Collier 2011, Zhao Yuezhi 2008, Tang and Parish 2000, Mok 2005.
10. Kipnis 2008.
11. In the imperial examination system, the gradual rise of the test preparation sys-tem coincided with the decay of the national universities, which by the Qing dynasty were only nominal institutions, understaffed and overenrolled, with low-status teachers who did little teaching, existing simply to grant student status. Miyazaki describes the decay of the schools and the rise of private test prep services as a de facto government policy, based on a logic that is strikingly similar to neoliberalism: "Giving examinations at intervals was much cheaper than providing proper schooling continuously. That, in practice, was left to the

people themselves" (1981: 36). Most of students' study was organized privately, as examinees started in home tutorials or private *xiaoxue*, and passed into independent study.

12. See Man-Cheong 1991 and De Weerdt 2007. A similar dialectic emerged in the imperial examination system by the Qing dynasty and persisted for several centuries. Miyazaki describes a continuous dialectic between test preparation marketers (such as publishers) and test officials, which he attributes to a universal utilitarianism: "In all times and places students find shortcuts to learning. Despite repeated official and private injunctions to study the Four Books and Five Classics honestly, rapid-study methods were devised with the sole purpose of preparing candidates for the examinations" (Miyazaki 1981: 17).

13. Woronov 2008, Hulbert 2007, Kipnis 2001; see chapter 5 for more on this question.

14. See Collier 2011, Boyer and Yurchak 2010, Wu Guogang 2000, Zhao Yuezhi 2008.

15. Thanks to Lai Lili for reminding me of this phrase and for her critical comments on this argument. "Above" can refer to any organization that generates policy, and "below" refers to the subjects of this policy, whether citizens or consumers. For example, a news segment about airline customers finding ways to get around new baggage rules is titled "ni you zhengci wo you duici"—you have policy, I have strategy. Here the spatial deictics "above" and "below" are replaced by pronouns, but the reference is clear. The "I" is poetically (by parallelism with the common version of the phrase) aligned with "below," the "you" (referring to the airlines) is aligned with "above," and we the viewers are indexically identified with the "I"/below. This situation is "dialogical" and not "dialectical" because it emphasizes relationships constituted by multimodal discursive forms and does not imply teleological progress.

16. See Silverstein 1992 on varieties of ideology.

17. For critical histories of Chinese discourses of population, see Greenhalgh 2008 and Anagnost 1997; for an overview of the demographic shift and the effects of population on governmentality, see Johnson-Hanks 2008. See Fong 2004: 86–104 on pressure and competition, and Kipnis 2011 on educational desire and its problematic relationship to population discourse.

18. Andrews 1994, Chang 1980.

19. Here I use "vision" as an analogue to "voice" (a key concept in linguistic anthropology and in many analyses of governmentality and the state, which tend to focus on more narrowly linguistic texts). I explain this usage in chapter 4.

20. In fact, as I argue in chapter 4, while the actual drawings do not circulate beyond the test system, the genres of realist imagery reproduced by the test—most importantly portraits of work-worn faces wearing blank, stoic, or resigned expressions—constitute a new realism that is "socialist," in a way particular to contemporary China, and which leaves aesthetic traces in other forms of Chinese contemporary visual culture, from photography to film.

21. Hartnett 1998, Hayhoe 1996, Tang and Parish 2000, Barlow and Lowe 1987.

22. Althusser (2006) describes the family as one of the ideological state apparatuses (ISAs), which include among others religious, educational, legal, communicational, and cultural institutions. The unity among ISAs is key to their structural power. "If the ISAs function massively and predominantly by ideology, what

unifies their diversity is precisely this functioning, insofar as the ideology by which they function is always in fact unified, despite its diversity and its contradictions, beneath the ruling ideology, which is the ideology of 'the ruling class'" (93). However, he also asserts that they may be sites of class struggle as historically existing classes and interests clash over control of them; and insofar as the position of "ruling class" is under diachronic contest, synchronic ideological conflict within the ISAs must be admitted as a possibility. In the absence of a teleological theory of history, there is no reason to believe that this dialectic will be resolved in one direction or another. It may be that it is the very overtness of Chinese Communist Party ideology—its aggressive self-representation as "party thought"—that opens space for this transparent ideological conflict.

23. Yang 1994, Kipnis 1997, Osburg 2013. See Kipnis (2011: 65) for an example of the tension between family "educational desire" and educational governance.

24. Mayfair Yang (1994) describes this as a relationship between tree (bureaucracy) and rhizomatic network (*guanxi* or exchange relations), and shows their interdependence at an early period. As for the media scandals and periodic trials related to official corruption, as Farley (1996) has argued in a different context, corruption scandals can themselves operate as a stabilizing force in a single-party government (see also Gupta 1995).

25. See Kipnis 2011 on college aspirations in rural primary schooling.

26. Almost everyone who tests for art school takes the humanities test, unless they are going into architecture or industrial design.

27. See chapter 2.

28. Consider two fieldwork anecdotes on school pressure: First, a third-grader was talking to a first-grader about homework; he said, "you think you're tired now—second grade is even harder, and third grade harder than that! By fourth grade, if you don't die of tiredness, you're an exception!" (Beijing 2008). Second, I saw an eight-year-old girl with a lot of white hair, walking with her mother. My friend noticed my surprise and said, "Yes, it's very sad, it's very common nowadays—white-hair disease." "But what causes it?" I asked. "*Yali* (pressure/stress)," he replied (Xi'an 2007).

29. A gruesome example is provided by a 2010 CCTV-4 news feature about a teenage boy fatally wounded in an accident, whose migrant-laborer parents decided to donate his organs, with the request that at least one organ go to a college student, so that "the dream of going to college" could be realized; his kidneys did in fact make it to campus. (Organ donation is very rare in China.) See also Zhao Yuezhi 2008: chap. 5 on the case of Sun Zhigang, the college graduate beaten to death by police because he was misrecognized as "merely" a migrant laborer.

30. These questions imply that you take interest in the class you call your favorite, as opposed to just naming a class in which the teacher is lenient, or in which you get the best grades; that the subjects of the national school curriculum (math, science, English, etc.) can serve as signs of personality type, allowing the adult to identify something about you; that your favorite subject and what you want to be are related, that both emerge from some essential aspect of you (order and precision, scientific curiosity, imagination, etc.); and that what you

actually will do for money (what you will "be") when you grow up might have anything to do with what you *want* or what you *like* when you are five, or eleven, or eighteen. Based on interviews with other young people, I suspect that when Lin Fan told me math was his favorite class, he meant it was the class in which he got the best grades.

31. Forced art study is especially widespread in the provinces of Shandong and Hunan, where the competition for college entrance is most intense. The *gaokao* scores required for a Shandong student to enter a particular department in a particular school—for example, Beijing Normal University's Chinese Language Department—may be as much as a hundred points higher than the average (by contrast, the few lucky children in possession of a Beijing *hukou*, or residency card, can enter with a score much lower than the average). Over the past five years, the number of students taking arts exams (*meishugaokao*) in Shandong province has gone from 70,000 to 170,000, one-third of the national total. A teacher at the Central Academy of Fine Arts jokes that if they did not cap the percentage of Shandong students allowed to matriculate, the school would be entirely composed of Shandong students.

32. There is an old prejudice against performers (*xizi*) that plays into questions of status for students in theater and dance, especially for girls: there is still a widely rumored overlap among the categories of actresses, dancers, and sex workers.

33. More than half were men; when I asked about the prominence of fathers at the testing grounds, several fathers said it was because men are better at managing information.

34. Many art students follow in the family business; I have rarely met a painter whose child was not preparing for the art test, and often met designers and painters whose fathers or mothers were provincial art teachers, or even test prep teachers.

35. See Wong 2014 and Hessler 2009.

36. Hessler 2009: 72.

37. Hessler writes, "Once, not long after we met, I asked her how she first became interested in oil painting. 'Because I was a terrible student,' she said. 'I had bad grades, and I couldn't get into high school. It's easier to get accepted to an art school than to a technical school, so that's what I did.' 'Did you like to draw when you were little?' 'No.' 'But you had natural talent, right?' 'Absolutely none at all!' she said, laughing. 'When I started, I couldn't even hold a brush!' 'Did you study well?' 'No, I was the worst in the class.' 'But did you enjoy it?' 'No. I didn't like it one bit'" (ibid., 73).

38. Wong 2014: 63.

39. For example, consider the undergraduate *trompe l'oeil* painters at the Wuhan Academy of Fine Arts.

40. For Chinese men, who are mostly habitual smokers, this is a common act of masculine deference: the younger or less powerful or supplicating man gives a cigarette to the older, more powerful, or currently-in-the-position-to-act-beneficently man. Lin is a nonsmoker, but he is also from Shandong, where people tend to stand on ceremony. However, I had never seen him give a cigarette to anyone, let alone a person in his twenties, so this was a highly marked act of deference. (See Wank 2000 in Davis 2000 for more on cigarette rituals.)

41. Lin Fan's desire to enter BAFD had emerged after enrolling at Xiaoze.
42. While bigger schools like Xiaoze have a manager and a few teachers, many *huaban* are run by one teacher and are located in residential apartments. Tuition at these smaller schools starts at around ten thousand renminbi a year.
43. Foucault 1977.
44. He closed it in 2008 when the number of students dropped by half after the institution of the *tongkao*.
45. Although people complain about the strictness of the *huaban* and its exhausting time, regulations are often looser in reality than in report: in a class that supposedly begins every day at eight o'clock, it may be nine before a sizeable group of students has congregated, and the teacher arrives shortly afterward. This fact might be taken as an example of the informality of the "informal institution," or a reminder of the amount of salt with which anthropologists should take their informants' claims. However, I noticed similar discrepancies between stated and actual event times in Chinese state-run educational institutions, such as the Central Academy of Fine Arts. This suggests a methodological point for historians and others who rely on documents: there are rationalized schedules and regulations, and then there are degrees of adherence to them, which can be discovered only ethnographically.
46. The scale of "place" depends indexically on the culturally construed distances between "there" and "here": in Beijing, people from Shandong are all *laoxiang*; in Jinan (the capital of Shandong), people from the same counties in Shandong are *laoxiang*, and others are not; etc.
47. For example, Teacher Wu's student Xiaomao (Little Mao, but also a pun for "kitten") ran away twice, and both times he used social media to contact her. The second time, when she did not respond to his text or QQ (instant messages), he waited in a popular chat room until she appeared (meaning that he recognized her screen name in that chat room), to tell her "your mother's gone crazy looking for you"; then she returned home and to the *huaban*.
48. She claimed that as a Jinan local she was unable to find work in Jinan-area veterinary offices, which would refuse to hire other locals out of fear that they would leave to open their own clinic. As a result she was applying for work at McDonald's, for which she had to interview several times and have her parents attest that she had no plans to find other work or leave the area.
49. Remember the way that Mr. Lin, the nonsmoker, gave cigarettes to the much younger Manager Zhang, expressing thanks and of course in the process suggesting a request for special consideration.
50. In Taiwan, school hours run very long and into the weekend. Despite the regulations and rhetoric against this practice in mainland China, there are other pressures—also neoliberal—for schools to engage in test prep. In my fieldwork I found that the state-run Shandong Academy of Fine Arts in Jinan and the Industrial Art Technical School in Zibo both operated their own test prep *huashi* as moneymaking ventures.
51. This inversion of the conventional assumption that economic advantages translate directly into educational capital is also recorded in Andrew Kipnis's 2001 ethnography of rural high school discipline in Shandong.
52. Bourdieu and Passeron 1977, Bourdieu 1996b.

53. Kipnis 2001. See Elman 2000 on the meritocratic aspects of the imperial examination system.
54. As Nancy Munn has argued, "positive value creation" is always in ongoing tension with negative potentials, "antithetical transformations that, in the perception of the community, specify what undermines this value or define how it *cannot* be realized" (Munn 1986: 3).
55. See Humphreys 2002 on the practice of bribery.
56. E.g., the field of *guanxi*: Yang 1994, Kipnis 1997.
57. Throughout my fieldwork, I found that female students outnumbered male students, and the imbalance became more striking as they went up the educational ladder, so that in MFA programs there were almost no male students. The same is true of art education in the United States. But in the United States, the conventional explanation is that there are more female MFA students because the upper-class women who get MFAs do not need to find gainful employment, but will rely on their husbands. In contrast, the standard explanation in China is that women in all fields need significantly higher levels of education to achieve the same professional success as men.

CHAPTER 4: NEW SOCIALIST REALISMS

1. See Wolf 2011 for a beautifully annotated collection of posters.
2. Northward drifters are migrant laborers whose official registration status is rural.
3. The unsmiling faces and slack poses of ATR are also strikingly similar to those that appear in high-art films and popular music videos.
4. Agha 2003: 243; see also Gal and Irvine 1995.
5. In drawing classes in the United States, by contrast, a short pose is usually thirty seconds, one minute, or five minutes; a long pose is one hour.
6. Like most museums in China, this is an art gallery with rotating shows and no permanent collection. There is as yet nowhere in the PRC where young art students can go to see the artwork of "great masters," Western or Chinese.
7. Barboza 2010.
8. Pan Qing, the exhibition curator and curator of the National Museum of China, quoted in Barboza 2010.
9. Kelley 2006.
10. Ibid.
11. Efimova 1997: 76.
12. Povinelli 2002: 12.
13. Agha 2005.
14. Take, for example, the body of photography produced by the WPA Federal Art Project: the migrant workers and job seekers who were photographed were unique individuals, but they appear in these photographs as characterological roles. The artists who took the photos, including Dorothea Lange and dozens of forgotten people, were also unique individuals; but the envisioner of all these pictures—the "leftist social critic" viewer indexed by framing, color, model selections, poses, etc.—is a social persona.

15. See Sontag 2003.
16. Thanks to Rihan Yeh for pointing out that Bakhtin's analysis of literary genre does focus on the social positionings implicit in those genres.
17. Carleton 1994.
18. Povinelli 2002: 39.
19. 2011 speech to the annual National Assembly.
20. Students taking *sumiao* tests are now frequently presented only with linguistic cues rather than living or plaster faces, e.g., "a forty-year old man." They have to learn to produce an appropriate face from these cues.
21. These techniques and modes of approaching the "real" are not exclusive to any particular image genre and can be combined in a variety of ways: while revolutionary romantic posters and Soviet-style history paintings bring together all five modes (light, space, color, body, face), 1930s (and 1980s) impressionism focused more on light and color, and new realisms have focused more on anatomy and physiognomy.
22. Xu 2005: 1.
23. This tactic, according to Andrews 1994, was actually first used by Japanese colonial forces.
24. Chen Yifan, quoted in Chang 1980: 32.
25. This is from a 1953 speech to the Shanghai Art Workers Political Study Group, quoted in Andrews 1980: 117.
26. For more on the question of national forms in revolutionary art, see chapter 6.
27. One interlocutor laments that because of the Cultural Revolution his adolescent drawing training ended, and he was unable to study painting seriously; instead, he spent part of the Cultural Revolution alone in a rural mountain village with nothing to do, part of it in a small town in the north of Fujian province painting pictures of Mao at the local one-room Cultural Affairs Bureau, and part of it as a Red Guard occupying the Central Academy of Fine Arts in Beijing. This was not an unusual trajectory.
28. Chang 1980: 9.
29. Cahill 1988.
30. During the Cultural Revolution many artists were punished for producing images that could be interpreted as references to contemporary events and figures only through complex semiotics drawing on prerevolutionary texts, images, and histories of interpretation.
31. Andrews 1980: 360.
32. Mao 1956.
33. "In an era when the novel reigns supreme . . . those genres that stubbornly preserve their old canonic nature begin to appear stylized. In general any strict adherence to a genre begins to feel like a stylization, a stylization taken to the point of parody, despite the artistic intent of the author. In an environment where the novel is the dominant genre, the conventional languages of strictly canonical genres begin to sound in new ways, which are quite different from the ways they sounded in those eras when the novel was not included in 'high' literature." Bakhtin 1982: 5–6.
34. Farquhar 2002: xx.
35. Greg Carleton, writing about Soviet socialist realism literature, calls this "a

semantic condition that overrides the importance of genre. . . . Any text could provide access to reality and its value (cultural utility) was predicated upon this ability" (1994: 1008).

36. Industrial arts (*gongyi*) were taught in separate schools until the late 1990s. Most "design" (*sheji*) schools were not established until the mid-1990s and early 2000s.

37. See Hoffman 2010, Kipnis 2001, 2011.

38. Quoted in Andrews 1980: 114.

39. Farquhar 2002: 23. An example is the famous "Yearning," *Kewang*.

40. As in the West, the real stars of Chinese period movies are the props, sets, and costumes that re-create a time as a material culture, and there are institutions devoted to preserving, cataloging, and organizing these objects in order to re-create these times. Such movies are often much less concerned with reproducing the immaterial features of the past, such as its modes of speech or social mores.

41. De Kooning used splashes and sloshes on a barely recognizable image of a woman; Pollock used random drips and sloshes of paint on standard-proportion canvases, with no images; Newman used highly controlled, industrial methods on irregular, unusual canvases; LeWitt used highly controlled, industrial methods on the wall of the gallery, eschewing canvases altogether.

42. Liu Xin 2009.

43. As Farquhar and Zhang argue, writing about the private self-cultivations of older Beijingers, "It is action itself that is being resisted. Activism under Mao led to such severe moral compromises and shattered social relations in communities—such as work units—where people once believed that they were likely to be surrounded by the same people in the same place for the rest of their lives. . . . Little wonder that citizens newly 'freed' by a liberalized economy turn to self-cultivation rather than overt action in search of power and influence" (Farquhar and Zhang 2005: 320–21). I would amend this to say *explicitly political* power and influence. Certainly, many middle-aged Chinese people who grew up in socialism and younger people born into the early years of reform have used the liberalized market as a sphere for vigorous "action in search of power and influence," but not of the kind imagined by a liberal political ideology—the kind that involves scenes of public chanting, placard waving, parading, and voting, scenes that feed the global liberal hunger for images of activism.

44. Contrary to Andrews, Chang, and Sullivan, 1982 did not mark the end of Soviet influence on Chinese visual aesthetics, nor did Maoist genres of popularizing propaganda disappear after the mid-1980s.

CHAPTER 5: SELF-STYLING

1. See Bailey 1990 for a general history of education reform, from Kang Youwei and Liang Qichao to Cai Yuanpei and John Dewey; see also Bai Limin for a detailed account of Liang Qichao's 1896 essays "On Reforms."

2. The phrase *gao chuangzao* or *chuangzuo* ("do creation") is roughly equivalent to "make art," as in "I'm not really making art any more" (*wo xianzai bu gao chuangzaole*); "What do you do all day? I make art" (*gao chuangzuo*).

3. E.g., Rose 1996, Harvey 1989, Ong and Nonini 1997.

4. Kunreuther 2010, Ochs and Capps 1996.

5. In contrast, college-level technical classes are not organized around dialogic group critique; rather, the teacher shows up in the studio once or twice a week, walks around to each drawing in turn, and briefly evaluates it, asking at most a few rhetorical questions.

6. As in "who are you reading?" (author) or "who are you wearing?" (fashion designer). "In creative work metonymy, a reference to a person is robustly construed as conveying a reference to their creative work product." Geoffrey Pullum, http://languagelog.ldc.upenn.edu/nll/?p=2356#more-2356.

7. Goffman 1981: 141.

8. Silvio 2010; see also Manning and Gershon 2013, and Nozawa 2013. Note the difference between this semiotic model—which puts the emphasis on the semiotic processes of projection and fetishization as a result of which objects come to be attributed agency—and actor network theory (or its dissolute heir, object-oriented ontology).

9. Manning 2010, Nakassis 2013a.

10. See Keane 1994a and Tambiah 1985. The ideology of visual language figures talk and writing as metalanguage: art and design are messages conducted in visual languages, and the metapragmatic discourse that circles around them (criticism, analysis, evaluation) is metalanguage. But of course the discourse is shaped by the metadiscourse, the language by the metalanguage. Developing a visual language requires developing proficiency in a metapragmatic discourse, conducted in a metalanguage: oral and written genres of speech and narrative. Learning to enregister a visual language is in large part a process of learning how to do metapragmatics.

11. Consider Mondrian's black grids, Warhol's Campbell soup cans, Gauguin's Tahitian women, Matisse's flat, bright colors, Pollock's drips, Gehry's silver curves.

12. Visual languages (both conventional iconographies and unconventional idiolects) are often said to transcend the social and geographical boundaries of languages: art, music, and dance are often called universal languages. They are regarded as semantically independent of speech and writing, although in practice they are routinely glossed, interpreted, or responded to with words: titles, taxonomies, labels, criticism.

13. Silverstein 1979, 1992, Woolard and Schieffelin 1994.

14. The concept of language ideology has inspired terms for the impact of ideas about semiotics on semiotic practice (semiotic ideologies) and for the impact of ideas about media on media use (media ideologies). The ways that art objects are presented, discussed, and analyzed in all kinds of situations, including critique class, are organized by semiotic ideologies about how meaning works in general and media ideologies about the communicative capacities of particular media. But because language remains a dominant model for thinking about meaning and communication, these semiotic and media ideologies are themselves shaped by language ideologies. Keane 2003, Gershon 2010.

15. Though I sat with the students, Professor Li and Jiang Laoshi regularly offered me coffee and cigarettes, signaling my status as a visiting scholar and a foreigner, hence a woman smoker; I was often invited to comment on American

art education, Western contemporary art, and other subjects relevant to my subject position.

16. This was before the advent of the smartphone or Wechat, when people still actually talked on the phone.

17. It is possible that by "quoting" particular phrases students downplay the unmarked voicing of the teacher that generally characterizes their speech.

18. As in the rhetorical question, "nizhege shenme yisi?" (what do you mean by [doing/saying] this?), an appropriate response to a dramatic action.

19. *Ni bi* (you pen) and *ni gou* (you dog) are not possible forms; these must be expressed as *nide bi* (your pen), *nide gou* (your dog).

20. The TA, earnestly failing to adequately voice the teacher, would ask students aggressively, "what are you trying to do?" (*ni daodi xiang gan shenme?*).

21. Keane 1994a, 1994b.

22. The question of the ontological relationship between *ganjue* and "thought" (*sixiang*) or "ideas" (*xiang fa*) never came up in this class, but it did not seem that these various forms of intention and response were opposed in the way that they are in Euro-American philosophy of mind.

23. Wallace-Hadrill (1986: 72), describing the proliferation of divine and political imagery in the coinage of Augustus.

24. Those tests use the qualia of drawings to evaluate students, but without reference to the students as persons. The qualia of test drawings are evaluated quantitatively, and never appear as icons or indexes of personalities. See Chumley 2013 for a comparison, and Gal and Irvine 1995 on rhematization.

25. Where in Silverstein's formulation the "language community" is at least potentially a subset of a "speech community," in this analogous case the "aesthetic community" oriented to norms of style can include multiple "practice communities" oriented to indexical norms of usage; thus the "traditional Chinese Tang-style" aesthetic community includes artists and designers working in a variety of fields, oriented to similar aesthetic norms, but with different forms of practice.

26. Like many artists of his generation he went to New York in the early 1990s and returned around 2008. He used to have a studio in Queens, but he gave it up, because his friends had all moved back and "it wasn't fun anymore."

27. One group converted Caracci's radically foreshortened *Body of Christ and the Implements of Martyrdom* into a massive landscape painting, with all the folds of cloth and flesh turned into folds of rock and tufts of trees; another group converted Botticelli's *Three Graces* into the similarly linear, romantic style of Tang dynasty mural.

28. Compare to Rose 1996.

29. When a socially awkward student who never talked in class tried to do a performance art piece, tearing up a paper and laying it out on the floor, his hands shaking with fear, Professor Li said, "We want to make you healthy, not afraid; a little more ordinary (*pusu*), a little more sober (*qingxing*). To help you relax. Not to be afraid to admit, I can't paint, I paint badly." He then proceeded to talk to the class about how this boy was twenty-four, and that meant he had tested repeatedly for years before getting into CAFA, how he often failed to turn in his homework in the foundation classes, and how he failed to engage in creativity class.

30. Here she is referring to Nike, or the *Winged Victory of Samothrace*, the famous headless Roman sculpture.
31. "Make it big" was a class assignment.
32. However, later in the class, when a student who always wore flowing, earth-tone dresses and ethnic prints presented a poorly realized painting of a Bodhisattva (also in brown), Professor Li asked where she was from. She said Inner Mongolia, and he said, "Religion is too hard, too complicated. Do something simple next time."
33. In this case thread means "clue," something like the meaning hidden with the image; it is a metaphor for a kind of indexicality.
34. The conversation ended after a little more discussion of this artist and some advice on the purchase and use of epoxy resin, not reproduced here.
35. The political implications of this piece and its critique are discussed in detail in the next and final section. Some readers, especially those aware of the history of the Freedom Goddess made at CAFA during the 1989 protests, which occupied a central place in Tiananmen Square and were destroyed by tanks, might also think that Professor Li (himself a student at CAFA during those protests) was directing her away from a political theme. This is certainly part of his general pedagogical practice. However, it must be noted that this student was completely unaware of that Freedom Goddess, had never seen a picture of it, and had only inadvertently inserted herself into this political history.
36. Long hair and fingernails on male persons signal artistic eccentricity rather than gender fluidity (as both were traditional for elegant literati men in the pre-Republican era).
37. Osburg 2013.
38. Farquhar and Zhang 2005.
39. Female nudes are acceptable in official exhibitions, but genitalia and sexual images fall under the restrictions on pornography. Professor Li communicated these limits to his students in his reaction to a boy who made two excellent pieces about sex: one a photograph of a "vagina" made out of a red lamp, some air conditioning tubing, and a bunch of cloth, the other an abstract painting of two shapes, one pink and protruding, the other a black cavity. The boy also did well in critique, articulating these pieces as expressions of his virginal curiosity about sex and reproduction. Professor Li was obviously impressed with his work but told him that he could not continue in that direction, that some things were too private, and the pieces—despite being among the best in the class—were not displayed in the final critique or in the end-of-year class exhibition.
40. Most people in mainland China have never seen images of the protests; most people who were not actually involved in protests in 1989 are not even aware that the protests began on April 16 with a commemoration of Hu Yaobang's death.
41. Yan Yunxiang 2005, 2009.
42. Farquhar 2002.
43. Oxfam Hong Kong pamphlet.
44. It is unlikely that any political movement would begin in elite schools like CAFA. Students at elite schools in China are much less politically disaffected than their counterparts in other countries, and consequently political opposi-

tion is more likely to come from migrant laborers than college students. See Hoffman 2010 on student patriotism.

45. On the postpolitical, see Chen Xiaoming 2000: 222; on self-care as an apolitical biopolitics, see Farquhar and Zhang 2005. See Lü Peng (2012: 363–90) on individualism in recent Chinese art.

CHAPTER 6: AESTHETIC COMMUNITY

1. "Creativity" and "community," "market" and "society" are here understood as dialectically related "indexical orders" (Silverstein 2003).
2. Gal 2002.
3. Silverstein 1993, 1997, Irvine 2002, Agha 2003, 2005.
4. For language registers, think of the Wolof castes griot and noble (Irvine 1990); for aesthetics, think of the subcultures in a 1980s movie about American high schools, systems of distinction almost as routinized as totemic categories: the rockers, the nerds, the preppies, the jocks.
5. Gal and Irvine 1995.
6. All of which, like genres, may be understood as "conventionalized yet highly flexible organizations of formal means and structures that constitute complex frames of reference for communicative practice" (Baumann and Briggs 1992: 144).
7. Hanks 1987: 670, quoted in Baumann and Briggs 1992: 143.
8. See Munn 1986 on mortuary exchanges.
9. Noise music is a very loud kind of experimental music involving industrial sounds, machine noises, and shrieks or drones. The aesthetic community of people who like to listen to noise music is almost exactly coextensive with the practice community of people who make, record, and sell noise music.
10. See Warner 2002.
11. This is similar to the usage popularized by Facebook, "to like," meaning to press a virtual button that lists you as a "liker" of this or that thing in its virtual identity page, and simultaneously lists this or that thing as one of your "likes," in your virtual identity page, thus establishing a relationship between you and it.
12. "In general, the most robust and effective metapragmatic function is implicit, not denotationally explicit. It resides in cotextual organization itself, that is, in token cooccurrence patterns of emergent entextualization itself" (Silverstein 2003: 196).
13. Warner 2002: 50.
14. McGill 2009.
15. The very same places may sometimes be called *jiuba* (bar) and other times *kafeiguan* (coffee shop); although they serve coffee, tea, and sandwiches, they also invariably sell beer, liquor, cocktails, and wine. I use the term "café" here to describe them, because they tend to be quiet, relatively well-lit places that open around noon, rather than loud, dark places that open at night.
16. In China, the art galleries do not organize themselves together to open their shows on the same day (as in the American tradition of the "First Friday" openings).

17. "Interests are not merely held by individuals in an unreflective manner, but are in fact quite ordinarily projected by one participant in discourse onto another. . . . By looking carefully at those discursive processes whereby interests are projected and assigned, we can begin to place interests against the complex and multifaceted representational ground which defines the making of social subjects" (McGill 2009: 268).

18. Appadurai 1986a, Kopytoff 1986.

19. *Weimiao* means "complicated," as in "it's complicated, don't ask," or "delicate," as in "it's a delicate matter, be careful"; a *weimiao* relationship is illicit.

20. Like the three-inch-thick catalogue of Chinese contemporary artists' resumes I translated for a small Beijing publisher; it was not a particularly successful publication.

21. Yang 1994, Kipnis 1997.

22. *Xiao* means "little," and is typically used before the surname of someone younger than you, as an informal address (*Lao*, which means "old," is used for those older than you). But employers and employers' friends and family typically refer to subordinates with whom they are familiar (drivers, maids, café servers, and their own company employees) as "Xiao (Surname)," regardless of their age. Calling someone older than you *Xiao* is a manifestation of elite status.

23. This tendency to separate by gender goes beyond the bourgeois household: at lunchtime in high schools, test prep schools, and small offices, boys and girls, men and women will almost always sit apart in small groups.

24. Osburg 2013.

25. Habermas 1989.

26. This was in 2007, when Ai Weiwei was associated with the bird's nest stadium, and had not yet begun engaging in public political activities.

27. See Zhang Li 2010 for a full analysis of the shift from socialist work-unit housing to private apartment buildings, and the class distinction and stranger sociality that results from that move.

28. This place lasted only two years before the studio district it was in was dismantled for a housing development, but he has found a new location even farther from the city.

29. Munn 1986.

30. See Tang and Parish 2000 for an overview of these changes.

31. See Yan Yunxiang 2009 for the sociological version of this argument.

32. In the apartment building in Beijing where I have lived intermittently since 2008, there is a large sign in bright yellow letters over the flower garden, reading "Establish a civilized community (*shequ*), and strive to become civilized city-citizens (*shimin*)." There are metal placards posted in the courtyard and in every building's lobby, listing twenty standards of ethical and moral behavior (starting with "fervently love the mother country" and "fervently love our community"); there are also red banners posted at various times, urging us to register in a civilized way, or civilly refrain from lighting fireworks at New Year's. These are exemplary of similar postings in most *shequ* or neighborhoods.

33. See chapter 2.

34. Agamben 2009: 49.
35. One of the ways that migrants maintain intimacy in the city is precisely by relying on connections to other people from their own regions. Close friends are often from the same province; groups of friends are more often from the same region of the country, or from a cluster of provinces. Over the course of a year, I spent many evenings at the house of a friend, a designer from Hunan, whose relatively spacious courtyard hosted many dinners and evenings of tea and beer drinking; the people I met there were all from southern provinces (Hunan, Fujian, Guangzhou, Zhejiang), with the exception of a director of television commercials from Beijing, who was quickly rejected from her circle because, as the Hunanese designer told me, "Ta zuoren you wenti" (literally, he has problems being a person, meaning his ethics or way of dealing with social relationships is problematic). In this group of southern friends, there was never anyone from farther north than Shandong; and in a group of artists from the north, there was never anyone from farther south than Shandong. Groups of friends often come from the same province, even if they met in Beijing, mostly because they met through networks but sometimes because being from the same province is reason enough to become friends.
36. Gorky 1932.
37. Mazzarella 2003.

NOTES TO CONCLUSION

1. The ratio of propaganda to commercials on the television or the subway TVs varies with events; in the run-up to and during the Olympics, or during catastrophes, the proportion of propaganda rises.
2. "The less the message is really believed and the less it is in harmony with the actual existence of the spectators, the more categorically it is maintained in modern culture." Adorno 1997: 141.
3. "Every spectator of a television mystery knows with absolute certainty how it is going to end. Tension is but superficially maintained and is unlikely to have a serious effect any more. On the contrary, the spectator feels on safe ground all the time. . . . Everything somehow appears 'predestined.'" Adorno 1997: 138.
4. Showing the truth in the "false realism" of television (Adorno 1997: 136).
5. "Professional" is a cipher for a certain type of educational certification given only by universities, and "nonprofessional" a euphemism for "uneducated," in the sense of non-college-educated. Education is discussed further in the next part of the essay.
6. See Barme 1995.
7. The relationship is similar whether the client is a firm making a commercial or a government agency making propaganda, though with subtle differences. See Liu Xin 2002 for an analysis of the situation of encounter.
8. "Culture monopolies are weak and dependent. . . . They cannot afford to neglect their appeasement of the real holders of power" (Adorno 1997: 122).
9. Ibid., 139.
10. Lee and Lipuma 2002.

11. Wolf 2009.
12. "The capitalists of Europe and of the United States of America are supplying the Japanese and Chinese with money and munitions, helping them to destroy each other . . . so that, when the bear has been killed, they may proceed to divide his hide among themselves. . . . I, personally, am of the opinion that the bear will not be killed, for Spengler, Van Loon and other comforters of the bourgeoisie who argue a great deal about the dangers threatening European and American 'culture,' forget to mention one thing. They forget that the Hindus, Japanese and Chinese are not really a uniform entity, but are divided up into classes" (Gorky 1932: 8).
13. Fukuyama 1992: 3.
14. Ibid., 3–5.
15. Liu Xin 2009, Osburg 2013.
16. Agamben 2009: 41.

REFERENCES

Adorno, Theodor. 1997. *Aesthetic Theory*. Translated by Robert Hullot-Kentor. Theory and History of Literature Vol. 88. Minneapolis: University of Minnesota Press.

Agamben, Giorgio. 2009. *What Is an Apparatus?* Stanford: Stanford University Press.

Agha, Asif. 2003. "The Social Life of Cultural Value." *Language and Communication* 23 (3/4): 231–73.

———. 2005. "Voice, Footing, Enregisterment." *Journal of Linguistic Anthropology* 15 (1): 38–59.

Ai Weiwei. 2002. *Chinese Artists Texts and Interviews: Chinese Contemporary Art Awards CCAA 1998–2002. Zhongguo Dangdai Yishu Fangtanlü*. Hong Kong: Timezone8.

———. 2010. *Ai Weiwei's Blog: Writings, Interviews and Digital Rants (2006–2009)*. Translated and edited by Lee Ambrozy. Cambridge, Mass.: MIT Press.

Althusser, L. 2006 [1979]. "Ideology and Ideological State Apparatuses (Notes towards an Investigation)." In *Anthropology of the State*, edited by Aradhana Sharma and Akhil Gupta, 86–111. Oxford: Blackwell.

Anagnost, Ann. 1997. *National Past-Times: Narrative, Representation and Power in China*. Durham, N.C.: Duke University Press.

Andrews, Julia. 1994. *Painters and Politics in the People's Republic of China, 1949–1979*. Berkeley: University of California Press.

Andrews, Julia F., and Gao Minglu. 1995. "The Avant-Garde's Challenge to Official Art." In *Urban Spaces: Autonomy and Community in Contemporary China*, edited by Deborah Davis et al., 221–78. Cambridge: Cambridge University Press.

Andrews, Julia, and Kuiyi Shen. 2012. *The Art of Modern China*. Berkeley: University of California Press.

Appadurai, Arjun. 1986a. "Introduction: Commodities and the Politics of Value." In Appadurai, *Social Life of Things*, 3–63.

———, ed. 1986b. *The Social Life of Things*. New York: Cambridge University Press.

Bai Limin. 2001. "Children and the Survival of China: Liang Qichao on Education before the 1898 Reform." *Later Imperial China* 22 (2): 124–55.

Bailey, Paul. 1990. *Reform the People: Changing Attitudes toward Popular Education in Early Twentieth Century China*. Edinburgh: Edinburgh University Press.

Bakhtin, Mikhail. 1982. *The Dialogic Imagination*. Translated by Caryl Emerson and Michael Holquist. Austin: University of Texas Press.

Barboza, David. 2010. "Christie's and China: An Artful Diplomacy." *New York Times*, November 19.

Barlow, Tani, ed. 2002. *New Asian Marxisms*. Durham, N.C.: Duke University Press.

Barlow, Tani, and Donald Lowe. 1987. *Teaching China's Lost Generation: Foreign Experts in the PRC*. San Francisco: China Books and Periodicals.

Barme, Geremie. 1991. "Beijing Days, Beijing Nights." In *The Pro-Democracy Protests in China: Notes from the Provinces*, edited by Jonathan Unger, 35–58. London: Sharpe.

———. 1994. "Soft Porn, Packaged Dissent, and Nationalism: Notes on Chinese Culture in the 1990s." *Current History* 98 (584): 270–75.

———. 1995. "To Screw Foreigners Is Patriotic: China's Avant-Garde Nationalists." *China Journal* 34: 209–34.

———. 1999a. "CCPTM and ADCULT PRC." *China Journal* 41: 1–23.

———. 1999b. *In the Red: Notes on Contemporary Chinese Culture*. New York: Columbia.

Barthes, Roland. 1968. *Elements of Semiology*. Translated by S. Heath. New York: Hill & Wang.

———. 1977. *Image, Music, Text*. Translated by S. Heath. New York: Hill & Wang.

Baudrillard, Jean. 1996. *The System of Objects*. Translated by James Benedict. New York: Verso.

Baumann, Richard, and Charles L. Briggs. 1990. "Poetics and Performance as Critical Perspectives on Language and Social Life." *Annual Review of Anthropology* 19: 59–88.

———. 1992. "Genre, Intertextuality and Social Power." *Journal of Linguistic Anthropology* 2 (2): 131–72.

Becker, Howard. 1982. *Art Worlds*. Berkeley: University of California Press.

Bloch, Maurice, and Jonathan Parry. 1989. "Introduction." In *Money and the Morality of Exchange*, edited by Maurice Bloch and Jonathan Parry, 1–32. Cambridge: Cambridge University Press.

Blum, Susan. 1997. "Naming Practices and the Power of Words in China." *Language in Society* 26 (3): 357–79.

Bourdieu, Pierre. 1984. *Distinction: A Social Critique of the Judgement of Taste*. Translated by R. Nice. Cambridge, Mass.: Harvard University Press.

———. 1993. *The Field of Cultural Production: Essays on Art and Literature*. New York: Columbia University Press.

———. 1996a. *The Rules of Art: Genesis and Structure of the Literary Field*. Translated by Susan Emanuel. Stanford: Stanford University Press.

———. 1996b. *The State Nobility: Elite Schools in the Field of Power*. Translated by L. Clough. Stanford: Stanford University Press.

Bourdieu, Pierre, and Jean-Claude Passeron. 1977. *Reproduction in Education, Society and Culture*. London: Sage.

Boyer, Dominic, and Alexei Yurchak. 2010. "American Stiob: Or, What Late Socialist Aesthetics of Parody Reveal about Contemporary Political Culture in the United States." *Cultural Anthropology* 25 (2): 179–221.

Buckley, Bernadette. 2008. "China Design Now." *Theory, Culture and Society* 25 (7–8): 341–52.

Buck-Morss, Susan. 2000. *Dreamworld and Catastrophe: The Passing of Mass Utopia in East and West*. Cambridge, Mass.: MIT Press.

Bürger, Peter. 1984. *Theory of the Avant-Garde*. Minneapolis: University of Minnesota Press.

Cahill, James. 1988. *Three Alternative Histories of Chinese Painting*. Franklin D. Murphy Lectures vol. 9. Kansas City: University of Kansas Press and Spencer Museum of Art.

Cai Yuanpei. 1984. *Cai Yuanpei quanji* [Complete works]. Edited by Gao Pingshu. Beijing: Zhonghua shuju.

Calhoun, Craig. 1994. *Neither Gods nor Emperors: Students and the Struggle for Democracy in China*. Berkeley: University of California Press.

Cameron, Deborah. 2000. "Styling the Worker: Gender and the Commodification of Language in the Globalized Service Economy." *Journal of Sociolinguists* 4 (3): 323–47.

Carleton, Greg. 1994. "Genre in Socialist Realism." *Slavic Review* 53 (4): 992–1009.

Chan, David, and Kaho Mok. 2001. "Educational Reforms and Coping Strategies under the Tidal Wave of Marketization: A Comparative Study of Hong Kong and the Mainland." *Comparative Education* 37 (1): 21–41.

Chang, Arnold. 1980. *Painting in the People's Republic of China: The Politics of Style*. Boulder, Colo.: Westview.

Changzheng Xiangmu [Long March Project]. 2006. "Talks at the Yan'an Forum on Art Education." Beijing: Long March Project.

Chen Ruilin. 2002. "Chinese Art at the time of Globalization." In *Chinese Art Today II*, edited by Guo Xiaochuan and Han Chao. Beijing: Beijing Chubanshe.

Chen Shiwei. 1997. "Legitimating the State: Politics and the Founding of Academica Sinica in 1927." *Papers in Chinese History* 6: 23–41.

Chen Xiaoming. 2000. "The Mysterious Other: Postpolitics in Chinese Film." Translated by Liu Kang and Anbin Shi. In *Postmodernism and China*, edited by Arif Dirlik and Xudong Zhang, 222–38. Durham, N.C.: Duke University Press.

Cheng Kaiming. 1994. "Young Adults in a Changing Socialist Society: Postcompulsory Education in China." *Comparative Education* 30 (1): 63–73.

Cheng Kaiming, Jin Xinhuo, and Gu Xiaobo. 1999. "From Training to Education: Lifelong Learning in China." *Comparative Education* 35 (2): 119–29.

Chu, Julie. 2010. *Cosmologies of Credit: Transnational Mobility and the Politics of Destination in China*. Durham, N.C.: Duke University Press.

Chumley, Lily Hope. 2013. "Evaluation Regimes and the Qualia of Quality." *Anthropological Theory* 13 (1–2): 169–83.

———. 2014. "Review of Justice, *China's Design Revolution*." *China Journal* 71: 261–63.

———. n.d. "The Symbolic Industry in the Modern City: Cultural Policy, Art and Commodification in Taiwan." Unpublished manuscript.

Chumley, Lily, and Nicholas Harkness. 2013. "Introduction: QUALIA." *Anthropological Theory* 13 (1–2): 3–11.

Clunas, Craig. 1991. *Superfluous Things: Material Culture and Social Status in Early Modern China*. Oxford: Basil Blackwell.

Cohen, Paul. 1997. *History in Three Keys: The Boxers as Event, Experience, and Myth*. New York: Columbia University Press.

Collier, Stephen. 2011. *Post-Soviet Social: Neoliberalism, Social Modernity, Biopolitics*. Princeton: Princeton University Press.

Collier, Stephen, and Aiwha Ong. 2005. "Global Assemblages, Anthropological Problems." In *Global Assemblages: Technology, Politics and Ethics as Anthropological Problems*, edited by Aiwha Ong and Stephen Collier, 3–21. New York: John Wiley.

Comaroff, Jean, and John Comaroff. 1990. "Goodly Beasts and Beastly Goods." *American Ethnologist* 17 (2): 195–216.

Davis, Deborah, ed. 2000. *The Consumer Revolution in Urban China*. Berkeley: University of California Press.

Dawson, Layla. 2005. *China's New Dawn: An Architectural Transformation*. New York: Prestel.

De Weerdt, Hilde. 2007. *Competition over Content: Negotiating Standards for the Civil Service Examinations in Imperial China (1127–1279)*. Cambridge, Mass.: Harvard University Asia Center.

Dirlik, Arif. 1989. *The Origins of Chinese Communism*. New York: Oxford University Press.

Douglas, Mary, and Baron Isherwood. 1979. *The World of Goods*. New York: Basic Books.

Duara, Prasenjit. 1993. "Bifurcating Linear History: Nation and Histories in China and India." *Positions* 1 (3): 779–804.

———. 1995. *Rescuing History from the Nation: Questioning Narratives of Modern China*. Chicago: University of Chicago Press.

Dumont, Louis. 1980. *Homo Hierarchicus: The Caste System and Its Implications*. Translated by M. Sainsbury. Chicago: University of Chicago Press.

Eagleton, Terry. 1990. *The Ideology of the Aesthetic*. Oxford: Oxford University Press.

Eckert, Penelope, and John R. Rickford. 2002a. "Introduction." In Eckert and Rickford, *Style and Sociolinguistic Variation*, 1–18.

———, eds. 2002b. *Style and Sociolinguistic Variation*. New York: Cambridge University Press.

Efimova, Alla. 1997. "To Touch on the Raw: The Aesthetic Affections of Socialist Realism." *Art Journal* 56 (1): 72–80.

Elman, Benjamin. 2000. *A Cultural History of Civil Examinations in Late Imperial China*. Berkeley: University of California Press.

Evans, Lin Jiang. 2001. "A History of Art Education in the Elementary and Middle Schools of the People's Republic of China 1949–1989: Political Currents and Influences in Visual-Arts Education." PhD dissertation, Ohio State University.

Farley, Maggie. 1996. "Japan's Press and the Politics of Scandal." In *Media and Politics in Japan*, edited by Susan J. Pharr and Ellis S. Krauss, 133–64. Honolulu: University of Hawaii Press.

Farquhar, Judith. 2002. *Appetites: Food and Sex in Post-Socialist China*. Durham, N.C.: Duke University Press.

Farquhar, Judith, and Zhang Qicheng. 2005. "Biopolitical Beijing: Pleasure, Sovereignty and Self-Cultivation in China's Capital." *Cultural Anthropology* 20 (3): 303–27.

Feld, Steven, and Aaron Fox. 1994. "Music and Language." *Annual Review of Anthropology* 23: 25–53.

Feng Yuan. 1999. "National College Entrance Examinations: The Dynamics of Political Centralism in China's Elite Education." *Boston University Journal of Education* 181 (1): 39–57.

Florida, Richard. 2002. *The Rise of the Creative Class and How It's Transforming Work, Leisure, Community, and Everyday Life*. New York: Basic Books.

Fong, Vanessa. 2004. *Only Hope: Coming of Age under China's One-Child Policy*. Stanford: Stanford University Press.

Foster, Hal. 1985. *Recodings: Art, Spectacle, Cultural Politics*. Seattle: Bay Press.

Foucault, Michel. 1977. "Part Three: Discipline." In *Discipline and Punish*, translated by Alan Sheridan, 135–230. New York: Vintage.

———. 1991. "Governmentality." In *The Foucault Effect: Studies in Governmentality*, edited by G. Burchell, C. Gordon, and P. Miller, 87–104. London: Harvester Wheatsheaf.

Fox, Aaron. 2004. *Real Country: Music and Language in Working Class Culture*. Durham, N.C.: Duke University Press.

Fraser, David. 2000. "Inventing Oasis: Luxury Housing Advertisements and Reconfiguring Domestic Space in Shanghai." In Davis, *Consumer Revolution in Urban China*, 24–53.

Fukuyama, Francis. 1992. *The End of History and the Last Man*. New York: Penguin.

Gal, Susan. 1989. "Language and Political Economy." *Annual Review of Anthropology* 18: 345–67.

———. 2002. "A Semiotics of the Public/Private Distinction." *Differences: A Journal of Feminist Cultural Studies* 13 (1): 77–95.

Gal, Susan, and Judith Irvine. 1995. "The Boundaries of Languages and Disciplines: How Ideologies Construct Difference." *Social Research* 62 (4): 967–1001.

Gao Minglu. 1993. *Fragmented Memory: The Chinese Avant-Garde in Exile*. Coedited with Julie Andrews. Columbus, Ohio: Wexner Center for the Arts.

———. 1998. *Inside Out: New Chinese Art*. Berkeley: University of California Press.

———. 2005. *The Wall: Reshaping Contemporary Chinese Art*. New York and Beijing: Albright Knox Art Gallery and China Millennium Museum of Art.

Gershon, Ilana. 2010. "Media Ideologies: An Introduction." *Journal of Linguistic Anthropology* 20 (2): 283–93.

Goffman, Erving. 1967. *Interaction Ritual: Essays on Face-to-face Behavior*. New York: Anchor Books.

———. 1974. *Frame Analysis: An Essay on the Organization of Experience*. London: Harper & Row.

———. 1981. "Footing." In *Forms of Talk*, 124–59. Philadelphia: University of Pennsylvania Press.

Gorky, Maxim. 1932. *On Which Side Are You, Masters of Culture?* Translated by Andryevskaya. Moscow: International Press.

Graeber, David. 2001. *Toward an Anthropological Theory of Value*. New York: Palgrave.

Granovetter, Mark. 1973. "The Strength of Weak Ties." *American Journal of Sociology* 78 (6): 1360–80.

Greenhalgh, Susan. 2008. *Just One Child: Science and Policy in Deng's China*. Berkeley: University of California Press.

Gumperz, J. J. 1968. "The Speech Community." In *International Encyclopedia of the Social Sciences*, 381–86. New York: Macmillan.

Guo Shengjian. 1995. "Art Education in China." PhD dissertation, Beijing Normal University.

Gupta, Akhim. 1995. "Blurred Boundaries: The Discourse of Corruption, the Culture of Politics, and the Imagined State." *American Ethnologist* 22 (2): 375–402.

Habermas, Jürgen. 1989 [1962]. *The Structural Transformation of the Public Sphere: An Inquiry into a Category of Bourgeois Society*. Cambridge, Mass.: MIT Press.

Hanks, William. 1996. "Exorcism and the Description of Participant Roles." In Silverstein and Urban, *Natural Histories of Discourse*, 160–202.

Hartnett, Richard A. 1998. *The Saga of Chinese Higher Education from the Tongzhi Restoration to Tiananmen Square: Revolution and Reform*. Lewiston, N.Y.: Mellen Press.

Harvey, David. 1989. *The Condition of Postmodernity: An Enquiry into the Conditions of Cultural Change*. Oxford: Basil Blackwell.

Hay, Jonathan. 2001. *Shitao: Painting and Modernity in Early Qing China*. Cambridge: Cambridge University Press.

Hayhoe, Ruth. 1996. *China's Universities, 1895–1995: A Century of Cultural Conflict*. New York: Garland.

Hebdige, Dick. 1979. *Subculture: The Meaning of Style*. London: Methuen.

Hertz, Ellen. 1998. *The Trading Crowd: An Ethnography of the Shanghai Stock Market*. Cambridge: Cambridge University Press.

Hessler, Peter. 2009. "Letter from Lishui: Chinese Barbizon." *New Yorker*, October 26.

Ho, Karen. 2008. *Liquidated: An Ethnography of Wall Street*. Durham, N.C.: Duke University Press.

Hoffman, Lisa. 2010. *Fostering Talent: Patriotic Professionalism in Urban China*. Philadelphia: Temple University Press.

Hulbert, Anne. 2007. "Can China Re-educate Its Education System?" *New York Times Magazine*, April 1.

Humphreys, Caroline. 2002. *The Unmaking of Soviet Life: Everyday Economies after Socialism*. Ithaca, N.Y.: Cornell University Press.

Ikegami, Eiko. 2005. *Bonds of Civility: Aesthetic Networks and the Political Origins of Japanese Culture*. Cambridge: Cambridge University Press.

Irvine, Judith. 1990. "Registering Affect: Heteroglossia in the Linguistic Expression of Emotion." In *Language and the Politics of Emotion*, edited by Catherine A. Lutz and Lila Abu-Lughod, 126–61. Cambridge: Cambridge University Press.

———. 2002. "'Style' as Distinctiveness: The Culture and Ideology of Linguistic Differentiation." In Eckert and Rickford, *Style and Sociolinguistic Variation*, 21–43.

Irvine, Judith, and Susan Gal. 2000. "Language Ideologies and Linguistic Differentiation." In Kroskrity, *Regimes of Language*, 35–83.

Jameson, Fredric. 1991. *Postmodernism, or the Cultural Logic of Late Capitalism*. Durham, N.C.: Duke University Press.

Ji Yan. 1999. "Bringing Up Ideal People for the Future." *China Today*, June, 59–61.

Johnson-Hanks, Jennifer. 2008. "Demographic Transitions and Modernity." *Annual Review of Anthropology* 37: 301–15.

Justice, Lorraine. 2012. *China's Design Revolution*. Cambridge, Mass.: MIT Press.

Karl, Rebecca. 2010. *Mao Zedong and China in the Twentieth-Century World*. Durham, N.C.: Duke University Press.

Keane, Michael. 2007. *Created in China: The Great New Leap Forward*. New York: Routledge.

———. 2011. *China's New Creative Clusters: Governance, Human Capital and Investment*. New York: Routledge.

Keane, Webb. 1994a. "The Spoken House: Text, Act and Object in Eastern Indonesia." *American Ethnologist* 22 (1): 102–24.

———. 1994b. "The Value of Words and the Meaning of Things in Easter Indonesian Exchange." *Man* 29 (3): 605–29.

———. 2001. "Money Is No Object: Materiality, Desire and Modernity in an Indonesian Society." In *The Empire of Things: Regimes of Value and Material Culture*, edited by Fred Myers, 65–90. Santa Fe, N.Mex.: School of American Research Press.

———. 2003. "Semiotics and the Social Analysis of Material Things." *Language and Communication* 23: 409–25.

———. 2008. "Modes of Objectification in Educational Experience." *Language and Education* 19: 312–18.

Kelley, Jeff. 2006. *The Three Gorges Project: Paintings by Liu Xiaodong*. San Francisco: Asian Art Museum.

Kipnis, Andrew. 1997. *Producing Guanxi: Sentiment, Self and Subculture in a North China Village*. Durham, N.C.: Duke University Press.

———. 2001. "The Disturbing Educational Discipline of 'Peasants.'" *China Journal* 46: 1–24.

———. 2007. "Neoliberalism Reified: Suzhi Discourse and Tropes of Neoliberalism in the PRC." *Journal of the Royal Anthropological Institute* 13: 383–99.

———. 2008. "Audit Cultures: Neoliberal Governmentality, Socialist Legacy or Technologies of Governing?" *American Ethnologist*, May.

———. 2011. *Governing Educational Desire: Culture, Politics and Schooling in China*. Chicago: University of Chicago Press.

Kong, Lily, Chris Gibson, Louisa-May Khoo, and Anne-Louise Semple. 2006. "Knowledges of the Creative Economy: Towards a Relational Geography of Diffusion and Adaptation in Asia." *Asia Pacific Viewpoint* 47 (2): 173–94.

Kong, Lily, and Justin O'Connor, eds. 2009. *Creative Economies, Creative Cities: Asian-European Perspectives*. New York: Springer.

Kopytoff, Igor. 1986. "The Cultural Biography of Things: Commoditization as Process." In Appadurai, *Social Life of Things*, 64–94.

Koselleck, Reinhart. 2004. *Futures Past: On the Semantics of Historical Time*. New York: Columbia University Press.

Kraus, Richard. 2004. *The Party and the Arty in China: The New Politics of Culture*. Lanham, Md.: Rowman & Littlefield.

Krauss, Rosalind. 1986. *The Originality of the Avant-Garde and Other Modernist Myths*. Cambridge, Mass.: MIT Press.

Kripke, Saul. 1980. *Naming and Necessity*. Cambridge, Mass.: Harvard University Press.

Kroskrity, Paul, ed. 2000. *Regimes of Language: Ideologies, Polities and Identities*. Santa Fe, N.Mex.: School of American Research Press.

Kuo, Jason. 2000. *Art and Cultural Politics in Postwar Taiwan*. Seattle: University of Washington Press.

Lahusen, Thomas, and Evgeny Dobrenko, eds. 1997. *Socialist Realism without Shores*. Durham, N.C.: Duke University Press.

Lee, Ben, and Edward Lipuma. 2002. "Cultures of Circulation: The Imaginations of Modernity." *Public Culture* 14 (1): 191–213.

Lei Guang. 2005. "Rural Taste, Urban Fashion: The Cultural Politics of Rural/Urban Difference in Contemporary China." *Positions* 11 (3): 613–46.

Lemon, Alaina. 2000. *Between Two Fires: Gypsy Performance and Romani Memory from Pushkin to Postsocialism.* Durham, N.C.: Duke University Press.

Levenson, Joseph. 1953. *Liang Ch'i-ch'ao and the Mind of Modern China.* Berkeley: University of California Press.

Levi-Strauss, Claude. 1969. *The Elementary Structures of Kinship.* Translated by J. H. Bell, J. R. von Sturmer, and Rodney Needham. Boston: Beacon.

Li Wuwei. 2011. *How Creativity Is Changing China.* Edited by Michael Keane. New York: Bloomsbury.

Lim, Louisa. 2014. *The People's Republic of Amnesia: Tiananmen Revisited.* Oxford: Oxford University Press.

Lin Jing. 1993. *Education in Post-Mao China.* Westport, Conn.: Praeger.

Liu Bin (Bruce). 2001. "The Diffusion of a Curricular Innovation in the Chinese Context: A Case Study of Discipline-Based Art Education and the Diffusion/Implementation Strategy of the Chinese Ministry of Education." PhD dissertation, University at Buffalo, State University of New York.

Liu, Judith, Heidi A. Ross, and Donald P. Kelly. 2000. *The Ethnographic Eye: Interpretive Studies of Education in China.* New York: Falmer Press.

Liu Kang. 2000. *Aesthetics and Marxism: Chinese Aesthetic Marxists and Their Western Contemporaries.* Durham, N.C.: Duke University Press.

———. 2002. "Aesthetics and Chinese Marxism." In Barlow, *New Asian Marxisms,* 173–204.

Liu, Lydia. 1995. *Translingual Practice: Literature, National Culture, and Transnational Modernity—China, 1900–1937.* Stanford: Stanford University Press.

Liu Xin. 2002. *The Otherness of Self: A Genealogy of the Self in Contemporary China.* Ann Arbor: University of Michigan Press.

———. 2009. *The Mirage of China.* New York: Berghahn Books.

Lu Hanlong. 2000. "To Be Relatively Comfortable in an Egalitarian Society." In Davis, *Consumer Revolution in Urban China,* 124–44.

Lu Xinyu. 2009. "Ritual, Television and State Ideology: Re-reading CCTV's 2006 Spring Festival Gala." In *TV China,* edited by Ying Zhu and Chris Berry, 111–28. Bloomington: Indiana University Press.

Lü Peng. 2012. *Fragmented Reality: Contemporary Art in 21st-Century China.* Milan: Charta.

Luvaas, Brent. 2010. "Designer Vandalism: Indonesian Indie Fashion and the Cultural Practice of Cut'n'Paste." *Visual Anthropology Review* 26 (1): 1–16.

Lynch Street, Nancy. 2004. *In Search of Red Buddha: Higher Education in China after Mao Zedong.* New York: Central European University Press.

MacFarquhar, Roderick, and Michael Schoenhals. 2006. *Mao's Last Revolution.* Cambridge, Mass.: Belknap.

Man-Cheong, Iona. 1991. "The Class of 1761: The Politics of the Metropolitan Examination." PhD dissertation, Yale University.

Manning, Paul. 2010. "Semiotics of Brand." *Annual Review of Anthropology* 39: 33–49.

Manning, Paul, and Ilana Gershon. 2013. "Animating Interaction." *Hau* 3 (3): 107–37.

Mao Zedong. 1956 [1942]. "Talks at the Yan'nan Forum on Art and Literature." In *Mao Tse-Tung Selected Works, Vol. III: 1941–1945,* 69–99. New York: International.

Marcus, George, and Fred Myers, eds. 1995. *The Traffic in Culture: Refiguring Art and Anthropology*. Berkeley: University of California Press.

Marx, Karl. 1976. *Capital*. Vol. 1. Translated by Ben Fowkes. London: Penguin.

Mazzarella, William. 2003. *Shoveling Smoke*. Durham, N.C.: Duke University Press.

McGill, Kenneth. 2009. "The Discursive Construction of the German Welfare States: Interests and Institutionality." *Journal of Linguistic Anthropology* 19 (2): 266–85.

McKenzie, John. 2001. *Perform or Else: From Discipline to Performance*. New York: Routledge.

Mertz, Elizabeth. 1998. "Language Ideology and Praxis in US Law School Classrooms." In *Language Ideologies*, edited by B. Schieffelin, K. Woolard, and P. Kroskrity, 149–62. New York: Oxford University Press.

———. 2007. *The Language of Law School: Learning to Think Like a Lawyer*. Oxford: Oxford University Press.

Miller, Daniel. 1998. *A Theory of Shopping*. Ithaca, N.Y.: Cornell University Press.

Miyazaki, Ichisada. 1981. *China's Examination Hell: The Civil Service Examinations of Imperial China*. Translated by Conrad Schirokauer. New Haven, Conn.: Yale University Press.

Mok, Ka-Ho. 1997. "Private Challenges to Public Dominance: The Resurgence of Private Education in the Pearl River Delta." *Comparative Education* 33 (1): 43–60.

———. 2005. "Riding over Socialism and Global Capitalism: Changing Governance and Social-Policy Paradigms in Post-Mao China." *Comparative Education* 41 (2): 217–42.

Munn, Nancy. 1986. *The Fame of Gawa: A Symbolic Study of Value Transformation in a Massim Society (Papua New Guinea)*. Durham, N.C.: Duke University Press.

Nakassis, Constantine. 2013a. "Brands and Their Surfeits." *Cultural Anthropology* 28 (1): 111–26.

———. 2013b. "Citation and Citationality." *Signs and Society* 1 (1): 51–78.

Nozawa, Shunsuke. 2007. "The Meaning of Life: Regimes of Textuality and Memory in Japanese Personal Historiography." *Language & Communication* 27 (2): 153–77.

———. 2013. "Characterization." *Semiotic Review* 3. http://www.semioticreview.com /pdf/open2013/nozawa_characterization.pdf.

Ochs, Elinor, and Lisa Capps. 1996. "Narrating the Self." *Annual Review of Anthropology* 25: 19–43.

Oguibe, Olu, and Okwui Enwezor, eds. 1999. *Reading the Contemporary: African Art from Theory to the Marketplace*. Cambridge, Mass.: MIT Press.

Ong, Aiwha. 2006a. *Neoliberalism as Exception: Mutations in Citizenship and Sovereignty*. Durham, N.C.: Duke University Press.

———. 2006b. "Neoliberalism as a Mobile Technology." *Transactions* 31: 1–6.

Ong, Aiwha, and Donald Nonini, eds. 1997. *Ungrounded Empires: The Cultural Politics of Modern Chinese Transnationalism*. New York: Routledge.

Ortiz, Horacio. 2013. "Financial Value: Economic, Moral, Political, Global." *HAU: Journal of Ethnographic Theory* 3 (1): 64–79.

Osburg, John. 2013. *Anxious Wealth: Money and Morality among China's New Rich*. Stanford: Stanford University Press.

Pang, Laikwan. 2006. *Cultural Control and Globalization in Asia: Copyrights, Cinema, and Piracy*. London: Routledge.

———. 2012. *China's Creative Industries and Intellectual Property Rights Offenses*. Durham, N.C.: Duke University Press.

Parmentier, Richard. 1994. "Pierce's Concept of Semiotic Mediation." In *Signs in Society: Studies in Semiotic Anthropology*, 23–44. Bloomington: Indiana University Press.

Pepper, Suzanne. 1996. *Radicalism and Education Reform in 20th Century China: The Search for an Ideal Development Model*. New York: Cambridge University Press.

Phillips, Ruth, and Christopher Steiner, eds. 1999. *Unpacking Culture: Art and Commodity in Colonial and Postcolonial Worlds*. Berkeley: University of California Press.

Pierce, Charles S. 1991. *Pierce on Signs*. Edited by J. Hoopes. Chapel Hill: University of North Carolina Press.

Plattner, Stuart. 1996. *High Art Down Home*. Chicago: University of Chicago Press.

Poole, Gregory. 2003. "Higher Education Reform in Japan: Amano Ikuo on 'The University in Crisis.'" *International Education Journal* 4 (3): 149–76.

Povinelli, Elizabeth. 2002. *The Cunning of Recognition: Indigenous Alterities and the Making of Australian Multiculturalism*. Durham, N.C.: Duke University Press.

Qiang Lianqing. 1996. "China's Higher Education under Reform." *International Journal of Educational Management* 10 (2): 17–20.

Ren Hai. 2010a. *Neoliberalism and Culture in China and Hong Kong: The Countdown of Time*. New York: Routledge.

———. 2010b. "The Neoliberal State and Risk Society: The Chinese State and the Middle Class." *Telos* 2010 (151): 105–28.

Rhodes, Gary, and Sheila Slaughter. 1997. "Academic Capitalism, Managed Professionalism and Supply-Side Higher Education." *Social Text* 51 (Summer): 9–38.

Rofel, Lisa. 1999. *Other Modernities: Gendered Yearnings in China after Socialism*. Berkeley: University of California Press.

Rose, Nikolas. 1996. *Inventing Ourselves: Psychology, Power and Personhood*. New York: Columbia University Press.

Ruchti, Lisa. 2012. *Catheters, Slurs, and Pickup Lines: Professional Intimacy in Hospital Nursing*. Philadelphia: Temple University Press.

Schein, Louisa. 2001. "Urbanity, Cosmopolitanism, Consumption." In *Ethnographies of the Urban: China in the 1990s*, edited by Nancy Chen, Connie Clark, Suzanne Gottschang, and Lyn Jeffrey, 225–41. Durham, N.C.: Duke University Press.

———. 2002. "Chinese Consumerism and the Politics of Envy: Cargo in the 1990s." In Zhang Xudong, *Whither China?*, 285–314.

Silverstein, Michael. 1979. "Language Structure and Linguistic Ideology." In *The Elements: A Parasession on Linguistic Units and Levels*, edited by Paul R. Cline, William F. Hanks, and Carol L. Hofbauer, 193–247. Chicago: Chicago Linguistic Society.

———. 1992. "The Uses and Utility of Ideology: Some Reflections." *Pragmatics* 2 (3): 311–23.

———. 1993. "Metapragmatic Discourse and Metapragmatic Function." In *Reflexive Language: Reported Speech and Metapragmatics*, edited by John Lucy, 33–58. Cambridge: Cambridge University Press.

———. 1997. "Encountering Language and Languages of Encounter in North American Ethnohistory." *Journal of Linguistic Anthropology* 6 (2): 126–44.

———. 2000. "Whorfianism and the Linguistic Imagination of Nationality." In Kroskrity, *Regimes of Language*, 85–138.

———. 2003. "Indexical Order and the Dialectics of Sociolinguistic Life." *Language and Communication* 23: 193–229.

———. 2004. "Cultural Concepts." *Cultural Anthropology* 45 (5): 621–51.

Silverstein, Michael, and Greg Urban, eds. 1996. *Natural Histories of Discourse*. Chicago: University of Chicago Press.

Silvio, Teri. 2010. "Animation: The New Performance." *Journal of Linguistic Anthropology* 20 (2): 422–38.

Slaughter, Sheila, and Larry Leslie. 1997. *Academic Capitalism: Politics, Policies and the Entrepreneurial University*. Baltimore: Johns Hopkins University Press.

Smith, Terry. 2006. "Contemporary Art and Contemporaneity." *Critical Inquiry* 32 (4): 681–707.

Sontag, Susan. 2003. *Regarding the Pain of Others*. New York: Farrar, Straus and Giroux.

Tambiah, Stanley J. 1985. *Culture, Thought, and Social Action*. Cambridge, Mass.: Harvard University Press.

Tang, Wenfang, and William Parish. 2000. *Chinese Urban Life under Reform: The Changing Social Contract*. Cambridge: Cambridge University Press.

Tang, Xiaobing. 2000. *Chinese Modern: The Heroic and the Quotidian*. Durham, N.C.: Duke University Press.

Thogersen, Stig. 1990. *Secondary Education in China after Mao: Reform and Social Conflict*. Aarhus: Aarhus University Press.

Tran, Allen L. 2015. "Rich Sentiments and the Cultural Politics of Emotion in Postreform Ho Chi Minh City, Vietnam." *American Anthropologist* 117 (3): 480–92.

Tsai, Kellee. 2002. Back-Alley Banking: Private Entrepreneurs in China. Ithaca, N.Y.: Cornell University Press.

———. 2007. Capitalism without Democracy: The Private Sector in Contemporary China. Ithaca, N.Y.: Cornell University Press.

T-Space. 2008. *Homesickness: Memory and Virtual Reality* [Xiangchou: jiyi yu xugou de xianshi]. Hong Kong: Timezone 8.

Urban, Greg. 1996. "Entextualization, Replication and Power." In Silverstein and Urban, *Natural Histories of Discourse*, 21–44.

———. 2001. *Metaculture: How Culture Moves through the World*. Minneapolis: University of Minnesota Press.

Veblen, Thorstein. 1924. *The Vested Interests and the Common Man*. London: Allen and Unwin.

———. 1994 [1899]. *Theory of the Leisure Class*. New York: Dover.

Wallace-Hadrill, Andrew. 1986. "Image and Authority in the Coinage of Augustus." *Journal of Roman Studies* 76: 66–87.

Wang Ban. 1997. *The Sublime Figure of History: Aesthetics and Politics in Twentieth Century China*. Stanford: Stanford University Press.

Wang Jing. 1996. *High Culture Fever: Politics, Aesthetics, and Ideology in Deng's China*. Durham, N.C.: Duke University Press.

———. 2009. *Brand New China: Advertising, Media, and Commercial Culture*. Cambridge, Mass.: Harvard University Press.

Wang, Peggy. 2013. "Art Critics as Middlemen: Navigating State and Market in Contemporary Chinese Art, 1980s–1990s." *Art Journal* 72 (1): 6–19.

Wang Xiaoshuai (Director). 2014. *Red Amnesia*. China: Liu Xuan.

Warner, Michael. 2002. *Publics and Counterpublics*. New York: Zone Books.

Weber, Max. 1930. *The Protestant Ethic and the Spirit of Capitalism*. Translated by Talcott Parsons. New York: Routledge.

Weiner, Annette. 1985. "Inalienable Wealth." *American Ethnologist* 12 (2): 210–27.

Weitz, Ankeney. 2002. *Zhou Mi's "Record of Clouds and Mist Passing before One's Eyes": An Annotated Translation*. Leiden: Brill.

Wilf, Eitan. 2014. *The Academic Jazz Program and the Paradox of Institutionalized Creativity*. Chicago: University of Chicago Press.

Williams, Raymond. 1982. *The Sociology of Culture*. New York: Schocken Books.

Willis, Paul. 1977. *Learning to Labour: How Working Class Kids Get Working Class Jobs*. Westmead: Saxon House.

Wolf, Martin. 2009. "Seeds of Its Own Destruction." *Financial Times*, March 8.

Wolf, Michael. 2011. *Chinese Propaganda Posters*. Cologne: Taschen.

Wong, Wendy Suiyi. 2001. "Detachment and Unification: A Chinese Graphic Design History in Greater China since 1979." *Design Issues* 17 (4): 51–71.

Wong, Winnie Won Yin. 2014. *Van Gogh on Demand: China and the Readymade*. Chicago: University of Chicago Press.

Woolard, K. A., and Bambi Schieffelin. 1994. "Language Ideology." *Annual Review of Anthropology* 23: 55–82.

Woronov, Terry E. 2008. "Raising Quality, Fostering 'Creativity': Ideologies and Practices of Education Reform in Beijing." *Anthropology and Education Quarterly* 39 (4): 401–22.

Wortham, Stanton. 2001. *Narratives in Action*. New York: Teachers College Press.

———. 2005. *Learning Identity: The Joint Emergence of Social Identity and Academic Learning*. New York: Cambridge University Press.

Wu Guogang. 2000. "One Head, Many Mouths: Diversifying Press Structures in Reform China." In *Power, Money and Media: Communication Patterns and Bureaucratic Control in Cultural China*, edited by Chin-Chuan Lee, 45–67. Evanston, Ill.: Northwestern University Press.

Wu Hung. 1995. *Remaking Beijing: Tiananmen and the Creation of a Political Space*. Chicago: University of Chicago Press.

———. 2000. *Exhibiting Experimental Art in China*. Chicago: David and Alfred Smart Museum of Art.

Wu Hung, with Peggy Wang. 2009. *Contemporary Chinese Art: Primary Documents*. MoMA Primary Documents. Durham, N.C.: Duke University Press.

Wu Jintao. 2002. *Privatizing Culture: Corporate Art Intervention since the 1980s*. London: Verso.

Wu Yuxiao. 2008. "Cultural Capital, the State, and Educational Inequality in China, 1949–1996." *Sociological Perspectives* 51 (1): 201–27.

Xu Beihong. 2005. *Xu Beihong jiang yishu* [Xu Beihong's lectures on art]. Beijing: Jiuzhou Press.

Yan Yunxiang. 2003. *Private Life under Socialism: Love, Intimacy and Family Change in a Chinese Village, 1949–1999*. Stanford: Stanford University Press.

———. 2005. "The Individual and the Transformation of Bridewealth in Rural North China." *Journal of the Royal Anthropological Institute* 11: 637–58.

———. 2009. *The Individualization of Chinese Society*. Oxford: Berg.

Yang Guobin. 2008. *The Power of the Internet in China: Citizen Activism Online*. Cambridge: Cambridge University Press.

Yang, Mayfair. 1994. *Gifts, Favors and Banquets: The Art of Social Relationships in China*. Ithaca, N.Y.: Cornell University Press.

Ying Zhu. 2005. "Yongzheng Dynasty and Chinese Primetime Television Drama." *Cinema Journal* 44 (4): 3–17.

Yurchak, Alexei. 2003. "Russian Neoliberal: The Entrepreneurial Ethic and the Spirit of New Careerism." *Russian Review* 62 (1): 72–90.

———. 2008a. "Necro-Utopia: The Politics of Indistinction and the Art of the Non-Soviet." *Current Anthropology* 49 (2): 199–224.

———. 2008b. "Suspending the Political: Late Soviet Artistic Experiments on the Margins of the State." *Poetics Today* 29 (4): 713–33.

Zhang Li. 2001. *Strangers in the City: Reconfigurations of Space, Power and Social Networks within China's Floating Population*. Stanford: Stanford University Press.

———. 2010. *In Search of Paradise: Middle-Class Living in a Chinese Metropolis*. Ithaca, N.Y.: Cornell University Press.

Zhang Li and Aiwha Ong, eds. 2008. *Privatizing China: Socialism from Afar*. Ithaca, N.Y.: Cornell University Press.

Zhang Qing. 2008. "Rhotacization and the 'Beijing Smooth Operator': The Social Meaning of a Linguistic Variable." *Journal of Sociolinguistics* 12 (2): 201–22.

Zhang Xudong, ed. 1997a. *Chinese Modernism in the Age of Reforms*. Durham, N.C.: Duke University Press.

———. 1997b. "The Power of Rewriting: Postrevolutionary Discourse on Chinese Socialist Realism." In Lahusen and Dobrenko, *Socialist Realism without Shores*, 282–309.

———. 2002. *Whither China? Intellectual Politics in Contemporary China*. Durham, N.C.: Duke University Press.

———. 2008. *Postsocialism and Cultural Politics: China in the Last Decade of the Twentieth Century*. Durham, N.C.: Duke University Press.

Zhao Dingxin. 2001. *The Power of Tiananmen: State-Society Relations and the 1989 Beijing Student Movement*. Chicago: University of Chicago Press.

Zhao Yuezhi. 2008. *Communication in China: Political Economy, Power and Conflict*. Lanham, Md.: Rowman & Littlefield.

Žižek, Slavoj. 1999. "Attempts to Escape the Logic of Capitalism." *London Review of Books* 21 (21–28): 3–6.

INDEX

Page numbers in italics refer to photographs in the text. Asterisks () indicate pseudonyms.*

239